PAINTING AND POETRY

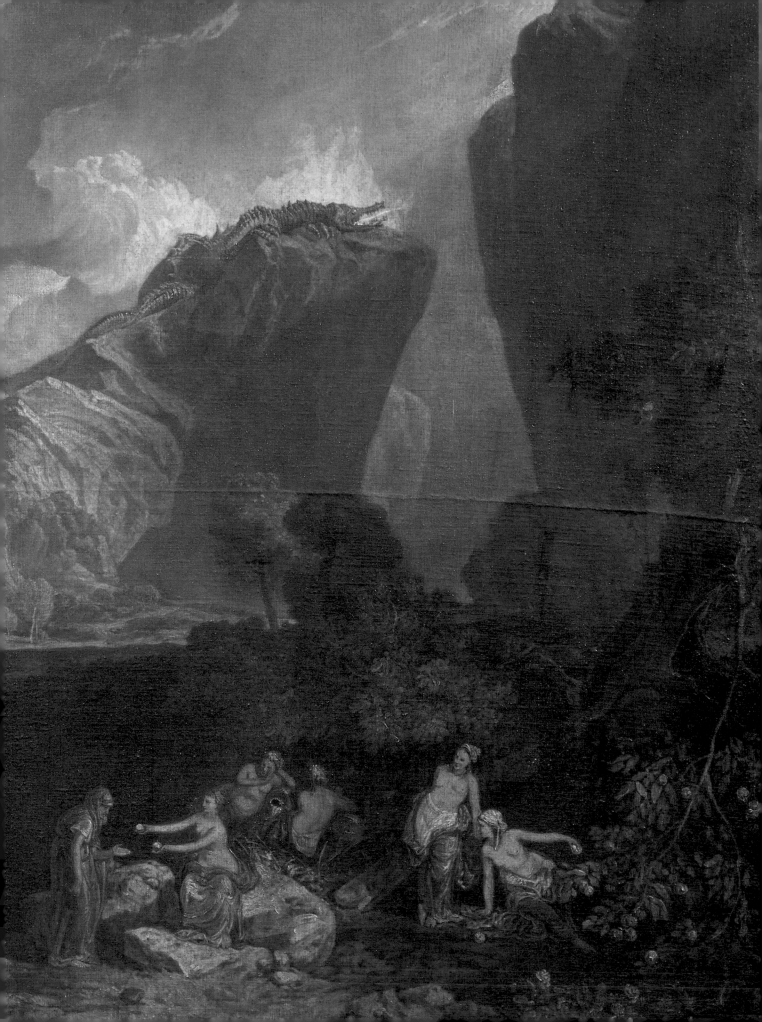

Painting and Poetry

TURNER'S *Verse Book* AND HIS WORK OF 1804–1812

ANDREW WILTON

with transcriptions by

ROSALIND MALLORD TURNER

TATE GALLERY

front cover/jacket
'The Garreteer's Petition' *c.*1808
(detail) No.42

frontispiece
'The Goddess of Discord choosing the Apple of
Contention in the Garden of the Hesperides' 1806
(detail) No.30

ISBN 1 85437 045 6 paper
ISBN 1 85437 046 4 cloth

Published by order of the Trustees 1990
on the occasion of the exhibition at the
Tate Gallery: 27 June–16 September 1990

Designer: Caroline Johnston
Published by Tate Gallery Publications, Millbank,
London SW1P 4RG

Printed on Parilux matt 150gsm and typeset in Baskerville
Printed by Balding + Mansell Limited, Wisbech, Cambs

Contents

Preface

It is not unusual for great artists to practise in media other than those in which they excel. The *violon d'Ingres* is a common enough phenomenon. Michelangelo's talent as a poet established at an early date the notion of the artist as creative genius unrestricted by the boundaries of any particular form, and many have followed his example, if not with the same success. Turner himself was probably stimulated to declare himself as a poet by the verse compositions of a fellow-painter. Yet it is still a matter of surprise, even astonishment, that an artist like Turner could have occupied so much of his time in the exercise of a completely different mode of expression. In his own day it was well known that he was a poetaster, and he was laughed at for what was perceived as the incompetence of his effusions. Time has confirmed the contemporary judgement and we are usually nowadays confronted by his pictures without the poetry that, in many cases, he intended to accompany them. Whatever our feelings about it, the poetry illuminates Turner's purposes and contributes significantly to our understanding of his art. There are times when it seems rather to confuse than enlighten; but even then it is not to be ignored.

Whether we should wish, in the end, to salvage any of his verse as being of value in its own right is another matter. There remains some doubt as to what is really his and what is copied from as yet unidentified sources, or altered by him from other poets. A few passages stand up well to analysis; several have some literary interest. But most, it must be admitted, is not worth preserving for its own sake. Fifty years ago A.J. Finberg (speaking of the long draft of a poem on the Southern Coast) gave it as his opinion that 'Turner's verses, even when polished with all his care, have very slight if any poetical value, but these fragments of doggerel have a certain personal interest. They display a warm-hearted sympathy with the common people, with their labours and the perils that beset them, and a keen interest in practical and economic affairs; but they are not worth the space and the toil that would be required to publish an accurate transcript of them' (*Life*, p.183). In his brief description of their contents, Finberg shows that the poetry deals with precisely the same subject-matter as the paintings; it can, therefore, provide a verbal explication, as it were, of many of the ideas that Turner wished to convey in his pictures. It is, at the very least, a kind of general guide to the mental processes that lay behind the creation of some of the greatest landscapes ever painted.

Turner studies have advanced considerably since Finberg's time. Obscure areas of his life and output have been subjected to close scrutiny. It no longer seems perverse or obsessive to want to know more about his poetry. This catalogue and the exhibition it accompanies are intended to explore the period when Turner's versifying was at its most intense – the relatively short period from 1804 to 1812 – and its immediate aftermath in the seven following years to 1819.

The transcriptions of all that is legible of the drafts in the notebooks of that period are offered as bearing directly on his work as a painter, and on his character as a man. Neither is irrelevant to a modern assessment of his contribution to western art.

A small group of scholars have been responsible for keeping the poetry in view as an essential ingredient in Turner's achievement. Andrew Wilton, Keeper of the British Collection and organiser of the exhibition, gratefully acknowledges all they have done to transcribe, clarify and expound the verses. Ann Livermore published the *Verse Book* as long ago as 1957, and Jerrold Ziff has explored Turner's fascination with other poets in a series of valuable articles. Jack Lindsay, both in his 1966 biography of Turner and in *The Sunset Ship* of the same year – the only anthology of Turner's verse ever printed – performed a signal service in emphasizing Turner's love of other people's poetry, and transcribing some of his own; and John Gage, in his many books and essays, has constantly drawn attention to the insights a careful study of the poetry can yield. The Tate Gallery is indebted to those who have kindly lent works to the exhibition, and to the many individuals who have helped in preparing both exhibition and catalogue, especially John Hanson, Sheila Huftel, Emily Lane, Richard Spencer, Clovis Whitfield, Robert Woof and the late Jonathan Griffin. Above all, Rosalind Turner has contributed many hours of devoted toil to deciphering and transcribing the drafts; for her enthusiasm and support we are particularly grateful.

Nicholas Serota *Director*

Debenham Tewson & Chinnocks is delighted to be sponsoring *Painting and Poetry: Turner's Verse Book and his Work of 1804–1812*. We feel that the value of this exhibition lies in being able to see the work of one of Britain's greatest artists in a broader context when shown with his poetry. Because our company strongly believes that research and detailed specialist knowledge is essential, we are particularly pleased that this exhibition will assist in widening the understanding of the work of J.M.W. Turner.

Richard N. Lay *Chairman*
Debenham Tewson & Chinnocks

A Note by Rosalind Mallord Turner

The *Verse Book* has been in the Turner family since the settlement in Chancery of the artist's Will in 1856, and has always been one of our most treasured heirlooms. It was passed down from my great-grandfather to my grandfather, then to my father, C.W.M. Turner, and, after his death in 1979, to myself. My grandfather, C.M.W. Turner, performed an immense service in caring for the family's unique inheritance, adding to it, cataloguing it and making it available to scholars. The most notable of these was perhaps A.J. Finberg, with whom he collaborated closely in research for the monumental *Life* of 1939. Their relationship is recorded in correspondence which has itself become an interesting addition to the family archive. Over the past ten years I in my turn have tried to build on my forebears' work, refurbishing and restoring the collection (which includes much of Turner's library), and researching the family genealogy and other areas that have remained obscure despite the recent proliferation of scholarly activity on and around Turner.

In addition to the *Verse Book* there are a few other pages on which Turner jotted poems. Their satisfactory transcription, and relation to the drafts in the sketchbooks in the Bequest, has always presented itself as a special challenge. It has therefore been very gratifying to be able to at last to tackle it – and an unexpectedly vast subject it has turned out to be. The poems are not, perhaps, in the class of his heroes Milton, Thomson and Pope; but they nevertheless provide valuable insights into his mind, yielding some intimate details that have not emerged before. Among these there is one especially refreshing discovery: that Turner once thought of asking, in a draft in the *Spithead* sketchbook, for this epitaph to be 'chiselled on his tomb':

Thank time for all his jewels.

Whatever yet in poetry held true
If duly weigh'd, holds just in painting too;
Alike to profit, and delight they tend,
The means may vary, but the same their end.
Alike from heav'n congenial first they came,
The same their labours, and their praise the same:
Alike by turns they touch the conscious heart,
And each on each reflects the lights of art.

> Walter Harte, *An Essay on Painting*, lines 1–8

Painting and Poetry flowing from the same fount mutually
by vision, constantly comparing Poetic allusions by
natural forms in one and applying forms found in nature
to the other, meandering into streams by application,
which reciprocally improved reflect and heighten each
others beauties like . . . mirrors

> J.M.W. Turner, Royal Academy lecture, 1812

It is this, her close relation to Poetry, which alone
raises Painting to so high a rank among the Liberal Arts.

> Henry Howard, *Painting and Poetry*, 1836

Introduction

The *Verse Book* which forms the focus of this exhibition is something of a rarity. It is one of the very few notebooks kept by Turner not to have been included in the 'Turner Bequest', now housed in the Clore Gallery;[1] it is unique in containing drafts of poetry alone, having no sketches or other memoranda of any kind. For this reason it was rejected by the Trustees of Turner's estate, and by the staff of the National Gallery, who had responsibility for adjudicating which of the vast quantity of papers in his house were works of art by his own hand and which were not. They also relinquished to the artist's family thousands of impressions of reproductive prints as not being his own work (although some in fact were), and discarded a number of his drawings that they judged to be inauthentic. Like the prints, however, the notebook is an important document of a far from negligible aspect of his creative personality.[2]

In the course of his career he used numerous notebooks as receptacles for his literary ideas, which more often than not took the form of verse. He began to scribble lines of poetry in the 1790s, and was still jotting down his thoughts, often in the margins of drawings, in the 1840s when he was in his seventies. But the most productive period of his activity in this field was the first decade or so of the nineteenth century, and it came to a climax in 1812, the year in which he exhibited his epoch-making historical landscape 'Snow Storm: Hannibal and his Army crossing the Alps' (No.59) with the first of his citations from a 'manuscript poem', the *Fallacies of Hope*, and delivered a lecture at the Royal Academy Schools in which he gave full expression to his sense that poetry can help to elucidate the task of the painter.[3] It is to those years that the *Verse Book* belongs.

That Turner read poetry became clear at an early point in his career. In 1798 the Royal Academy passed a resolution to the effect that thenceforward exhibitors at the Spring Exhibitions might, if they chose, give quotations in the catalogue entries for their submissions instead of, or in addition to, a title. (Their original habit of doing so had lapsed, more by accident and to save costs in typesetting, apparently, than because of any disapproval of the idea in principle.) Turner availed himself of the new dispensation. It was an affirmation of an evidently strongly held belief that poetry and painting are complementary arts.

The classic view, that the two are 'sisters' in the evocation of emotion through the description of the natural world, was all-important in defining eighteenth-century attitudes to painting, and to landscape painting in particular.[4] More was involved than simply a matter of reciprocity or opposition, the idea that poetry is 'word-painting' while painting aspires to be 'poetic'. The whole understanding of what constitutes a work of art was conditioned by the principle expressed by Horace in his famous phrase *ut pictura poesis* – that poetry is a means of describing verbally what painting presents visually, and vice versa.[5] Much debate arose over the exact train of causality between experience, perception, memory and

description, and over the ways in which poetry and painting differed in their technical capacity to render the effects on our senses of these epistemological events. The dimension of time was the prerogative of poetry: movement and sequence are ideas inimical to the visual image, while on the other hand the evocation of space, distance and atmosphere is peculiarly suited to painting. Even more important, the faculty of association, whereby literary and philosophical ideas, historical and mythological events are brought into relation with present experience, contributes a further dimension to both media.[6] We cannot contemplate an ancient building, for instance, without calling to mind the uses to which it has been put at different periods, the people who have been connected with it, and its significance as the scene of specific events. A building of universal interest will be associated with important moments in the history of its neighbourhood, even of the nation, or may have been the setting of some particularly intense personal drama. Yet another layer of association is added by the arts of painting and poetry themselves: the spot may have been celebrated by a poet, or recorded by an artist, in such a way that it has become endowed with a special character dependent in part on our knowledge of that writer or painter. The literary bias of so much eighteenth-century painting – and certainly of all that claimed to be fully serious – is explained by this important assumption about how we perceive the world. Sir Joshua Reynolds, in his third Discourse to the students of the Royal Academy Schools, had enunciated a principle that must itself have exercised considerable influence on Turner, who greatly admired him: he spoke of the serious artist as one 'who enlarges his understanding by a variety of knowledge, and warms his imagination with the best productions of ancient and modern poetry'.[7]

It was, then, a matter of course and indeed a professional necessity that artists should be well-read. Turner was no exception to this rule. He must have availed himself of the library at the British Museum, very close to his early home in Covent Garden, and the Royal Academy library provided access to many relevant works. But he also built up his own collection of books.[8] One of the earliest publications to come into his possession seems to have been a comprehensive edition (called 'Complete' on its engraved title-page) of *The Works of the British Poets. With Prefaces, Biographical and Critical*, by Robert Anderson, M.D. (No.1). It was published in London in 1795, having appeared originally two years earlier in Edinburgh, and so when Turner first needed it, in 1797 or 98, was among the most recent compendiums of its kind. The thirteen volumes, finely bound in leather with gold-tooled spines, have survived in good condition, hardly betraying the extensive use to which they must have been subjected. But there can be no doubt that Turner did use them: on the back flyleaf of volume XII are memoranda in his hand, referring to the translation of Lucan's *Pharsalia* that is printed there. Although there are omissions obvious enough to the modern reader, Anderson's claim that the collection was complete was not unreasonable: Chaucer does not appear, but the first volume contains the poems of Spenser and Shakespeare, as well as those of two minor figures, Sir John Davies

and Joseph Hall. Some of the Metaphysical poets, such as Marvell and Herbert, are noticeably absent; but Donne is there, along with Johnson's famous strictures against his lax metre and fantastical imagery. *Paradise Lost* and the rest of Milton are present, and a host of lesser seventeenth-century men, including Michael Drayton with his *Poly-Olbion* and Samuel Butler with *Hudibras*. The eighteenth century is represented very fully, although we should remark on the absence of Cowper and Burns. (Turner made up for this latter omission by acquiring a four-volume edition of the works of Robert Burns published in 1802.) In addition to all this material, Anderson's last two volumes offer important translations from the classical authors, including Hesiod, Anacreon, Sappho and Theocritus; the *Iliad* and *Odyssey* in Pope's celebrated versions; Dryden's Virgil (the *Eclogues* and *Georgics* as well as the *Aeneid*) and his Juvenal; Nicholas Rowe's Lucan and Gilbert West's Pindar. Apart from any other books of poetry that Turner may have possessed, we can be sure that he had at his finger-tips the bulk of the literature that was of significance for his time. Over the following decade he read a great deal of it.

Of his ten submissions to the Royal Academy's exhibition in 1798 five bore substantial quotations, one from *Paradise Lost* and four from Thomson's *Seasons*. The following year there were six more (among a total of twelve entries), taken from *Paradise Lost* and the *Seasons* again, and also from Langhorne's *Visions of Fancy* and Mallet's *Amintor and Theodora*. One reviewer went so far as to say that Turner 'appears rather too much inclined to shackle Nature in the magic bonds of Poetry, than give her chaste beauties their full and unaffected display'. In the context of the exhibition catalogues he was rarely in future to spread his net so widely. Milton and, more particularly, Thomson were to be favourites for many years; but he very quickly abandoned these orthodox sources and began on a fresh tack. The next extracts, appended to two Welsh subjects shown in 1800 (see No.5), are printed without references and their authorship has never been established, though scholars are increasingly inclined to credit them to Turner himself. In the next few years, apart from a quotation from Addison's translation of Ovid's *Metamorphoses* with the 'Narcissus and Echo' of 1804 (No.11), there is a pronounced sparsity of verse; but he makes up for it in 1809, when 'Thomson's Aeolian Harp' (No.44) is expounded in no fewer than thirty-two lines of poetry – not, as might have been expected, Thomson's, but Turner's own. These exercises led, in 1812, to the appearance of lines from the *Fallacies of Hope* in the catalogue entry for 'Hannibal'. With that gesture he announced the literary work with which he was to become most closely associated, and which, by the end of his life, was looked upon as a complete verbal explication of the artist as poetaster, pessimist and public laughing-stock. Even today, much of his achievement as a painter is interpreted in terms of that strange, inchoate and amorphous collection of scraps.[9]

From the outset his drafts were rough and rapid. His handwriting, once he had reached maturity, was and remained a scrawl, elegant in its fundamentals but variable and erratic in practice. Although it conforms to a fairly standard type of

its period, it is in certain respects highly characteristic of the man – slovenly despite a profound underlying aesthetic sense, and almost wilfully obscure at times. In general, though, this obscurity is simply a consequence of his having done most of his writing in small private pocket-books and sketchbooks, sometimes no doubt in a moving carriage – for the urge to scribble seems to have gripped him at all sorts of unpredictable moments – and answerable to no-one but himself. He was probably glad that his struggles with words were in-decipherable to any who might by chance pry into them. To these observations must be added the fact that, with all his reading and perceptive comprehension of literature, he was a man of little formal education who to the end of his life was in the habit of spelling some words phonetically, or according to a hypothetical orthography of his own. His grammar and syntax, too, are often confused, and trains of thought tend to become lost in a welter of apparently unrelated subordinate clauses or new ideas.

The combination of all these factors renders his manuscripts extremely difficult to interpret; the poetry is even more challenging than the prose because, although it often proceeds by clichés, it is more unpredictable in its thought-processes; and when, as often happens, Turner resorts to the placing of vaguely word-like squiggles on the page[10] in the hope, as it were, that they will turn of their own accord into apt verse, the problem can become a nightmare. A particularly curious phenomenon is his occasional drafting of a poem by another writer as if it were his own, with rephrasings and alterations of lines which seem to follow the usual patterns of spontaneous composition. An example of this is his work on Charles Cotton's poem *Laura Sleeping* in the *Lowther* sketchbook (TB CXIII, f.65v), where he seems to be pressing stanzas from elsewhere into service to lengthen his own poem.[11] There are, therefore, unexpected hazards to be encountered, and most transcriptions are necessarily imperfect; even when comparatively full and accurate they may be incomprehensible. For these reasons Turner's poetry has only rarely been tackled as a subject in its own right;[12] and for these reasons the reader's indulgence is begged when the going becomes difficult.

But the graphological and orthographic characteristics outlined above seem to indicate a more profound problem than a mere lack of education. Turner's devotion to literature and his innate intelligence would surely have enabled him to overcome that disadvantage, to master basic syntax and spelling. Literary criticism of the order found in his letter to Britton on 'Pope's Villa' of 1811 (see No.56) is the product of a highly sensitive and disciplined mind, not ordinarily compatible with the muddled inconsequence of much of the poetry he wrote himself. The evidence strongly suggests that he was to a considerable degree dyslexic: the frequency with which characters are transposed or otherwise confused even in words that must have been familiar to him, the garbled phraseology, the tendency to lose grammatical threads, the lack of verbal confidence in public – as is well testified by those who attended his lectures, for instance – are all typical of certain types of dyslexia. Such a diagnosis would go a long way to explain the perennially puzzling fact of the prodigiously creative

genius with a strong penchant for verbal expression who nevertheless repeatedly made himself ridiculous when he gave vent to it.

His persistence in spite of an evident awareness of all these shortcomings is an indication of the profound need he felt to create in words. He was not merely seeking the 'palm of worth', as he phrased it,[13] in competition with others whom he regarded as rivals for fame. He was responding to an inner impulse as vital to him, in its way, as the urge to paint. When he found himself on the threshold of a serious commitment to public communication in words he set himself to conquer his inadequacies in a practical way. Probably in 1809, about a year before his first scheduled lectures as Professor of Perspective at the Royal Academy Schools, and at the moment when he was beginning to draw heavily on his own verses for use in the catalogues, he studied the technicalities of English grammar, syntax and vocabulary as they were laid out in the *Lectures on Rhetoric and Belles-Lettres* of Hugh Blair, D.D. These had been first published in 1783, and went through several editions. In his *Cockermouth* sketchbook (see No.47), he copied out passages from Blair on 'Style' and 'Structure of Sentences' (volume 1, lectures x–xiii), with examples of synonyms and different sentence-types.[14] Like so many other exercises of the kind in his sketchbooks of all periods, this is a fragmentary sample of what may have been only a passing interest; but his summaries of Blair's arguments, and the examples of good writing by authors like Pope and Sir William Temple which he copied out, indicate more than a casual examination of Blair's highly intelligent and wide-ranging book. The *Lectures* covered, in fact, every aspect of literary theory and history, and Turner must have valued Blair as much for his discussions of 'Sublimity' or 'The Nature of Poetry' (volume 1, lectures iii, iv; II, xxxviii) as for his practical advice on the structure of language or the art of public speaking (I, viii, ix; II, xxv). Blair's lucid account of 'The Origin and Progress of Poetry' (II, xxxviii), and his critical discussions of Homer, Virgil, Lucan, Tasso and other writers ancient and modern (II, xliii–xlvii), must have constituted a valuable adjunct to Anderson's collection. Indeed, the classes of poetry that Blair describes may have had a direct influence on Turner's own classifications in his *Liber Studiorum*: Pastoral, Lyric, Didactic, Descriptive and Epic are the main poetic types, and it seems likely that Turner was drawing a deliberate parallel with such literary definitions when he sought to present landscape under the categories of Pastoral, Historical, Mountainous, Architectural and Marine.[15]

A further plea should be lodged in extenuation of his eccentricities as a poet. It is generally held against him that he made indiscriminate use of other writers' work, borrowing and plagiarizing at will. The verses published in the exhibition catalogues are replete with reminiscences and allusions as well as downright thefts of whole lines; and throughout the drafts in the notebooks there are frequent echoes of this kind. Turner may have copied out ballads and other short poems from time to time, from motives of pure interest or admiration; but his use of Cotton's *Laura Sleeping* seems to have served a quite different purpose. To argue that these procedures are a kind of 'cheating' is absurd. Turner must have been

well aware that his contemporaries would recognize the references in the passages that were printed, and it is much more likely that he used them deliberately to advertise his own reading and to extend the range of reference of both verses and pictures. The borrowing from *Paradise Lost*, for instance, in his 'Ode to Discord' (see No.30), obviously serves an important purpose in associating the classical and Biblical myths that are central to the theme of the picture. In doing this he is surprisingly 'modern'; despite his dedication to the verse styles of the eighteenth century he employs a device that was not to be established as legitimate until Eliot's *Waste Land*, and anticipates some of the free association so dear to the Structuralists. In fact, of course, it is precisely the characteristic eighteenth-century issue of association ('Associationism') that explains and justifies the device: just as Turner consciously gave weight and significance to his pictures by alluding to the styles of Poussin or Salvator Rosa, or by invoking the heroic past of a particular region, so he sought to enlarge the field of reference of his poetry by incorporating in it the thoughts, the phraseology, of other writers. No doubt, just as he considered his painter colleagues as his 'Brothers in Art', he felt towards the denizens of the poetical Parnassus of his day as a confrere and fellow author.[16]

Early Drafts and Jottings

It is possible that Turner planned to use his own compositions as glosses on his pictures from the beginning: the first notes of verse in the sketchbooks occur at precisely the time when citations were first permitted by the Academy. There are some in a small book, the *Swans* sketchbook (TB XLII), used mainly in Wales during his tour in the summer of 1798. There is no obvious connection, however, between sketches and verses. One is a nautical ballad, written out in full and telling the story of a sailor and his Nancy from his departure to the ship's cheerful homecoming after battle and storm:

> The Breeze was fresh the Ship in stays
> Each breaker hush'd the shore a haze
> When Jack no more on duty call'd
> His true love's tokens overhaul'd
> The broken gold the braided hair
> The tender motto writ so fair
> Upon his bacco box he views
> Nancy the Poet love the Muse
> If you loves I as I loves you
> No pair so happy as we two
> (ff.129, 139, back flyleaf)

The completeness of the text strongly suggests that this is copied from some independent source. Turner himself would have been unlikely to achieve anything so fluent or finished. Some of his own efforts are also to be found in the *Swans* book. There is a second ballad, which various alterations reveal as his own handiwork, written out inside the front cover. The first line, 'Tell me Babbling echo why', is immediately modified to read 'Babbling Echo tell me why', and the poem proceeds:

> You return me sigh for sigh
> When I of Slighted Love complain
> *You delight* to Mock my Pain
> 2
> Bold intruder Night and Day
> Busy telltale [*alternative:* censor] hence away
> Me and my care in silence leave
> Come not near me while I grieve

The no doubt unconscious borrowings from the fairies' song in *A Midsummer Night's Dream*[17] are typical of Turner's way of absorbing other men's poetry and using it in his own verse – and, as often happens, in his letters.[18] He was a keen theatre-goer, and must have gleaned much of his knowledge of the dramatists from stage performances.

More conspicuously Turnerian are the other verses in this book, which seem to be cast antiphonally for three or more voices, identified by letters:

> Faint and wearily the way worn traveller
> Plods uncheerily afraid to stop
> s Wand[er]ing drearily and sad unraveller
> Of the Mazes toward the Mountain top.
> A Doubting fearing while his course he's steering
> s Cottages appearing as he's nigh to drop
> B Oh how briskly then the way worn traveller
> Threads the mazes towards the Mountain's top
> A Tho' so melancholly day has past by
> T'would be folly now to think on't more
> s Blithe and jolly he [the] can hold fast by
> As he's sitting at the goatherd's door
> A Eating quaffing at past labours laughing
> s Better by far half in spirits than before
> A Oh how merry then the rested traveller
> Seem[s] while sit[t]ing at the Goatherds door
> (TB XLII, ff. 129, 128)

The dramatic element in this exercise is slight, but it sheds interesting light on Turner's instinctive use of devices associated with the stage. At the same time, there is perhaps another influence at work. These last years of the century were

those of his friendship with the composer and organist John Danby, and after Danby's death in 1798 with his widow Sarah and niece Hannah, with both of whom Turner remained in more or less close association all his life. He seems to have had a love-affair with one or other of the two women,[19] and the love poems in the *Swans* book may well have been prompted by this experience. It is possible that the whole outpouring was directly occasioned by the Danbys' love of singing: Danby himself composed a number of glees and similar part-songs. It is unlikely that the initials S, A and B stand for Soprano, Alto and Bass, but the circumstances make it at least a possibility.[20]

There are more verses from this time which suggest the context of convivial song. A draft of lines on the uncertainty of love, jotted down inside the front cover of the *Salisbury* sketchbook (TB XLIX), in use in 1799, when, we may guess, his affair with Sarah or Hannah Danby was at its height, might easily have been intended as the text of a madrigal or glee:

> Love is like the raging Ocean
> [?Wind] that sway, its troubled motion
> Woman's temper ever bubbling
> Man the early bark which sailing
> In the unblest treacherous Sea
> When Cares like Waves in fell succession
> Frown destruction oer his days
> Orwhelming . . . [?crews] in [?traitrous] way
> Thus [?thru] life we surely tread
> Recr[e]ant poor or vainly wise.
> Unheed[ing] seeks the bubble Pleasure
> which. Bursts in his [?Grasp] or flies.

The picture of life as a journey, on a rough path as in the antiphonal verses just quoted, or over a rough sea as here, or down the course of a river, is one that he returns to repeatedly. The final image was also to recur in his verse: he took it up again, memorably, in the lines he wrote to accompany his picture 'Light and Colour (Goethe's Theory) the Morning after the Deluge – Moses writing the Book of Genesis' of 1843 (B&J 405), a composition which is, in effect, itself a huge bubble:

> The Ark stood firm on Ararat; th'returning sun
> Exhaled earth's humid bubbles, and emulous of light,
> Reflected her lost forms, each in prismatic guise
> Hope's harbinger, ephemeral as the summer fly
> Which rises, flits, expands, and dies.

Oddly enough, the pair to 'Light and Colour' exhibited in the same year, 'Shade and Darkness – the Evening of the Deluge' (B&J 404), is anticipated in a few lines noted in another book of 1799. They occur on the front flyleaf of the *Lancashire and North Wales* book (TB XLV), used on the tour of that summer. It is a

characteristically incoherent passage, even though it purports to have been copied from elsewhere – the quotation is annotated 'Transcribed by Mr Lloyd from Pennent':

> Snowdon Mountains while every House
> crow usually croacks
> there is no good of much sleep
>
> Snowdon Mountain ravenous snow
> melted windy often
> in Distress best is a relation

This appears to be a literal translation of some Welsh verses cited by Thomas Pennant in his *Tour of Wales* (volume II, 1781, p.169). The translation given by Pennant himself is rather more sophisticated than Mr Lloyd's, though only a little more mellifluous:

> While the hill is clad with snow,
> Fowls for food scream out below,
> Fierce the winds on plow-lands blow.
> WHEN DEEP GRIEF AFFECTS YOUR MIND
> BALMY CURE FROM KIN YOU'LL FIND.

There seems to be no particular reason for Turner's having copied out this fragment; but the motif of the croaking crow or 'screaming fowls' recurs in his own verse – for example in the 'screeching owl' of 'Come Oh Time' in the *Spithead* sketchbook (see No.31), and, most notably, in the line 'The birds forsook their nightly shelters screaming' in the verses he attached to 'Shade and Darkness' at the Academy in 1843. Nevertheless, he was apparently interested in the relationship between Welsh scenery and Welsh poetry, as concomitant expressions of the grandest and most heroic epoch of Welsh history.

Welsh subjects provided the occasion for an important departure in his career as poet. In 1800 two views in North Wales, one in oil, the other in watercolour, appeared with verses that commentators have come to believe were his own compositions. Before this, he had relied on established sources – Milton, Thomson and others. In 1798 he provided quotations for five out of his ten submissions. Thomson's *Seasons* supplied all but one of the quotations, the exception being 'Morning amongst the Coniston Fells', to which he added some lines from book v of *Paradise Lost*, the foundation-stone of all eighteenth-century poetry and a principal influence on Turner's own taste. He was to cite it again the following year, in connection with 'Harlech Castle, from Twgwyn Ferry' (B&J 9), when he used a sonorous passage describing a summer evening, once more from book v, and with his 'Battle of the Nile' (B&J 10), quoting from book VI. The extracts he selects are those in which the epic poet describes natural phenomena: Turner consciously invokes the most august authority for his own interest in landscape. When he cites Thomson's *Seasons* it is with the same consciousness of the established authority of a major literary voice.

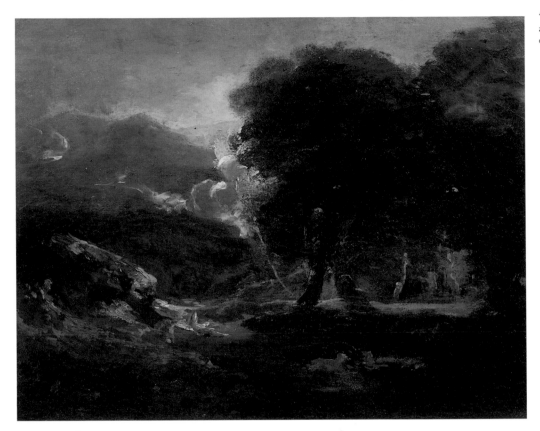

'Dark Landscape with Trees and Mountains', *c.*1799. Oil on canvas (No.4)

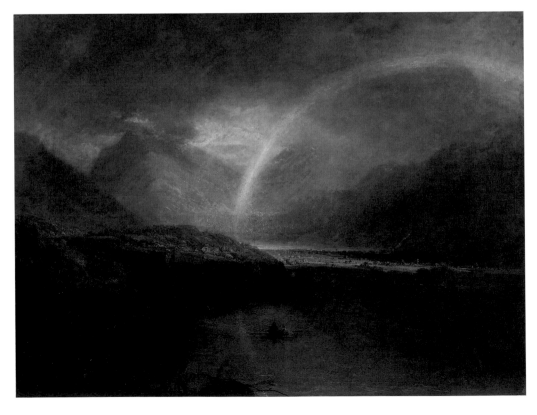

'Buttermere Lake with Part of Cromackwater, Cumberland, a Shower', RA 1798. Oil on canvas (No.3)

'Morning amongst the
Coniston Fells, Cumberland',
RA 1798. Oil on canvas
(No.2)

'Caernarvon Castle, North Wales', RA 1800. Pencil and watercolour with scraping-out and stopping-out (No.5)

'Scene in the Welsh Mountains with an Army on the March', 1799. Watercolour with stopping-out (No.6)

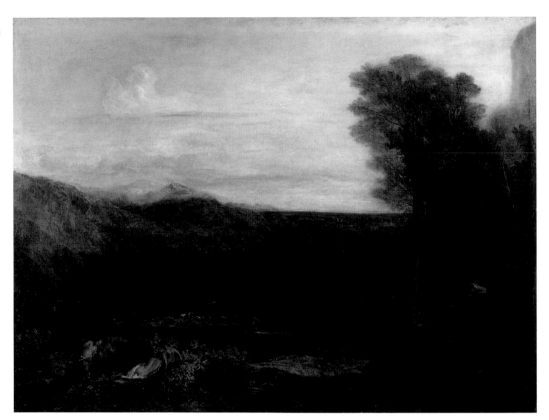

'Narcissus and Echo',
RA 1804; BI 1806. Oil on
canvas (No.11)

prominence as a controversial figure. Already by 1804 he had taken to absenting himself from the meetings on account of the acrimony he had met with there.[27] But in his picture for the British Institution he sublimated these local disagreements to produce a monumental statement on the causes of the Trojan War, the first in his lifelong exploration of the themes of hope, ambition, pride and disappointment in the retelling of the wanderings of the Trojan hero Aeneas and the history of Carthage.[28]

The concrete presence of poetry was clearly fundamental to Turner's conception of much of his own art; yet he could always have used quotations from other authors for this purpose, and it is to be doubted whether he would have undertaken such a determined (and presumably time-consuming) course as to work on hundreds of lines of his own verse if he had not received a specific stimulus to prove his capacity in this respect. That stimulus was surely the publication of Shee's *Rhymes on Art*, which may well have seemed to Turner to bear a particular and personal message for him.

Shee published his poem in two parts, the first, in 1805, containing the more immediately topical passages; the remainder appeared in a sequel of 1809 under the title *Elements of Art*. The verse itself is really only the springboard for his argument, which proceeds in lengthy footnotes on almost every page. He takes as his starting-point the disparity between the reputation abroad of British literature, science or philosophy, and that of British painting:

Insult! to think the land where Shakespeare sprung,
The heav'n *he* breath'd – where seraph Milton sung!
In strains more sweet than erst from fabled shell
Of Orpheus old, or fam'd Amphion, fell:
Where Pope, where Dryden swept the sounding lyre,
With Maro's melody, and Homer's fire!
Where Science, (long on weak Conjecture's wing,
A thwarted falcon, flutt'ring from the string,)
Loos'd by her Newton's hand, first shot on high,
And perch'd amid the mansions of the sky:
Insult! to think, where valour, virtue sway!
Where beauty sheds around her brighest ray!
Where reason boasts how Locke – how Bacon shone!
And triumphs on her philosophic throne:
Insult! to think this garden of the globe,
This spangle shining bright on Nature's robe!
From finer joys in cold seclusion plac'd,
A kindless clime beyond the beam of taste!

(pp. 7–8)

The passage is quoted at length here as it refers to several of Turner's own favourite themes: Britain's international reputation; Pope, Virgil ('Maro'), Homer and Newton. It seems to be inevitable that in England the visual arts should always take second place to literature; Shee unconsciously acknowledges the point even while mounting his defence of painting, which he so specifically bases on the popular acceptance of literature, observing that 'the public judgment' is 'more matured in books than in pictures' (p.38, note). The poem then becomes an attack on what was later to be called philistinism:

Is Taste the only suffering stranger known,
That finds no refuge 'neath Britannia's throne?

(p.78)

Only in the private collections of a few great men – not necessarily accessible to the public – was the lamp of true taste, or more precisely an appreciation of modern British art, to be found lit. Shee names in particular the Duke of Bridgewater, who had bought from Turner a large seascape, 'Dutch Boats in a Gale' (B&J 14), in 1801. On recording this, Shee cannot resist a dig at Turner's already notorious interest in money:

Though possessed of the finest examples of the old masters, he [Bridgewater] was not one of those affected admirers of art, who regard the productions of their own time with indifference or contempt; nor did he conceive it an impeachment of his taste, to place as an ornament in his collection, a work of ability from the pencil of a living artist (Mr Turner), though selected at a

price, which even the merit of Wilson could never extort from the parsimonious patronage of his day. (p.97, note)

An important remedy for this unsatisfactory state of affairs would be the establishment of public collections. Shee makes the suggestion that

A few examples of the different schools, collected with judgment, and placed within the reach of the student, either to copy or contemplate at leisure, is a desideratum of the highest consequence to the advancement of British art. (p.66, note)

He adds that Reynolds had

lost a noble opportunity of setting an example of public spirit and munificence, which might have been attended with the best effects . . . If . . . he had selected a successful specimen of his own powers with two or three good examples of the old masters, and bequeathed them to the Royal Academy, expressly to operate as the germ of a future collection, they would have formed the nucleus, around which a gallery might have grown by this time, from the liberal contributions of those who would have been induced to follow an example so truly patriotic, and thereby connect their names most honourably with the arts of their country. (p.67, note)

Here in essence is the idea of a public collection of old and modern masters, illuminated by the genius of a single major artist, that was to haunt Turner throughout his life and ultimately dictate his bequest of a hundred finished pictures to the newly formed National Gallery – itself a direct consequence of the kind of advocacy that Shee's book exemplifies.

The argument is polarised between an assertion of the importance of the artist as 'genius' and a scathing attack on contemporary art criticism:

> Dolts from the ranks of useful service chas'd
> Pass muster in the lumber troop of Taste;
> Soon learn to load with critic shot, and play
> Their pop-guns on the genius of the day.

(Resentment of the critics was, of course, nothing new; Turner was to take up the matter of genius and its relation to criticism when he later annotated the *Elements of Art*.) Shee went on the define the true critic,

> bred in nature's school,
> Who neither talks by rote nor thinks by rule;
> Who feeling's honest dictates still obeys,
> And dares, without a precedent, to praise
> (p.99)

and concluded with a triumphant rehearsal of the qualities of the true artist. These hardly accord with Shee's own abilities – his output did not include

The 'Verse Book'

The earliest drafts in the *Verse Book* (No.27) to which even a rough date can be attached suggest that Turner began to use it soon after Shee's *Rhymes on Art* had scored such a success. They are for the 'Ode to Discord', his poetical gloss on 'The Goddess of Discord' which appeared at the British Institution early in 1806 (see No.30). However, it is possible that only after the picture was exhibited did he begin to contemplate a poem on the same subject, and there are drafts for it in the *Windsor, Eton* sketchbook (TB XCVII) which was probably in use later in 1806 and in 1807. He exhibited the picture again at his own gallery in 1808, and the verses may have been prepared with that showing in mind. At all events, they were intended to amplify and extend its significance.

There are other drafts that can be related to particular pictures, but Turner did not limit himself to the subject-matter that he explored in his paintings. Other facets of his life at the time are drawn on just as readily. There is, for instance, a satire in sprightly Hudibrastics on the classical orders of architecture. This was a subject to which Turner began to devote much time following his appointment as Professor of Perspective at the Academy Schools in 1807: the illustrations that he made for the lectures, first delivered in 1811, often show details of classical buildings, cornices, columns and so forth. (He had, of course, been a highly proficient architectural draughtsman since his youth.) Still more to the point, perhaps, was a burgeoning interest in architecture as an activity of his own. In 1807, just at the time when the Professorship was being settled, he purchased a plot of land at Twickenham, where he proposed to build himself a country retreat; his plans matured gradually over the next five years, and the house – Solus Lodge, later renamed Sandycombe Lodge – was finished in 1813, so that its genesis coincides almost exactly with the period of his most intense interest in poetry.

Books on architecture figured in his reading for the Perspective lectures, but he must also have tackled some manuals more specifically for guidance in designing his house. Vincenzo Scamozzi's *Mirror of Architecture*, which had been available in an English translation since the late seventeenth century, was one to which he in all probability referred. In most eighteenth-century editions it was published with an abridged reprint of an important early English text by Sir Henry Wotton, *The Elements of Architecture*, which had first appeared in 1624, and represents the dawning awareness of true Vitruvian principles in England. Turner may have consulted Wotton's original edition, but it seems more likely that he came across the work in the course of his perusal of Scamozzi, or in Roland Fréart de Chambray's *Parallel of the Ancient Architecture with the Modern*, which had been issued with an edition of Wotton's *Elements* in the early eighteenth century. None of these works was available in the Royal Academy library, and none appears to have been in Turner's own possession, so it must be assumed that he used the British Museum library.

Although many of Wotton's observations were cut from the abridged version, including his remarks about painting and sculpture which Turner would surely have been interested to read, the passage in which he describes the five orders of classical architecture was reprinted more or less verbatim; and it is this that Turner makes use of in his poem, lightheartedly characterising them as human types, as Wotton does, but modifying them to create an ingenious satire on contemporary life. Wotton's comments on the Tuscan column are that it is 'a plain, massie, rurall Pillar, resembling some sturdy well-limbed labourer, homely clad, in which kinde of comparisons Vitruvius himselfe seemeth to take pleasure.' Turner begins:

> Sir William Wootton often said
> Tuscan like to the labourer is made
> And now as such is hardly used
> Misplaced mouldings much abused
> At Gateway corners thus we find
> That carriage wheels its surface grind
> Or placed beneath some dirty wall
> Supports the drunken cobler's stall

Not untypically, Turner manages to get Wotton's name slightly wrong. The comments on modern usage are, of course, Turner's, not Wotton's; they give a vivid insight into his habits of close observation. The passage encapsulates the central concern of his topographical work: the interaction of human behaviour with its setting, natural or man-made. It is this which informs his subsequent observations on the other orders.

He omits the 'masculine' Doric and proceeds to the Ionic, which, according to Wotton, 'doth represent a kinde of Feminine slendernesse, yet with Vitruvius, not like a light Housewife, but a decent dressing, with much of the Matrone'. Turner, however, gives a rather different account that combines Wotton's Ionic with his Corinthian:

> Ioniac with her scrowl like fan
> The meritricious courtezan
> It now is used at front of Houses
> To shew those horns belong to spouses
> And at a place thats entre no[u]s
> Not many steps from Charing Cross

– he evidently associates the order with a particular house of pleasure, and the connection stimulates him to lively comment, pointing out the ironic contradiction between Wotton's theory and the reality of life. Architecture is always, and essentially, a setting for human affairs. In this it is like landscape. Turner's fascination with both is hardly surprising. And so he sees not simply the building but its denizens, who become the key to its quality and character:

> architecture has her plea
> And the chaste matron keep[s] the key
> But Chastity does sometimes lean
> And man doth slip alack between
> The painted columns at the door
> Prove Vice is strong & Virtue poor

Another Ionic doorway, on a pawnbroker's shop, provokes an almost Dickensian sequence of images in which architectural and human characteristics are wittily linked:

> The scrowl bespeaks a labyrinth of woe
> Who once gets in must onward go
> The little dentils in sofiete [= soffit]
> Show grinding power here complete
> And placed as the teeth of Shark
> Alike unerring at their mark

The Corinthian order, on the other hand, gives rise to ideas more in harmony with Wotton's. He had characterised the order as 'a Columne, lasciviously decked like a Curtezane, and therein much participating (as all Inventions doe) of the place where they were first borne; Corinthe having been without controversie one of the wantonest Townes in the world'. Turner begins by endowing the Corinthian with the merits of Wotton's Ionic order:

> Corinthian grave mature grace
> At every shop front shows her face

– but quickly goes on to suggest that this is a superficial impression:

> Can it be said that she is chaste
> or like the Corinth maid in haste
> Where she is so often out of place
> or like the damsel out of place
> Who fears the thought of bursting lace
> Her full blown beauties float around
> Acanthus leaves and budding horns abound
> With great display above below
> Placed any where . . . to make a show
> Now the beauty of her flutes are gone
> So long they have been play'd upon

The concluding pun is unmistakably of the early nineteenth century, though it anticipates by a decade or more the plays on words that frequently occur in Turner's letters of the 1820s, the period in which Thomas Hood was publishing his dazzling displays of punning – displays of which Turner was to be well aware, making occasional allusions to them in his own writing.[29] But the main inspiration for the poem, if not Samuel Butler's *Hudibras* itself, is perhaps not

unexpectedly to be found in Thomson, whose highly serious survey of the development of architecture occurs in part II of his *Liberty*:

> First, unadorned
> And nobly plain, the manly Doric rose;
> The Ionic then with decent matron grace
> Her airy pillar heaved; luxuriant, last,
> The rich Corinthian spread her wanton wreath.
>
> (lines 381–4)

Thomson, it is clear, must himself have derived this scheme of imagery from Wotton.

So vividly were these ideas of architectural 'order' impressed on Turner's mind that he applied them by way of illustration to the principles of picture construction, outlined in the notes he made for his fourth lecture in 1811 (see p.86):

> the construction of a picture like the arguments of Architecture, requires the properties which her regulations enforce, Ionice softness Dorice simplicity and Corinthian magnificence for Grecian introductions while the Tuscan and Composite should always characterize ancient Rome. (f.13r)

His own pictures are indeed distinguished for their architectonic stability, a quality which lends them a strongly classicising flavour even when they are least concerned with themes from Antiquity.[30]

There is no direct connection between this satirical view of architectural history and the allegorical account of the origin of painting that he gives in the sequence of quatrains that he entitled 'The origin of Vermillion or the Loves of Painting and Music', which is the first poem in the *Verse Book*; but the two subjects complement each other as statements of aesthetic themes in which he took a deep interest. What links them is their shared awareness of the historical dimension of art, the sense that what the modern practitioner takes for granted has evolved in a social or human context. This is at once clear in the opening lines of 'The origin of Vermillion':

> In days that's past beyond our Ken
> When painters saw like other men
> and Music sung the voice of truth
> Yet sigh'd for Paintings homely proof

He proceeds to a direct narration of the story, in which the primal artist, inspired by the beauty of a sleeping girl, is led from outline to colour by the blush on her cheek. The idea of the artist inspired by beauty was a familiar Neo-classical one: the story of the Maid of Corinth who outlined the shadow of her lover on the wall as he slept had been treated by Joseph Wright of Derby, William Blake and many others.[31] Here Turner creates a fable in which colour already imbues the creative outline – an entirely appropriate emphasis for him to make.

> Her modest blush first gave him taste
> And chance to Vermill first in place
> as Snails trail oer the morning dew
> he thus the lines of Beauty drew

Turner then reflects that this is a myth that reverberates significantly throughout the history of art:

> Those far fam'd lines Vermillion dyed
> With wonder view'd enchanted cri[']d
> Vermillions honors mine and hence to stand
> The Alpha & Omega in a painters hand
>
> To dim futurity descend to oer all time prevail
> Envy o'er heard, and gab[b]ling told the tale

The draft degenerates still further into restatements of the ideas already given, but some new strands are introduced, necessitating a reordering of what has gone before:

> It chancd one day the dame was tired
> Recumbent Beauty Genius fir'd
> and Dutch Vermillion close at hand
> Scrowl'd on the marble forth as coarse as sand
> . . .
> but practice never heard him sigh
> Nor taste on him had cast her eye

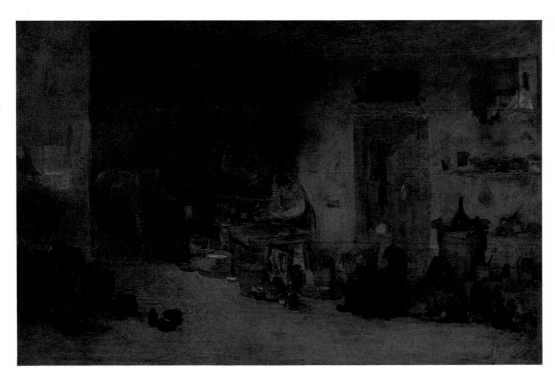

'An Artist's Colourman's Workshop', c.1807. Oil on pine panel (No.34)

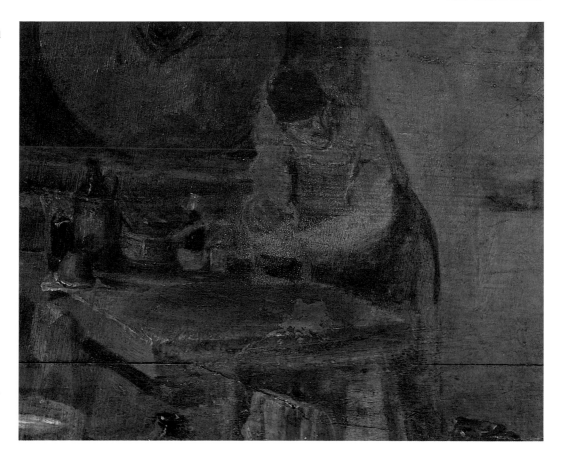

and natures charms so check his haste
Trembling the pencils course of color trace
. . .
Those far famd lines Vermillion dy'd
He wondring view'd with conscious pride
and self-conceit alas too near allied
Grasps the whole range of art & cried
Vermillion

The allegory of 'The origin of Vermillion' is recounted in suitably practical terms. The process of grinding the colour, described here in the line 'Scrowl'd on the marble forth as coarse as sand', may have overtones of the legend of Apelles painting Campaspe, the mistress of Alexander the Great, on which occasion, iconographic tradition suggests, Cupid himself ground the colours. The atmosphere of that story pervades Turner's poem, but certainly does not obtrude in the painting which also illustrates the subject, known as 'An Artist's Colourman's Workshop' (No.34). This is Dutch rather than classical in inspiration, showing the dark interior of a place of work full of pots, tubs, cauldrons and other vessels. In the background a horse-mill is dimly visible. In place of the allegorised genius of Turner's poem, the down-to-earth colourman is

eyeing not a recumbent myth but a slouching woman, with a basket on her knee and her head in her hand. He is grinding a quantity of red pigment on a marble slab; analysis has shown that this is not chemically true vermilion, but it may be taken as a pictorial equivalent.[32]

The relationship between the poem and the picture is tenuous; neither 'illustrates' the other; the verses can hardly have been intended as part of an entry for the picture in the Academy catalogue. Yet there is a clear connection between the two which suggests that although Turner perceived poetry as an accessory to some of his paintings, he could also allow his literary and visual imaginations to take off from a common starting-point in directions of their own. His purpose in writing the poem was to express in a traditional literary form the notion of Genius inspired by Beauty – an idea that must have been very much present to him in these early years of his success. The reference to 'music' rather than poetry in the title is a further indication of the way Turner viewed all the arts as fused in a single creative purpose. Besides this, the close association of music and poetry had been established by the ancient Greeks, who identified the god Apollo with both. The activities of Apollo were a recurrent theme of Turner's art in this decade. The picture of the colourman's shop, on the other hand, is a wry comment on the inherent absurdity of the conventional means of expression employed in the poem. It borrows its idiom from the low-life subjects of artists like Pieter Brouwer and Isaac van Ostade, to which Turner's attention had recently been drawn by David Wilkie's first London successes, 'Village Politicians' and 'The Blind Fiddler'. His own 'Blacksmith's Shop' (B&J 68), an immediate response to the 'Village Politicians', appeared at the Academy in 1807, and 'The Unpaid Bill, or the Dentist reproving his Son's Prodigality' (B&J 81) a year later.

All three of these works by Turner, it will be noticed, deal with tradesmen of one sort or another – the artist's colourman, the blacksmith and the dentist. Another subject of this period, 'The Garreteer's Petition' (No.42), exhibited in 1809, introduces another *métier* – that of the poet. He would not normally be classed as a 'tradesman' in the sense that the others are; but Turner treats his poet with deliberate irony as a member of the artisan class, characterised as he is by an absence of inspiration. The sheer drudgery of making a living by versifying is his theme. The agony of the poet abandoned by his Muse was one all too familiar to Turner. It is clear from the drafts in his notebooks that the writing of poetry did not come naturally to him, even if he was well stocked with ideas that he wished to express in verse. The question is, why he nurtured that wish. As we have seen, the connection between poetry and painting was well established, even taken for granted, in the period, not merely as a philosophical idea but as a practical aspect of the showing of pictures in public. He accepted it as a matter of course, and at the same time conceived his own works as contributions to a discussion carried on simultaneously in the two media. During the first decade of the nineteenth century the quantity of his draft poems, the energy with which he tried, over and over again, to perfect them, suggests that he regarded them as equally important. It was only his lack of talent – the absence of the Muse – which forced him to

'The Unpaid Bill, or the Dentist reproving his Son's Prodigality', RA 1808. Oil on panel. Private Collection

abandon any regular appearance as artist-poet; and even so, he maintained his publicly stated concern for poetry throughout his life.

A subtle dialogue is then in train here between the idea of honest – and highly competent – professionalism in the pursuit of a craft or trade, and the notion of technical inadequacy, of professional failure. This, of course, is precisely where Turner's sense of his own limitations becomes apparent. And there is an irony of which he was perhaps not conscious, that the whole field of genre painting, in which figures play a prominent role, was one for which he was not entirely suited. The critics were quick to point this out when he showed these works at the Academy, praising his 'effect' while condemning his figure drawing. It should be said that in several instances, notably 'The Blacksmith's Shop' and 'The Garreteer's Petition', he leaves little to be desired in this latter respect; but it was at once assumed that his essays in genre were undertaken more in a spirit of competition with Wilkie than as a natural and inevitable extension of his own sphere of activity. In fact there can be little doubt that this group of pictures was vital to his developing perception of the role of the painter in society, and of the part played by the human figure in landscape painting.[33]

Turner seems to have perceived his own professional avocation, painting, as one of the 'useful' trades he celebrates in these works – an essential service to society, just as was the art of the poet. 'Art is cunning', as he put it in the draft poem in his copy of *The Artist's Assistant* (No.43). The long-established perception of him as a prototype (along with Beethoven) of the modern idea of the artist as

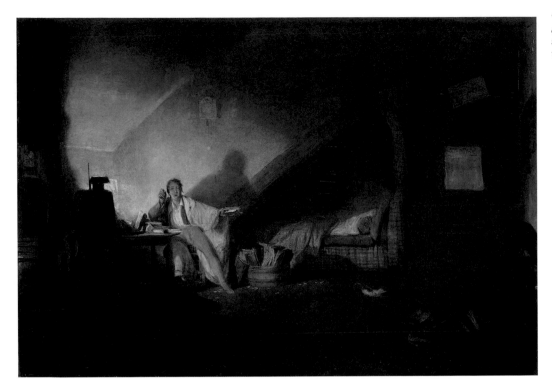

'The Garreteer's Petition', *c.*1808. Pen and brown ink and wash with some watercolour (No.42)

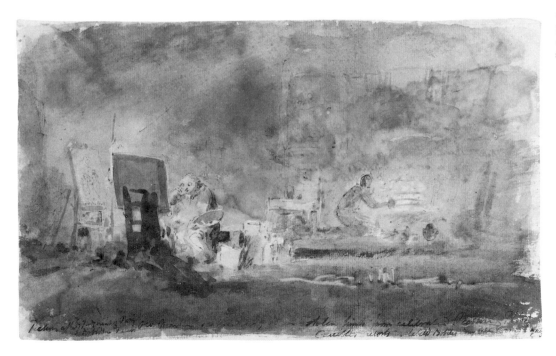

'The Artist's Studio', *c.*1808. Pen and brown ink and wash with some watercolour and scraping-out (No.40)

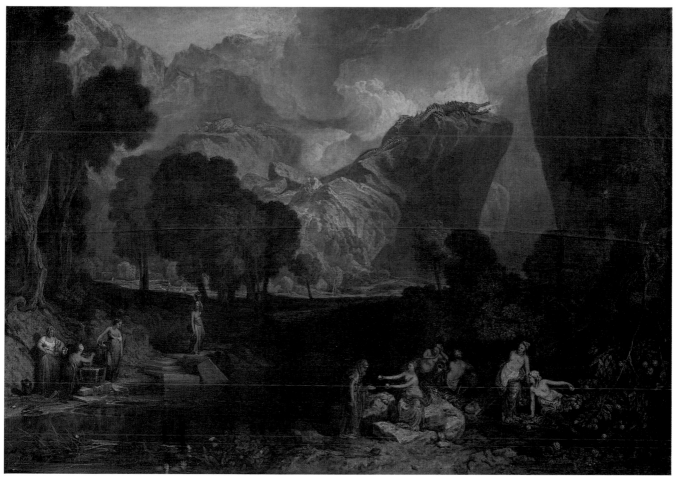

'The Goddess of Discord
choosing the Apple of
Contention in the Garden of
the Hesperides', BI 1806;
Turner's Gallery 1808. Oil
on canvas (No.30)

recluse and rebel has obscured his very traditional view of himself as a craftsman belonging to a 'guild' – the Academy, to which he professed complete loyalty. These pictures honour the idea of professionalism in various fields; but they do so, as often as not, in terms of satire, defining professionalism by its limits, as demonstrated by incompetent or uninspired performers. Turner apparently planned a further picture as a pair to the 'Garreteer' in which a painter is similarly circumscribed by his creative shortcomings. The evidence is a drawing, 'The Artist's Studio' (No.40), executed at the same time as that for the 'Garreteer': it shows an artist gloating over a canvas on an easel in a room crowded with bric-a-brac. In the background another figure is visible, holding something up to the fire. On the back of the sheet are some verses, essayed in various forms:

> Pleas[d] with his Work he views it o'er and o'er
> And finds fresh beauties never seen before
> The Tyro mind another feast controuls
> The Master loves his art, the Tyro butter'd rolls.

It has been suggested that this is a comic pendant to the serious subject of the Muse-forsaken poet; certainly Turner could be expected to have had more sympathy with the latter, since that more closely reflected his own case; but there is surely a touch of parody in his histrionically posed garreteer, just as there is in the eagerly uncritical artist, surrounded by 'Stolen hints from celebrated Pictures', as a note on the drawing tells us. The room is cluttered with a still-life of 'Phials/ Crucibles retorts, label'd bottles . . . varnish', professional impedimenta which link it again to the rest of the series. Whether the background figure is preparing some pigment or varnish, or toasting a roll, is not clear. The notes on this drawing also make suggestions as to what paintings should be visible in the room: 'Pictures either Judgment of Paris, Forbidden Fruit'. The artist, however inadequate, has ambitious ideas as to subject-matter.[34]

The two titles evoke the grandest of Turner's own historical pictures of these years, 'The Goddess of Discord choosing the Apple of Contention in the Garden of the Hesperides' (No.30). The significance of this work for him can hardly be overstated. It treats of a classical subject associated with the Trojan War, and hence establishes the mythological foundation of the long series of Carthaginian pictures that forms a kind of backbone around which his life's work hangs. The next work in the sequence was to be 'Hannibal', which depicts a moment towards the end of the Carthaginian story. 'The Goddess of Discord' was his response to the Poussins he had seen in the Louvre in 1802, and to the Alps which he had drawn on the same trip. That experience was powerful enough to generate not only the picture, and the many drawings and notes that he made on tour, but the rhetorical lines written out in two versions in the *Verse Book*:

> Discord dire sister of Etherial Jove
> Coeval hostile even to heavenly love
> Unasked at Psyche's bridal feast to share
> Mad with neglect and envious of the fair
> Fierce as the noxious blast thou cleav'd the skies
> And sought the Hesperian Garden golden prize.
>
> The Guardian Dragon in himself an host
> Aw'd by thy presence slumber'd at his post
> With vengeful pleasure pleas'd the Goddess heard
> of future woes and then her choice preferred
> The shiny mischief to herself she took
> Love felt the wound and Troy's foundations shook

The whole foredoomed history of Troy and Carthage is prophesied in the final line: it is as though Turner knew that the story would occupy him for the rest of his life. The Garden of the Hesperides is an image that pervaded his thinking at this time. It recurs in his verse as the symbol of Arcadian innocence threatened by man's stupidity and the vengeance of fate, a symbol that explicitly invokes landscape as the medium and substance of a profound philosophical idea. It was

natural that he should have chosen to represent it in the language of the most philosophical of painters, Nicolas Poussin; indeed, he creates in this picture the most solidly designed landscape of his career: a proper foundation for all that was to follow. The story of Discord choosing an apple that will cause the fall of Troy is superimposed here on the story of the Judgement of Paris, referred to in the note on the drawing for 'The Artist's Studio'. Similarly the notion of 'forbidden fruit' brings together the Trojan apple and that of Eden, so that this garden is both Hesperidean and Edenic, the idyllic cradle of the world in Greek and Judaeo-Christian terms simultaneously. In Ruskin's view the whole Carthaginian series was a vast allegory of the decline and fall of modern England, and 'The Goddess of Discord' was Turner's 'first great religious picture'. The epithet is hardly too strong. Landscape is here presented in an almost ritual way, geographically and art-historically transfigured to communicate the grandest ideas about nature as the setting for man's existence.[35]

There is a further fragment in the *Verse Book* which seems to relate to the world of the sublime and the supernatural, a brief but evocative snatch apparently unrelated to any of the other poems:

> Hor[r]or
> by the hollow roots of trees
> Whose bald tops catch the Morn[ing] breeze
> Horror skill[ed] in magic spells

The mood anticipates that of Turner's much later picture, 'Vision of Medea' (B&J 293), exhibited in Rome in 1828, for which he composed some of his most dramatic verses. If there is a context among the pictures of the 1800s, it must be the canvas known rather vaguely as 'A Subject from the Runic Superstitions' (No.37), which, while it remains difficult to interpret, is evidently a scene of incantation, of witches and goblins, of 'horror' and hollow-rooted trees. But there is no clear connection between the picture and this brief verbal sketch. There is a possibly connected fragmentary draft in the *Spithead* sketchbook (TB C, back cover):

> Hind head tho[u] cloud-capt winded hill
> In every wind that heaven does fill
>
> On thy dark hearth [=?heath] the traveller mourns
> Ice[y] nights approach & groans
>
> The low wan sun has downwards sunk
> The steamy Vale looks dark & dank
>
> The doubtful roads scarce seen
> Nor sky lights give the doubtful green
> But all seem[s] d[r]ear & horror
>
> Hark the kreaking irons
> Hark the screaching owl

This gives the 'horror' a topographical reference that makes good sense of it, and explains the presence of the lines among his other drafts here. The *Spithead* book contains drawings of Gibbet Hill, between Godalming and Hindhead in Surrey, made in 1807 and used as the basis for a *Liber Studiorum* design published in 1811. But the reference to 'magic spells' in the passage in the *Verse Book* perhaps indicates that there Turner had rather different and more occult subject-matter in mind than the wind-blown gibbet on a hilltop beside the road to Portsmouth.

The remaining verses in the book are pitched neither at this level of sublimity nor at that of satire. They are concerned with a pastoral world, the landscape of the Thames and its environs. The decade of these essays in poetry was also the period of Turner's exploration of the Thames valley both as draughtsman and as citizen. In the spring of 1804 his mother, confined for some years in a lunatic asylum, at last died. The year was spent in sorting out and rearranging his affairs; and by the time he was preparing to work on 'The Goddess of Discord', in 1805, he had acquired a country retreat in the village of Isleworth, just upriver from Brentford where he had spent much time as a child. His new home was the first of a long line of alternative residences in which he could hide from people he was unwilling to deal with: his mistress and the two daughters she had borne him; his more distant family, a hard-nosed set of cousins who occasionally made sorties from Devonshire to involve him in their family wrangles; his colleagues and

'A Subject from the Runic Superstitions', ?Turner's Gallery 1808. Oil on canvas (No.37)

'A Thames Backwater with
Windsor Castle in the
Distance', *c.*1805. Oil on
canvas (No.22)

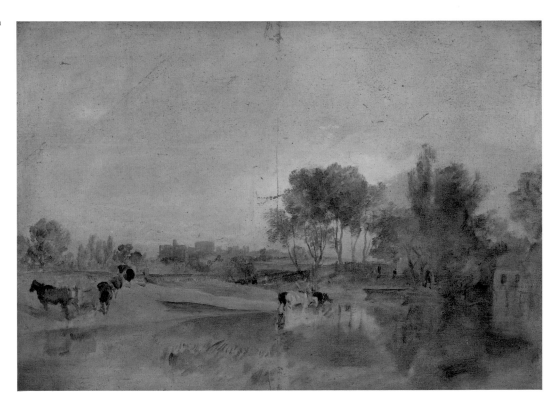

'A House by the Thames',
*c.*1805. Watercolour with
stopping-out (No.18)

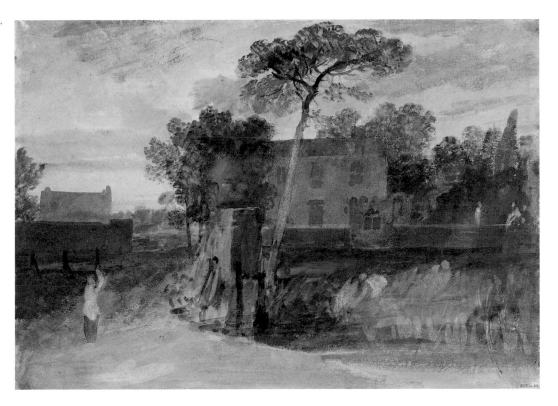

collaborators both in the Academy and out of it. Within a year or two he had moved to West End, Upper Mall, Hammersmith; and in 1807 he acquired a small parcel of land at Twickenham, where he set about building a house. He was to live there, intermittently, from 1813 to 1825. His last years were spent in even more secluded retreat on Thames bank at Chelsea.[36]

For despite his predilection for grandiose subject-matter, his preferred surroundings were modest. He lived the life of a petit-bourgeois, his tastes reflected accurately in the plain, functional, sturdy little stuccoed house that he designed for himself. That predilection can be seen in numerous studies of the Thames valley, in both oil and watercolour, made during the decade; and it is perhaps even more manifest in his poetry. Rivers – either specifically the Thames or more generalised streams – figure repeatedly in his versifyings; and they form a recurrent motif of his art. The *Rivers of England*, the 'Great Rivers of Europe', the 'Rivers of France', were all projects that inspired him to particularly creative flights; and it is clear from his poems that the idea of the river embodied for him the type of human existence: it was paradigm and parable, a living, light-reflecting truth that was central to his perception of landscape. The tarry river of the Pool of London emphasised in traditional accounts of his inspiration, from Ruskin on, was of nothing like so fundamental a significance as the pastoral stream that wound through wooded meadows from Oxford to Windsor and on to the Middlesex and Surrey towns and villages of Twickenham, Richmond, Kew and Isleworth.

His thoughts on the subject of rivers ranged widely, and surface unexpectedly in many places in the drafts. They reiterate traditional ideas, of course; they also adumbrate new ones. One untitled draft in the *Verse Book* anticipates a classic statement on the subject, Tennyson's *The Brook*, not written until sixty years later:

> The early river feed
> from Marsh or Bog or rushy mead
> In silver rippling wandring wild
> As the puking chang[e]ling child
> lolls its head
> The Nurse's fair Breast its downy bed
>
> So gay so fair – so mild Serene
> Seems every weed beneath its stream
> And seems more fresh than those in air
> Kissing its parent as it flows
> As Children's love by kindness grows
> Disturb the stream it quick refines
> It passes on in chequer'd pride
> From Child to Man and love its guide

Till nature difficulties interpose
For ever sally and deny repose
Across the way the rocky barrier throws
With manly power

This vividly allegorical perception of the river of life is one that must be taken as underlying all Turner's depictions of waterways. It is entirely of a piece with his observations of the multifarious activity that takes place on river banks; the teeming, swarming crowds or isolated rustic labourers who embody the burden of his idea. Concomitantly, he draws the river itself into the dramas on its shores, and the Thames becomes a principal actor in events in its vicinity. In seeking to live beside it, Turner thus consciously entered into the drama of life that he wished to record.

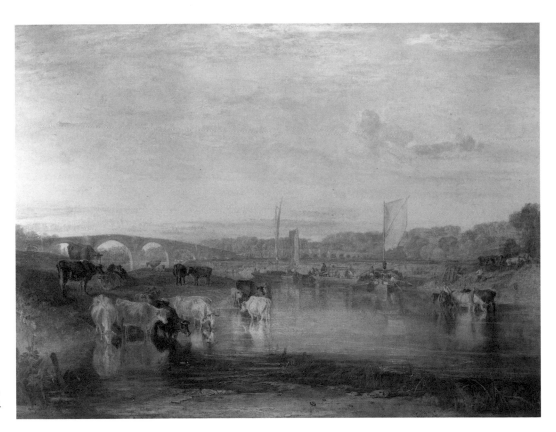

'Walton Bridges', ?Turner's Gallery 1806. Oil on canvas. The Loyd Collection

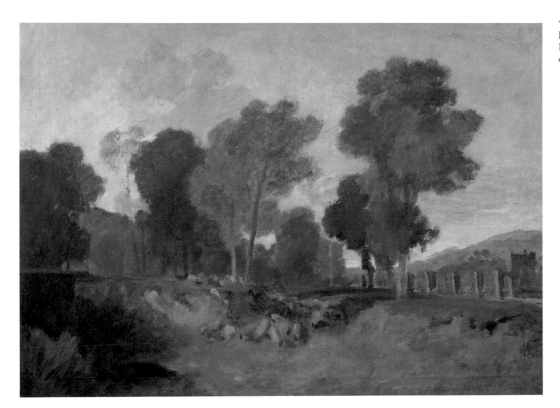

'Trees beside a River with a Bridge in the Middle Distance', *c.*1805. Oil on canvas (No.26)

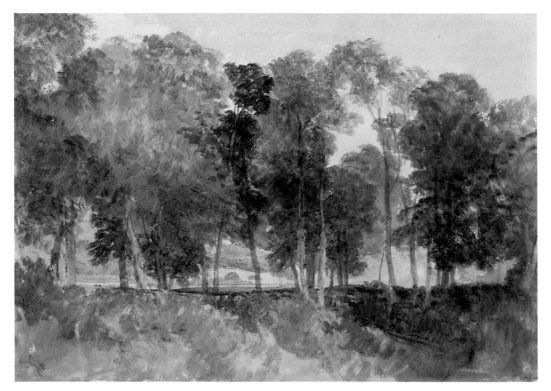

'A Group of Trees beside the Thames', *c.*1805. Pencil and watercolour (No.20)

'View of Richmond Hill and Bridge', Turner's Gallery 1808. Oil on canvas (No.36)

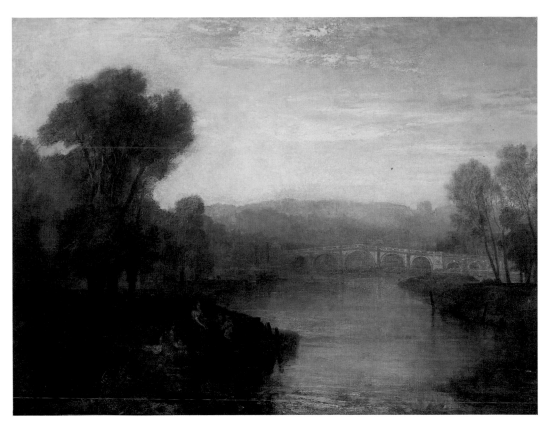

Turner, Pope and Thomson

By chance, at just the moment when he was embarking on his most ambitious poetry and consolidating his personal and material commitment to the Thames valley near Twickenham, his interests were summed up in a publication which might have been a model even more potent than Shee's, though there is no record of Turner's having known it. This was a handsome book, privately printed, entitled *Richmond Hill; a Descriptive and Historical Poem: Illustrative of the Principal Objects viewed from that Beautiful Eminence*, by 'The Author of Indian Antiquities'. The modesty of this oblique designation is redressed in the dedication to Lord Sidmouth, where the writer's name is given boldly as Thomas Maurice. Maurice is of interest as an early historian of India, but his poetry is dull – smoothly predictable Augustan couplets of a type that Turner himself, if he had been more fluent, might have bettered. The poem appeared in 1807, at a time of national gloom while the Napoleonic Wars seemed to sap all vitality and prosperity from the country. It was calculated as a patriotic attempt to glorify Britain, its

landscape, its statesmen, its painters and writers. In its efficiently banal way, *Richmond Hill* encompasses all, or nearly all, the topics that Turner chose to write about in his many drafts about the Thames and its associated characters: his own heroes Pope, Thomson and Reynolds figure as the most celebrated denizens of the neighbourhood, and Maurice refers to several other poets and artists, not all of local extraction: Sir John Denham, William Collins, Capability Brown, Titian, Rubens and Phidias. Typically, but interestingly, he hails Raphael as the 'great Homer of thy day' (p.165), exemplifying in a phrase the automatic contemporary assumption that painting and poetry existed to be compared. The point is made again in the course of a description of Reynolds's 'bright poetic canvass' (p.100). Of political figures he favours especially Pitt and Fox. Turner rarely mentions such men; the reference to Whitbread in connection with Pope's Villa (TB CXXIX, f.2r; see p.99) is an exception. But Maurice's greatest hero, Nelson, is Turner's too. And his main point, the point with which the poem begins, is of peculiar relevance to Turner. Maurice apostrophises Richmond Hill as

> Thou fair Parnassus of the British Isles!
> Where Freedom still, 'mid crumbling empires, smiles.
> . . .
> Thy beauteous vale *their* boasted Tempe shames,
> A nobler Peneus, glides thy winding Thames;
> Through lovelier pastures rolls her fostering wave,
> And nourishes a race more nobly brave.
>
> (pp.32–3)

Thomson had made the point long before in his *Summer* (see No.67); Maurice demonstrates that the parallel between England and Arcadia was by no means an outdated Augustan fancy. It was as potent as ever. If Turner saw the region in which he had chosen to live in precisely this light he was not *retardataire* but a subscriber to a well-established and vital perception of modern England. His poetry, together with the notes and sketches for pictures in several of his sketchbooks of the period, shows him exploring the possibility that it was here, among the woods and water-meadows, the tributary rivers and willow-lined streams of the Thames, that the golden age was once more realised; and it was only a short step from this proposition to the suggestion that it might have been beside the Thames that the great events of classical mythology recorded by Ovid had actually taken place. The modern pantheon of Thomson, Pope, Reynolds and the rest succeeded naturally to the older order, in which Hercules wrestled with Nessus and Achelous, Apollo slew Python or chased Daphne through the woods, Pan and his fellow satyrs lurked in wait for Syrinx and her sisters. In the course of his reading, Turner made particular note of a passage by Lucan in his *Pharsalia* (book VI; Anderson, volume XII, p.798) which is a 'description of the Vale of Tempe'. This is not so much a picture of the physical appearance of the place as a summary of its mythic history in terms of the events that took place on

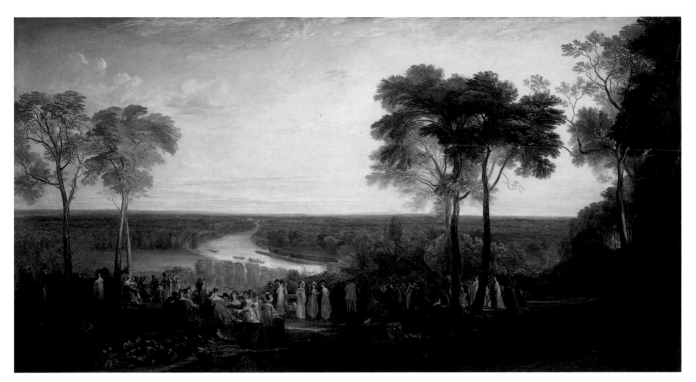

'England: Richmond Hill, on the Prince Regent's Birthday', RA 1819. Oil on canvas (No.67)

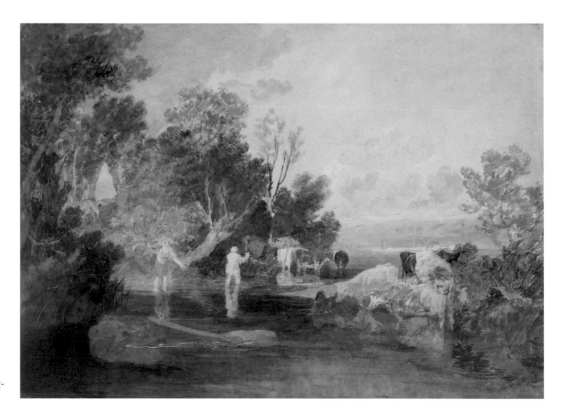

'The Ford', c.1805. Pencil and watercolour with stopping-out and scraping-out (No.21)

the banks of its many rivers, the 'thousand little brooks, unknown to fame' which 'Are mix'd, and lost, in Peneus' nobler name'. Pope himself had attempted to invoke the connection between ancient and modern landscapes in his elaborately designed garden at Twickenham, which had become in the course of the eighteenth century a place of pilgrimage for all who admired modern poetry or classical literature and philosophy.

The two most important poems in Turner's *Verse Book* are related to pictures which deal specifically with the life and culture of Thames side as described by Maurice. They were executed in the years following the publication of *Richmond Hill*, and provide the climax of Turner's many representations of the Thames in this decade: 'View of Pope's Villa at Twickenham, during its Dilapidation' of 1808 (No.35) and 'Thomson's Aeolian Harp' of 1809 (No.44). Their titles make explicit the point that both pictures deal with poetry and celebrate two poets he particularly admired; he goes so far as to liken Pope to Virgil, calling him 'the British Maro'. It is no surprise that he devoted immense pains to the composition of verses on these subjects. 'Thomson's Aeolian Harp' was exhibited at the Academy accompanied by the longest of all his published poems (see below, pp.71–2). He showed 'Pope's Villa' in his own gallery without verse, and his planned poem never appeared in print; ideas for it are to be found in the sketchbooks he was using in the second half of the decade. Some occur in the *Windmill and Lock* book (TB CXIV) which bears the watermark 1808 and seems to belong mostly to about 1811, suggesting that Turner's interest in the subject was renewed when John Britton proposed to publish an engraving after his picture in his *Fine Arts of the English School*, which appeared in that year (see No.56). In all the drafts for both these poems, the Thames features prominently as a crucial presence, responding, feeling and suffering as the embodiment of that spirit of Nature which expresses the passions of humanity.

The draft 'On the Demolition of Pope-House at Twickenham' in the *Verse Book* is a particularly interesting example of Turner's use of the river motif, being framed as a lament by the Thames herself for the demolition of Pope's house by Baroness Howe in 1807, an act of vandalism and cultural blindness for which plenty of parallels could be found today, but which did not put an end to public interest in the house. Turner's celebration of it was only one of many that appeared in literature and art during the nineteenth century:

> Dear Sister Isis tis thy Thames that calls
> See desolation hovers o'er those walls
> The scatterd timbers on my margin lays
> Where glimmering Evening's ray yet lingering plays
> There British Maro sung by Science long endear'd
> And to an admiring Country once rever'd
> Now to destruction doom'd thy peaceful grott
> Pope's willow bending to the earth forgot
> Save one weak scion by my fostering care

Nursd into life . . . wild fell destruction there
On the lone Bank . . . to mark the spot with pride
dip the long branches in the rippling tide
And sister stream the tender plant to rear
On Twickenham's shore Pope's memory yet to hear
Call all the rills that fed our spacious Urn
Till twylight latest gloom in silence mourn

The sense disintegrates at this point: the shepherd Alexis is substituted for Pope as the object of the lament, and the classical stream Lodona takes the place of Thames.

Turner never finished his poem, and Britton did not publish any of his lines. But an exchange between the two men concerning the prose text that Britton compiled for the plate reveals all Turner's thoughtful concern for the subject. It illuminates, for instance, the allusion to the willow tree which, we learn, is the dead trunk in the foreground, symbolic of Pope's slighted achievement: the weeping willow he had planted, one of the first to be introduced into Britain, had itself become synonymous both with Pope's achievement as a poet and with his genius in garden design. Britton had apparently suggested that this trunk was to be read as 'Pope's willow', but Turner felt this to be too literal an interpretation of the picture; 'cannot you do it by allusion?' he asked. The delicate and subtle interplay of representation, allegory and metaphor is always to be understood in his work; but he warns us to avoid heavy-handed interpretations that give too much prominence to direct parallels or obvious symbolism.[37]

Turner's regard for Pope, as expressed here, is obviously warm and almost personal: he seems to feel a special bond with the poet. This is perhaps surprising, seeing that he never cited Pope's work in connection with any of his pictures. There was possibly one entirely private reason for his interest: Pope's maternal grandfather, lord of the manor of Towthorpe, Yorkshire, was called William Turner – a detail Turner would have learned from the biographical notice of Pope in Anderson's *British Poets*. There was almost certainly no connection between the two families, but Turner may have derived some satisfaction from the coincidence. His frequent references to Binfield, near Windsor, Pope's family home, show that he was familiar with the details of the poet's biography. Pope's reputation, too, like those of Reynolds and Thomson, added lustre to that stretch of Thames bank to which Turner was attached as a place that had contributed significantly to the history of English arts and letters.

Pope provided much of the substance of thought that Turner was to experiment with in his own poems about the Thames. The early pastorals (1709) of *Spring*, *Summer*, *Autumn* and *Winter* anticipate the subject-matter of Thomson's great work, and together with *Windsor Forest* (1713) supply hints as to the content and meaning of many incoherent notes in Turner's *River* sketchbook (No.32) and elsewhere. 'Alexis' is the swain whose name gives the subtitle to Pope's *Summer*:

A Shepherd's Boy (he seeks no better name)
Led forth his flocks along the silvery Thame,
Where dancing sunbeams on the waters play'd,
And verdant alders form'd a quiv'ring shade.
Soft as he mourned, the streams forgot to flow,
The flocks around a dumb compassion show,
The Naiads wept in ev'ry wat'ry bow'r,
And Jove consented in a silent show'r.

(lines 1–8)

Turner's own roughly drafted lines in the *Verse Book*, following those quoted earlier, are:

Lodona gratefull flows, Alexis all deplore . . .
And flowing murmurs oft Alexis is no more.

The history of Lodona is given by Pope in *Windsor Forest*: she was a 'rural nymph', banished from the service of Cynthia, goddess of the moon and of the chase (i.e. Diana), who, pursued by Pan, was eventually transformed into a stream of tears which, Pope says, became the river Loddon, a tributary of the Thames. This could be said to render canonical the notion that the Thames valley was a modern Tempe or Arcadia. Later in the poem, there is a eulogy of the Thames, with London (Augusta) on its banks; and Pope gives an inventory of its tributaries –

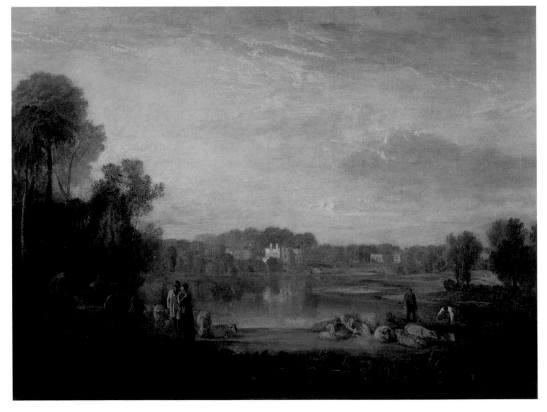

'View of Pope's Villa at Twickenham, during its Dilapidation', Turner's Gallery 1808. Oil on canvas (No.35)

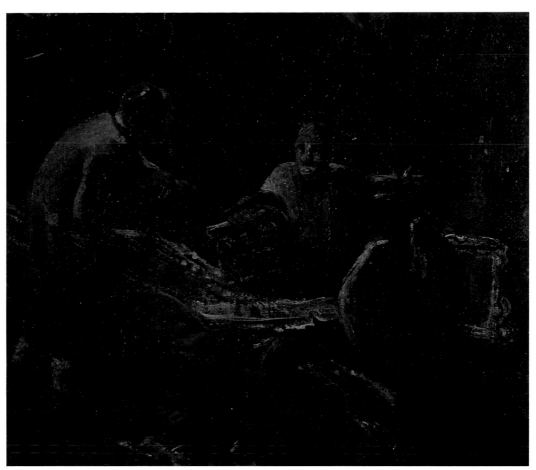

which perhaps echoes Lucan's list of the Greek rivers – and sketches out the topography of Turner's work in the Thames valley with all its local resonances:

> The winding Isis and the fruitful Thame,
> The Kennet swift, for eels renown'd,
> The Loddon slow, with verdant alders crown'd;
> Cole, whose dark stream his flowery islands lave;
> And chalky Wey, that rolls a milky wave:
> The blue, transparent Vandalis appears;
> The gulfy Lee his sedgy tresses rears;
> And sullen Mole, that hides his diving flood;
> And silent Darent, stain'd with Danish blood.
>
> (lines 340–48)

This is the Pope that Turner imitates in his verse, not the more sardonic poet of the *Satires*. He deliberately modelled himself on the most purely Augustan types, of which Pope, together with Thomson, is the supreme example.

James Thomson was a Scot, born twelve years after Pope in 1700, who had come to London in 1725, the year in which he began the composition of his masterpiece, the *Seasons*. The four poems, *Spring*, *Summer*, *Autumn* and *Winter*, were

first published together in 1730, but revised several times thereafter. It was immediately acknowledged as the greatest of all essays in landscape poetry, and remained a much-read classic until the late nineteenth century. Another important work, *The Castle of Indolence*, appeared in 1748; it took the form of an archaising pastiche of Spenser. *Liberty*, a long and rather unsatisfactory poem on the development of politics and culture throughout history, had come out in 1735 and 1736, and in the latter year Thomson moved to Kew Road, Richmond. As his own verses on the Thames at Twickenham make clear, he was as conscious as Turner himself of the illustrious presence of Pope, at the time these lines were written mortally ill:

> Slow let us trace the matchless vale of Thames;
> Fair-winding up to where the muses haunt
> In Twit'nam's bowers, and for their Pope implore
> The healing god
>
> (*Summer*, lines 1425–8)

Turner's interest in Thomson has long been acknowledged; Jack Lindsay in particular has emphasised the importance of the poet's work in forming the painter's vision.[38] But we may go even further. Turner's early quotations from the *Seasons*, as well as his important picture of 1809, make it clear that Thomson was both a formative influence on his thought and a sustaining force behind the progress of his art. In his notes on painting and poetry in the *Perspective* sketchbook (No.49) he calls Thomson 'the great poet of nature'; and it is perhaps not an exaggeration to say that Turner aspired to be the Thomson of painting. This implies an Augustan, rather than a strictly 'Romantic', view of art which in fact accounts very satisfactorily for many aspects of his work that are difficult to assimilate into Romantic or modernist interpretations of his painting. There is hardly an idea in Turner's output that cannot be traced to Thomson's *Seasons* or *Liberty*; and where his ideas diverge, their tone and general assumptions seem almost invariably to hark back to the atmosphere of early eighteenth-century thought. This applies particularly to Turner's strikingly consistent view of landscape as economic complex, both cause and consequence of human activity – a view considerably at odds with the notion of him as purveyor of sublime natural effects for their own sake.

When he showed his first Thomsonian works at the Royal Academy in 1798, he at once pointed to the central thesis of Thomson's natural history: the generative power of the sun. This theme has become so firmly identified with Turner's own view of nature that Thomson's emphasis on it has perhaps been neglected. Turner repeatedly cites the passages in which Thomson makes the point, and in his own verse adapts Thomson to the same purpose:

> But yonder come the powerful King of Day,
> Rejoicing in the East: the lessening cloud,
> The kindling azure, and the mountain's brow
> Illumin'd – his near approach betoken glad.

These lines, slightly modified from the published poem (*Summer*, lines 81–5), were appended to the watercolour of 'Norham Castle on the Tweed, Summer's Morn' (w.225) which announced a motif that he was to pursue in his art until the last decade of his life. The verses are equally prophetic. It is revealing of both men that in looking for a quotation suitable for 'Frosty Morning' (shown in 1813; No.61), Turner should have picked on a passage in which Thomson points out the power of the sun even in a winter landscape (though the description was moved back a season in later editions):

> The rigid hoar-frost melts before his beam.
>
> (*Autumn*, line 1169)

The role of light in the formation and perception of natural objects and the communication of ideas about them, celebrated by Thomson as a central feature of his immediately post-Newtonian universe, becomes the main thesis of Turner's art. If there is a literary antecedent of the Turnerian solar glare it is to be found in Thomson:

> 'Tis raging noon; and, vertical, the sun
> Darts on the head direct his forceful rays.
> O'er heaven and earth, far as the ranging eye
> Can sweep, a dazzling deluge reigns; and all
> From pole to pole is undistinguish'd blaze.
>
> (*Summer*, lines 432–6)

One of the most celebrated of Turner's blazing suns is his repainting in 1837 of 'Regulus' (B&J 294), a subject he may well have remembered from Thomson's catalogue of ancient heroes in *Winter* (line 513), and which he himself treated in verse in the course of his long draft poem on the Southern Coast of England (see p.172). More specifically, as has often been pointed out, the quintessentially Turnerian subjects of a mountain avalanche and a tropical storm at sea which the painter depicted in his 'Fall of an Avalanche in the Grisons' of 1810 (No.52) and in the much later 'Slavers throwing overboard the Dead and Dying – Typhon coming on' of 1840 (B&J 385) rely heavily in numerous details on Thomson's description of two such scenes – even, in the latter case, to the shark devouring the castaway slaves – respectively in *Winter* (lines 414–23) and in *Summer* (lines 980–1025). Here, as frequently elsewhere, Thomson's conscientiously scientific description of nature is the inspiration for Turner's relentless search for natural truth which Ruskin was later to seize upon as a token of his modernity.[39]

But Thomson deliberately combined his scientific approach with the picturesque. He has often been singled out for his conspicuous reliance on the tradition of classical landscape painting in the conception of his set-pieces – the 'landskip of the shepherd tending his flock with lambs frisking around him', for instance, in *Spring* (lines 830ff.; the epitome is Thomson's own, from the table of contents published in the 1729 edition). It may well have been this trait which recommended him to the new generation of landscape painters that sprang up in

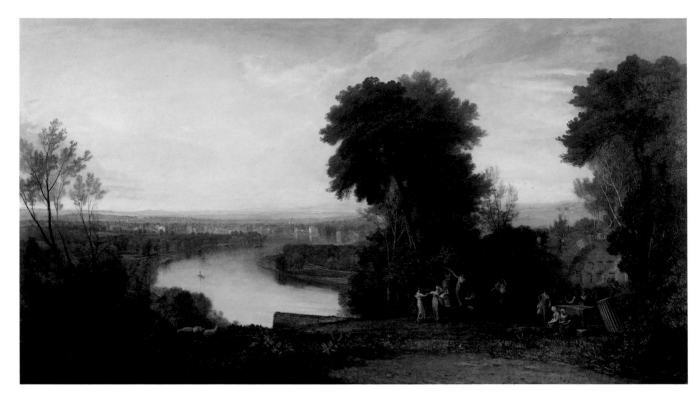

'Thomson's Aeolian Harp',
Turner's Gallery 1809.
Oil on canvas (No.44)

'Frosty Morning', RA 1813.
Oil on canvas (No.61)

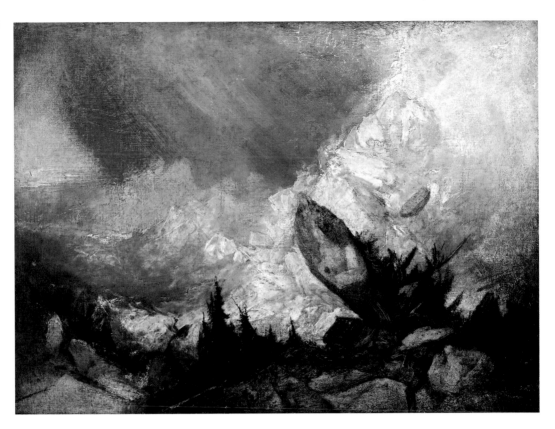

England in the later eighteenth century; certainly the Thomsonian blend of
pictorial charm with informative description provided a literary precedent for
the basic formulas used by the topographical watercolourists whose example
Turner followed in his early years. He continued to respond creatively to those
formulas all his life. The watercolour view of 'Salisbury, Wiltshire' that he drew
for Heath's *Picturesque Views in England and Wales* as late as about 1828 (w.836) can
perhaps be seen as a fresh interpretation of this very passage, in which Thomson
describes the shepherd, surrounded by his flocks, seated on an iron age fort (Old
Sarum?) which leads him to meditate on 'ancient barbarous times' and the new,

> deep-laid indissoluble state
> Where wealth and commerce lift the golden head,
> And o'er our labours liberty and law
> Impartial watch,

and to continue to a contemplation of

> Inspiring God! who, boundless spirit of all
> And unremitting energy, pervades,
> Adjusts, sustains, and agitates the whole.
> (*Spring*, lines 845–8, 853–5)

In the watercolour the great cathedral rises above the landscape as an invocation

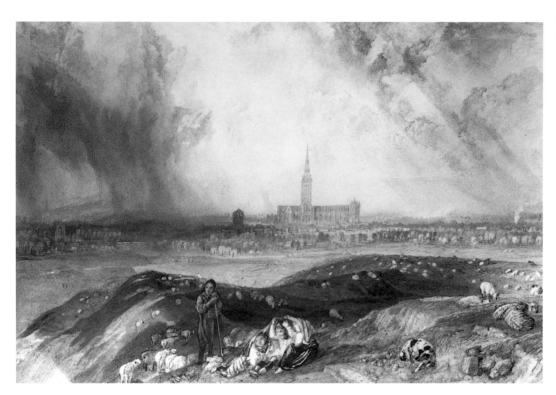

'Salisbury, Wiltshire', *c.*1828, Watercolour. Private Collection

to God exactly parallel to Thomson's. His inevitable linking of small with great, of the minutiae of country life with a broad economic pattern in its turn locked into the natural environment, prompting consciousness of the wonders of creation and the numinous force of all life – this goes far beyond the intentions of the seventeenth-century landscape painters, and forms a framework exactly analogous to the way Turner lays out his panoramas of modern or ancient civilisation.[40]

The human activity with which he almost invariably loads his landscape subjects is repeatedly anticipated by Thomson: the sheep-washing at Walton Bridges in the picture of 1807 (B&J 63) glances back to *Summer*, lines 371–85; harvesting of the vintage, as in dozens of his watercolours and the painting of 1803 'The Festival upon the Opening of the Vintage at Macon' (B&J 47), recalls *Autumn*, lines 683–706; and had it been exhibited, Turner's 'Harvest Home' of about 1809 (B&J 209) might have attracted a citation from *Autumn*, lines 1221–34. Angling, Turner's favourite pastime and one he frequently introduced into his work, is discussed in detail by Thomson in *Spring* (lines 382–442).

Even some of Turner's more widely known ideas about the futility and frailty of life, if not derived from Thomson, found their expression in Thomsonian terms. The 'summer fly/ Which rises, flits, expands, and dies', figuring in his own verses for the painting 'Light and Colour' of 1843 (B&J 405), surely refers back to Thomson's frequent descriptions of ephemerids, 'the little summer race . . . to the sun allied' (*Summer*, lines 237–9). Even the tone of Turner's Romantic disillusionment is foreshadowed here:

Thick in yon stream of light, a thousand ways,
Upward and downward, thwarting and convolv'd,
The quivering nations sport; till, tempest-winged,
Fierce Winter sweeps them from the face of day.
Even so luxurious men, unheeding, pass
An idle summer life in fortune's shine,
A season's glitter! Thus they flutter on
From toy to toy, from vanity to vice;
Till, blown away by death, oblivion comes
Behind and strikes them from the book of life.

(*Summer*, lines 342–51)

Nevertheless Thomson's philosophy is Augustan, not Romantic; his train of thought again and again moves from the individual to the community, to the State, the sun and the deity. A typical sequence is that which follows the description of sheep-shearing:

A simple scene! yet hence Britannia sees
Her solid grandeur rise: hence she commands
The exalted stores of every brighter clime,
The treasures of the sun without his rage:
Hence, fervent all with culture, toil, and arts,
Wide glows her land: her dreadful thunder hence
Rides o'er the waves sublime, and now, even now,
Impending hangs o'er Gallia's humbl'd coast;
Hence rules the circling deep, and awes the world.

(*Summer*, lines 423–31)

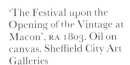

'The Festival upon the Opening of the Vintage at Macon', RA 1803. Oil on canvas. Sheffield City Art Galleries

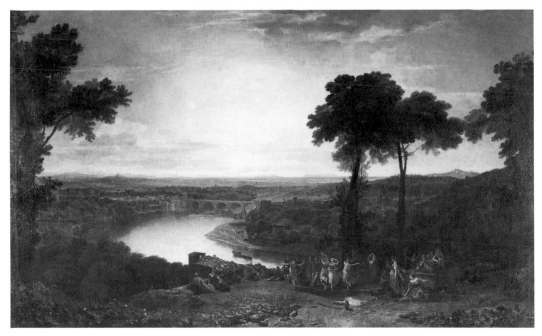

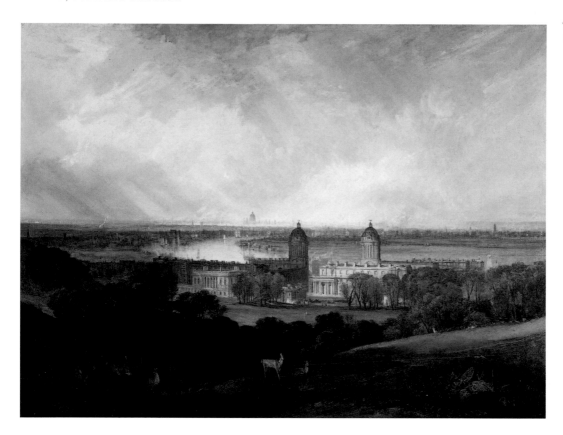

'London', Turner's Gallery 1809. Oil on canvas (No.45)

That this fundamentally patriotic and optimistic world-view chimes closely with Turner's is apparent in the very tone and atmosphere of a high proportion of his pictures. More specifically, it can be found expressed in his own writings, notably in the long topographical poem that he planned as an accompaniment to the series of *Picturesque Views on the Southern Coast of England* in about 1811. Here he discusses the hemp industry of Bridport in Dorset:

> Behold from small beginnings like the stream
> That from the high raised downs to marshy ream
> First feeds the meadows where grows the line
> Then drives the mill that all its powers define
> . . .
> Pressing dividing all vegetation pass
> Withdrawn high swells the stony mass
> On the peopled town who all combine
> To throw the many strands in lengthened twine
> Then onward to the Sea its freight it pours
> And by its prowess holds to distant shores
> The straining vessel to its cordage yields
> So Britain floats the produce of her fields
> Why should the Volga or the Russians
> Be coveted for hemp[?] why thus supply'd
> The sinew of our strength our naval pride

. . .
> Plant but the ground with seed instead of Gold
> Urge all our barren tracts by Agriculture skill
> And Britain Britain British canvass fill

The final line is evidently a reminiscence of Thomson's

> thus united Britain Britain make
> Entire, the imperial mistress of the deep
> (*Autumn*, 2nd ed., lines 927–8)

Such a world-view was common to nearly all the Augustans: Mark Akenside, another poet whom Turner admired and read with care, gave expression to it in a quite different form in his *Hymn to the Naiads* of 1746 (see p.88). From Pope, too, Turner absorbed the same attitudes; and it has been suggested that he was influenced in many of his mature watercolours by Defoe's *Tour through the whole Island of Great Britain* (1724–6).[41] Although there is no evidence to support that contention, the idea bears out an intuition of the broad sympathy between Turner's outlook and that of the early eighteenth century.

There is evidence enough that Thomson, especially the Thomson of the *Seasons*, was an important stimulus to the Romantics. Haydn's second great oratorio, of 1801, is based on those poems; and it is probable that Beethoven was well aware of them when he framed the programme of the Pastoral Symphony. Wordsworth early on acknowledged his debt to Thomson in his *Remembrance of Collins*, written in 1789, and, more directly, in the *Stanzas written in my pocket-copy of Thomson's 'Castle of Indolence'*, composed in 1802 and published in 1815. Indeed, his most substantial work, *The Prelude*, is unthinkable without the example set by the *Seasons*, whose pattern of alternating description and meditation or apostrophe he took over and remodelled for his own purposes. Turner similarly adopted and adapted the poet's grand vision as a thematic source for much of his art.

The 'Fallacies of Hope'

It is not surprising, then, that Turner should have paid Thomson the tribute not only of a large and important picture but also of some of his most sustained exercises in poetry. The lines that he appended to 'Thomson's Aeolian Harp' in the Academy catalogue in 1809 are the most accomplished as well as the longest of his published verses (see No.44); and he spent much time working away at his own set of poems celebrating the seasons. All these efforts were either drafted or copied out in the *Verse Book*. But it may be that he paid even more sustained homage when he embarked on his own *Fallacies of Hope*. The poem was first

revealed to the public in 1812, but Turner had probably been working on it for a few years before that date. It was to occupy him obsessively, if occasionally, for the rest of his life, and its title, although apparently an allusion to other long philosophical poems of the time such as Campbell's *Pleasures of Hope* and Rogers's *Pleasures of Memory*, echoes a phrase that can be traced back through the eighteenth century. In *Autumn* (lines 1257–8), for instance, Thomson speaks of

> a solid life, estrang'd
> To disappointment and fallacious hope –
> Rich in content, in Nature's bounty rich,
> In herbs and fruits . . .

'Fallacious hope' was far from being Thomson's personal property; indeed, it was a commonplace of Augustan thought. Another of Turner's favourite writers, John Langhorne, uses it in a poem to which Turner alluded in a (lost) watercolour exhibited in 1799, 'Morning, from Dr Langhorne's Visions of Fancy' (w. 255).[42] The *Visions of Fancy* take the form of four 'Elegies', from which Turner borrowed nine lines for his catalogue entry – the first eight from *Elegy IV* (lines 21–8), the last adapted from *Elegy II*, line 9:

> Life's morning landscape gilt with orient light,
> Where Hope and Joy and Fancy hold their reign,
> The grove's green wave, the blue stream sparkling bright,
> The blythe hours dancing round Hyperion's wain.
>
> In radiant colours youth's free hand pourtrays,
> Then hold[s] the flattering tablet to his eye,
> Nor thinks how soon the vernal grove decays,
> Nor sees the dark cloud gathering o'er the sky.
>
> Mirror of life thy glories thus depart.

The last line, with its continuation, actually runs:

> Mirror of life! the glories thus depart
> Of all that Youth and Love and Fancy frame,
> When painful Anguish speeds the piercing dart,
> And Envy blasts the blooming flowers of fame.

Langhorne's next stanza is:

> Nurse of wild wishes and of fond desires,
> The prophetess of Fortune, false and vain,
> To scenes where Peace in Ruin's arms expires
> Fallacious Hope deludes her hapless train.

Turner's conception of hope as inherently deceitful and dangerous is thus one which derives from a standard philosophical position of the early and mid-eighteenth century. In so far as it is characteristic of much Romantic thought, it

must be seen as having its origins in the Deistic rationalism of Thomson's epoch. It expresses not so much cynicism (which Turner scholars have frequently interpreted as a profound pessimism) as a common-sense view of what the world and human nature are really like. In fact, hope represented two distinct and contrasting values for eighteenth-century Christians like Langhorne (a clergyman of the Church of England). He analysed them and their interrelationship in a *Hymn to Hope* where, significantly perhaps for the Turnerian connection, he apostrophises hope as 'Sun of the Soul!' Just as the sun, in the Augustan worldview, is the source and sustainer of all physical life, so hope is the vital illuminator of life's spiritual path. Yet, within a few lines, Langhorne calls hope both 'fair' and 'vain'. In an image of potent significance for Turner Langhorne evokes the calm sea suddenly stirred into a storm. Here again the telling phrase occurs:

Life's ocean slept – the liquid gale
Gently moved the waving sail.
Fallacious Hope! with flattering eye
You smil'd to see the streamers fly.
The thunder bursts, the mad wind raves:
From slumber wake the frighted waves:
You saw me, fled me thus distrest,
And tore your anchor from my breast.

(stanza VI)

But if hope is delusory it is necessary to the construction of a workable philosophy of living:

To soothe Ambition's wild desires;
To feed the lover's eager fires;
To swell the miser's mouldy store;
To gild the dreaming chymist's ore;
Are these thy cares? or more humane?
To loose the war-worn captive's chain,
And bring before his languid sight
The charms of liberty and light;
The tears of drooping grief to dry;
And hold thy glass to sorrow's eye?

(stanza VII)

Turner was to build on these eighteenth-century foundations in his own characteristic ways; but it seems clear that in making 'fallacious' hope a theme of his art, he was taking over a well-defined and well-understood value, one that was not in any way antipathetic to standard Christian belief; rather an essential ingredient in any balanced view of life, and one which he, with his particular predilections in the way of landscape subject-matter, might legitimately seize on and elaborate. It is apparent that from the beginning he was anxious explicitly to 'place' his subject-matter within this nexus of received ideas; for his first citation

from what he identified as '*M.S.P.* [i.e. Manuscript Poem] *Fallacies of Hope*', in connection with 'Snow Storm: Hannibal and his Army crossing the Alps' (No.59) when it appeared at the Academy in 1812, is one of his most obvious plagiarisms from Thomson. In *Winter* Thomson had written (lines 41–51):

> Now, when the cheerless empire of the sky
> To Capricorn the Centaur-Archer yields,
> And fierce Aquarius stains the inverted year –
> Hung o'er the farthest verge of heaven, the sun
> Scarce spreads o'er ether the dejected day.
> Faint are his gleams, and ineffectual shoot
> His struggling rays in horizontal lines
> Through the thick air; as cloth'd in cloudy storm,
> Weak, wan, and broad, he skirts the southern sky;
> And, soon descending, to the long dark night,
> Wide-shading all, the prostrate world resigns.

Turner's verses for 'Hannibal' include the following lines:

> still the chief advanc'd,
> Look'd on the sun with hope: – low, broad, and wan;
> While the fierce archer of the downward year
> Stains Italy's blanch'd barrier with storms.
> In vain each pass, ensanguin'd deep with dead,
> O['e]r rocky fragments, wide destruction roll'd.

'Snow Storm: Hannibal and his Army crossing the Alps', RA 1812. Oil on canvas (No.59)

'Low, broad, and wan' is a manifest recasting of 'Weak, wan, and broad'; 'downward' is a characteristic Thomsonian epithet, as in

> Till, in the western sky, the downward sun
> Looks out effulgent
>
> (*Spring*, lines 189–90)

and the 'fierce archer' is evidently an adaptation of Thomson's 'Centaur-Archer'. 'Ensanguin'd' occurs several times, for instance in *Winter*, line 825; and the whole tenor of Turner's evocation of a battle closely follows Thomson's style.

The verses published in the Royal Academy catalogue are the first that Turner associated with the *Fallacies of Hope*; before this moment, there is no direct evidence that he had any intention of composing such a poem. There are, however, extensive drafts in the sketchbooks which date from precisely this time, and may be regarded as parallel enterprises, and even perhaps as preliminary *ébauches* for the *Fallacies of Hope* itself. In the *Hastings* book (TB CXI), in use during 1810 and 1811, there are drafts of a long poem concerned with the imagination (see pp.100–101); among them are some lines related to the theme of hope.

> Outcast with misery the felon
> Who tho all the course of the law parts
> Een at the last faint glimpse of hope
> Hopes with a steady firmness and views
> The ignominious scaffold hand in hand
> Upon his last breath to Fancy'd Hopes & fear[s] . . .
> Gives that in disgrace to all before
> A Solemn benediction to the croud who press
> By thy overwhelming powers to behold
> The great grasp of human misery
>
> (f.64v)

Even more relevant are the verses Turner appended to his 'Fall of an Avalanche in the Grisons' (No.52) when he showed it at his own gallery in 1810. These are given no reference, but could easily have formed part of the 'Manuscript Poem' that was to be announced two years later. The Thomsonian epithet 'downward' appears at the very start of the passage; and the whole tone and sense of it anticipates both the 'Hannibal' verses and those for 'The Battle of Fort Rock' (No.63) of 1815.

What, then, impelled Turner to give a title and a very specific intention to his verses in 1812? The question cannot be answered conclusively. He had happily quoted himself anonymously in past catalogues, both at his own gallery and at the Royal Academy. What is clear is that he attached special importance to 'Hannibal'. He made an unusual fuss about its position in the Great Room at Somerset House when the 1812 exhibition was being hung, and it may be that he judged the moment ripe for a more noticeable entry in the catalogue.[43] Possibly, too, he had reached a point at which he really felt that a sustained and successful

'The Battle of Fort Rock, Val d'Aouste, Piedmont, 1796', RA 1815. Watercolour with scraping-out and stopping-out (No.63)

poem was nearly achieved. Certainly the long drafts in the *Hastings* and *Perspective* sketchbooks, not to mention the lengthy poem on the Southern Coast in the *Devonshire Coast No.1* book (No.57), must have seemed to him a substantial achievement, confirming that he could indeed write poetry, and suggesting that it would not be immodest of him to admit his efforts.

More specifically, it is possible that he had conceived an ambition to compose a particular kind of poem – one belonging to the category that Hugh Blair had designated the 'Didactic', including in it Virgil's *Georgics*, Lucretius's *De Rerum Natura*, Lucan's *Pharsalia*, Pope's *Essay on Criticism* and Akenside's *Pleasures of Imagination*, which were all works we know Turner admired. By giving his own poem a title that echoed the last example and others in the same vein that were highly regarded at the time, he tacitly pleaded for its admittance into a special class of poetry in which he must be assumed to have felt he had a rightful interest. His activities as Professor of Perspective and author of the instructive manual of landscape, *Liber Studiorum*, were fruits of the same pedagogical impulse.

Given this background, we must assume that he had in mind a recent and highly successful poem on a similar subject – Thomas Campbell's *The Pleasures of Hope*, which had first appeared in 1799, when Campbell was twenty-one. It was the kind of youthful achievement that frequently spurred Turner on to feats of rivalry in his early years. What is interesting about Campbell's view of hope is that it lacks the dualism of Thomson's or Langhorne's. It is a source of unalloyed benefit to humanity: 'sweet', 'auspicious', 'congenial', 'unfading' are Campbell's epithets. Hope relieves human suffering, abets the wisdom of the scientist, brings

its 'handmaid arts' to the service of civilisation, and ushers in the triumph of Truth. Above all, it offers the assurance of immortality. If the conditions of life become unendurable, hope is withdrawn. There is no suggestion that it is after all illusory. If Turner designed his own 'poem' as a sequel or response to Campbell's, then he must have intended to restore the earlier, subtler view. He does so not simply by reasserting the old duality, but by offering the two kinds of hope as superimposed ironically one upon the other. Campbell's clear-cut distinctions are now blurred; where he could write

> Oh! sacred Truth! thy triumph ceased a while,
> And Hope, thy sister, ceased with thee to smile

Turner portrays nature melting into confusion 'At Hope's delusive smile'.

This contradiction does not really explain why Turner chose the subject. It has been suggested that he was reacting to the disillusionments of the Luddite movement, and the war in Europe as depicted in the early cantos of Byron's *Childe Harold*.[44] The testimony of Turner's poetry is that he was not likely to have responded thus directly to contemporary politics, and we have no evidence that he read *Childe Harold* before 1817. But it may be that *The Pleasures of Hope* does after all provide a clue to his motives. In spite of the apparent antagonism of his ideas, Campbell is in fact dealing with one topic particularly close to Turner's heart: the imagination and its relation to human creativity. The published *Analysis of Part the First* tells us that Campbell was specifically concerned with 'The inspiration of Hope, as it actuates the efforts of genius', and he discusses Newton and Linnaeus as examples of this. In Part the Second he links hope and the imagination as 'inseparable agents':

> Above, below, in Ocean, Earth, or Sky,
> Thy fairy worlds, Imagination, lie;
> And Hope attends, companion of the way,
> Thy dream by night, thy visions of the day!

Another poem of the same period may have had a complementary influence on the ideas generated by Campbell: Samuel Rogers's *The Pleasures of Memory*. This had first appeared in 1792, and propounded an argument analogous to Campbell's, asserting that it is the faculty of memory that enables us to make retrospective sense of experience. Like hope, it evokes ideas from many contrasting fields of action, and brings them together in an interpenetrating pattern of associations which is the foundation of a balanced philosophy and, of course, of art. These ideas lead us directly to some of the central themes of Turner's own verse, in which the fruits of imagination are an ambiguous hope balanced against an equally fragile memory – two faculties between which the creative spirit oscillates in its effort to come to terms with reality past, present and future.

What is distinctive about Turner's account is its sharper, more questioning tone, its willingness to play on the irony inherent in the comparison of past,

Beyond each mortal touch the most refined,
The god of winds drew sounds of deep delight:
Whence, with just cause, the Harp of Aeolus it hight.

Ah me! what hand can touch the strings so fine?
Who up the lofty diapasan roll
Such sweet, such sad, such solemn airs divine,
Then let them down again into the soul?
Now rising love they fanned; now pleasing dole
They breathed, in tender musings, through the heart;
And now a graver sacred strain they stole,
As when seraphic hands an hymn impart:
Wild warbling Nature all, above the reach of Art!

It is this description of the aeolian harp that is referred to specifically by William
Collins in his *Ode on the Death of Mr Thomson* of 1748 (printed in Anderson's *British
Poets*):

'Thomson's Aeolian Harp'
(No.44), detail

In yonder grave a Druid lies
 Where lowly winds the stealing wave!
The year's best sweets shall duteous rise,
 To deck its poet's sylvan grave!

In yon deep bed of whispering reeds
 His airy harp shall now be laid,
That he, whose heart in sorrow bleeds,
 May love through life the soothing shade.

Then maids and youths shall linger here,
 And while its sounds at distance swell,
Shall sadly seem in pity's ear
 To hear the woodland pilgrim's knell.

Remembrance oft shall haunt the shore
 When Thames in summer wreaths is drest . . .

Collins explains in a footnote that the 'airy harp' is 'The Harp of Aeolus, of which see a description in the Castle of Indolence', and tells us in a gloss on the title of the *Ode* that 'The Scene of the following Stanzas is supposed to lie on the Thames, near Richmond'. The whole poem might be a proposal for Turner's picture 'Thomson's Aeolian Harp' (No.44). It is even possible that the quatrain form employed by Collins dictated the scheme adopted by Turner in many of the drafts of his Thomsonian celebration of the seasons, apparently worked on at the same time as the couplets which he ultimately printed in the Academy catalogue. Some of those drafts are titled 'Invocation of Thames to the Seasons – upon the demolition of Pope's House', demonstrating that Turner did not separate his acts of homage; the Pope and Thomson pictures pay tribute to both poets simultaneously.

Collins's line 'Remembrance oft shall haunt the shore' – quoted by more than one writer in the years after Pope's Villa had been demolished[45] – closely anticipates a recurrent motif in Turner's own poems about Pope. The plangent tones of the aeolian harp stimulated memory as one of the principal associations that together created the conceptual 'mood' of the spot in which it was placed. In his poetry Turner places great emphasis on the role of memory, which imbues much of what he writes with a tender, somewhat nostalgic melancholy:

Autumn rich in nodding sheaves
Will withhold the falling leaves
Not to check thy plaintive thrills
That gentle Pity's Eye e'en fills
Now Winter follows and decay
Will all thy melting softness lay
 (*Verse Book*, p.31)

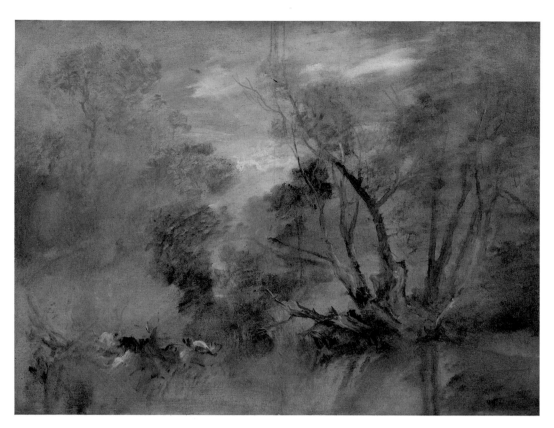

'Willows beside a Stream',
c.1805. Oil on canvas
(No.23)

> Here hills and vales, the woodland and the plain,
> Here earth and water seem to strive again;
> Not Chaos-like together crush'd and bruis'd,
> But, as the world, harmoniously confused:
> Where order in variety we see,
> And where, tho' all things differ, all agree.
> Here waving groves a chequer'd scene display,
> And part admit, and part exclude the day;
> . . .
> There, interspers'd in lawns and op'ning glades,
> Thin trees arise that shun each other's shades.
> Here in full light the russet plains extend:
> There wrapt in clouds the bluish hills ascend.
>
> (*Windsor Forest*, lines 11–23)

This passage, written as early as 1704 (some time before the whole poem was finished), considers nature as a composition, pleasing to the eye by virtue of the appropriate juxtaposition and variation of its different elements. It is the transposition of pictorial terms of reference to the realm of literature, a remodelling of nature to accord with the demands of painting. Taken up a few decades later by the Rev. William Gilpin and others, the principle became

established as the Picturesque aesthetic which was to govern landscape painting until well into the next century;[48] effectively, indeed, until Turner's death.

One of the factors contributing to Pope's heightened perception of nature was derived very specifically from the locality of Windsor Forest. As we know, he was brought up in that neighbourhood, at Whitehall House in Binfield, a few miles west of Windsor. There his father had undertaken extensive planting of trees, improving the natural advantages of the place with an eye to visual effect and the evocation of the Antique notion of rural felicity. When he planned his own garden at Twickenham after taking a lease on the property in 1718 Pope went much further in satisfying both eye and mind, laying out walks, lawns, groves of trees, occasional buildings and monuments, so as to stimulate philosophical and meditational trains of thought in a context of continually changing vistas and varied objects of contemplation.[49] The idea had already been developed by Burlington at Chiswick; his example, and Pope's, was followed by Cobham at Stowe, by Hoare at Stourhead, and by Shenstone at the Leasowes, among many landowners. The idea of the Picturesque garden became a paradigm not only for planters but for painters. 'All gardening is landscape-painting. Just like a landscape hung up', Pope said.[50] Beside his achievement as a poet, then, he had contributed something of fundamental importance to the aesthetic climate of Turner's own age and Turner, one of the most self-consciously art-historical of artists, paid due tribute to his influence in both painting and verse.

There is yet another way in which Pope's innovations as a gardener affected

'Washing Sheep', c.1805.
Oil on canvas (No.24)

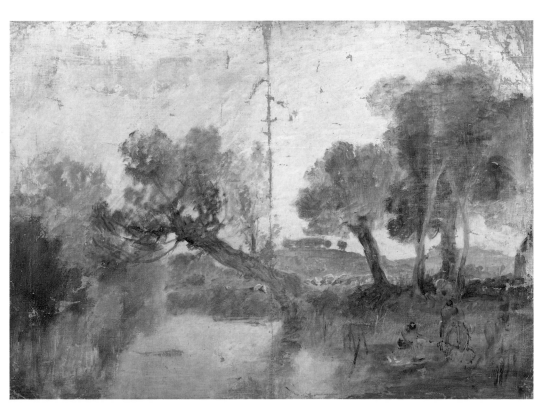

him. We have a considerable body of evidence to suggest that Turner was very much interested in gardens and their design. His early training as architectural topographer would have involved him in the observation of gardens and the various ways they relate to buildings; and he was fond of garden views that lead the eye gently from point to point, just as he would do in a complex topographical subject. He hardly extended his activities as architect to the design of real gardens, though an elaborate plan occurs in one of the sketchbooks, together with a perspective view of what seems to be the same scheme (TB CXXIX, f.14v). There is also a plan for the layout of the piece of land on which he built Sandycombe Lodge (TB CXXVII, f.21v), a plan that is like his buildings, plain and functional with none of the brio of those he included in his pictures of imaginary gardens which are thought out with as much care as if they were to be executed. The furniture and properties that he scatters about his actual gardens always bring them to life in a vivid and tender way, as though he was particularly happy in such surroundings. Throughout his work, there are innumerable indications of his pleasure in gardens and sense of the physical reality of horticulture: the trim sweep of an English lawn is seen to be the result of affectionate labour, summed up in a still-life of wheelbarrow and rake, as in the watercolour view of Rose Hill in Sussex (W.438), or one of two paintings of Mortlake Terrace (B&J 235). The other view of this house (B&J 239) has, in addition to a pair of steps, a hoop and a chair with, propped against it, a portfolio of drawings – instantly evocative of the pleasure of the place.

But Pope's garden was not only a lawn on which one might play or sit and draw; it was a sequence of views designed to prompt meditations on classical history and philosophy, and for Turner the implications for his work as a recreator of classical history and myth were wide-ranging. A main part of his mature achievement is the long sequence of historical subjects set in the ancient past in which landscape, architecture and sentiment interlock just as they would do in the Picturesque garden. In creating the wooded terraces of ancient Carthage (B&J 131,135), disposing the fountains, pools and temples of 'The Fountain of Indolence' (B&J 354), or presenting a bird's-eye view of Phryne's Athens (B&J 373) he is a garden designer on the grandest scale, and his subject-matter becomes the object of philosophical contemplation in a vast park. When he exhibited 'Childe Harold's Pilgrimage – Italy' (B&J 342) in 1832 he cited lines from Byron's poem:

> and now, fair Italy!
> Thou art the garden of the world [. . .]

Indeed, his idealised perception of the Mediterranean lands in all these mature paintings is that of the landscape gardener.

If the eighteenth-century garden was the fertile ground in which many of his most evolved landscapes took shape, he was also well aware of the more disciplined classical garden types against which Pope had reacted. What is perhaps the supreme instance of Turner as garden designer shows him reverting

to the original villa garden of the Ancients, which is both the foundation-stone and the antithesis of what Pope had tried to achieve. The picture is 'Cicero at his Villa' (B&J 381), exhibited in 1839, which displays what is in effect a complete, elaborate and brilliantly conceived Italian garden, formal in its layout but presented by Turner, as Pope would have wished, so that the eye can wander through it as if it were a three-dimensional reality.

The house itself is based on the Villa Mondragone which Turner had sketched at Frascati. This was a place frequently cited as a *locus classicus* of the ideal villa type to which Pope's house and many other Thames-side residences aspired; and Thomas Maurice had likened Richmond to Frascati in his poem. But Cicero's garden is entirely of Turner's own invention. The trees are stone pines and cypresses rather than English oaks or willows, of course; and the combination of lawns, walks, water and sculpture is derived from the Italian gardens Pope himself had rebelled against, and which were only returning to fashion in these years.

The scale is splendid. A semi-circular lake lies in the centre of the main axis, immediately in front of the entrance to the villa; it is flanked, to left and right, by curving balustraded walks leading to groves dotted with cypresses and sculpture. Beyond it, along the main axis, are a lawn and then an oval lake with a fountain. Beside the lake are large sculptural groups that mark the start of various subsidiary axes: a principal one to the left (as one comes from the house) is a broad avenue lined with sculptures on plinths; while further from the villa, and immediately below the terrace on which we are standing with Cicero, is a small

'Cicero at his Villa',
RA 1839. Oil on canvas.
Evelyn de Rothschild Esq.

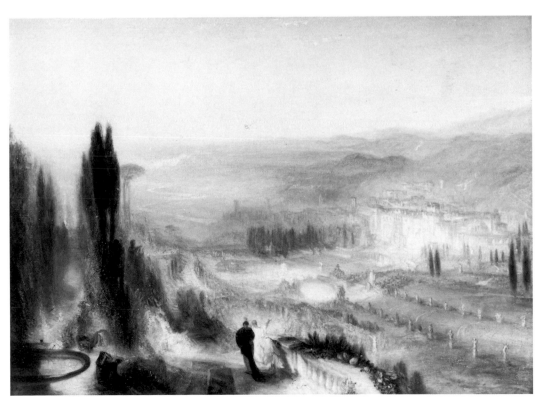

ruined amphitheatre. Behind this, a high cascade falls into a basin at the foot of two symmetrical flights of balustraded steps, over which presides a huge statue of a seated figure with a lyre, probably Apollo; the waters are supplied by a canal that runs between tall cypresses under a high arch into the distance at the left of the picture. In front of it, close to the spot on which we stand, is a raised basin beside a stone seat where papers and a cloak have been left – Cicero interrupted in his work by the arrival of the guest to whom he shows the glories of his man-made landscape and the expanse of the Abruzzi and Campagna beyond. The whole picture is a vividly imaginative realisation of a historical garden, replete with the classical associations and objects of contemplation that Pope included in his own, deliberately more 'English' layout. Turner demonstrates his extraordinarily vivid grasp of the practicalities of man-made landscape; he turns Pope's aphorism on its head. Painting is garden design.

'Jason', RA 1802.
Oil on canvas (No.9)

The Poets of Antiquity

No Augustan was ignorant of classical literature; Homer, Theocritus, Ovid, Virgil and Horace were more immediately important to the eighteenth-century poets than their own predecessors in English or any modern European language. The great exception, Milton, had modelled his own style on the syntactical structures of Latin; even his lyrical verse is invested with a Roman orotundity and weight that distinguish it from the poetry of earlier generations. His eminence and influence were undisputed throughout the eighteenth century, and the literary atmosphere that he had breathed was that of every civilized Englishman of the period. Turner was not by any means a complete eighteenth-century gentleman; but he was deeply imbued with the literature of the epoch immediately preceding his own, and if he could not read the classical authors in the original, he certainly read them in the translations that were widely available. His set of Anderson's *British Poets* printed numerous short pieces of this kind, by Addison, Gray, Garth, and a host of minor, now forgotten figures; and there were endless paraphrases and imitations: Walter Harte's paraphrase of Pindar or Ovid; Ambrose Philips's pastorals in the style of Theocritus or Virgil; William Hamilton's imitations of the *Odes* of Horace. As we have already noticed, volumes XII and XIII were devoted entirely to translations from the classical authors, including Musaeus and Apollonius Rhodius, both of whom Turner cited. He could also acquaint himself there with other figures essential to an understanding of Antiquity, among them Hesiod, Theocritus, Sappho and Lucretius. At the head of all the English versions stood two great works: Dryden's *Aeneid*, and

'Apollo and Python', RA 1811. Oil on canvas (No.55)

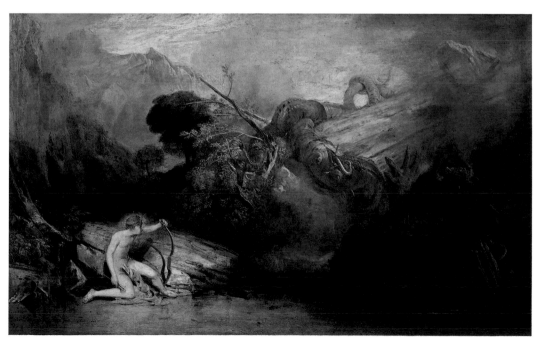

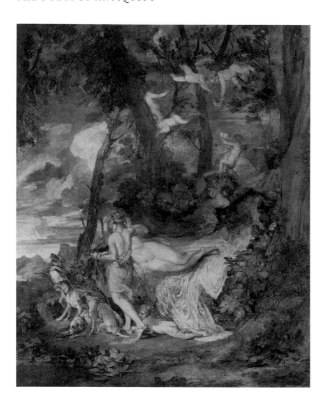

'Venus and Adonis, or
Adonis departing for the
Chase', c.1803–5. Oil on
canvas. Private Collection

Pope's *Homer*, definitive translations for their time and long after, which brought
the major epics to everyone who could read. It was these monumental works that
had reasserted the dramatic validity of rhyming pentametric couplets, a form
eschewed by Milton, who couched his own epics in blank verse. Turner used both
forms in his most serious writing, though he preferred couplets. He also possessed
and annotated the 1786 edition of Goldsmith's *Roman History* and a 1657 copy of
North's famous translation of Plutarch's *Lives of the Noble Grecians and Romans*. In
the front of the Goldsmith he noted these possible subjects: 'Cleopatra sailing
down the Cydnus/ Hannibal crossing the Alps/ his departure from Carthage the/
decline of that Empire – Regulus returns . . . / Pompey. arrival at Lisbon after the
Battle', and made a sketch of Caesar turning away from a man holding up the
head of Pompey.

The extent of his reading of classical literature becomes apparent when we run
through the titles of his exhibited works, and the lists of proposed titles that he
scattered through his sketchbooks. The *Hesperides 1* and *2* and *Studies for Pictures:
Isleworth* sketchbooks in particular (Nos.12–14) have many such notes, with
related compositions. The most fertile and suggestive of the works to which he
referred was undoubtedly Ovid's *Metamorphoses*. In the course of the first few years
of the century he contemplated pictures dealing with the stories of Venus and
Adonis (see Nos.7,10), Apollo and Python (Nos.8,55), Narcissus and Echo
(No.11), Jason and the Argonauts (see Nos.8,9), Mercury and Argus (see No.20),
Glaucus and Scylla (see No.58), Achelous (see No.14), Phaeton, Aesacus and
Hesperie, Actaeon, Nessus, Dryope, Cephalus and Procris, and others. Some of

these were treated not in exhibited pictures but in designs for the plates of the *Liber Studiorum* after its inception in 1806. Ovid may also have been initially responsible for suggesting the fruitful subject of Dido and Aeneas to Turner. As to where and how Turner first discovered Ovid, no definite answer can be given. We do not know whether he owned a complete translation of the *Metamorphoses*, but he would have encountered substantial passages among the translations printed by Anderson.

It may be that a more immediately pictorial impulse directed him to the *Metamorphoses*: his enthusiasm for the paintings of Claude. A significantly large number of Claude's subjects are taken from Ovid, and the Arcadian overtones of the stories in the *Metamorphoses* provided apt resonances with the idyllic landscapes that Turner set out to paint. Indeed, Claude and Poussin provided him with most of the hints for historical subject-matter that he either contemplated or developed into finished works. A literary intermediary such as Shakespeare or Goldsmith was probably responsible for his thinking of a classical subject like Antony and Cleopatra (TB XC, f.84v). Given his inability to approach the ancient authors in their own languages, this would be no more than natural, equivalent to his use of Pope in studying Homer. Dramatisations and translations created a happy union between the classics and modern English literature, a way of paying homage to the great men of the past and present simultaneously that was entirely congenial to the mind of the period, paralleling the pleasing evocations of Antiquity that were to be found in the paintings of Poussin and Claude. So when Turner acknowledged the genius of Pope he could list among his achievements the descriptions of 'Patroclas corse defiled with dust and gore', and 'Pale Hector' in his translation of the *Iliad (*TB XCVI, f.68v), and speak of the 'lament over Troy' alongside a reference to 'poor Eloisa' from Pope's entirely original poem *Eloisa to Abelard* (f.74v).

Homer did not in fact inspire him to many pictures. The importance of Homer for the conception and atmosphere of 'The Goddess of Discord' (No.30) is evident; and the watercolour 'Chryses' of 1811 was exhibited with a quotation from 'Pope's Homer's Iliad, book I' a passage significantly describing the sun, 'The God who darts around the world his rays' (see No.28). But thereafter no specifically Homeric subject appears until 'Ulysses deriding Polyphemus' of 1829 (B&J 330), catalogued with a simple reference to 'Homer's Odyssey'. On the other hand Virgilian subjects were to become a mainstay of his repertoire. Virgil had made three essential contributions to the literature of Augustan Rome: the epic *Aeneid* which consciously and deliberately took up from Homer the story of the Trojan hero Aeneas and traced his wanderings, including his love-affair with Dido, Queen of Carthage, to his arrival in Latium in central Italy and the foundation of Rome; and two sequences of rustic poems, the ten *Eclogues* and the four *Georgics*. The latter are essays on rural life and the conduct of husbandry; the former, together with Ovid's *Metamorphoses*, brought the Greek Arcadian world of Theocritus' *Idylls* into Latin literature.

Turner was not slow to recognize the Virgilian source of much of Pope's early

'Dido and Aeneas', RA 1814.
Oil on canvas (No.62)

pastoral writing: it was the relationship of *Windsor Forest* to the *Eclogues* that led him to refer to Pope as 'the British Maro', and it was that aspect of Pope's output that Turner set out to imitate. The bucolic subjects of the first decade of the century, and especially the scenes of shepherding, reaping, haymaking and digging which are so often incorporated into his views along the Thames, can as we have seen be referred directly to the economic model of the countryside offered by Thomson; but the ultimate sanction for such subject-matter was the Arcadian precedent evoked by Pope.

However, Virgil's rustic descriptions were not, in the end, as important to Turner as the grand human drama of the *Aeneid*, and in particular the story told in book IV of the epic, which is summarised by Dryden in the Argument that heads his translation: it concerns

> Dido's passion for Aeneas, and her thoughts of marrying him. She prepares a hunting match for his entertainment. Juno, by Venus's consent, raises a storm which separates the hunters, and drives Aeneas and Dido into the same cave, where the marriage is supposed to be completed. Jupiter despatches Mercury to Aeneas, to warn him from Carthage. Aeneas secretly prepares for his voyage. Dido finds out his design, and, to put a stop to it, makes use of her own and her sister's entreaties, and discovers all the variety of passions that are incident to a neglected lover. When nothing would prevail upon him, she contrives her own death, with which this book concludes.

This, it is true, is the episode summarised by Ovid in book XIV of the *Metamorphoses*; and it was the scene of the hunt that was the subject of Turner's

'Dido building Carthage; or
the Rise of the Carthaginian
Empire', RA 1815. Oil on
canvas. The National
Gallery

'Regulus', 1828; reworked
1837. Oil on canvas. Turner
Collection, Tate Gallery

first canvas dealing with the story: 'Dido and Aeneas' of 1814 (No.62). Yet it was not Ovid but Virgil whom he quoted in his catalogue entry for the picture. He seems to have pursued his research from the pastoral to the epic poet as he delved deeper into the subject.

Before 1800, he had painted an Italian landscape with the figures of Aeneas and the Sibyl illustrating an episode in Virgil's book VI (B&J 34); this was never exhibited. And by this date he had already shown at the Academy 'Hannibal crossing the Alps' (No.59), which dealt with an episode in the recorded history – as opposed to the mythology – of Carthage. It was followed by 'Dido building Carthage' in 1815 (B&J 131) and 'The Decline of the Carthaginian Empire' in 1817 (B&J 135), pictures which have something of the status of a complementary pair, but which deal respectively with, once more, the mythology and the history of the city. 'Dido directing the Equipment of the Fleet' appeared in 1828 (B&J 241), and 'Regulus' was painted that year during Turner's stay in Rome. Again, mythology and history alternate. 'Regulus' was repainted and shown in London in 1837 (B&J 294). The brilliant, not to say blinding, dazzle of sunlight for which it was particularly noticed became a leading motif of the final pictures of the series, the four subjects he exhibited at the Academy in 1850.[51] These were all episodes derived from book IV, but instead of being accompanied by quotations from Virgil they were given tags from the *Fallacies of Hope*, none longer than two lines, though all in their way are intense, condensed statements of the tragedy of existence that have something of the succinct effectiveness of Turner's late pencil sketches. In this last year of his life as a contributor to the exhibition, he attempts the final apotheosis of his own most significant poem: to press it into service in lieu of Virgil himself.

Theory

Turner volunteered for the post of Professor of Perspective at the Royal Academy in 1807. He was proud of the position, and frequently signed his pictures with the initials 'P.P.' as well as 'R.A.' after his name. It was not until January 1811 that he actually delivered his course of lectures, and the interim had been filled with intensive reading on and around the subject of perspective. He did not regard it as a purely mechanical science, to be studied in a vacuum, but aspired to introduce to his audience (which consisted principally of fellow Academicians and members of the Academy Schools) the range of his ideas on painting, especially landscape. The standard text-books on perspective – Brook Taylor, Kirby, Malton and the rest – served him well enough for the practical side; when it came to the theory of painting, and his notions of the artist's purposes in making a picture, Turner had recourse to authorities of a very different stamp.[52]

He referred, of course, to the great thinkers on art and architecture, Lomazzo, Lairesse, Dufresnoy, De Piles, and Reynolds; he depended still more on the insights provided not by theoreticians but by the practitioners of the different, parallel, art of poetry. His lecture notes are strewn with quotations, from which he wanted his audience to infer a great deal of relevant information about how to view the world and the process by which the subjective vision of the eye is translated by the mind into the statements of art. He strove to relate theory to practice, and specifically to analyse the ways in which perspective affects landscape painting. A rough draft for one of the lectures in the *Perspective* sketchbook (No.49) shows him exploring these ideas in a private and somewhat obscure fashion. The names of Pope and Thomson occur, not only in a general philosophical context but even in the middle of a discussion of the laws governing the casting of shadows.

Several of these jottings are concerned with the central differences between painting and poetry, and in particular with the greater difficulty the painter has in dealing with abstractions. The poet may relate his descriptions to ideas summoned by the imagination; 'he seeks for attributes or sentiments to illustrate what he has seen in nature', while 'the Painter must adhere to the truth of nature and has to give that dignity with the means of dignity or must produce it by other means'. The newly-risen sun, for instance, has little glory while still seen through mist. The poet can suggest the hidden grandeur directly, while the painter must in some way evoke it in spite of the visual evidence to which he is confined – the 'local contrarieties of his art', as Turner puts it. Motion, too, the painter cannot convey, except by implication: he is 'trammled with mechanical shackles' unknown to the poet. Thomson can describe the hare limping through the grass (*Summer*, lines 57–8); Dryden speaks of 'wave impell'd on wave harsh breaking on the shore'; and Turner may also have been thinking of a passage from Rowe's translation of Lucan that had particularly struck him in Anderson (volume XII):

> So when fierce winds with angry ocean strive,
> Full on the beach and beating billows drive.
> (*Pharsalia*, book VI)

He notes that Pope too could be cited in illustration of the dynamism of which words are capable. By means of words 'impetuosity is given to the most sluggish of perception[s]'. The tone of the whole note is one of complaint: Turner resents the immobility of the painted image, which the flexibility of poetic thought seems to hold up to ridicule. He took it as a personal challenge; his own art was to be concerned to a large extent with the problem of creating movement, convincing and sometimes violent movement, within the confines of the picture-space.

Elsewhere he is much more optimistic about the status and potential of painting. In a long note on ff.45v–43v of the *Cockermouth* sketchbook (No.47), in use during the summer of 1809, he compares landscape with history painting and portraiture, arguing that it ought to be regarded as an 'ally' to the other branches

of art, and that it is wrong to denigrate it by association with low genre: 'her commonality should be above common life as to convey the simplicity of pastoral ease, not riot and debauchery incidental to low life.' This superiority of utterance is a consequence of superior sensibility: 'combining the force of nature and of truth the commonality of Landscape is the mere incidents of everyday occourance but there are more perceptive feelings of these everyday occourances evinced by one more than the other who has the book of nature before his view'. He goes on to quote 'the poet of the Seasons', once more, though in a garbled form:

> To one who ever Natures volume be displayed
> and happy catching inspiration thence
> Happy the passage enraptured to translate

– and compares the process of 'translation' into the language of poet and painter respectively, 'delineation in one and description in the other, their sentiments being frequently the same'. He admits that 'by long acceptation . . . the Painter['s] utmost need is to be Poetical[, to] follow the Poet and define his descriptions'; but the painter's ideas 'must be evinced by the sentiments contained in the transcripts of one happy, fleeting passage surpassing all description'. Then, 'if the Painter succeeds he is poetical, "or conceived in true Poetic Vein"'; but he has succeeded nevertheless in his own terms, his own language. Turner concludes in triumph: 'their pursuits are different tho the[y] love and follow the same cause and have a mutual regard in admiration'.

These passages seem to have been written down as expressions of ideas that Turner wanted to include in one of his Perspective lectures. These were being revised and polished during 1811 in preparation for the second course that he delivered early in 1812. One of them, the fourth, he embellished with additional material, including several references to poetry, amplified by quotations from Milton and others. The surviving manuscript[53] consists of extensive drafts in his own hand, added to the text of the original lecture as it was written out by W. Rolls, his copyist, early in 1810. These additions are typical of Turner's attempts to broaden the basis of his discussion of perspective. Characteristically, he makes his points by showing how the poets approach the subject, how they evoke associations, describe emotions, and generally convey all the conceptual, as well as visual, ideas involved in the depiction of nature. Having established these points in words, he goes on to explain how the painter must tackle the same problems, even though he is deprived, by the nature of his chosen medium, of the means to express purely abstract ideas. This was the topic to which he always returned in his ruminations on the subject of poetry and painting.

He felt quite entitled to dilate upon such matters in the course of what were ostensibly talks on a purely technical subject. His instinct was always to penetrate beyond the surface practice of any skill, the outward reasons for any phenomenon. When he was writing his poem on the Southern Coast he read treatises on the geography of the region. His reading for the responsibilities he

undertook as Professor of Perspective was conscientious and wide-ranging; and, having decided to extend his brief towards the more imaginative aspects of the art of painting, he made a point of brushing up his aesthetic theory. It was inevitable that he should prefer to do so by reference to poetry rather than to the prose writings of aestheticians. His sources range widely, from Callimachus to Shakespeare, from Milton and Dryden to Thomson and Akenside. He begins with a round statement of the general theory of imitation in art, citing Dryden, who

> says that art reflecting upon nature endeavours to represent [it] as it was first created without fault[.] This idea becomes the original of art and being measur'd by the compass of the interlect is itself the measure of the Performing hand by immitation of which imagin'd form all things are represented which [are] under human sight and therefore in form and figures there is some-what which is excellent and perfect to which imagin'd species all things are referr'd by immitation which immitation of nature is the ground work of our art (f.4r)

This exposition of what is essentially the Platonic view of representation forms the starting-point for his discussion of the rules of Perspective, the basis for the understanding of nature. His annotations make the point vivid by an opening (mis)quotation from *Macbeth*:[54]

> The air hath bubbles as the water hath, and these are of them to all who know the rules but are consider[ed] a weakness that render the knowledge of any rules necessary or less apparently absolute: Nature Nature Nature stands like Socractes advice (f.4v)

In these notes he goes on to suggest that all the arts – sculpture, architecture and painting – are subject to the rule that 'introductory objects [and] incident[s] accessory or positive' must be 'required by the nature of the story, connected by style, time, or order'; and he suggests that the propriety of such elements will be dictated by our experience of 'the less limited and [?restrictive] Ideas of the Epic, Dramatic or Pastoral, Poetry' (f.6v). In particular, colour, for the painter,

> often clothes the most inauspicious formalities, arising from rules, lines, or localities of Nature, by a diffused glow or gathering gloom which destroys abstract definition as to tone, and prevents contemplation of any formal [?qualities] therein existing – Color is universal gradation . . . from the simple pastoral to the most energetic and sublime conceptions while Light and Shade can be classed without color, producing likewise gradation of tone, by compatible strengths of dark to light, while color . . . [is] productive or destructive of Light or distance, as well as an appropriate tone to peculiar combinations considered Historic, or Poetic, color. (f.7r)

In other words, colour is a means whereby the painter may allude to those conceptual circumstances which give context and meaning to a landscape.

Turner goes so far as to press a comparison with the various modes of music: 'every tone must be Dorian, Lisian, Lydian, Ionia[n], Bacc[h]anal' (f.7v). The painter is for ever

> calling upon those mysterious ties which appear wholly to depend upon the association of ideas. Thus the busy power [of] memory preserves her ideal train entire; or when they would elude her watch

>> Reclaims their fleeting footsteps from the waste
>> Of Dark Oblivion; thus collecting all
>> The various forms of being to present
>> Before the curious aim of mimic Art
>> the[ir] largest choice

> of combined property of colors, quality and quantity of Light, shade, forms, and lines: at once impressive and impressing contemplation, into the Sentiment or feelings depicted which in nature line by line and feature after feature we refer [*note:* and to which poetic color must assimilate]

>> To that sublime exemplar when[ce] it stole
>> Those animating charms,

– thus

>> color's mingle[,] features join,
>> and lines converge; the fainter parts retire
>> the fairer eminent in light advance
>> and every image on its neighbour smiles

In the last three quotations Turner alludes to a particularly important source for his ideas in this manuscript. The lines are taken from Akenside's *Pleasures of Imagination*, which he was able to read in its original (1744) and revised (1757–70) versions in volume IX of Anderson's *British Poets*. (The references are to the 1744 version, book III, lines 348–54, 423–4, 405–8.) We may conclude from the many errors in transcription that he was writing the lines from memory; this applies in several other instances, and indicates that he carried a great deal of the poetry he admired in his head. Akenside had been a favourite of his for some time: Turner alluded to his *Hymn to the Naiads* in the Academy catalogue entry for his watercolour of 'The Fall of the Clyde, Lanarkshire: Noon' in 1802 (see No.39).[55] Akenside was a friend and protégé of Pope, a fact that must have had its due weight with Turner. One point which may particularly have appealed to him was the fact that the poet was by profession a doctor, and a learned one, who had published several serious works on human physiology; his philosophy could, therefore, be regarded as sound, intellectually rigorous and appropriate to use as the foundation for a didactic exercise. As Anderson's *British Poets* informed Turner, he was known as 'the British Lucretius': *The Pleasures of Imagination* was seen as a modern parallel to Lucretius's *De Rerum Natura*, with which Blair had

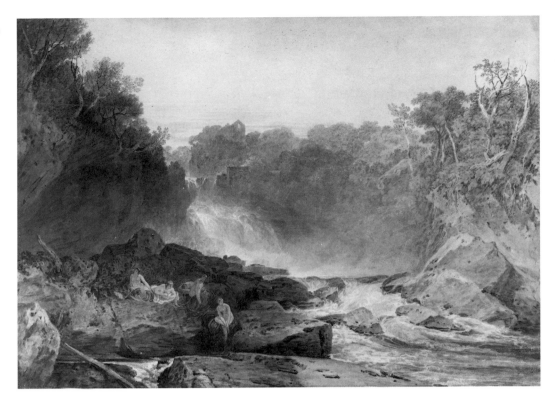

'The Fall of the Clyde,
Lanarkshire: Noon. – Vide
Akenside's Hymn to the
Naiads', RA 1802.
Watercolour. Walker Art
Gallery, Liverpool

listed it among the exemplary didactic poems in his *Lectures on Rhetoric*. It was
conceived, and regarded in its own time, as a work of aesthetic philosophy, and
remained influential into the nineteenth century: Constable quoted from it in his
English Landscape Scenery, which did not appear until 1830. For Turner two
decades earlier, Akenside supplied an entirely suitable literary peg on which he
could hang theoretical ideas about his art. Indeed, at about the time of these
lecture notes he seems to have essayed his own poem on the subject of fancy and
the imagination, in the *Hastings* sketchbook (TB CXI, ff.93–5).

 The Pleasures of Imagination begins by pointing out the distinctive and superior
gifts of artists, to whom

> the Sire Omnipotent unfolds
> The world's harmonious volume, there to read
> The transcript of himself. On every part
> They trace the bright impressions of his hand:
> In earth or air, the meadow's purple stores,
> The moon's mild radiance, or the virgin's form
> Blooming with rosy smiles, they see portray'd
> That uncreated beauty, which delights the mind supreme.
>
> (book I, lines 99–107)

Akenside the Platonist presents the artist as mediating between men and those
ideal forms which constitute eternal truth. It is both a classical concept and one
that presages the fiery aspirations of Romanticism:

Else
. . . wherefore darts the mind,
With such resistless ardour to embrace
Majestic forms; impatient to be free,
Spurning the gross control of wilful might;
Proud of the strong contention of her toils,
Proud to be daring?

(book 1, lines 166–74)

For a young painter convinced of his own genius, this was heady stuff. In selecting quotations from the poem to read to his 'young friends' in the Perspective class, Turner was no doubt trying to fire them with something of the fervour that he had admired in Reynolds's Discourses.

Akenside goes on to list the stimuli of the imagination in ascending order of importance, beginning with ' colours mingling with a random blaze' (book 1, line 448) and concluding with animate and sentient and, finally, moral beings as the primary sources of beauty:

Mind, mind alone, (bear witness earth and heaven!)
The living fountains in itself contains
Of beauteous and sublime . . .
. . . is aught so fair
In all the dewy landscapes of the spring,
In the bright eye of Hesper or the morn,
In nature's fairest forms, is aught so fair
As virtuous friendship? as the candid blush
Of him who strives with fortune to be just?
The graceful tear that streams for others' woes?

(book 1, lines 481–506)

This formulation presented Turner with a serious challenge to his practice as a landscape painter, one which he felt it his duty to meet. The mere delineation of nature is not enough: the moral significance of human deeds and thoughts must inform the artist's vision. Yet Akenside seems to suggest a way out of this dilemma: by the operation of the imagination the human mind can invest nature with moral grandeur. In the end, as Turner stresses in his lecture notes, the artist must bring the power of creative imagination to bear on the problem:

In these elevated branches of Art Rules my young friends languish, all they can contribute here is but propriety of judgement, as to practicality or discriminating the most proper in choice of subjects, compatable and commensurate with the powers of art . . . Gradation of line, gradation of tone, gradation of color is all that ariel perspective can theoretically ask, or practically produce. The higher quality of sentiment or application of interlectual feeling, forming the Poetic, historic, or perceptions gaind from nature and her works are far beyond dictation; here rules are conducive only

> to select compatibilities . . . to produce the feeling excited by Poetic numbers [*interlin.*: Pictorial numbers]; or judicious selections of Historic incidents thus the active powers of the Mind, may not lead the immitative power of the Hand into a labyrinth through false choice (f.8r)

The alternation between 'Poetic numbers' and 'Pictorial numbers' here epitomises the identification of poetry and painting in Turner's own mind as he threaded his way through the mazes of this argument. He finds it quite natural to have recourse to literary criticism as a means of approaching pictorial analysis. For instance, he tackles Pastoral landscape (a category he had used among those into which the subjects of his *Liber Studiorum* were divided) by discussing Milton's *L'Allegro*, throwing off phrases and fragments of a work he obviously knows extremely well, despite various mistakes – interesting substitutions which suggest the way his own mind envisaged the landscape Milton describes (the original, where different, is given in square brackets):

> to commence with the Pastoral the lines in la Allegro are generally admitted, and attempted, as beautiful in the conception, admirably contrasted, full of incident, and Pastoral simplicity but graphically considered upon the dismemberment of the whole to parts, we find that two aged Oaks convey even a dignity, a greatness in decay, tho' their tops are bald with dry antiquity, they contrast too forcibly the peaceful cottage then towers and Battlements and tufted Trees, where lies the Cynosure of neighbouring eyes russet leaves [lawns] fallow[s] gray, shallow Brooks and River[s] wide, Mountains on whose airy [barren] breast the labouring clouds do often rest all offer jewels of poetic beauty but asking if it can collectively be considered a pastoral poetic Picture, or a Poetic Pastoral description (f.8v)

The concluding question goes to the very heart of the matter, reiterating the principle of *ut pictura poesis* in a form which perfectly reflects Turner's exactly parallel and complementary interests in the two arts. He pursued the matter in some detail:

> here then if aerial Perspective from the known difficulty of natural formation of hill, dale, vales, turrets, towers, and Trees, meets with incongruity and feels a difficulty even to accomplish approximation of lines how far apart must it be from the sentiment whether of color or arrangements incidental of pastoral rusticity[.] Thus Poetic description[s] most full most incidental and display[ing] the greatest richness of verse, are often the least pictorial and hence *hasty* practice to use no harsher term is lead astray. (f.8v)

He proceeds to give a further example, taken this time from Thomson's *Seasons*, although he says that

> The description of any river might be selected from Drayton or most of the poets as an example, but the Nile by Thompson [*sic*] may be selected as

poetic, Metaphorical, Historical, and with geographical truth, considered as in the foregoing the severall beautifull allusions as to parts to produce a whole (f.8v)

He then quotes at length the passage from *Summer* in which Thomson dilates on the Nile, 'Rich king of floods!' (lines 805-21). It was a passage he knew particularly well: the Nile figures prominently in his long poem on fancy and imagination in the *Hastings* sketchbook, and he half-quoted Thomson in some lines celebrating the genius of Pope in the *River* sketchbook (No.32):

> With conscious power the manly Nile doth break

which echoes Thomson's own

> Ambitious thence the manly river breaks
>
> (line 812)

His comments on the passage are characteristic of his view of poetry as the ideal vehicle for landscape painting:

> every line possess[es] beauty[;] they are all Poetic but separate them where lies the majestic continuity of the Nile, or the blushing brilliance bearing along the liquid weight of half the globe, and Ocean trembling for his green domain. (f.8v)

He has lapsed into quotation again; the last phrases occur in Thomson a few lines after the Nile passage, following descriptions of the Niger, Orinoco and Plate (lines 857–8). Turner has a potent sense of the physical force of the verse, enacting the meaning in its very language, and seems to ask that painting should have a similar relationship to its content, profound, organic and structurally inevitable.

Having discussed the whole composition of a subject he returns to the question of colour as an element of special importance to the artist, and analyses its corresponding importance in two passages of verse. He had used both in association with pictures exhibited at the Academy in the 1790s: lines from *Summer* that he printed with the title of 'Norham Castle on the Tweed, Summer's Morn' in 1798, and the description of evening from book IV of *Paradise Lost*, used in conjunction with 'Harlech Castle, from Twgwyn Ferry' in 1799 (see p.19). One, he says, depends on 'color active, the other passive', and 'at the last, solemnity of Chiaroscuro, by color'. In passing, he likens Thomson's 'kindling azure' to 'Shakespeare's beautiful simple ballad that fancy, when established, dies' – referring to 'Tell me where is fancy bred?' from *The Merchant of Venice*.[56] A propos of Milton's 'Now came still evening on and twilight grey', he seizes on Milton's use of 'grey' as an epitome of the way in which the language of painting may invade poetry, and set up a challenge to the painter to parallel the verbal effect: 'what can graphic art ask incidents or aid foild by a word of her own *grey* defining dignify'd purity without producing monotony of color' (f.11r).

Turner's sensitivity to the visual implications of descriptive poetry is

extraordinarily intense, and provides the impulse behind many of his attempts to prove the relevance of poetry to painting. In criticism of this kind he reveals himself as exceptionally aware of the purpose and methods of great literature, and seized by a kind of obsession to apply its principles to the painter's art. Turner seems to judge painting as a literary activity; his identification with the poets is almost complete.

'The Artist's Assistant'

Turner's immersion in the poet's life and ways of thought is to be measured not only by his comment and criticism but by the range of his own compositions. If in painting he was temperamentally a Bottom, wanting to play all parts including the lion's, that trait manifested itself just as much in his instincts as a versifier. The mode he adopted as proper for his utterances in the Academy catalogues was a sober one founded on that of Milton, or at least on the Miltonic idiom as it had been reinterpreted in Thomson's *Seasons* and the more pastoral of Pope's works, and in the landscape poets generally. But in his private jottings he essayed as many other forms as he could manage. The impact of Shee's *Rhymes on Art* must have encouraged him to try his hand at their type of urbane satire; and he was capable, too, of a robust and informal brand of comic verse, derived partly from Burns and partly from popular ballads, that can be equally sharp at times.

Some of the most extensive of his satirical poetry is not to be found in the *Verse Book*, but on the endpapers of a mid-eighteenth-century manual, *The Artist's Assistant* (No.43), where he scribbled at length and largely incomprehensibly. One or two passages however, emerge as a sort of inchoate sense, and we can gather that the intended poem drafted here is cast in heroic couplets, like the *Rhymes on Art*. Internal evidence helps to date the manuscript more precisely. There is, for instance, an allusion to Robert the Bruce; the same hero figures in drafts jotted in the *Hastings* sketchbook (TB CXI, f.94r) which contains accounts for 1811 and was apparently in use a year or two before that date. There is also what seems to be a reference to the print of 'Pope's Villa' engraved by John Pye in 1811 (see No.56). From these hints we gather that the long satire that Turner was engaged on in *The Artist's Assistant* was stimulated by the second, rather than the first, of Shee's books – the *Elements of Art*, of 1809, which we know he owned and annotated. Shee concerned himself extensively in that second part of his poem with the education of young talent, and Turner responded warmly with comments of his own, inscribed in his interleaved copy.

Nevertheless it is possible that Turner was prompted as much by *The Artist's Assistant* itself as by Shee's work to write his own poem on art theory, and the place of the artist in society. The full title of the book indicates how closely it could meet these interests: *The Artist's Assistant, In the Study and Practice of Mechanical Sciences.*

S.W. REYNOLDS AFTER JOHN
OPIE, 'Thomas Girtin', 1817.
Mezzotint (No.64)

Calculated for the Improvement of Genius. Its principal purpose is to describe the
technicalities of the various processes of drawing, painting and colouring, as well
as more mechanical skills like engraving, staining, casting, lacquering and
gilding. There is also a section on perspective, presumably Turner's main reason
for owning the book. These topics are preceded by an introduction 'Preliminary
to Drawing' which touches rather grandly, if platitudinously, on more general
matters, somewhat removed from the humdrum information purveyed later, but
no doubt also of interest to Turner.

> The first and indispensible requisite towards forming a painter is Genius, for
> the absence of which divine gift no human acquirements can compensate; as,
> without that spark of aetherial flame, study would be misapplied, and labour
> thrown away. Painting bears a very near resemblance to her sister Poetry,
> and the Painter, like the Bard, must be born one. A picture, as well as a poem,
> would afford little pleasure, though formed according to the strictest rules,
> and worked up with the most indefatigable industry, were genius wanting to
> complete the design. . . . But, though genius is absolutely necessary, since
> nothing can be well done without it, it will not, alone, do all things, but must
> be assisted by rules, reflection, and assiduity. . . . Above all, nature is the
> grand object of his meditation, and ought never to be out of his sight. Nature
> is the only source of beauty, for nothing can be pleasing that is not natural . . .

Turner himself was to emphasise the same point when he opened his Perspective lectures in 1811: 'True rules are the means, nature the end.'[57] His own 'annotations' to the book – if they can be called that – take the form of verses drafted on the endpapers at front and back. But they are hard to decipher. We gather from an almost illegible opening scrawl that a main theme was to be the dependence of painting for its validity on 'Nature's book' – an observation reminiscent of Akenside's reference to 'the world's harmonious volume'. The remainder of the jottings seem to fall into two distinct compositions, the first of which appears to be a lament. The elegiac form was one that seems to have been particularly stimulating to Turner; the word 'Elegaic' is written by itself in the middle of a page of the *Verse Book* as though to remind him of its ubiquitous potency for him. But the lament here is of special interest, since it commemorates his friend and colleague Thomas Girtin (see No.64). Girtin, his exact contemporary, had died at the age of twenty-seven in 1802 and was buried in St Paul's, Covent Garden – the church in which Turner himself had been christened. Turner's supposed remark 'If Tom Girtin had lived I should have starved' is central to the mythology of their friendship. All his life he retained a high regard for Girtin as the outstanding watercolourist of his generation. In this context the lines that can be deciphered on the front endpaper of *The Artist's Assistant* take on a certain poignancy:

> 'Twould call the memory from his C[ovent?] G[arden?] room
> Where lies the honor'd Girtin's narrow tomb
> Not so by this he fits thy powrfull sway
> While his frail tenement of mortal clay
> and thou who must not sup thy Bohea tea
> or show us living artists where in he lay
> amongst his kindred

The passage may perhaps be interpreted as embodying a notion of the power of a great example, and of the political importance for artists of their recognized participation in a shared heritage of aesthetic values. A few lines later the subject has shifted to the familiar topic of patronage, its pretensions and its betrayals:

> here struggling with each other for the palm of worth
> Need not the palm of Patronage accursed
> The sweet fore finger of a man of taste
> sure held if offered but withdraw[n] in haste
> hark the dear teacher guards the . . .
> and evade the debt like a soapt pig tail

In the context it is reasonable to suppose that 'the palm of worth' is being contested by Girtin and Turner himself – a rare allusion to the rivalry of the two men. The identity of the 'man of taste' who arouses such bitter satire is less easy to determine. Turner may have had in mind one of the patrons whom he shared with Girtin in the 1790s – men like Dr Thomas Monro and Edward Lascelles of

Harewood; but by the date of the draft, Turner was plagued by the reiterated and virulent criticism of Sir George Beaumont, an extremely influential collector and critic who had conspicuously preferred Girtin to him during their period of rivalry. Beaumont was precisely the kind of person whom Turner may have wished to lampoon, if only in private.[58]

Patronage recurs as a theme of what seems to be a second poem, sketched on the blank sheet at the back of the book:

> a City master one [?author] subtlety of line displayed
> and all together tasting grapes portrayed
> But they were sowr, and old and can[']t be reacht
> But had you, substituted knees for feet
> You had a patron in every narrow street

Turner outdoes Shee in the discursive scope of his poem. The precise argument of the draft is unclear, but an important motif was apparently provided by the revelation of John Pye's engraving skills in the plate of 'Pope's Villa' for Britton's *Fine Arts of the English School* (No.56). Turner speaks of the spectrum of colours as exemplified in Newton's analysis of the rainbow 'like Joseph[']s coat of many

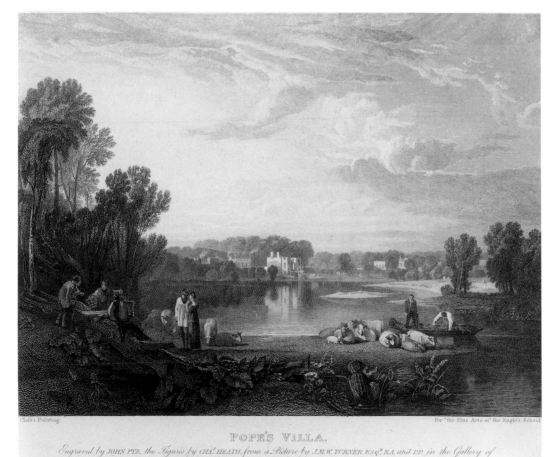

JOHN PYE AND CHARLES HEATH AFTER J.M.W. TURNER, 'Pope's Villa', 1811. Line engraving (No.56)

color[s] dyed', and goes on to contrast the idea that 'naught was thought value
but black', following this with the fragmentary line 'see I have change[d] my . . .'
and then 'Pye has [?relished] my many color[s] . . . to /Dip in oblivious obsequies
for you . . .' These sibylline phrases seem to refer to the process of translating
colour into the black and white of line engraving (presumably as a gesture in
honour of Pope), which Turner found so impressive when he first saw Pye's plate.
The idea may provide the reason for his introduction of Robert the Bruce and his
strategy at the Battle of Bannockburn:

> Had the Bruce placed with less art
> His rank and file, every man apart . . .
> One blow had levelled all, the rank and file
> There have made one lot ere while
> The Enemy had triumphed oer his guile

– the notion of combined strength being likened to the building up of a strong
tone by means of closely engraved parallel lines in a print. But this itself is
evidently a metaphor for the weakness of the professional artists in not presenting
a unified front – a message that he was to reiterate much later in a speech to the
Royal Academy students heard and recorded by William Powell Frith.[59]

Ranging still further afield, Turner also plunges into a detailed vision of
modern industry; though the relevance of this imagery is less clear:

> Has he not built a house that hath a door
> Hang equal on its hinges to right[e]ous poor
> Thus giving temper wheel and click clonk click
> And the great engines belches smoking quick
> and the steamers Piston spouting thick and thin

This passage might be interpreted as an indication that Turner was worried
about the effects of the industrial revolution on the common people – the
'righteous poor'; commentators who have imagined a sympathy with the Luddite
movement would no doubt find corroboration here. But the implication, in so far
as it can be made out, is that the factory door 'equal on its hinges' signals benefits
on both sides, for owner and worker alike. The far more articulate evidence of
Turner's pictures is that he accepted the realities of the modern world first and
foremost as an artist, conscious of their value as subject-matter for his work. If
anything, the passage provides an unexpected and very early foretaste of the
excitement that is manifest in his late masterpiece 'Rain, Steam, and Speed – the
Great Western Railway' of 1844 (B&J 409).

Longer Poems

Most of the drafts of poetry in the sketchbooks, and in the *Verse Book* itself, are relatively short, and even when Turner reverts again and again to the same subject, as with his lines 'On Thomson's tomb' (see above, p.61), it is usually to refine the expression of a brief statement rather than to expand a lengthy one. This is partly because he found sustained composition difficult, partly because he was often working at ideas which were naturally couched in lyrics or brief sequences of quatrains. Another factor was his preoccupation with poetry that related specifically to his paintings and might be printed in the Academy's catalogues. But his ambitions as a poet certainly did not end there. His references to the *Fallacies of Hope* are reiterated hints of a work of substantial length. They are indication enough that he at any rate wished to be taken for a poet capable of sustained seriousness. His sketchbooks contain the drafts of several poems of some length, which bear on many of his central interests and reflect tangentially all the other poetic activity of these years. How many such works there are is hard to assess. Much depends on how their subject-matter is defined, and how we group the various fragments. The extensive sketches for the poem on the Seasons celebrating Thomson may, for instance, be classed as such a piece, though their intention seems to have been compressed, ultimately, into the relatively short poem that he published with the catalogue entry for 'Thomson's Aeolian Harp' (No.44).

The longer poems are concerned with epic ideas of particular concern to Turner personally. There are three main ones. The slightest, which occurs in the *Greenwich* sketchbook (TB CX), is nevertheless grand in its theme. It treats of the building and launching of a ship which Turner identifies as the *Argo*. The whole process of boat-building is described, with allusion both to Jason, architect of the *Argo*, and (in a characteristic coupling of Biblical and mythological imagery) to Noah. William Falconer's famous narrative poem *The Shipwreck*, printed in Anderson's volume X, may well have provided the precedent for Turner's unashamed use of technical terms:

> The planks are sever'd with a Sawyer's art
> From each that proved its Counterpart
> And placed side by side alternatly
> Then crossed by pieces transversely . . .
> Sides timbers bolted to receive the shock
> And bear her burthen on the dreadfull rock
> Sails, scuppers, gridi[r]ons, pintels all
> and loud for pitch the noisy workmen call
>
> (f.22r)

The central thrust of the poem is patriotic: whether *Argo* or Ark, the ship is a paradigm of the British merchant vessel venturing onto the Thames to the glory

of the nation's commerce; and Turner laments the lack of national pride in such
an achievement:

> Exulting Greece, saw the first to float
> And Argo Argo strained each Grecians throat
> Why not in Britain Novelty is found
> Why should not novelty again resound
> Then try on Thamias fertile shore
>
> (f.20r)

The poem may form part of a work dealing with the rise of commerce and
imperial ambition in the growth of modern Britain, a subject that was to recur in
his Southern Coast poem a little later. It had been a theme of central concern to
the Augustans and innumerable poems of the eighteenth century deal with it in
greater or less detail: Thomson's long and justly neglected poem *Liberty* is perhaps
the *locus classicus* of the interest. Turner gave it ambiguous expression in his
rainswept view of London from Greenwich (No.45) and the lines of verse he
published to accompany that picture; and there are several other passages among
the drafts which broach the theme of 'burthen'd Thames'.

But while he was aware of the darker, Blakean implications of commercial
prosperity he cannot be said to have deplored British achievements in that
sphere, or to have weighed the human sacrifice in the balance with them and
found them wanting. In so far as the draft poems give us an insight into Turner's
private opinions – and we know for certain that very little of what he scribbled
was ever read by anyone else – they do not substantiate modern speculation
that he was a committed radical in politics.[60] Indeed, there is remarkably little
of any political import to be found, save the customary observations, typical of
eighteenth-century meditative verse, on the hard lot of the poor. These are
frequently offset by equally commonplace descriptions of comfortably housed
and well-fed cottagers cheerfully going about their daily toil. Turner's political
consciousness appears to have been relatively little developed, which confirms the
strong sense conveyed by almost everything he ever said or did that his primary
concern was with art – with the creative process and how that process can be used
to enhance for us the value of the world we live in. If he found himself in sympa-
thy with his friend Walter Fawkes on the subject of Parliamentary reform, that
is as much a testimony to his lack of political commitment as to firm alignment,
although he was no doubt perceptive enough to recognise that on that subject the
Radicals had the right of it. When Turner mentioned the Whig Samuel
Whitbread in some scrappy drafts of about 1811 (see p.176) he may possibly have
intended to criticise Whitbread as a half-baked Radical unwilling to give his full
support to the cause of Parliamentary reform that Fawkes so stoutly advocated. If
so (and it is perhaps unlikely), it may be significant that this was precisely the time
of Turner's first close and regular contact with Fawkes on his home ground at
Farnley in Yorkshire.[61] However, when, much later, he painted a watercolour of
the Northampton election (w.881) we sense that his interest in the scene was that

of the artist concerned with all human experience, rather than the dedicated propagandist possessed by a theory. Fawkes was clearly a politically-minded man; Turner was almost as clearly not. But they had a love of art among other things in common, and the distinction does not invalidate their friendship.

Another fairly substantial essay is a meditation on fancy and the imagination in what we may assume was intended to be the style of Akenside's *Pleasures of Imagination* or Mallet's *Excursion*. The preliminary ideas for this are jotted in the *Hastings* sketchbook (TB CXI). The book contains several fragmentary sketches for his poem on Apollo and Python (see No.55), and it may be that he was pondering the subject of inspiration and creativity as symbolised by Apollo, god of music and poetry as well as god of light. The theme is introduced as 'fancy' in the context of a reference to yet another poet: Thomas Otway, who, he says, was lured by fancy

> from a parents side
> By Arun['s] sedgy stream to feel the power
> Of fortune
>
> (f.95r)

As Anderson informs us (volume VI), Otway was actually born near Woolbeding on the Rother, a Sussex river that runs into the Arun; but Turner was evidently fond of the 'sedgy Arun' and celebrated it elsewhere (see No.50). Fancy, it seems, can prompt our worst nightmares

> When the livid dog star rages denying rest
> To the weak Ey[e]lids
>
> (f.94r)

(here Turner echoes Pope's *Epistle to Dr Arbuthnot*); and like a devil impels men on to their greatest achievements: Columbus, Raleigh, Robert the Bruce, all were susceptible to its promptings. But the poem, in so far as it is intelligible, does not distinguish clearly between fancy and imagination, which Turner seems to invest with something of the comprehensive significance that Coleridge allowed it as 'the living power and prime agent of all human perception'.[62] Turner speaks of 'Imaginations flowery meeds' (f.93v) as a dangerous, if desirable, attraction, whose 'enchanting prospects' overwhelm

> the cold cold eye of sense
> and sends all headlong in the wild turmoil

– a turmoil of 'grandeur' and

> all the full form[ed] charm
> Of Abessinian beauties like the Hesperides of old
>
> (f.93r)

But these visions are illusory; imagination, like hope, is fallacious. Neverthe-less, even the great attainments of science – themselves, presumably, partly

attributable to the imagination – cannot invalidate the truths revealed by the more primitive faculty:

> Witness the various accidents that have caused
> The deepest wisest most profound of search
> The laws of Gravity thou assisted to inspire
> . . .
> The first great cause cannot be overturned
>
> (f.93r)

The drafts end with a picture of Sir Walter Raleigh in prison, offering up his great *History of the World* as a triumphant negation of the tyranny of his 'Prince' – James I; though the precise import of Turner's final observation, in which fancy seems to operate very much as Coleridge suggested, as 'a mode of memory',[63] is hard to interpret:

> So nobly . . . he dyed his History with his death
> That Englands armies never can wash out
> Even with Fancy's utmost tears to come
>
> (f.92v)

By far the longest of these compositions is Turner's poetical tour of the Southern Coast of England, drafted in the *Devonshire Coast No.1* sketchbook which he used during his journey to Cornwall and back in 1811 (No.57). This discursive work takes in many of the other subjects that occupied him elsewhere, and is surprisingly lucid, though it never attains consistent readability for more than a line or two at a time.

When he was asked by the engraver-publishers George and William Bernard Cooke to undertake a series of views on the Southern Coast, Turner seems to have responded enthusiastically. He devoted two months in the summer of 1811 to a tour from London to Cornwall and back, making drawings along that part of the coast he did not know, west of Southampton, from Poole to Penzance and up to Minehead in Somerset. He also submitted to the Cookes an article on St Michael's Mount, which he evidently hoped to have published – a trailer, perhaps, for a full accompanying text to the series. The Cookes had commissioned William Combe as author of their letterpress; but they were apparently anxious to accommodate Turner's wishes if possible, and sent Combe the text for his comments and improvements. His response was to be expected:

> I am really concerned to be obliged to say that Mr T——'s account is the most extraordinary composition I have ever read. It is impossible for me to correct it, for in some parts I do not understand it. The punctuation is everywhere defective, and here I have done what I could . . . I think the revise should be sent to Mr T——, to request his attention to the whole, and particularly the part that I have marked as unintelligible. In my private opinion, it is scarcely an admissible article in its present state . . .

Combe tried to incorporate Turner's prose into his own text, but eventually admitted defeat, and the Cookes, on receipt of his report, decided firmly to reject the whole piece, asking him 'not to insert a syllable' of Turner's writing.[64] Turner nevertheless pursued his intention of composing a literary comment on the subject-matter he was to draw, and in the *Devonshire Coast No.1* sketchbook alternated pencil drawings of the places he visited with drafts of a long poem. This alternation of drawing and poetry is somewhat analogous to the alternation of classical and modern landscapes in the *Studies for Pictures: Isleworth* sketchbook (see No.12). In both instances Turner demonstrates his awareness of contrasting ways of interpreting the facts he is collecting. The implications of objectively observed data for the creative artist are manifold, and can lead him in several different directions. His task is to choose the most appropriate, the most expressive. He may also point out the value of utilising contrasting methods, in order to develop the implicit depths and subtler dimensions of the perceived world.

In planning his poem he availed himself of a characteristic of verse which he would have been very conscious was not accessible to painting. Whereas his series of watercolour views must remain a series, each view sufficient in itself and isolated from the rest of the sequence, his poem could be a continuous argument, a kind of topographical epic. The information and reflection it offered could be cumulative, so that a general statement might be made about the nature of England's coastline, its economy, history and defences. In practice, the argument is not restricted to the coast, but follows Turner's actual route, which took him from Hounslow, west of London, across Bagshot heath and Salisbury plain to Old Sarum and Salisbury and so down to the coast at Poole. Long passages of the draft therefore do not relate to the subject-matter of the Cookes' *Picturesque Views on the Southern Coast of England*, and it may be that commentators have been mistaken in assuming that Turner intended a direct relation. The traditional format of the Picturesque illustrated tour was one in which the plates were accompanied by separate prose descriptions, not by continuous text, so if he hoped for publication it would have been sensible to compose his verse in discrete sections. 1811 was a year of prolific literary activity for him, and it is likely that he was simply inspired by his journey to pen a verbal description of it.

That description takes the form of a philosophical meditation on the places he visits, with digressions on history, agriculture, industry, geology and naval science. As in his lines on the imagination he is following the general pattern of the eighteenth-century philosophical poetry he particularly admired. But the topographical poem as a form can be traced back to Drayton's *Poly-Olbion* of 1622, printed by Anderson in his volume III. This is a tour of England covering a wider area than Turner's and divided into 30 songs or cantos. Drayton begins in Cornwall and moves eastward and gradually north, so that his first three songs cover Turner's territory in reverse, including 'Mount Michael', the Tamar, Poole, Salisbury and Stonehenge. His approach is for the most part simply descriptive, but parallels many of Turner's concerns. The lines on Bridport in

'St Mawes at the Pilchard
Season', RA 1812. Oil on
canvas (No.60)

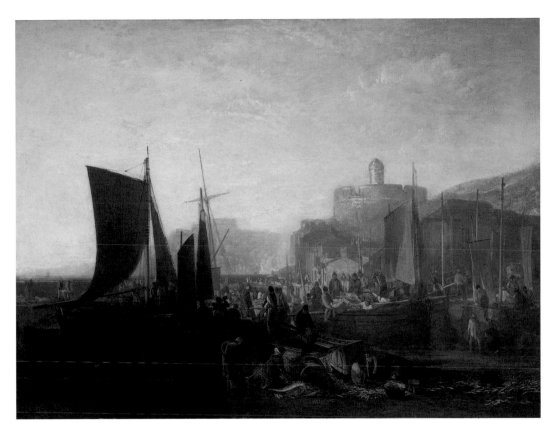

the second song, for instance, anticipate Turner's interest in the industrial
importance of the place (see pp.60–61):

> Through the Dorsetian fields, that lie in open view,
> My progress I again must seriously pursue . . .
> . . . to Bert-port, which hath gain'd
> That praise from every place, and worthily obtain'd
> Our cordage from her store, and cables should be made,
> Of any of that kind most fair for marine trade.

Turner starts with a dedication to 'that kind Providence that guides our step',
the customary preamble to a lengthy and serious poem. It is so typical of
traditional attitudes that it lends support to the view that his use of the Augustan
idea of 'fallacious hope' in so much of his other verse was precisely that: an
allusion to be understood in its traditional context of Christian teaching. But
although the framework of the poem is conventional, and much of the moralising
obvious enough, it contains flashes of unexpected originality, which are
invaluable insights into the way Turner associated places and ideas.

At Maiden Castle outside Dorchester, for example, he is impelled not only to
contemplate the 'prowess' of the Normans (to whom the fortifications were then
attributed) but to compare them with the Romans, and in particular with

Regulus whose 'self control' and 'firm soul' are a paradigm of bravery and determination; or to liken the 'commanding fort' to the 'famd Jungfrau' and 'Simplon summits'. His paintings of Roman history ('Regulus' appeared in 1828; B&J 294) or of the Alps can be related directly by such trains of thought to his experience as a topographer of the English landscape: as Akenside had taught him, the world is a vast network of interlinked ideas, moral, historical and scientific.

Much of the latter part of the draft is taken up with descriptions of the sea, 'the waste of waters which the Atlantic pours' on England's rocky coast. Struggling to find words to describe effects that he had successfully rendered in paint since the outset of his career he may have sought inspiration in Falconer's *Shipwreck*; though he eschews the elaborately accurate nautical technicalities that made Falconer's poem famous in its day. Perhaps he was more impressed by the lines about a 'Sea Storm upon a Coast' and an 'Approaching Sea Storm' in Rowe's translation of Lucan's *Pharsalia* (book VI; Anderson, volume XII, pp.780 and 797), which he noted in a memorandum on a flyleaf. He describes the plight of fishermen, of shipwrecked mariners, the nefarious activities of wreckers and scavengers – all subjects that occur repeatedly in his watercolours and paintings. He likens the wreckers' 'sloop boat' laden with its booty to the 'triumphant Argo quest' and its prize of the Golden Fleece (f.166v). The discussion of shore life and the history and economics of the coast leads Turner to conclude his draft with a long panegyric of Nelson, mentioning Aboukir and 'gory Trafalgar'. He laments that 'Alas no second Blenheim yet is found' and proposes a monument to the great man:

> our eyes
> Would pleasing view his Cenotaph arise
> On some bold promontory where the western main
> Rich with his actions ever blesst by fame
> . . .
> Us[e]full as the Eddystone beams its honor drest
> And high the lighted gleam in flamey vest[65]
> A Sea mark emul[at]ing reverd and ever known
> My nation['s] gratitude [in] monumental stone
>
> (f.176v)

This is the most unambiguous of Turner's statements to the outside world: it is clearly no personal reflection, no philosophical gloss belonging to the private thoughts of a private person. It translates the sentiments inspired by the place into a programme for action, a manifesto to the public at large. It is the practical proposal of an artist in one medium to the practitioners of another for the celebration of a national hero, a suggestion that Turner must surely have made in other, social contexts, in the company of his friends at the Academy and elsewhere. Like the cherished project for a national gallery of painting, it was a scheme that was indeed to be realised, though not quite as Turner envisaged. No

colossus ever materialised on the cliffs of Cornwall, but he was no doubt delighted when, in 1842, Nelson's column was erected immediately opposite the new National Gallery building in Trafalgar Square.

Turner and Contemporary Poetry

While the Southern Coast poem follows Turner's usual pattern in being written in rhyming couplets, it will have been noticed that the drafts on the imagination are in blank verse, which he essayed less frequently. It was the most serious of forms, but had gone into disfavour during most of the eighteenth century. It had received new life at the hands of the young Wordsworth, many of whose longer meditations were framed as blank pentameters. Among the fragments in the *Hastings* book (TB CXI, f.66v) there occur fifteen lines of blank verse which may belong with the poem on the imagination, but which stand by themselves both as the complete statement of an idea and as a highly uncharacteristic example of almost unflawed prosody for which no obvious sketches exist. The sentiment they express is very much in tune with Turner's own feelings about the imperfect response of the world at large to the attainments of the artist; but they have a measured dignity, a sort of grand modesty, that is more Wordsworthian than Turnerian. The flow of the argument, despite a hiccup around the eighth line, is better sustained and more coherent than Turner generally managed. Furthermore, he would hardly have couched his ideas in so modern a style of writing. The passage is evidence of an interest, not otherwise discoverable in these early years, in contemporary, that is to say Romantic as opposed to Augustan, poetry. The inference must be that the lines are copied (perhaps not entirely accurately) from some other writer, simply because Turner admired them; but no alternative author has yet been found.

> World I have known thee long & now the hour
> When I must part from thee is near at hand
> I bore thee much goodwill & many a time
> In thy fair promises repos'd more trust
> Than wiser heads & colder hearts w'd risk
> Some tokens of a life, not wholey passed
> In selfish strivings or ignoble sloth
> Haply there shall be found when I am gone
> What may dispose thy candour to discover
> Some merit in my zeal & let my words
> Out live the Maker who bequeaths them to thee
> For well I know where our possessions End

Thy praise begins & few there be who weave
Wreaths for the Poet['s] brow, till he is laid
Low in his narrow dwelling with the worm.[66]

The unwonted modernity of this passage prompts the question whether Turner ever felt the influence of new developments in poetry. If a watercolour of his could be praised in verse by Southey,[67] did he ever aspire to write in the style of the Lake Poets? Despite the possibility suggested by these fifteen lines, there is little evidence that he did. He cannot have been wholly ignorant of Wordsworth and Coleridge, and if his competitive spirit in the sphere of painting is anything to go by, he ought to have been anxious to imitate them. Southey's poem did not appear until 1829, and it may be that we should allow for a time-lag in calculating the incursion of new literary ideas into his creative practice. Traditionalists like Shee and Thomas Maurice were perhaps closer to his own taste than the more innovative voices of the time. Although his reputation is that of a revolutionary in painting he was himself essentially conservative, upholding the time-honoured standards of European art, as enshrined in the works of the most revered masters of the past and perpetuated in the teaching of the Royal Academy, of which he was a proud and active member. He may well have been cautious in accepting the revolutionary in fields he had not completely mastered. We know he was well aware of one important representative of the new poets of the 1810s – Byron – but even in his case he may have been late off the mark.

Byron had forged his reputation in the years when Turner was most preoccupied with poetry, publishing *English Bards and Scotch Reviewers* in 1808 and the first cantos of *Childe Harold* in 1812. Turner does not seem to have noticed these; but when in 1817 he visited the battlefield of Waterloo, he took with him a guidebook which quoted from a new and expanded edition of *Childe Harold* that

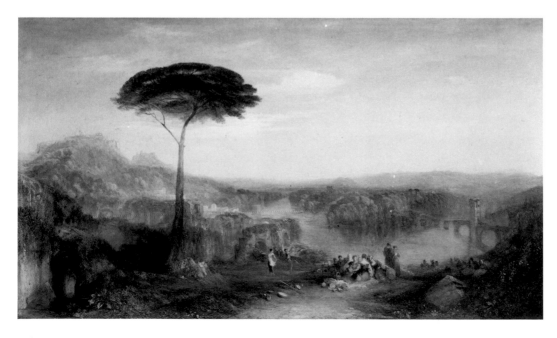

'Childe Harold's Pilgrimage – Italy', RA 1832. Oil on canvas. Turner Collection, Tate Gallery

'The Field of Waterloo',
RA 1818. Oil on canvas
(No.65)

had appeared the previous year.[68] He cited a stanza of it with his submission to the 1818 Academy exhibition, 'The Field of Waterloo' (No.65), and made occasional raids on the poem for many years afterwards. In 1832 he even painted a large picture which he entitled 'Childe Harold's Pilgrimage – Italy' (B&J 342), a full-scale homage to a particular poet that takes its place beside 'Pope's Villa' (No.35) and 'Thomson's Aeolian Harp' (No.44) as one of the great literary pictures of his career. The attraction of the poem for him may have partly been that he saw it as the latest in that long line of 'didactic' poems to which Blair had drawn his attention, and to which he so much wished to contribute. *Childe Harold*, with its sustained description of a many-faceted, populous and war-torn Europe seen through the eyes of a passionate but solitary traveller, must have seemed to Turner the apogee and climax of a literary tradition extending from Antiquity to his own time that he had followed with intense commitment. It was an account of the modern world that precisely coincided with his own preoccupations and expressed many of his personal sentiments in a vigorous, sympathetic and colourful way.

By the early 1830s, when 'Childe Harold's Pilgrimage' was exhibited, we may say that the style in which Turner was composing his excerpts from the *Fallacies of Hope* had become modified to accommodate Byron's rhythms and phraseology: there is a Romantic swing, an irregularity of metre, in some of the later citations that cannot be derived from Thomson or Gray, although he continued to quote from the eighteenth-century writers as well. When he reflected on Napoleon's downfall and the re-emergence of peace in Europe for his picture of 'The Opening of the Walhalla, 1842' (exhibited in 1843; B&J 401) he was surely remembering

such stanzas as those he had quoted in conjunction with his 'Bright Stone of Honour (Ehrenbreitstein) and the Tomb of Marceau, from Byron's *Childe Harold*' of 1835 (B&J 361):

> By Coblenz, on a rise of gentle ground,
> There is a small and simple pyramid,
> Crowning the summit of the verdant mound;
> Beneath its base are heroes' ashes hid,
> Our enemy's – but let that not forbid
> Honour to Marceau -----
> ---- He was freedom's champion!
> Here Ehrenbreitstein, with her shattered wall,
> Yet shews of what he was.

By this date Turner had been involved for more than a decade in the illustration of Byron's works, and those of Walter Scott, Thomas Campbell and Samuel Rogers. We have already considered the likelihood that he had read something at least of the two last as a young man. He incorporated a reminiscence of Campbell's Naval Ode *Ye Mariners of England* into the catalogue entry for 'The Fighting "Temeraire"' (B&J 377) in 1839; and we may imagine him relishing the *Stanzas to Painting* in which Campbell spoke of the art as

> Possessing more than vocal power,
> Persuasive more than poet's tongue;
> Whose lineage, in a raptured hour,
> From Love, the Sire of Nature, sprung.

Rogers had been a collector of his work for some time. Neither he nor Campbell was truly a poet of the new generation, any more than Scott, whose verse dates for the most part from the last years of the eighteenth century. Of Shelley and Keats, as far as we know, Turner was unaware, although it has been argued that he alluded to Shelley's *Lines written in the Euganean Hills,* in the lines he appended to 'The Sun of Venice going to Sea' of 1843 (B&J 402).[69] But those are much more clearly based on Gray's *Bard*: even at so late a date, he still founded his arguments on the eighteenth-century poets, just as he still turned to the *Metamorphoses* and the *Aeneid* for subject-matter. His love for Ovid and Virgil, Milton and Thomson never faded, though by the end of his life he had added to his large repertoire of classic writers a modest array of moderns, with whom he formed a new set of relationships, rather different from those of his youth, but governed by the same passions, and by his abiding sense of the enduring and inescapable interconnection of the two arts.

'The Bright Stone of Honour (Ehrenbreitstein) and the Tomb of Marceau, from Byron's *Childe Harold*', RA 1835. Oil on canvas. Private Collection

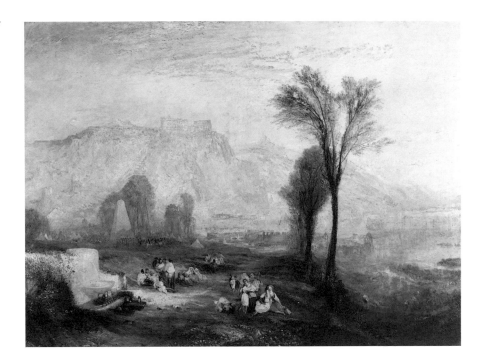

Notes

1 There are only four others; for information about all of them see A. Wilton, 'A rediscovered Turner Sketchbook', *Turner Studies*, vol.6, no.2, 1986, pp.9–23, esp. p.18, notes 3–5.

2 It was originally published in Livermore 1957.

3 This lecture was first elucidated in Ziff 1964a.

4 A standard modern survey of the subject is Jean H. Hagstrum, *The Sister Arts*, 1958.

5 Horace, *Ars Poetica*, 9.

6 The classic statement of 'Associationism' is that of Archibald Alison in *Essays on the Nature and Principles of Taste*, 1790.

7 Sir Joshua Reynolds, *Discourses*, ed. Robert R. Wark, 1975, p.50.

8 The contents of Turner's library are listed in Wilton 1987.

9 All the published portions of the *Fallacies of Hope* are transcribed below, pp.180–81.

10 e.g. in the drafts of a pastoral on the endpapers of the *Verse Book*; see transcripts below, pp.152–3.

11 Charles Cotton's *Laura Sleeping* was not printed in Anderson; it is not known where Turner encountered the poem. Lindsay 1966b, pp.107–8, prints the poem as Turner's own, as on p.128 he prints Turner's quotations from Akenside as his own work.

12 The most thoroughgoing discussion of the subject is that in Jack Lindsay's two books, 1966a, ch.5, and 1966b.

13 See transcripts, p.179 below.

14 We have no means of knowing whether Turner read the whole of Blair's comprehensive book, but he could have found relevant advice in nearly every chapter. Volume I dealt, broadly, with taste, style and the history of language, volume II with public speaking, and a critical survey of literature.

15 See Finberg 1924.

16 The phrase 'my Brothers in Art' was used by Turner in the fourth Codicil to his Will; see Thornbury 1877, p.627.

17 Act II, sc. ii, lines 9ff.

18 See Turner's letters *passim*, and especially those to James Holworthy, Gage 1980, nos.65, 68, 70, 90; and A. Wilton, 'Turner as Letter-Writer' (review of Gage 1980), *Apollo*, Jan. 1981, pp.56–9.

19 Doubt has recently been cast on the assumption that Sarah was his mistress; see Jean Golt, 'Sarah Danby: Out of the Shadows', *Turner Studies*, vol.9 no.2, 1989, pp.3–10.

20 For more detailed discussion of this subject see Ann Livermore, 'Turner and Music', *Music and Letters*, vol.38, 1957, pp.170–79, and Jack Lindsay, 'Turner and Music', *Turner Society News*, Oct. 1975, pp.14–18; Spring 1976, pp.37–40.

21 An analysis of the early verse citations is to be found in Ziff 1982.

22 See Wilton 1984, pp.28–9.

23 The suggestion that Turner was consciously imitating Gray in the lines for 'Dolbadarn Castle' comes from Lynn R. Matteson, 'The Poetics and Politics of Alpine Passage: Turner's *Snow-storm: Hannibal and his Army crossing the Alps*', *Art Bulletin*, vol.62, 1980, pp.385–98.

24 Turner's response to Shee is discussed in Venning 1982.

25 See M. Butlin, M. Luther and I. Warrell, *Turner at Petworth*, 1989, and F. Owen and D.B. Brown, *Collector of Genius, A Life of Sir George Beaumont*, 1988.

26 The point is developed in Owen, Brown and Leighton 1988, p.26.

27 See Finberg 1961, pp.93–7, 102–7.

28 An unexhibited picture of *c*.1798 acts as a kind of prologue: 'Aeneas and the Sibyl, Lake Avernus' (B&J 34); see p.84.

29 See Wilton 1981 (note 18 above).

30 See A. Wilton, 'Turner at Bonneville', *In Honor of Paul Mellon*, 1986, pp.403–27.

31 For the iconography of the Maid of Corinth see R. Rosenblum, 'The Origin of Painting: a Problem in the Iconography of Romantic Classicism', *Art Bulletin*, vol.39, 1957, pp.279–90; and idem, *Transformations in late Eighteenth-Century Art*, 1967, p.21, note 57.

32 I am indebted for information on Turner's pigments to Joyce H. Townsend.

33 See Wilton 1984–5.

34 The genre pictures of these years are discussed in Ziff 1964a, and Gage 1969 and 1972. Owen and Brown 1988 (above, note 25) have recently suggested (p.166) that Sir George Beaumont was the target of Turner's attack in 'The Artist's Studio'.

35 For Ruskin's extended interpretation of the 'Goddess of Discord' see Ruskin 1905, VII, pp.389–440.

36 See Finberg 1961, pp.132–3; Youngblood 1982, p.34, note 9.

37 Ruskin inaugurated the idea that Turner's paintings (especially those of the later period) were capable of being interpreted in terms of symbolism. On the whole he did not abuse this approach. There has been a noticeable increase in speculation as to the symbolic content of Turner's work in the specialist literature of the past decade or so. Symbolism is sometimes confused with the legitimate action of 'Associationism' to produced garbled and implausible theories of the intention and meaning of the pictures; a recent example is Eric Shanes, *Turner's Human Landscape*, 1990.

38 See Jack Lindsay, *J.M.W. Turner: His Life and Work*, 1966, pp.58–62, and Lindsay 1966b.

39 The whole Thomsonian method, combining the entertaining, the instructive and the moral, besides surviving in the long popularity of the *Seasons* themselves, pervaded nineteenth-century thinking through another channel: Thomas Day's *Sandford and Merton* of 1783–9 combined the world-picture of the *Seasons* with the philosophy of Rousseau's *Emile* to provide standard nursery reading for the radical thinkers of Victorian England. It is full of specific reminiscences of Thomson, such as the description of a nocturnal traveller misled by the will-o'-the-wisp, inspired by *Autumn*, lines 1145–59.

40 Ruskin's analysis of the Salisbury watercolour confirms this reading; see Ruskin 1905, VII, p.190.

41 Ann Livermore, *Turner and Defoe*, unpublished typescript.

42 Jerrold Ziff (1964b) first drew attention to the connection between Turner's title and Langhorne's poem.

43 See Joseph Farington, *Diary*, ed. Kenneth Garlick and Angus Mackintyre, and Kathryn Cave, 16 vols, 1978–84; entries for 10–14 April 1812.

44 See Lindsay 1966b, p.48. For Lindsay, a Marxist, it is natural to assume that all significant intellectual developments in an artist's career have a political basis.

45 See for instance the plates to Cooke's *Views on the Thames*, rev. ed., 1818, described in Brownell 1980, p.49, no.47.

46 See Martin Butlin, *The Paintings and Drawings of William Blake*, 2 vols, 1981, nos.769, 1–20.

47 See Brownell 1978, pp.98–101. Brownell suggests (p.74) that 'it might be argued that Pope is as much the poet of the picturesque as Thomson is of the sublime landscape.' He repeats the observation on p.97.

48 Gilpin's most influential work was *Observations relative chiefly to Picturesque Beauty, made in the Year 1772, on several Parts of England*, 2 vols, 1786. The classic modern account is Christopher Hussey, *The Picturesque, Studies in a Point of View*, 1927. See also Elizabeth Wheeler Manwaring, *Italian Landscape in 18th Century England; A Study chiefly of the Influence of Salvator Rosa and Claude Lorrain on English Taste, 1700–1800*, 1925, and Walter Hipple, *The Beautiful, the Sublime, and the Picturesque in Eighteenth-Century British Aesthetic Theory*, 1952.

49 An exhaustive account of Pope's theory of garden design is in Brownell 1978, especially chs 4 and 5, pp.102–45.

50 Brownell 1978, p.109.

51 B&J 429–432; see transcripts pp.180 and 181.

52 For a discussion of Turner's Perspective lectures in this context see Jerrold Ziff, '"Backgrounds, Introduction of Architecture and Landscape": A Lecture by J.M.W. Turner', *Journal of the Warburg and Courtauld Institutes*, vol.26, 1963, pp.124–47; and Ziff 1964a.

53 British Library, Add. MS 46151 N.

54 Act I, sc. iii, lines 79–80: 'The earth hath bubbles as the water has,/And these are of them.'

55 This allusion is discussed at length in Gage 1969, pp.41, 143–44.

56 Act III, sc. ii, lines 63ff.

57 British Library, Add. MS 46151 E, f.19.

58 For Beaumont's attitude to Turner see Owen and Brown 1988 (above, note 25), pp.152–5, 165–8, 174.

59 William Powell Frith, *My Autobiography*, 1887, I, pp.137–9.

60 Lindsay provides the most interesting, because the most intelligent, example of the political model for an interpretation of Turner's mind; see note 44 above. More recent examples such as Eric Shanes, *Turner's Picturesque Views in England and Wales*, 1980, are less convincing.

61 For Turner and Fawkes see A.J. Finberg, *Turner's Watercolours at Farnley Hall*, 1925; David Hill, *Turner in Yorkshire*, exh. cat., York, 1980; and idem, *In Turner's Footsteps*, 1984, pp.17–22.

62 Samuel Taylor Coleridge, *Biographia Literaria*, ch.XIII (Everyman rev. ed., 1960, p.167).

63 ibid.

64 Thornbury 1877, pp.189–90.

65 Turner made a watercolour of the Eddystone Light in the early 1820s (W.506); see Rawlinson 1908, 1913, nos.771, 773.

66 The lines were published as Turner's own in Lindsay 1966b, pp.126–7.

67 Robert Southey's 'Stanzas, Addressed to J.M.W. Turner, Esq., R.A. on his view of the Lago Maggiore from the Town of Arona' were published in *The Keepsake*, 1829, p.238. The watercolour of 'Arona' is W.730.

68 See TB CLIX, *Itinerary Rhine Tour* sketchbook, f.101r, and A.G.H. Bachrach, 'The Field of Waterloo and Beyond', *Turner Studies*, vol.1, no.2, 1981, pp.4–13, esp. pp.8, 10.

69 See Gage 1969, pp.145–7.

Select Bibliography

Morris R. Brownell, *Alexander Pope and the Arts of Georgian England*, 1978

Morris R. Brownell, *Alexander Pope's Villa*, exh. cat., Marble Hill, London, 1980

Julius Bryant, *Finest Prospects*, exh. cat., Kenwood, London, 1986

Martin Butlin and Evelyn Joll, *The Paintings of J.M.W. Turner*, 2 vols, 1977, rev. ed., 1984

Stephen Deuchar, *Paintings, Politics and Porter: Samuel Whitbread and British Art*, 1984

Alexander J. Finberg, *A Complete Inventory of the Drawings of the Turner Bequest*, 2 vols, 1909

Alexander J. Finberg, *The History of Turner's Liber Studiorum with a new Catalogue Raisonné*, 1924

Alexander J. Finberg, *The Life of J.M.W. Turner*, 2nd ed., 1961

John Gage, 'Turner and the Picturesque', *Burlington Magazine*, vol.107, 1965, pp.16–25, 75–81

John Gage, *Colour in Turner*, 1969

John Gage, *Turner: Rain, Steam, and Speed*, 1972

John Gage, *Collected Correspondence of J.M.W. Turner*, 1980

Jean Golt, 'Beauty and Meaning on Richmond Hill: New Light on Turner's Masterpiece of 1819', *Turner Studies*, vol.7, no.2, 1987, pp.9–20

John Dixon Hunt, 'Ruskin, "Turnerian Topography" and *Genius Loci*', unpublished paper, 1986

Jack Lindsay, *Turner: a Critical Biography*, 1966 (a)

Jack Lindsay, *The Sunset Ship*, 1966 (b)

Ann Livermore, 'Turner's Unknown Verse Book', *Connoisseur Year Book*, 1957, pp.78–86

Kathleen Nicholson, 'Turner's "Apullia in search of Appullus" and the dialectics of Landscape Tradition', *Burlington Magazine*, vol.120, 1980, pp.679–84

Kathleen Nicholson, 'Style as Meaning: Turner's Late Mythological Landscapes', *Turner Studies*, vol.8, no.2, 1988, pp.45–54

Felicity Owen, David B. Brown and John Leighton, '*Noble and Patriotic*': *The Beaumont Gift 1828*, exh. cat., National Gallery, London, 1988

W.G. Rawlinson, *The Engraved work of J.M.W. Turner*, 2 vols, 1908, 1913

W.G. Rawlinson, *Turner's Liber Studiorum*, 2nd ed., 1906

John Ruskin, *The Works of John Ruskin*, Library Edition, ed. E.T. Cooke and Alexander Wedderburn, 39 vols, 1905

Sam Smiles, 'Picture Note on St Mawes at the Pilchard Season', *Turner Studies*, vol.8, no.1, 1988, pp.53–7

Walter Thornbury, *The Life of J.M.W. Turner, R.A.*, 2 vols, 1862, rev. ed., 1877

Barry Venning, 'Turner's Annotated Books: Opie's "Lectures on Painting" and Shee's "Elements of Art"', *Turner Studies*, vol.2, no.1, 1982, pp.36–46; no.2, pp.40–49

Gerald Wilkinson, *The Sketches of Turner, R.A. 1802–20: Genius of the Romantic*, 1974

Andrew Wilton, *The Life and Work of J.M.W. Turner*, 1979

Andrew Wilton, *Turner and the Sublime*, exh. cat., Art Gallery of Ontario, Toronto, 1980

Andrew Wilton, *Turner in Wales*, exh. cat., Llandudno, 1984

Andrew Wilton, 'Sublime or Ridiculous? Turner and the Problem of the Historical Figure', *New Literary History*, vol.16, 1984–5, pp.343–76

Andrew Wilton, *Turner in his Time*, 1987

Patrick Youngblood, 'The Painter as Architect: Turner and Sandycombe Lodge', *Turner Studies*, vol.2, no.1, 1982, pp.20–35

Jerrold Ziff, 'J.M.W. Turner on Poetry and Painting', *Studies in Romanticism*, vol.3, 1964, pp.207–12 (a)

Jerrold Ziff, 'John Langhorne and Turner's "Fallacies of Hope"', *Journal of the Warburg and Courtauld Institutes*, vol.27, 1964, pp.340–42 (b)

Jerrold Ziff, 'Turner's First Poetic Quotations: an Examination of Intentions', *Turner Studies*, vol.2, no.1, 1982, pp.2–11

Jerrold Ziff, 'Turner, the Ancients, and the Dignity of the Art', *Turner Studies*, vol.3, no.2, 1983, pp.45–52

Jerrold Ziff, 'Turner as Defender of the Art between 1810–20', *Turner Studies*, vol.8, no.2, 1988, pp.13–25

Catalogue Note

Unless otherwise stated, all works are by J.M.W. Turner.
All measurements are given in centimetres followed by inches,
height before width.

Abbreviations

B&J Martin Butlin and Evelyn Joll, *The Paintings of J.M.W. Turner*,
2 vols, rev. ed., 1984

R. W.G. Rawlinson, *The Engraved Work of J.M.W. Turner*, R.A.,
2 vols, 1908, 1913 or
W.G. Rawlinson, *Turner's Liber Studiorum*, 2nd ed., 1906

TB A.J. Finberg, *A Complete Inventory of the Drawings of the Turner
Bequest*, 2 vols, 1909

W. Andrew Wilton, *The Life and Work of J.M.W. Turner*, 1979,
catalogue of watercolours

RA Exhibited at the Royal Academy

BI Exhibited at the British Institution

Catalogue

1 Anderson's *British Poets*

Robert Anderson, M.D., ed., *The Works of the British Poets. With Prefaces, Biographical and Critical*, London, printed for John & Arthur Arch; and for Bell & Bradfute, and J. Mundell & Co. Edinburgh. 1795. Bound in calf
Private Collection

Volume IX of a thirteen-volume set, containing the works of Swift, Thomson, Watts, Hamilton, Ambrose Philips, G. West, Collins, Dyer, Shenstone, Mallet, Akenside and Harte. The set may have been acquired by Turner in about 1798, in response to the Royal Academy's revised ruling on the use of quotations in catalogue entries for submitted works. He must have consulted it constantly from the time of his earliest catalogue citations in that year. Volume XII, containing Pope's translations of the *Iliad* and *Odyssey*, West's Pindar, Dryden's *Aeneid*, Persius and Juvenal and Rowe's Lucan, is annotated by Turner on the back flyleaf: '797 Approaching Sea Storm arising/ 6 Book of Pharsalia/ [7]98 a description of the Vale of Tempe/ Bk 4 Sea Storm upon a Coast',

referring to Lucan's *Pharsalia*. Volume VI, which includes the works of Dryden, among them his translations of Ovid, has a folded sheet of paper on which is written (not in Turner's hand) a trite poem of four quatrains entitled 'Ballad', signed 'E Atkins' and annotated 'Written at Sittingbourne July 30th. 1808'. These details bear no relation to anything at present known of Turner or his circle, but the sheet was presumably given to him by a friend.

> Open at pp. 180–81
> The opening of Thomson's *Spring*

On the opposite page is the conclusion of Anderson's 'Life of Thomson', which quotes Robert Burns's *Address to the Shade of Thomson*. Turner was introduced in this way to much poetry that was not printed in Anderson's main collection. Burns's poem is another example of the abbreviated celebration of the seasons that Turner essayed in his *Verse Book* and elsewhere.

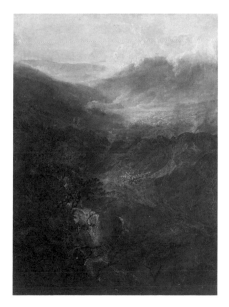

2 Morning amongst the Coniston Fells, Cumberland RA 1798 (196)
Oil on canvas, 123.9 × 89.7
($48\frac{3}{8} \times 35\frac{5}{16}$)
B&J 5; N00461 [*col. pl. p.21*]

Of Turner's ten entries to the Academy exhibition of 1798, five were accompanied by verse, all except the present picture having quotations from Thomson's *Seasons*. This, numerically the first in the catalogue, cites the literary basis of Thomson's own inspiration, *Paradise Lost*. The verses are from book V, lines 185–8:

Ye mists and exhalations that now rise
From hill or streaming lake, dusky or gray,
Till the sun paints your fleecy skirts with gold,
In honour to the world's great Author, rise.

Milton's original gives 'steaming' for 'streaming' in the second line. The alteration may be a simple misprint; but it would be characteristic of Turner to have added (if unconsciously) his own sense of dynamism to the description. The quotation is from Milton, but the sentiments prefigure those of Thomson, and especially the eighteenth-century perception of the power of the sun within the framework of God's creation – a perception Turner was already making his own.

The composition of 'Coniston Fells' leads from the sun and the mist to the flocks being herded along the steep mountain path, and to the cottage with its smoking chimney just visible at the top of the track – inanimate, animate and human creation in closely knit harmony. The falling water in the lower part of the (significantly) upright design is a realisation of the idea of condensation inherent in the cycle that, as the poetry suggests, is the main point of the picture, which forces the eye to enact an ascent from the shadowy gullies of the foreground to the illuminated heights and bright sky of the upper part of the subject. The nacreous pinks, blues and yellows with which, in a creamy impasto, Turner renders these warmer passages are to be found in several works of about this year, including the second version of 'Dunstanburgh Castle' (B&J 32) and some small canvases apparently also associated with the North of England tour of 1797. They seem to derive from the practice of

Richard Wilson, the model for all Turner's work in oil during this brief period; though it is possible that he had also been looking at some of Wilson's followers, notably William Hodges (1744–97) and George Barret the elder (1728?–84), whose palette often takes on a similar rosy glow.

3 Buttermere Lake with Part of Cromackwater, Cumberland, a Shower RA 1798 (527)
Oil on canvas, 91.5 × 122 (36⅛ × 48)
B&J 7; N00460 [*col. pl. p.20*]

This was one of the four works sent by Turner to the 1798 exhibition with titles amplified by lines from Thomson's *Seasons* (see No.2). Like the watercolour of 'The Dormitory and Transept of Fountains Abbey – Evening' it was concerned with atmospheric effects at the end of the day, though we should scarcely realise this were it not for the verses that accompany it. They are taken from *Spring*, where in a substantial passage Thomson describes the breaking through of the sun after a rainstorm, and the appearance of a rainbow:

Till, in the western sky, the downward sun
Looks out effulgent [from amid the flush
Of broken clouds, gay-shifting to his beam].
The rapid radiance instantaneous strikes
The illumined mountain[, through the
 forest streams,
Shakes on the floods, and] in a yellow mist,
[Far smoking o'er the interminable plain,
In twinkling myriads lights the dewy gems.
Moist, bright, and green, the landscape
 laughs around.
Full swell the woods; their every music wakes,
Mixed in wild concert, with the
 warbling brooks
Increased, the distant bleatings of the hills,
The hollow lows responsive from the vales,
Whence, blending all, the sweetened
 zephyr springs.
Meantime, refracted from yon eastern cloud,]

Bestriding earth, the grand ethereal bow
Shoots up immense; and every hue unfolds,
[In fair proportion running from the red
To where the violet fades into the sky]
 (lines 189–207)

Turner abridged this to a mere five lines (his omissions are indicated by square brackets). The scope of these cuts, which leave a text that, as printed, barely makes sense, suggests that he hardly intended the passage he published to stand self-sufficient, but rather referred the reader to Thomson's original, with its much fuller detail. It continues with a brief address to Newton:

Here, awful Newton, thy dissolving clouds
Form, fronting on the sun, thy showery prism;
And to the sage-instructed eye unfold
The various twine of light, by thee disclosed
From the white mingling maze.
 (lines 208–12)

Thomson's characteristic interest in the accurate rendering of scientific detail is picked up by Turner in his elaborate and naturalistic treatment of the rainbow, which he had studied on the spot in Westmorland. The coloured drawing that he made of the subject is in the *Tweed and Lakes* sketchbook (TB XXXV, f.84), and shows him concerned with the accurate recording of climatic phenomena just as Thomson was. The quotation is evidently intended to draw attention to the precision with which he too describes what he sees in nature. Turner will have found an even more self-consciously 'scientific' description of the rainbow, however, in Akenside's *Pleasures of Imagination* (1744), book II, lines 103–20.

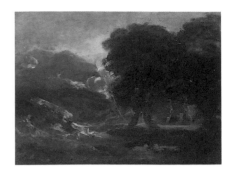

4 Dark Landscape with Trees and Mountains *c*.1799
Oil on canvas, approx. 31.5 × 39
(12¼ × 15¼)
B&J 34a; TB LI M; D02380 [*col. pl. p.20*]

The immediate source for this obviously unresolved study is a drawing in the *Dinevor Castle* sketchbook (TB XL, f.8v) which Turner used during his tour of Wales in 1798. The wild, brooding atmosphere seems to have sprung directly out of his perception of Welsh landscape, which was to yield several works in watercolour that share the same mood (see, for instance, the 'Scene in the Welsh Mountains with an Army on the March', No.6). Butlin and Joll comment on the unusual presence of a pink ground; although this is not common in the oil paintings, it occurs among the Welsh watercolour studies of precisely this moment (cp. for example the view towards Snowdon from above Traeth Bach, TB XXXVI U; repr. Wilton 1984, p.19, no.67). The threatening atmosphere is enhanced by the presence of a bloody corpse lit by a livid and fitful ray; Turner may be telling a story from Welsh history, as he was to do in his Bard subjects (Nos.5, 6). It is also possible that this is an early example of his recourse to Ovid, and depicts the tragedy of Pyramus and Thisbe. As with the 'Jason' of 1802 (No.9), the influence of Salvator Rosa is strong, but Turner may also have been thinking of Poussin's picture of 'Pyramus and Thisbe' (Städelsches Kunstinstitut, Frankfurt), for which he had a high regard and to which he alluded at length in the notes for his Perspective lectures. Several other Ovidian subjects might be candidates, among them Cephalus and Procris, which he was to adopt for a *Liber Studiorum* subject of 1812 (R.41).

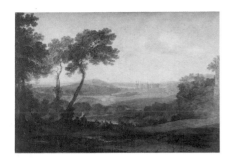

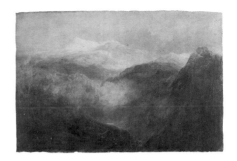

5 Caernarvon Castle, North Wales
RA 1800 (351)
Pencil and watercolour with scraping-
out and stopping-out, mounted by the
artist on a thin board, washed grey,
66.9 × 99.4 (26⅜ × 39⅛)
TB LXX M (W.263); D04164 [col. pl. p.24]

The Bard, a Pindaric Ode first published in
1757, was Gray's most celebrated poem,
even including the *Elegy written in a Country
Churchyard*, for it showed his abilities in the
field of the Sublime. The subject of the
Bard, the last remaining representative of
an oppressed and soon-to-be-extinguished
culture, beleaguered on a remote crag by
the army of Edward I, provided many
artists with a vehicle for some of their
grandest ideas. The poem was printed
in Anderson's volume X and Turner res-
ponded to it at an early date by embarking
on his most ambitious scheme in water-
colour up to that time: a pair of elabor-
ately conceived landscapes contrasting
peace and war, the pastoral and the
Sublime in nature and in man's behav-
iour. The second was never finished; see
No.6. The first is this work, which he
showed at the Academy in 1800 with
verses which do not come from Gray, and
which we must suppose to be his own,
perhaps the first he ever dared to print
(though the lines attached to the view of
Dolbadarn Castle of the same year may
also be his; see p.22).

And now on Arvon's haughty tow'rs
The Bard the song of pity pours,
For oft on Mona's distant hills he sighs,
Where jealous of the minstrel band,
The tyrant drench'd with blood the land,
And charm'd with horror, triumph'd in
 their cries,
The swains of Arvon round him throng,
And join the sorrows of his song.

This was the first time that he had
exhibited a watercolour with a historical
subject, a sure indication of his ambition to
place works in that medium on a par with

oil paintings. The unrealised intention of
producing a pair – thwarted, perhaps,
because of the large number of pressing
commissions with which he was faced by
this time – signals his determination to
emphasise the new-found strength of the
medium by insisting that it could carry the
weight of a sustained intellectual idea. The
yoking of poetry to such a purpose would
follow naturally. If the pendant had been
finished it would have illustrated Gray's
poem; in adding his own lines to his
exhibited work, Turner may have wished
to prove (to himself at least) that in poetry
too he could vie with the established
masters.

**6 Scene in the Welsh Mountains
with an Army on the March** 1799
Watercolour with stopping-out,
67.9 × 99.6 (26¾ × 39¼)
WM: J Whatman 1794
TB LXX Q; D04168

Turner apparently intended to complete
this large watercolour as a pair or comple-
ment to his exhibited view of 'Caernarvon
Castle, North Wales' (No.5). There is
another large sketch (TB LXX-h; repr.
Wilton 1984, p.68, no.95) in which the
figures of a Bard and some companions are
indicated, evidently as staffage that he
proposed to add to his composition. They
provide evidence that Turner planned to
illustrate Gray's poem in detail, with the
Bard hurling defiance at Edward I:

Ruin seize thee, ruthless king!
Confusion on thy banners wait,
Though fann'd by conquest's crimson wing
They mock the air with idle state.
Helm, nor hauberk's twisted mail,
Nor e'en thy virtues, tyrant, shall avail
To save thy secret soul from nightly fears,
From Cambria's curse, from Cambria's tears!
Such were the sounds that o'er the
 crested pride
Of the first Edward scatter'd wild dismay,
As down the steep of Snowdon's shaggy side
He wound with toilsome march his long array.

The presence of the medieval army in this
grandiose mountain scene makes it plain
that Turner is illustrating Gray, and not
simply responding to his recent experience
of Snowdonia. Indeed, this is an early
example of his instinct to exploit the
association of particular places, and of his
reliance on poetry for hints as to how this
could be done. But he was not content to
leave the subject as Gray describes it: he
wanted to introduce a dynamic element of
contrast between the states of peace and
war; hence the pairing of this design with
the view of Caernarvon showing the Bard
in time of peace immediately before the
arrival of Edward.

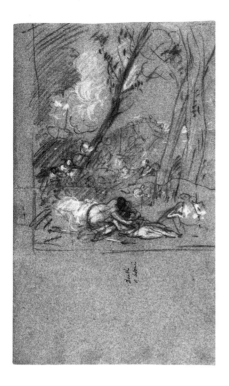

7 *Calais Pier* sketchbook

*c.*1799–1805
Marbled boards, leather spine and
corners (renewed), with two brass
clasps. Contains 86 leaves of blue laid
paper (paginated, not foliated, by
Finberg), 11.5 × 18.1 ($4\frac{1}{2}$ × $7\frac{1}{8}$).
WM: 1794; VI and Strasburg Lily

A large book used by Turner during the
period of transition from his early success
to his first maturity, and illustrating the
continuity of his thought throughout that
time. In it he planned some of the most
important of his pictures of the years
following his election as Associate and full
Royal Academician in 1799 and 1802.
They include the three great marines of
those years, the Bridgewater and Egre-
mont Sea-pieces, and 'Calais Pier' (B&J 16,
18, 48), which do not seem to be related to
Turner's literary interests but have
obvious roots in his admiration for the
Dutch marine masters, such as van de
Velde and van de Capelle. 'The Festival
upon the Opening of the Vintage at
Macon' (B&J 47) is also planned here
(pp.116–17). It bears close affinities with
other landscape compositions of the per-
iod, including those on the large sheet of
blue laid paper exhibited here (No.16)
which is rather similar to the paper of this
book. Among more explicitly 'historical'
themes are Biblical subjects, including the
Destruction of Sodom (pp.110–11), the

Deluge (pp.120–21), several Plagues of
Egypt (pp.25, 42–3) and the Rest on the
Flight into Egypt (pp.60–63); and myth-
ology, including Hero and Leander
(p.57), Apollo and Python (p.68), and
scenes from the story of Adonis (see
below). Classical and modern history are
also represented: there are ideas for 'Han-
nibal crossing the Alps' (No.59) and an
unrealised subject, 'William Tell escaping
from the Boat' (pp.38–9, 36–7). The use of
black and white chalks, and occasionally
pen, on blue paper suggests a conscious
attempt to imitate the drawing techniques
of the Old Masters whom Turner was
assiduously emulating. The flow of ideas is
revealing. Poetry and literature are clearly
of crucial importance, but they can be seen
to take their place in the general context of
pictures stimulated by art, whether of
seventeenth-century Holland or Renais-
sance Venice.

> Open at p.52; D04954
> Composition Study: the Death of
> Adonis
> Black and white chalks
> Inscribed below, parallel with right
> edge: 'Death/ of Adonis'

This study can be taken with those in the
Hesperides 2 sketchbook (No.14) as an
Ovidian death scene set in Arcadian
woodland. Turner was no doubt reliant on
book X of the *Metamorphoses* for his subject,
though he may also have known such
works as Theocritus' *Idyll* XXX, 'On the
Death of Adonis', of which Fawkes's trans-
lation was printed in Anderson's *British
Poets* (volume XIII). He will certainly have
been familiar with Shakespeare's famous
poem *Venus and Adonis*, which Anderson
printed in his first volume. While he was in
Paris in 1802 Turner was much impressed
by Titian's famous altarpiece from the
Venetian church of SS. Giovanni e Paolo,
the 'Death of Peter Martyr'. He made
extensive notes on it in one of his sketch-
books (TB LXXII, ff.27v–28v), notes which
he used when writing his Perspective
lecture on landscape backgrounds. The
combination of natural observation, in
the sky and trees, with a dramatic human
subject exemplified for him the potential of
landscape as a vehicle for the expression of
the grandest human emotions. Typically,
he set himself to imitate the composition
closely in one of the large paintings that he
tackled on his return to England.

The basic format of an upright compo-
sition dominated by tall trees was one that

he was to adopt in many different guises,
and it enabled him to bring extra sig-
nificance to his studies of trees along the
Thames (see Nos.20, 23, 26). There are
several sketches in the *Calais Pier* book
which reflect a preoccupation with the
motif of tall trees combined with figures,
notably those on pp.44–5, 48, 50, 52 and
60–63. These pages are often inscribed
with titles – 'Holy Family', 'Parting of
Venus and Adonis' (p.50) or 'Death of
Adonis' (this sheet). It seems that the
various ideas were at first interchangeable,
but, unusually, Turner developed both
the Holy Family and Adonis subjects into
finished works. Eventually the Holy
Family idea became horizontal in format
(p.60), and the trees were cropped; the
result was the picture shown at the Acad-
emy in 1803 (B&J 49); while the myth-
ological subject retained its upright
composition and became 'Venus and Ado-
nis, or Adonis departing for the Chase'
(B&J 150; see p.80), which was not sent to
the Academy but was presumably exhib-
ited in Turner's own gallery in the follow-
ing year or in 1805. He eventually submit-
ted it to the Academy exhibition in 1849.
A small oil sketch known as 'Venus and the
Dead Adonis' (No.10) probably belongs
to the same group of experiments. Inter-
estingly, James Barry, an Academician of
the preceding generation whom Turner
much admired, had exhibited a 'Death of
Adonis' in the year of Turner's birth,
displaying a similar interest in the expres-
sive interplay of landscape and figures,
though characteristically relying on the
precedent of Salvator Rosa rather than
Titian.

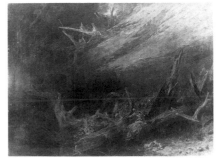

8 *Rhine, Strassburg and Oxford sketchbook* c.1802

Bound in boards, inscribed on front cover: 'IMWT'; and on label on spine (destroyed): 'R from Strasburg. Oxford'. Contains 49 leaves of white wove paper, 15.3 × 24.2 (6 × 9½)
TB LXXVII

A book used on the tour to Switzerland in 1802, and filled with drawings of Continental views; there are also a few Oxford subjects, and the studies noted below.

Open at ff.43v–44r; D04787–8
Studies for 'Apollo and Python' and another work (?'Jason')
Pencil

The composition study on f.43v is fairly close to the final form of the picture exhibited in 1811 (No.55). That on f.44r is either an idea for part of the background, or a note of a new subject; Finberg considered that it might relate to 'Jason' (No.9) which is obviously a cognate work, and which had already appeared at the Academy in 1802, before Turner set off for France. Since there is little reason to suppose that the two drawings were made at different times, the inference must be that he had conceived 'Apollo and Python' in considerable detail at an early date. He cannot have referred to that experience of the Alps which, it has been generally agreed since Ruskin, was to inform the landscape of 'The Goddess of Discord' (No.30) a little later. This would help to account for the somewhat archaic quality of the 1811 canvas. Finberg's suggestion that the detail of snakes and bones on the floor of a rugged valley on f.44r is a sketch for 'The Goddess of Discord' seems less likely than that it represents a further idea connected with the dragons combated by Apollo, Jason and Cadmus.

9 Jason RA 1802 (519)

Oil on canvas, 90 × 119.5 (35½ × 47⅛)
B&J 19; N00471 [*col. pl. p.78*]

Turner was much fascinated by the story of the Argonauts and their quest for the Golden Fleece; he drafted a poem on the subject in his *Perspective* sketchbook (No.49), and proposed to himself several possible pictures illustrating their adventures or those of their leader, Jason (see No.29). In the event he completed only two: this early work, and the much later 'Vision of Medea' (B&J 293) which he showed in Rome in 1828.

'Jason' was not accompanied by verses, but it is probable that the subject was suggested by poetry; certainly when Turner re-exhibited the picture at the British Institution in 1808 he cited 'Ovid's Metamorphosis' in the catalogue. Ovid's account of the slaying of the dragon is skimpy: he concentrates on the sowing of the dragon's teeth to create an army of soldiers – a subject which Turner may possibly have considered illustrating, to judge from some enigmatic studies in the *Jason* and *Hesperides* sketchbooks (TB LXI; and see Nos.13, 14). It has been suggested that a more likely source for this picture is the translation of Apollonius Rhodius' *Argonautics* by Fawkes in Anderson's *British Poets* (volume XIII), because Fawkes uses the word 'serpent' to describe the monster, as Turner represents it here. But in fact 'dragon' is the term used in the essential passages:

With high arch'd neck, in front the dragon
 lies . . .
The dragon thus his scaly volumes roll'd,
Wreath'd his huge length, and gather'd fold in
 fold
 (book IV, lines 139, 157–8, etc)

An equally important impulse behind the work seems to have been the influence of Salvator Rosa, which was particularly strong on Turner in the years round 1800.

The overhanging cliff and sombre tonality, as well as the 'terrific' subject, are all characteristic of Salvator. His influence may have been conveyed through the medium of de Loutherbourg, who had in fact painted a 'Jason enchanting the Dragon' and a scene from the very similar story of Cadmus and the dragon; both could have been seen by Turner.

10 Venus and the Dead Adonis

c.1803
Oil on canvas, 31.5 × 45 (12½ × 17¾)
B&J 151; N05493

The subject-matter of this sketch has not been identified with certainty, but there seems little reason to doubt the assumption that it relates to Turner's meditations on the Ovidian story of Venus and Adonis which had, of course, also been treated by Shakespeare. This subject, like that of the large finished picture of 'Venus and Adonis' (B&J 150), was considered in studies in the *Calais Pier* sketchbook (No.7) which explore the motif, derived from Titian, of tall trees combined with figures. The landscape background, so expansive and joyous in that work, is here abbreviated into a dense assemblage of tree boles, which create a gloomy and enclosing space that confirms the tragic mood of the subject. It is perhaps unlikely that Turner

would have completed two substantial pictures based on this story, but he may possibly have contemplated a pair of contrasted works, happy and tragic, as he had done in the case of watercolours inspired by Gray's *The Bard* (see Nos.5 and 6).

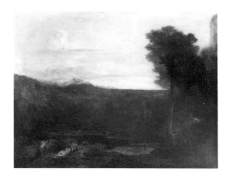

11 Narcissus and Echo RA1804 (207); BI 1806 (22)
Oil on canvas, 86.3 × 116.8 (34 × 46)
B&J 53; T03869 [*col. pl. p.25*]
Tate Gallery, Petworth Collection

The verses that Turner appended to his Academy catalogue entry for this picture are taken from Addison's translation of part of Ovid's *Metamorphoses*, printed in Anderson's *British Poets* (volume VII):

So melts the youth, and languishes away;
His beauty withers, and his limbs decay;
And none of those attractive charms remain
To which the slighted Echo sued in vain.
She saw him in his present misery,
Whom, spite of all her wrongs, she
 griev'd to see:
She answer'd sadly to the lover's moan,
Sigh'd back his sighs, and groan'd to
 every groan;
'Ah! youth belov'd in vain!' Narcissus cries;
'Ah! youth belov'd in vain!' the nymph replies.
'Farewell!' says he. The parting sound
 scarce fell
From his faint lips, but she reply'd 'Farewell!'

Ovid was to remain an important source for Turner's historical landscapes throughout his life. In this he followed the example of Claude, who had frequently taken subject-matter from Ovid. Indeed, Turner may well have been influenced in his choice of subject for this work specifically by a Claude 'Landscape with Narcissus and Echo' in the collection of Sir George Beaumont (now in the National Gallery). Like the Claude, his picture is distinctively laid out with a long flat horizon contrasted

with the dark upright mass of a tree to one side; though Turner adopts a deliberately rather solid composition, with emphatic verticals and horizontals announcing his appreciation of the geometry of Poussin, as in his slightly later view of Windsor Castle, also at Petworth (see No.51). The reclining nude figure in the lower left corner of the composition is clearly an allusion to the nymph prominently placed in the corresponding position in Claude's design, and many other elements in the landscape find parallels there – the lake in the foreground, the distant castle, and the mountain which rises up on the horizon.

It is possible that Turner intended the canvas to be recognised by Beaumont as a deliberate homage to his own picture, a gesture of friendship at a time when Beaumont's animosity was beginning to become apparent. He was to use Ovid and Claude again for a not dissimilar purpose when he borrowed Claude's motif of the metamorphosis of the shepherd Apullus, a picture then in the possession of a member of the family of his patron the Duke of Bridgewater, for the work he submitted for the Premium of the British Institution in 1814. This was 'Apullia in search of Appullus vide Ovid' (B&J 128), which in fact departs considerably from the story given in the *Metamorphoses*. Beaumont was a Director of the British Institution, and it has been argued that 'Apullia', a more than usually close pastiche of Claude borrowing in particular from a work in the collection of another Director, Lord Egremont (the 'Landscape with Jacob and Laban'), was intended to flout criticism of Turner's idiosyncratic style by demonstrating how slavishly he could imitate the Old Masters if he chose. The suggestion has also been made that Turner was attempting to show how he could 'improve' on Claude; but this is not borne out by the picture, which is very clearly as exact an imitation as Turner could achieve. He has perhaps never been given due credit for this almost virtuoso suppression of his own manner.

Several other Ovidian subjects appeared during these years as plates in the *Liber Studiorum*; see for instance No.58. He returned to Ovid for several pictures in the years round 1840: in 1836 he submitted 'Mercury and Argus' (B&J 367) and the next year a work entitled 'Story of Apollo and Daphne' (B&J 369) was shown with verses from Dryden's translation of

the *Metamorphoses*; in 1839 he exhibited his 'Pluto carrying off Proserpine' (B&J 380) with a reference (without quotation) to '*Ovid's Metam.*'; and in 1840 showed 'Bacchus and Ariadne' (B&J 382). 'Glaucus and Scylla – *Ovid's Metamorphoses*' (B&J 395) appeared in 1841. Of these, 'Mercury and Argus' makes use of the Claudean format, though this time it is upright, a type rarely found in English collections. The outstanding example was the small 'Landscape with Hagar and the Angel', by that date in the National Gallery, but formerly in Beaumont's collection; and there are similarities between Turner's composition and that of another upright, the 1645 'Rest on the Flight into Egypt' which was in England during Turner's lifetime.

12 *Studies for Pictures: Isleworth* sketchbook *c*.1805
Bound in calf with four brass clasps, Turner's label on spine inscribed: '37 Studies for Pictures Isleworth'. Contains 80 leaves of white paper prepared with a wash of grey, with two flyleaves of white paper at each end, 14.7 × 25.6 (5⅝ × 10 1/16). All leaves numbered consecutively 1 to 84
WM: 1794, 1799

Inside the front cover of this important book Turner has inscribed 'J.M.W. Turner Sion Ferry House Isleworth' – an address to which he moved in the winter of 1804–5. He remained there until the autumn of 1806 when he took lodgings in Hammersmith. His pen sketches of Thames scenery alternate with compo-

sition studies for imaginary historical subjects, often annotated with possible titles and dramatis personae. There is also (on f. 56v) a reference to Pope's pastoral *Summer*. The sequence provides classic documentation of the dovetailing in his mind of observation from nature and flights of pure imagination. The bulky forms of Kew and Richmond Palaces, Sion House, Ham, or Windsor Castle become the terraces and battlements of Antique cities, and the Duke of Northumberland's shooting lodge by the water at Sion, the Alcove, a circular 'temple' like that at Tivoli (see also Nos.53, 54). He incorporated the idea into his lecture notes of 1811 (see p.86), where he asked,

> As we cannot compromise with ancient art which (we fain would) to have their beauties and defects[,] why should immitation continue to diffuse the mannered parts of each master[?] The familiar scenes and incidents of [?] are even allow'd to pervade History and Architecture transported as Grecian in Latinum Rome in Attica diversity beauty richness majesty and dignity are obtainable by arrang[e]ments of the simple as well as the more complex forms and sentiments or feeling[s] excited more by different modes or styles [. . .] that were localities of time and place and ought to be considered so in Pictorial effect. The latitude which the ancient master[s] took (from whatever motive) should not therefore regulate tho their beauties should stimulate [us]. For we might follow like principles of their introductory parts[;] make use of our localities and the Water Gate of York buildings of Inigo Jones, becomes the Portal of Misenum Brundisium the meeting of Brutus with Portia after his defeat or the departure of Regulus with as much propriety as the Roman temple on the towering Acropagus [*sic*] (British Library, Add. MS 46151 N, f.14r)

Open at ff.32v–33r; D05538–9
Study of Classical Architecture, and an Ideal River Landscape
Pen and brown ink, and pen and brown ink with black and white chalks

Although the river landscape shows cypress trees and Italianate buildings, including a round embattled tower, the general disposition of the scene is apparently that of Richmond Hill seen from the Petersham shore of the Thames. A more direct transcript of the view occurs on f.19r. The drawing embodies Turner's habit at this date of transforming English reality into Mediterranean ideal, and perhaps expresses something of his private

sense of the 'classic' significance of the spot, including as it does the house of Sir Joshua Reynolds, present here as a substantial building on the horizon at the left.

13 *Hesperides 1* **sketchbook** *c.*1805
Marbled boards, leather spine and corners, with two brass clasps; Turner's label on spine inscribed: '72 Hesperides Bk'. Contains 44 leaves, ff.2–42 prepared with a grey wash; ff.1 and 43, 44 white laid paper, 26.4 × 16.8 (10$\frac{7}{16}$ × 6$\frac{5}{8}$). WM: Haye & Wise 1799
TB XCIII

A book in use at much the same time as the *Studies for Pictures: Isleworth* sketchbook (No.12), and preoccupied with similar ideas. It contains more studies for works that were actually executed, including 'The Goddess of Discord' (No.30), 'Richmond Hill and Bridge' (No.36), 'Apollo and Python' (No.55), 'The Blacksmith's Shop' (B&J 68), 'Dido and Aeneas' (see below), and several shipping scenes. Some of the pen sketches anticipate Ovidian subjects used for the *Liber Studiorum* (see No.58). It also has a few watercolour studies which share the character of those in the *Thames from Reading to Walton* sketchbook (see No.18).

Open at ff.4v–5r; D05773–4
Figure Studies; Composition Study for 'Dido and Aeneas'
Pen and brown ink and wash

The composition study is for the picture

that Turner exhibited in 1814 (No.62), some years after this book was in use. A similar study, in colour, occurs in the *Studies for Pictures: Isleworth* book (f.21r; repr. Wilkinson 1974, p.106). The figure studies opposite, and those on two succeeding pages, are for the same picture; f.4v has been torn across by Turner, so that part of f.3v is visible beneath; this has a rough study for 'The Goddess of Discord', and is inscribed 'Garden of the Hesperides'.

14 *Hesperides 2* **sketchbook** *c.*1805
Marbled boards, leather spine and corners, two brass clasps; Turner's label on spine inscribed: '72 H[esperides]'. Contains 43 leaves, ff.3–42 prepared with a grey wash; ff.1, 2 and 43 white laid paper, 22.9 × 14 (9 × 5$\frac{1}{2}$). WM: J WHATMAN 1801.
TB XCIV

Like its companion, the *Hesperides 1* book (No.13), this was used in about 1805–6, and contains many ideas for pictures amalgamating the scenery of the Thames with classical subject-matter. Three incidents from Ovid's account of the story of Hercules and Deianera (*Metamorphoses*, book IX) are considered: the death of Achelous (see below); the death of Nessus, showing Hercules shooting the centaur across the river Evenus as he makes off with Deianera on his back (f.14r); and the death of Lichas (f.15r), in which Hercules' attendant is punished for bringing him the poisoned shirt from Deianera by being flung into the sea from a high cliff. Landscape studies titled 'Dryope' and 'Birth of Adonis' appear on the two following leaves. Adonis figures in several plans for pictures of this time, notably in the *Calais Pier* sketchbook (No.7), and in the finished picture of Venus and Adonis (B&J 150).

Open at ff.12v–13r; D05865
Composition Study: the Death of
Achelous
Pen and grey and brown ink and wash
Inscribed lower right: 'Death of
Achelous'

Turner's proposed title is not strictly
accurate: Ovid tells how the river god
Achelous fought with Hercules for the
hand of Deianera, and, having been
defeated by the hero in the form of a man,
turned himself first into a snake and then
into a bull. Hercules again vanquished
him, tearing out one of his horns (which
became the Cornucopia). Achelous was
then transformed into a river again. This
final struggle is the subject of the compo-
sition study. The introduction of mytho-
logical figures into a scene of riverside trees is
typical of the subjects Turner was contem-
plating while exploring the Thames in the
years around 1805.

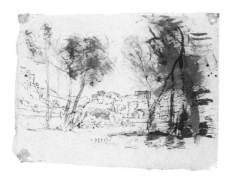

15 Composition Study: an Ideal Landscape with a Distant Acropolis c.1805

Pen and brown ink on blue laid
paper, approx. 23.6 × 31 (9¼ × 12¼)
TB CXIX I; D08196

Originally part of the large sheet of
studies, TB CXIX H (No. 16), and evidently
cut out by Ruskin to facilitate the display
of the pen drawing on the verso, a com-
position somewhat reminiscent of the
'Macon' of 1803 (B&J 47), which is now
considerably faded from exposure. The
recto, shown here, is still fresh and is the
most powerful of the studies on the sheet.
Like that on the lower right of TB CXIX H it
shows boats moored along a shore in the
foreground, but these seem to have no
sails, and to be powered by numbers of
rowers. Both designs may be related to
Turner's consideration of a subject depict-
ing the Argonauts in search of the Golden
Fleece (see No.9).

16 Sheet of Composition Studies

c.1805
Pen and brown ink on blue laid
paper; the sheet folded in four, with
one quarter cut away (see No.15);
approx. 45.8 × 61.7 (18 × 24¼)
TB CXIX H: D08195

This large sheet was used by Turner to
make several composition studies charac-
teristic of his meditations on the subject of
classical landscape design in the years
around 1805. The four on the recto (one
has been removed: see No.15) are all
variants on the theme of a broad landscape
seen between groups of trees, in the
manner of Claude. Turner had already
produced two works in which he adopted
this idealising format: the watercolour
'Caernarvon Castle, North Wales' of 1800
(No.5), and, more significant still, the
large canvas he showed at the Academy in
1803, 'The Festival upon the Opening of
the Vintage at Macon' (B&J 47), for which
he had made studies in the *Calais Pier*
sketchbook (see No.7). These too are in
pen and brown ink on blue paper, and the
present sheet may date from as early as
1803; but it is more likely to belong to the
period of the *Studies for Pictures: Isleworth*
sketchbook (No.12). The round temple
and bridge, for instance, which appear in
the upper of the three studies, are similar
to those occurring in several similar com-

positions in that book, and are perhaps
related, too, to the 'temple' and bridge
which Turner recorded on ff.8 and 11 of
the *Thames from Reading to Walton* book of
about the same date (see Nos.18, 54). The
composition on the lower left is perhaps a
variant of that noted on f.54r of the
Isleworth book, with the inscription 'Mer-
cury & Argus'. The eminence with build-
ings glimpsed beyond the trees may be an
idealised version of Richmond Hill. The
reverse of the sheet has another compo-
sition study, with a prominent sailing boat
on a river in a wooded landscape. This is
perhaps connected with the landscape
with ships moored which is the third
design on the recto. Also on the verso is a
rough pencil drawing which Finberg iden-
tified as possibly Python or a tree root. It is
in fact a sketch-map of the Thames,
annotated with compass bearings: 'N–S',
'SSW', 'SW', 'SS', and 'W–N', and the
following, written vertically:

S
E
|
W
E
S

Several loops of the river are indicated, in
one of which is an island or ait. One or two
bridges are faintly marked. The area

referred to may be that round Isleworth, Richmond and Twickenham, but it is possibly further upstream, near Walton and the junction of the Thames with the Wey.

17 Composition Study: a Classical Landscape *c.*1805
Pen and black ink on paper washed with grey, 32.8 × 47.9 (12⅞ × 18⅞)
Inscribed below: 'Homer reciting to the Greeks his Hymn to Apollo' and 'Attalus declaring the Greek states to be free'
TB CXX verso; D40000

A study typical of Turner's preoccupations in the early years of the new century, and especially at the time when he was living at Sion Ferry House in Isleworth. It shows a spacious landscape crowded with classical temples and other buildings, a low sun, and elegantly grouped trees following the patterns laid down by Claude. There is also a gathering of people in the foreground; what they are congregated for Turner has not decided. The two subjects noted at the bottom of the sheet show that he was considering either Homer or Attalus as his hero. The range of ideas from literature to politics is characteristic: poetry and history were equally viable as the starting-point for serious subject-matter. The alternative suggestions are of a piece with those scattered through the *Studies for Pictures: Isleworth* sketchbook (No.12), where similarly diverse themes appear and are discarded. The round temple glimpsed through the trees to the left (see No.54) figures in those drawings as it does here, returned to its rightful habitat in the ideal landscape of classical antiquity. On the recto of this sheet is a study of trees; the coupling also recalls the *Isleworth* book in opposing the observation of nature to the re-use of natural elements in grandiose historical compositions.

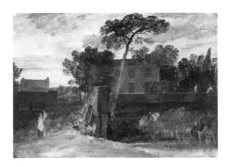

18 A House by the Thames *c.*1805
Watercolour with stopping-out, 25.7 × 36.7 (10⅛ × 14½)
TB XCV 48; D05952 [*col. pl. p.43*]

A sheet from the *Thames from Reading to Walton* sketchbook, in which pencil studies of Thames-side scenes are to be found along with more elaborate watercolour studies combining spontaneous freshness with a strongly classicizing formality of conception (see also No.19). Here, the frontal rectangle of the house and the carefully placed vertical of the pine tree lend a free sketch something of the dignity and inevitability of a painting by Poussin. As a consequence, these drawings, however obviously concerned with modern England, are imbued with an atmosphere of antique calm and seem to hold tacitly within themselves some allusion to the poetry of Ovid or Theocritus (see also No.20). It is possible that this watercolour records a scene close to Turner's temporary home in Isleworth, and the suggestion has been made that this is Sion Ferry House itself.

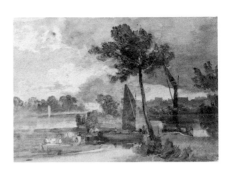

19 Scene on the Thames with Barges and Rowing-boats: Windsor Castle in the Background *c.*1805
Watercolour with stopping-out, 26.5 × 36.5 (10 1/16 × 14¾)
TB XCV 12; D05916 [*col. pl. p.29*]

The interaction of naturalism and idealism in Turner's work along the Thames in his Isleworth and Hammersmith years is well demonstrated in this sheet from the *Thames from Reading to Walton* sketchbook. Ostensibly an unaffected and rapidly executed view of an informal rural subject, it is in fact carefully constructed as a classical landscape, with balanced elements – tree, sails, water and sky – emulating the dignified layout of the seventeenth-century masters. The implications of such a study were realised in a large watercolour of this date, now in the Yale Center for British Art (W.370), which presents Lake Geneva and Mont Blanc in a similar composition (though the main vertical emphasis is now on the left). As in the study of a Thames-side house from the same book (No.18), the demands of formal and ideal picture-making override and reconstruct the observed facts of nature.

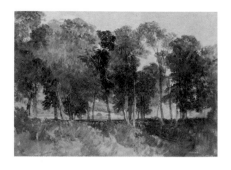

**20 A Group of Trees beside the
Thames** *c*.1805
Pencil and watercolour, 25.6 × 36.6
($10\frac{1}{16} \times 14\frac{7}{16}$). WM: J WHATMAN
TB XCV 46; D05950 [*col. pl. p.46*]

This sheet from the *Thames from Reading to
Walton* sketchbook has frequently been
adduced to demonstrate Turner's fresh
and spontaneous approach to the scenery
of the Thames in the early years of his
residence at Isleworth and Hammersmith.
Its rapid execution and the informality of
its design suggest an instantaneous re-
sponse to an arbitrarily selected specimen
of random 'nature'. Some of the water-
colour studies in this book, e.g. that of eel-
pots at 'Benson' on f.13, have been com-
pared with the open-air colour sketches of
Constable. Other pages, however, display
a characteristically Turnerian self-con-
sciousness in the matter of composition,
being laid out as if with formal and
classicising finished compositions in mind
(see Nos.18, 19). Here, the cool rhythms of
the tree-stems and the subtle orchestration
of colours in the foliage suggest a sophisti-
cation of purpose that goes rather further
than that of the direct *plein-air* sketch; and
in fact Turner seems to have made draw-
ings of this type often with very grand
intentions. The *Studies for Pictures: Isleworth*
sketchbook (No.12) contains a drawing of
trees very similarly arranged, which is
annotated 'Mercury & Argus' (f.54r): the
rural scene is conceived as the setting for a
story from Ovid which Turner was to take
up in an important painting of the 1830s
(B&J 367). As he tended to associate
Ovidian subjects with the work of Claude,
it is not unreasonable to draw a parallel
with Claude's working methods, and to
liken these Thames-side studies to the ink
and wash drawings that Claude made in
the Roman Campagna to provide him
with the basic information on which his
paintings were essentially, albeit usually
remotely, based. Another seventeenth-

century master who may have influenced
him in these compositions of figures reclin-
ing beneath trees is Pier Francesco Mola,
whose work had attracted him in Paris in
1802: his copy of Mola's 'Vision of St
Bruno' from the Incisa Collection in
Rome, at that time in the Louvre, is on f.2r
of the *France, Savoy, Piedmont* sketchbook
(TB LXXIII). The resolved use of such rustic
settings for mythological subjects can be
seen in several plates of the *Liber Studiorum*,
such as the unpublished 'Pan and Syrinx'
(R.80; and see No.58).

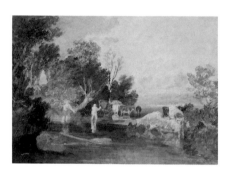

21 The Ford *c*.1805
Pencil and watercolour with stopping-
out and scraping-out, 54.5 × 75.9
($21\frac{1}{2} \times 29\frac{7}{8}$)
TB LXX K; D04162 [*col. pl. p.49*]

One of a small number of large colour
studies apparently made at the same time
as the drawings in the *Thames from Reading
to Walton* sketchbook (see Nos.18–20), this
sheet epitomises the fresh clarity of
Turner's work in direct response to the
landscape of the rural Thames. It is as
apparently uncomplicated in its intentions
as the watercolour studies in the sketch-
book; but the context of Turner's work
and thought at this time leaves open the
possibility that strong literary associations
are in operation. The two rustic figures
chasing cows across the stream may
perhaps be standing in for Arcadian shep-
herds, or the rustic nymph and swain of
some Ovidian pastoral. It is interesting,
however, that in general Turner's more
overt references to the literary pastoral
tend to feature sheep rather than cows
(see, for example, 'Pope's Villa', No.35).
Cows are used to populate more directly
picturesque accounts, such as the 'Union
of the Thames and Isis' (B&J 70) or 'Sketch

of a Bank, with Gypsies' (B&J 82), both of
1809. This may well be a reflection of the
symbolic role played by flocks of sheep in
Theocritan pastoral; such flocks are a
commonplace of Turner's own pastoral
verse.

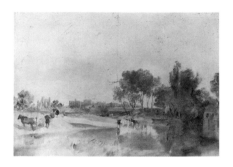

**22 A Thames Backwater with
Windsor Castle in the
Distance** *c*.1805
Oil on canvas, 86.5 × 121 ($34\frac{1}{8} \times 47\frac{5}{8}$)
B&J 163; N02691 [*col. pl. p.43*]

Seventeen sketches of this size exist in the
Turner Bequest; they are generally agreed
to have been executed at about the same
time, in the years when Turner was first
a regular resident on the banks of the
Thames, that is to say after his arrival at
Sion Ferry House in late 1804 or early
1805. The *Studies for Pictures: Isleworth*
sketchbook (No.12) dates from this period,
and so does the *Thames from Reading to
Walton* book (see No.18), with both of
which links can be demonstrated. Perhaps
more important evidence is the fact that it
was precisely at this moment that the series
of finished Thames subjects began to
appear at Turner's gallery, starting with a
view of Walton Bridges in 1806 (see
No.33), and continuing until 1809, the
year of 'Thomson's Aeolian Harp' (No.44)
and a positive outpouring of Thames
views, after which there is a decisive
abandonment of the topic. The exhibited
pictures themselves (e.g. No.36) partake of
a certain schematic quality which main-
tains their links with the sketches.

Turner seems to have been experiment-
ing with the ways in which his obser-
vations of nature could be most economi-
cally translated into finished 'works of the
imagination'. He rarely recorded nature
more directly than in these studies: there is
evidence that he painted them on the
river, in an open boat, possibly straight

onto a roll of unstretched canvas. Working in oil out of doors was a most rare procedure for him at any time; at this one moment he seems to have conducted a long series of experiments, embracing smaller works on panel as well as canvases like this, and also the watercolours in the *Thames from Reading to Walton* sketchbook. In all of them, a freshness of observation and a summary readiness of handling make for some of the most uncompromisingly immediate nature studies of the Romantic period, akin to the work of Constable in the next decade. Indeed, it is to be inferred that Constable's concern to record the 'scientific' truth of nature was the motivation for Turner's essays as well: the finished Thames subjects, culminating as they do in 'Thomson's Aeolian Harp', are exercises in a calculatedly 'Thomsonian' account of the pastoral life of the river, and are intended to rest, as Thomson's *Seasons* do, on a thorough mastery of the physical realities behind natural phenomena. This is not to gainsay the point made elsewhere in this catalogue that direct observation was often overlaid with classical and literary connotations.

The sight of Windsor Castle in its flat Berkshire landscape was one on which Turner commented in his poetical tour of the Southern Coast (see pp.101–5):

Westward the sandy tracks of Bagshot rise
And Windsor further brave[s] the circling skies
Alas the gloomy care dreams [on her] create
Concomitant ever of a Princely State
(TB CXXIII, f.28v)

The presence of the labouring poor in scenes of this kind, as in the Petworth view of Windsor (see No.51) and many of these oil sketches (e.g. 'Washing Sheep', No.24), adds a further dimension to the reflection, one that Turner takes up in several passages in the poem.

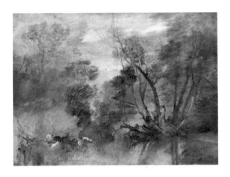

23 Willows beside a Stream *c*.1805
Oil on canvas, 86 × 116.5 ($33\frac{7}{8}$ × $45\frac{3}{4}$)
B&J 172; N02691 [*col. pl. p.74*]

Several of the large Thames sketches in oil on canvas that Turner executed in a boat (see No.22) are concerned with the disposition of trees along the banks of the Thames or its tributaries. There are others in pencil or watercolour in the *Thames from Reading to Walton* sketchbook (e.g. No.20); one of these (f.36r) is very similar to this composition, but has a more easily decipherable human incident in the form of a punt which appears to be manned by eelmen fishing (though Finberg considered that they are cutting rushes). Here, the event hinted at in the left foreground is very obscure. Butlin and Joll have suggested 'dogs attacking a stag, a reminiscence of one of Rubens's boar hunts'. If such a scene is intended, it is more likely to be an Ovidian subject such as the death of Actaeon, which would be consistent with Turner's preoccupation with such motifs at this date. As Butlin and Joll observe, there are also connections between this study and the unpublished *Liber Studiorum* design of 'Pan and Syrinx' (R.80), a circumstance which tends to corroborate such an interpretation.

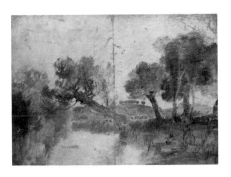

24 Washing Sheep *c*.1805
Oil on canvas, 84.5 × 116.5
($33\frac{1}{4}$ × $45\frac{7}{8}$)
B&J 173; N02699 [*col. pl. p.75*]

The inclusion of schematic figures in this study brings it closer than, say, the 'Thames Backwater' (No.22) to the condition of a formal compositional statement like the 'View of Richmond Hill and Bridge' (No.36) which prompted a critic to invoke Theocritus. It serves to remind us how rarely in practice Turner ever made studies which did not in some respect partake of the qualities of 'finished' works, and how easy it is to be misled by the evident freedom and 'naturalness' of the Thames sketches as a group into believing that they were an exercise in pure Romantic individualism. On the contrary, they served a precise functional purpose, with some kind of final statement replete with literary and classical associations already clearly in mind. Theocritus might quite properly be recalled here; though Turner may more probably have been thinking of Thomson's description of sheep washing in *Summer*:

in one diffusive band
They drive the troubled flocks, by many a dog
Compell'd, to where the mazy-running brook
Forms a deep pool; . . .
Urg'd to the giddy brink, much is the toil,
The clamour much, of men, and boys, and
dogs,
Ere the soft fearful people to the flood
Commit their woolly sides.

(lines 371–9)

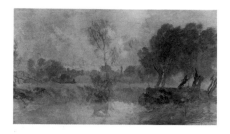

25 Eton from the River *c.*1805

Oil on panel, 37 × 66.5 (14¼ × 26⅛)
B&J 181; N02313 [*col. pl. p.29*]

The small Thames sketches on panel (B&J 177–94) are generally dated a year or two later than the larger ones on canvas (B&J 160–76), but there is little reason to do so. It is likely that Turner completed his exploration of the Thames and Wey in one concentrated 'campaign', and differences of finish between the two groups may be accounted for by the different types of support used. The fact that subjects at Walton occur among the panels suggests that the group belongs, like the canvases, to the summer before the first of the two 'Walton Bridges' pictures was exhibited at Turner's gallery, in 1806.

If Pope and Thomson were the presiding deities of the greater part of Turner's Thames, it was Gray who dominated literary imagination in the vicinity of Eton. The *Ode on a distant Prospect of Eton College* was a poem which, if not as strikingly as *The Bard*, had an important influence on his work. This was partly, no doubt, because in his own distinctive way Gray reflected the Augustan climate of thought in which Turner took so much interest through the output of Thomson and Pope. But Gray, like Akenside, a near-contemporary, brought poetry a step closer to Romanticism by his insistence on the personal and individual, rather than the social and universal, in human experience. The physicality of his account of schoolboys swimming in the Thames, for instance, would have recommended itself to a painter who was intensely concerned to render the human reality of landscape. Turner quoted Gray's lines when he exhibited his picture 'Near the Thames' Lock, Windsor' at his own gallery in 1809 (see No.46):

> Say father Thames for thou hast seen
> Full many a sprightly race,
> Disporting on thy margin green,
> The paths of pleasure trace,
> Who foremost now delight to cleave,
> With pliant arms the glassy wave.

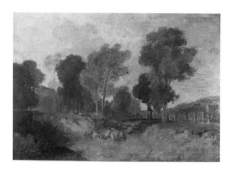

26 Trees beside a River with a Bridge in the Middle Distance

*c.*1805

Oil on canvas, 88 × 120.5 (34⅝ × 47½)
B&J 169; T02692 [*col. pl. p.46*]

Although this canvas is generally placed with the informal sketches produced on Turner's boating excursions up the Thames and Wey during his time at Isleworth (see Nos.22–5), it is decidedly more classical in mood than most of that series. The broken bridge in the background, with its square tower or bridge-house, is evidently derived from depictions of the bridge at Narni in central Italy (which of course Turner had not yet seen for himself). The row of trees, on the other hand, is a resolution of his Thames-side sketches. In its combination of English pastoral and classical ideal, the mood of the canvas comes close to the atmosphere of the drawings and watercolours in the *Studies for Pictures: Isleworth* book (No.12); and indeed it derives directly from two of them (ff.55r, 56r), and illustrates the kind of design that Turner had in mind when he made these studies. It is nevertheless unlikely that he intended to continue with the picture on this scale: if he had resolved to transform the scene into an Ovidian subject like Mercury and Argus, as he suggested to himself on f.54r of that book, he would in all probability have recast it on a large canvas.

27 The *Verse Book* *c.*1805–10

Bound in green paper boards with leather spine and fore-edges, loops for a pencil. Contains 75 leaves of pale blue laid paper, one white laid paper flyleaf at each end, 21.9 × 14 (8⅝ × 5½)
Private Collection

For a full discussion of the contents of the book see pp.30–45; transcriptions of the drafts are on pp. 149–53. Like several that Turner dedicated to specialised purposes (e.g. the *Scotch Figures* and *Swiss Figures* sketchbooks, TB LIX, LXXVIII), this book devoted to verse alone is not filled up: only twenty of its seventy-five pages are written on. But just as the figure studies in those two sketchbooks were of immediate relevance to his finished works, so these drafts must be seen as bearing directly on his activities as painter in the first decade or so of the century. They do not all relate to particular pictures, though several obviously do, and are discussed in that light here.

The poem beginning 'Sir William Wootton often said' was no doubt the product of his deliberations as Professor of Perspective, or perhaps as designer of his own picture gallery, for it treats of architecture in a historical and allegorical way. 'The origin of Vermillion', with which the book begins, is an allegorised version of colour theory, or perhaps more simply an attempt to make poetry out of the technical practicalities of painting; at any rate it illustrates the readiness with which Turner was prepared to discuss professional concerns, as well as literary or iconographic ideas, in verse.

The handwriting tends to be neater and clearer here than in most of the sketchbooks, partly because he deliberately gave himself more room; even so, there are many revisions and alterations which show that it was intended as a working

notebook and not a collection of fair copies. The physical appearance of the *Verse Book* is unlike any others in the Turner Bequest: with its coarse bluish paper it may never have been considered suitable for drawings. It is odd that despite the many blank pages there are drafts on the flyleaves – a further indication, perhaps, that the book was not used at all systematically.

Open at pp.6–7
Draft of the 'Ode to Discord'
Ink

One of the more complete of Turner's drafts. The text, like that for the lines 'On the Demolition of Pope-House at Twickenham' in this book, has been given its title. The assumption must be that he intended to use both these poems in the catalogues of his annual exhibition in Harley Street, but was perhaps prevented from doing so by lack of space on the small sheets he elected to use (see No.46). The numbered syllables testify to the care he took in creating publishable verse; elsewhere in the book, when drafting the poem 'On Thomson's Tomb' which was printed in 1809, he notes the aggregate number of syllables at the end of each line. The first stanza, of six lines grouped in rhyming couplets, is essayed in two forms. The text is unusually free of errors either of spelling or of syntax, though the transposition of vowels in the 'Etherael' of the first line is typical, as is the omission of the genitive 's' for 'Psyche' in the third, and the spelling of 'vengeful' as 'vengfull' in the antepenultimate line on the same page.

28 *Wey, Guildford* sketchbook

*c.*1805–7
Marbled boards, leather spine;
Turner's label on spine inscribed: '74.
Wey Guilford'. Contains 138 leaves of
white wove paper, 18.1 × 11.2
($7\frac{1}{8} \times 4\frac{7}{16}$)
TB XCVIII

Like so many of the sketchbooks of the first decade of the century, this one epitomises Turner's parallel interests in topography and classical landscape at the time. It contains many direct records of his exploration of the Thames and Wey, as far south as Godalming (f.119v), including views of Windsor Castle and of Newark Abbey, the subject of a small unexhibited picture (B&J 201) and of a more elaborate canvas probably shown at Turner's own gallery in 1807 (B&J 65). There are also several studies for mythological subjects, including Ascanius and the Stag, Dido and Aeneas, and Ulysses and Polyphemus (ff.1–3, 5r). The last was to be the only Homeric subject that Turner would treat in oil, though not until 1829 (B&J 330).

Open at ff.3v–4r; D06184–5
Two Composition Studies for 'Chryses'
Pen and brown ink and wash

Turner's first exhibited illustration to Homer was a watercolour which appeared at the Academy in 1811 under the title 'Chryses' (w. 492). Chryses was a Trojan priest of Apollo whose daughter Chryseis was taken as a prize of war by the Greeks; having pleaded for her return in vain, Chryses invoked a plague upon them. His prayer is the subject of the lines from book 1 of Pope's translation of the *Iliad* that are quoted in the catalogue:

The trembling priest along the shore return'd,
And in the anguish of a father mourn'd;
Disconsolate, not daring to complain,
Silent he wander'd by the sounding main;
Till safe at distance to his God he prays;
The God who darts around the world his rays.
(lines 47–52)

Turner's interest in the passage was no doubt enhanced by its reference to the sun-god Apollo, and his watercolour attempts to suggest the all-pervasive warmth and brilliance of Mediterranean light. Indeed, light is almost the sole subject: Chryses is the only, fairly small, figure; of landscape features there are relatively few, and those are hardly emphasized. The composition studies shown here indicate Turner's thinking: a broad sweep of shore provides a framework for the action of pure light, and the setting sun itself becomes a protagonist of the drama, the object of the priest's allocution. This presentation of natural phenomena as *dramatis personae* anticipates the scheme of 'Ulysses deriding Polyphemus' (B&J 330), where various elements – mountain, sea and sun – are given their appropriate numinous manifestations, very much according to the view of nature suggested by Akenside in his *Hymn to the Naiads* (see No.39), and, of course, entirely in keeping with the ancient, and specifically the Ovidian, interpretation of nature. It is interesting that it was in his two rare Homeric subjects that Turner exploited this idea to the fullest extent.

29 Composition Study: a Classical Harbour *c.*1806–10
Pencil, pen and brown ink on white
paper washed with grey; the sheet
folded in four; 24.6 × 36.7 (9$\frac{11}{16}$ × 14$\frac{1}{2}$)
TB CXIX G; D08194

Turner adumbrates here one of his most
enduring compositional ideas: the har-
bour of antiquity, flanked by fine classical
buildings, filled with crowds of people and
elegantly prowed ships. It derived from
the harbour compositions of Claude,
notably those in the collection of John
Julius Angerstein, which Turner had
admired in 1799 and almost immediately
imitated in his watercolour view of Caer-
narvon Castle, exhibited at the Academy
in 1799 (W.254). Its most famous mani-
festation in his *oeuvre* is 'Dido building
Carthage; or the Rise of the Carthaginian
Empire' of 1815 (B&J 131). Its sequel, 'The
Decline of the Carthaginian Empire' exhi-
bited in 1817 (B&J 135), makes use of a
composition evolved from this drawing.
'Dido directing the Equipment of the
Fleet, or the Morning of the Carthaginian
Empire' (B&J 241) appeared in 1828,
taking up once again the general layout of
these compositions. 'Regulus', the smaller
canvas that Turner executed later that
year in Rome and reworked for the British
Institution in 1837 (B&J 294), also follows
this pattern. The connotations of Roman
civilisation were properly expressed
through the medium of Roman architec-
ture (see p.33), and he used the same
visual devices repeatedly to evoke the
atmosphere of Virgilian epic or of the
(necessarily associated) later history of
Carthage.

Finberg put forward the plausible but
unprovable suggestion that this sheet is
actually a design for a composition depict-
ing the Argonauts, a subject with which
Turner was preoccupied in the years of his
stay at Isleworth, and which he had begun
to explore in the 'Jason' of 1802 (No.9). He

drafted many lines of a substantial poem
on the subject in his *Perspective* sketchbook
(No.49), and the idea of the *Argo* and her
precious booty was one that he used in his
Southern Coast poem in the *Devonshire
Coast No. 1* sketchbook (No.57), as a
metaphor for the plunder of wreckers after
a storm (f.166v). There are several har-
bour scenes in the *Studies for Pictures:
Isleworth* sketchbook (No.12), where
Turner has noted many possible subjects,
including, against a composition very like
this one (on f.49v), 'Jason: arrival at
Colchis', with the memorandum opposite
(f.50r): 'Females dancing and crowning
the rower[s] with flowers or the Fore-
ground Figures rejoicing – the left – the
Priests attending to receive the Fleece –
Jason & Argonauts on Board bearing the
Fleece'. An alternative idea was that the
scene should show Ulysses returning Chry-
seis to her father Chryses (see No.28).

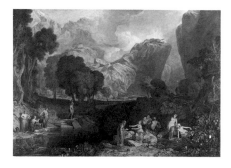

**30 The Goddess of Discord choosing
the Apple of Contention in the
Garden of the Hesperides** BI 1806
(55); Turner's Gallery 1808
Oil on canvas, 155 × 218.5 (61$\frac{1}{8}$ × 86)
B&J 57; N00477 [*frontispiece* and *col. pl.
p.39*]

The golden apples of the Hesperides were
planted in the garden of the gods by Gaea,
Earth, as a gift for Hera at her marriage to
Zeus, Gaea's brother, most powerful of the
gods. They were guarded by four nymphs,
Aegle, Arethusa, Erytheia and Hesperia,
and by the serpent Ladon. The eleventh of
Hercules' twelve labours was to steal the
apples. At the wedding of Peleus and
Thetis on the summit of Mount Pelion
Eris, Goddess of Strife, threw one of them,
inscribed 'For the Fairest', among the
assembled deities and Paris, son of Priam,
King of Troy, was asked to give it to

whichever he judged the most beautiful of
the three goddesses Aphrodite, Athene
and Hera. His choice of Aphrodite won
him Menelaus' wife Helen, and prompted
the enmity of both Hera and Athene for
the Trojans. The apple was thus the
immediate cause of the Trojan war.

None of Turner's paintings illustrates
better than this one the union of the arts at
which he was aiming in the first decade of
the century. Its basis in the epic storytel-
ling of Homer (though in fact the episode
of Eris at the wedding of Thetis is a post-
Homeric accretion) is apparent in its
whole conception. The methods by which
Turner alludes to the classical literary
tradition are interesting: he relies heavily
upon the appropriate associations evoked
by reference to more recent classicising
artists, especially Poussin. At the same
time, he contrives to entangle the myth he
is ostensibly engaged in illustrating with
other myths equally rich in association.
The obvious parallel between the apple of
the Hesperides and that of Eden was one
that Turner deliberately suggested in the
verses he composed for the picture – verses
he never published in any catalogue,
though they cast important light on his
intentions in the work. He gave them the
title 'Ode to Discord':

Discord, dire Sister of Etherael Jove
Coeval, hostile even to heavenly love
Unask'd at Psyche['s] bridal feast to share
Stung by revenge and envious of the fair
Fierce as the noxious blast of wintry skies
Rushed oer the vale where Hesperian
 Garden[s] rise

The Guardian Dragon in himself a host
Aw'd by thy presence slumber'd at his post
The timid sisters feard thy wrathful ire
Proffer the fruit told by prophetic fire
what mischief would insue. The Goddess heard
With vengfull pleasure then her choice preferd
The shiny mischief to herself she took
Love felt the wound [and] Troys foundations
 shook
 (*Verse Book*, p.7)

Turner worked on a draft of these verses in
his *Windsor, Eton* sketchbook (TB XCVII,
f.83). The final lines echo those in book IX
of *Paradise Lost*,

 her rash hand in evil hour
Forth reaching to the Fruit, she pluck'd,
 she eat:
Earth felt the wound, and Nature from her seat
Sighing through all her works gave
 signs of woe,
That all was lost.

 (lines 780–84)

It is therefore not only the Biblical myth that Turner invokes, but the epic precedent of Milton as well as Homer. In so far as the picture signalled a lifelong preoccupation with the legend of Troy and its aftermath in the wanderings of Aeneas (which supplied the subjects for his last four exhibited pictures in 1850), he may be said to have invoked Virgil as well. The subject is constructed to bear out these allusions: replete with rolling clouds, vertiginous crags and chasms, noble trees and Arcadian valleys, it deploys the whole vocabulary of the Sublime – a vocabulary which had been largely defined for the eighteenth century by Homer, Milton and the other epic poets.

Ruskin's essay on the picture in volume v of *Modern Painters* is one of his most important insights into Turner's approach to the problem with which he was pre-eminently concerned, to render the conceptual dimension of landscape in painting. He cites several literary sources, including Hesiod, Apollodorus and Milton (*Comus*), and suggests that for Turner the Hesperides, the 'nymphs of the west', were 'natural types, the representatives of the soft western winds and sunshine, which were in this district [i.e. Cyrenaica, in North Africa] most favourable to vegetation' (*Works*, VII, p.392). Their particular association with the garden and its golden apples would seem to confirm that they embodied, if not the sun and winds, at any rate the fertile principle of the place. In this capacity they occupy a role exactly analogous to that of the naiads of the Clyde in Turner's large watercolour of that river (see No.39). They, as Turner acknowledged, owed their existence to ideas that he had derived from Akenside's Platonic view of nature. So in depicting an incident from epic myth he was in effect dramatising a commentary on nature that he had already offered in lyric form, while expanding the *dramatis personae* of symbolic landscape into a cast that was to remain of crucial value to him as a painter committed to presenting the inner meanings of nature through the depiction of the observable phenomena of the world.

31 *Spithead* **sketchbook** 1807
Bound in brown calf, with one brass clasp; Turner's label on spine inscribed: 'Shipping' and on back cover 'River Thames [Margate *del*]'. Contains 75 leaves of white wove paper, 10.7 × 18.8 (4 3/16 × 7 7/16)
TB C

The 'shipping' of Turner's label was observed at Portsmouth in 1807. The sketches were used in his large picture 'Two of the Danish Ships which were seized at Copenhagen entering Portsmouth Harbour', which was exhibited in his own gallery in 1808 and at the Academy in the following year under a new title, 'Spithead: Boat's Crew recovering an Anchor' (B&J 80). There are several pages of figure studies, with notes; and some sketches related to the *Liber Studiorum* project. One of these is the poem about Hindhead Hill (see pp.41–2).

Open at inside front cover and f.1r;
D06518
Draft Poem
Ink

A lively poem about Time, which uses a slightly unusual verse form. It was one that had been favoured by Robert Burns, among others, and although here there is no attempt at dialect, the lines have a freshness and colloquial immediacy that are endearing. Indeed, since they are in the nature of an autobiography, and include references to education at Christ Church, Oxford and training in Law at the Temple, to neither of which institutions Turner ever belonged, it is conceivable that he is here adapting lines by another poet. The references to Coke and Blackstone are surely too specific and 'private' to have been invented by an outsider. However this may be, and instances of such 'borrowing' can be cited (see p.14), the subject is clearly one that Turner treated personally, and we may probably regard the general sentiments as his own.

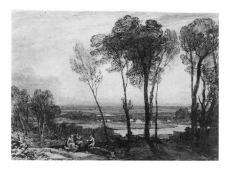

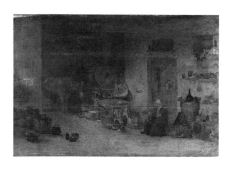

32 *River* **sketchbook** *c.*1807
Bound in calf with one brass clasp;
Turner's label on spine inscribed: '21
River'. Contains 75 leaves of white
laid paper, 9.1 × 16 ($3\frac{9}{16} \times 6\frac{5}{16}$). Inscr.
inside front cover: 'JMW Turner/
West End Upper Mall/
Hammersmith'.
TB XCVI

This little book, in use while Turner was a
lodger at Upper Mall, Hammersmith,
sums up many of his interests at that
moment: it is full of pencil drawings made
along the Thames and in its neighbour-
hood, including studies of Walton Bridges,
More Park (f.76r; the *Rivers of England*
subject, W.734, was derived from this),
and a characteristic group of trees anno-
tated '3 Arbele Trees at Cobham' (f.28r).
There are also extensive drafts of poetry;
see pp.153–5.

Open at f.45r; D06015
View of Pope's Villa at Twickenham
Pencil

The sketch made on the spot from which
the finished picture (No.35) derives. It
includes the fallen tree which was to
become the symbolic willow to which
Turner alludes in his letter to Britton of
1811 (see No.56).

33 **The Bridge in the Middle
Distance** *c.*1807
Pen and brown ink and wash with
scraping-out, 18.3 × 26 ($7\frac{13}{16} \times 10\frac{1}{4}$)
TB CXVI P; D08117

This is Turner's drawing for one of the
most celebrated of all the *Liber Studiorum*
plates (R.13). He etched the outline for it
himself, and it was engraved by Charles
Turner for publication in the summer of
1808. It was assigned to the 'Elevated
Pastoral' category in that series, but given
no title. It has long been known by its
current name and the idyllic, idealising
mood of the scene has always been con-
sidered the most striking feature of the
design. Turner's use of warm red-brown
washes in the drawing enhances the
hushed, Arcadian atmosphere he creates,
and the figures are evidently designed to
reinforce the classical reference implied
in the whole composition. The scene is
nevertheless based on the topography of
the Thames: it is a view of Walton Bridges,
which were the subject of two pictures
probably exhibited at Turner's own gal-
lery in 1806 and 1807. Those show the
bridges close up, with prominent staffage
illustrating the economic life of the river:
cows watering, sheep-washing, barges and
so forth. In the *Liber* subject the bridges are
seen further off, through a screen of
elegant trees, in the golden light of a
declining sun.

The composition was recapitulated in
one of the series of paintings on themes
from the *Liber* on which Turner worked in
the mid-1840s (B&J 511). In these late
works, the palette of warm browns and
yellows seems to have been chosen to
reproduce the rich reddish or sepia washes
of the original drawings and the prints
made from them. For Turner's pencil
studies of Walton Bridges, see No.38.

34 **An Artist's Colourman's
Workshop** *c.*1807
Oil on pine panel, 62 × 91.5
($24\frac{1}{2} \times 36$)
B&J 207; N05503 [*col. pls. pp.34,35*]

Stylistically this picture has been likened
to 'The Blacksmith's Shop' which Turner
exhibited in 1807, and clearly they are
both essays in the manner of seventeenth-
century Dutch genre painting, no doubt
prompted by the success of David Wilkie's
'Village Politicians' at the Royal Acad-
emy in 1806. Turner was evidently suffi-
ciently piqued by Wilkie's success to
mention him in a satirical poem he com-
posed about this date: see No.40. Butlin
and Joll believe that 'The Garreteer's
Petition' (No.42) of 1809 shows a develop-
ment of style beyond both. The subject-
matter places this work conceptually at a
point half-way between the other two, for
whereas the blacksmith is a workman and
the poet an artist, the colourman is a
workman who serves the artist. He stands
for the link between the creative artist, the
possessor of Akenside's 'Imagination', and
the world of everyday reality, of toil and
unpretentious existence, which provides
the material from which the artist deve-
lops his ideas. The act of grinding the
colour, which forms the central episode in
the picture, is the act of transforming
earthy matter into a substance capable of
being used for expressive purposes. It
would be unwise to read too much into
what is, apparently, an unfinished picture;
but it is difficult to avoid placing it in a
sequence of genre subjects which progress
with some logic through various trades
and professions, more or less creative,
whose precise relation to the creative act is
Turner's central concern.

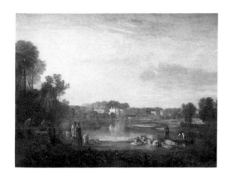

35 View of Pope's Villa at Twickenham, during its Dilapidation

Turner's Gallery 1808
Oil on canvas, 91.5 × 120.6 (36 × 47½)
Signed lower left: 'I M W Turner RA
PP'

B&J 72 [*col. pls. pp.52,53*]
The Sudeley Castle Collection

The first owner of this picture was Sir John Fleming Leicester, whose collection of contemporary British painting was of great importance in defining the achievements of the national school at the beginning of the nineteenth century. In acquiring this relatively modest example of Turner's work (he had bought other, more spectacular things from him) Leicester was no doubt influenced by the generally recognised cultural importance of Pope's work at Twickenham. The modest house had been transformed in 1720 by James Gibbs into a villa and the garden redesigned by Pope himself in a style that was to have an incalculable effect on English design for the next century. Pope himself opened the grounds to the public, and the place became something of a shrine, continuing to attract visitors throughout the century. It was the irritation caused by these admirers that seems to have determined Baroness Howe, who acquired the property in 1807, to carry out a wholesale demolition of the place. The house had already been altered by Sir William Stanhope, who had removed the loggia and added wings in the 1750s; it is in this form that Turner represents it. Baroness Howe left only the grotto, in the basement of the villa, and built her own house nearby. She also stripped the grounds of all the characteristic features placed there by Pope.

At first sight the canvas appears to be an idyllic house-portrait, but it is in fact shot through with elegiac feeling. It shows a surviving memorial to one of the great men of English letters in the process of being destroyed. Turner was by no means the only person to respond with anger to the Baroness's activities. She became known as 'the Queen of the Goths', and there were published protests in plenty, often employing language very close to that adopted by Turner in his verses. He commented bitterly on the event in some draft poetry in his *River* sketchbook (No.32):

O lost to honor and the sence of shame
Can Britain so forget Pope's well earnd fame
To desolation doom the poet's fane
The pride of T[wickenham's] bower and silver
 Thame . . .
Hark the rude hammer
 harsh steel the sawn rafter Breaks
Down from the roof the massy [beams]
 give way
Rent [from] the wall, and let in the day
. . .
No more I'll wear the lily on my brow
But sooty weeds now Popes fair fane is low
 (ff.71v–72r)

Even in the course of his long poem on the Southern Coast (see No.57 and pp.100–105) he refers to 'Alexis' – i.e. Pope – 'and the demolition of thy house forsooth' (f.21r); and again on the western tour of 1811, in the *Plymouth, Hamoaze* sketchbook, he associated the destruction of Pope's house with the demise of Thomson (TB CXXXI, f.188v):

Oer Thomson['s] tomb Morn dewy
 dew drop beams
True friendship tribute shed for Popes lost fane
Sunk is his House

The full measure of Turner's outrage is perhaps best appreciated, however, from the lines he essayed in an explicitly satirical spirit in his *Woodcock Shooting* book (TB CXXIX). Here the Baroness's philistinism is discussed as a case of physical blindness, with reference to a well-known oculist of the day:

Doth W. Phipps continue on
to practice or lie still
a Blindness case required him now
To act even more by knowing Howe
 (f.1v)

There are numerous references in the various drafts to the grotto for which the garden of Pope's house was famous; for example, in the *River* sketchbook, f.74. It is invoked also in the context of Phipps, for whom, it seems, Turner had as little sympathy as for the Baroness herself:

Twas the Oculist['s] hope
In the Grotto of Pope
To retire yet still lie on
Lie still from practice from prying and peeping
But the nymph of the Grotto lay in not sleeping
 (f.6r)

The identity of Phipps is not certain, but he may be Jonathan Wathen Phipps, whose work on cataract and ophthalmia had been published in the 1780s and 90s. Another contemporary figure mentioned in the verses in the *Woodcock Shooting* book is Samuel Whitbread, the brewer, politician and collector:

Whitbread known by blue and buff
Still raised once
and potent held for humming stuff
Frothy tho poor is a Rodney wig
Reform be gentle eer you swig
Drink deep or taste not lest your brains
Tis gas at top or bottom be the gains
 (f.2r)

Although Turner seems to be mainly concerned with the quality of Whitbread's beer, he makes it the occasion for a reference to Pope's famous couplet in the *Essay on Criticism* (lines 215 16):

A little learning is a dang'rous thing;
Drink deep, or taste not the Pierian spring

and may possibly have intended a comment on Whitbread's efforts in rebuilding the Drury Lane Theatre, burnt down in February 1809, which he perhaps saw as an ironic parallel to Baroness Howe's work at Twickenham. If so, he was still labouring away at the poem after the painting had been exhibited.

Despite these strongly satirical currents, and the evident anger that gave rise to the painting, the ultimate purpose of the work was to be calmly commemorative, to celebrate genius rather than to deplore vandalism. The atmosphere of the picture makes this clear; and the poem on which Turner seems to have settled as the final expression of his intention is gently pastoral and elegiac. It is sketched in the *Windmill and Lock* book (TB CXIV, ff.4, 77), and the *Verse Book* contains a variant on what is drafted there: see above, pp.50–51.

The picture is a visualisation of the various elements treated in the poem. It is a pastoral scene on the banks of the Thames; the most prominent life is that of the shepherds and their flocks which graze on the foreground banks and in a distant field. The tranquil river too is fertile: eelmen are at work in their punt, which is laden with pots. To the left, a shepherd

stands with other figures round a fallen tree – representative of the famous weeping willow that Pope had planted and which had been blown down in a storm a few years earlier. Its prone, denuded state is symbolic of the destruction of Pope's 'fane'; though it is not to be taken as literally Pope's own tree; see Turner's comments under No.56. The rustics are evidently discussing the demolition of the house, to which one of them points. Its condition is at first not apparent, but we notice on closer inspection that it is roofless, with gaping windows and some scaffolding on the river front. The pointing man is holding a Composite pilaster capital, evidently spoil from the demolition, though it is not known whether the house had any such features. The pedlar to whom this man is talking seems to be holding a picture frame – further symbolic of the destruction of a treasure-house of art, or perhaps of the strong connection in Pope's mind between landscape gardening and painting (see p.75).

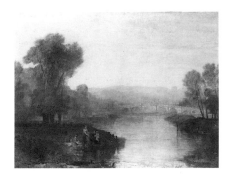

36 View of Richmond Hill and Bridge Turner's Gallery 1808
Oil on canvas, 81.5 × 122 (36 × 48)
B&J 73; N00557 [*col. pl. p.47*]

One of several Thames subjects shown in Turner's own exhibition in 1808; they included the 'View of Pope's Villa at Twickenham, during its Dilapidation' (No.35). Richmond was popular with the topographers: Edward Dayes, among others, had made a watercolour of it, which was published as an engraving in the 1790s. The town was regarded as a picturesque spot, with its hill overlooking a majestic bend of the Thames, and for Turner its significance was greatly enhanced by its associations with Reynolds and Thomson. Reynolds's house, near the Star and Garter inn, on the brow

of the hill, is included in this view. More frequently, Turner drew the dramatic prospect from above, near the inn, looking upriver to Twickenham and Ham, one of the most celebrated panoramas in southern England (see No.67). The surface of this picture has become rubbed and it is now difficult to appreciate the subtle and poetical effects of atmosphere at which Turner was aiming.

He evidently succeeded, for a critic of the exhibition was moved to quote Gray's *Elegy in a Country Churchyard*: 'We feel delighted with the effects which we here behold "of incense breathing morn".' The same critic (probably John Landseer: see Butlin and Joll) also invoked the name of Theocritus, commenting that the group of figures in the foreground, three women with a child, was 'worthy of the pastoral Muse of painting' – an acknowledgement of the classical, generalising quality of the work which Turner must have approved. He seems to be imitating in terms of a specific English location the character and atmosphere of mythological subjects like 'Narcissus and Echo' (No.11); in this the picture anticipates the achievement of 'Crossing the Brook', exhibited in 1815 (B&J 130). It is possible that 'Richmond Hill and Bridge' was conceived as a pendant to the canvas of 'The Thames near Windsor' (B&J 64) which may have been shown in Turner's gallery in the preceding year. This also contains a group of women with a child, while its composition is a reversal of the Richmond subject.

The process of transition from direct recording of topography to classical or ideal pastoral can be watched in the *Hesperides 1* sketchbook (No.13), f.35v, where this subject is noted in the guise of an Italianate landscape with cypress trees and pantiled buildings. A much later treatment of the view of the bridge with the hill beyond, though seen from the opposite bank of the river, occurs among the *England and Wales* designs, engraved in 1832 (w.833). There the classicising elements have been completely dispensed with in favour of Turner's mature topography.

37 A Subject from the Runic Superstitions ?Turner's Gallery 1808
Oil on canvas, 91.5 × 122 (36¼ × 48)
B&J 79; N00464 [*pl. p.42*]

The subject of this picture is obscure; we know that Turner had completed a composition showing Rispah watching over the bodies of her sons in illustration of a passage from II Samuel 21 which corresponded to this in general design, and which is recorded in the *Liber Studiorum* plate of 'Rispah' published in 1812 (R.46). By that date Turner had long since modified the original picture, transforming Rispah into a more ambiguous hooded figure, surrounded by dancing sprites, snakes, frogs and the paraphernalia of the witch's cave. It is an incantation scene which spans the gap between the horrific supernatural subjects favoured by John Hamilton Mortimer and Benjamin West in the 1770s and the 'fairy' pictures of Francis Danby in the 1820s and 30s. The revision we see today has been supposed to show Saul and the Witch of Endor, a Biblical motif from I Samuel 27 that Turner would have known from the work of several eighteenth-century painters; but confirmation of this has not been found, and no other precise explanation has come to light. If we are to rely on a clue given by John Landseer in the *Review of Publications of Art* in 1808, where he refers to 'an unfinished picture . . . the subject of which is taken from the Runic superstitions . . . the artist has conjured up mysterious spectres and chimeras dire', then the Witch of Endor idea is presumably incorrect. The canvas is the only surviving work of this date which corresponds in any way to Landseer's description.

Despite its obvious affinities with the theatre, the 'Runic' subject does not seem to have prompted any poetical effusions on Turner's part; but the notion of magic

is never very far from his mind. The fragment in the *Verse Book* about 'Horror skill[d] in magic spells' (see p.41) is only vaguely relevant; there is a perhaps more pertinent passage in the poem beginning 'O Gold thou parent of Ambition's ardent blush' in the *Greenwich* sketchbook (TB CII, f.1v): speaking of the ill-fated expedition to the Arctic of the sixteenth-century explorer Sir Hugh Willoughby, Turner evokes the northern wilderness by a double comparison:

> the vast profound
> Fiercer than the savage war-hoops yell
> More fierce than Medea charms or Runic spell

In doing so he anticipates the subject of a much later incantation scene, his 'Vision of Medea' of 1828 (B&J 293), which was exhibited at the Royal Academy in 1831 with some lines from the *Fallacies of Hope*.

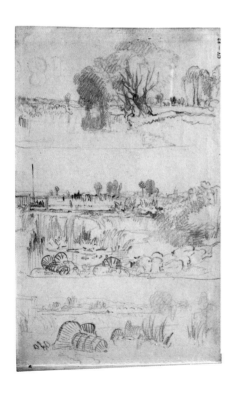

38 *Tabley No. 3* sketchbook 1808
Bound in calf with one brass clasp. Contains 82 leaves, 18.2 × 10.7 $(7\frac{3}{16} \times 4\frac{3}{16})$
TB CV

This book was used both on the tour to Cheshire, when Turner stayed with Sir John Fleming Leicester at Tabley in 1808, and along the Thames in London itself

and, apparently, in the neighbourhood of Walton. It also contains studies of systems of lighting which Turner made use of in redesigning his own gallery in Harley Street, and, on f.24r, a note of the 'Gamut for the Flute', which provides evidence that he was learning to play that instrument. There is little to show that he ever made any progress as an executant musician; but his interest in music is very much part of the nexus of concerns that preoccupied him in this decade. His poem 'The origin of Vermillion or the Loves of Painting and Music' (see pp.33–6) testifies to the place music held for him in the scheme of things. Indeed, it seems there to have ousted poetry as the natural and inevitable partner of painting in the expression of feeling. At the same time, he is pursuing his researches into perspective and optics: the sketchbook contains an often-quoted essay on reflections (inside front cover and f.1r). We are also given a hint of his current concern with architecture: on ff.81v and 80v some notes taken from Suetonius, concerning the status of Britain as a Roman province under Claudius and the foundation of the first Christian church at Glastonbury in AD 44, lead on to comments about primitive British architecture, which include a brief glance at poetry as represented by Ovid:

> Geraldus Cambrensis says Arnulphus de Montgomery in Henry III time built Pembroke Cas. with Twigs and Turf the Twigs being peel'd as a mark of nobility and according to Ovid the Old Roman Capital was built so, it may be presumed that Joseph of Arimathea sent by Philip the Apostle into the Island, brought [h]ither the Roman love of Building

Open at f.92r; D07130
Three Composition Studies of Scenes on the Thames near Walton, with Eel-pots
Pencil

Walton was a favourite spot for Turner, who made several drawings and oil sketches there, and finished two oil paintings of the famous pair of bridges in the first decade of the century, reworking them into a new design for the *Liber Studiorum* (see No.33), to which he reverted for a late canvas (B&J 511). His interest in the technicalities of eel-pots is recorded in his letter to John Britton of 1811 (see No.56).

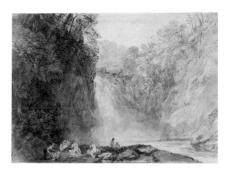

39 Falls of the Clyde *c.*1808
Pencil, pen and brown ink with brown and grey washes and scraping-out, 17.4 × 26.1 $(6\frac{13}{16} \times 10\frac{1}{4})$
TB CXVI U; D08122

The drawing for a plate in the *Liber Studiorum* etched by Turner and engraved by Charles Turner. It was published in 1809 (R.18). It repeats, with some variations, the large watercolour that Turner had shown at the Academy in 1802 under the title 'The Fall of the Clyde, Lanarkshire: Noon' (W.343), with a reference to 'Akenside's Hymn to the Naiads' of 1746. The work itself was not quoted; as Gage suggests, Turner was probably drawing attention to Akenside's general argument, which is summarised at the head of the poem:

> The nymphs, who preside over springs and rivulets, are addressed at day-break, in honour of their several functions, and of the relations which they bear to the natural and to the moral world. Their origin is deduced from the first allegorical deities, or powers of nature; according to the doctrine of the old mythological poets, concerning the generation of the gods and the rise of things. They are then successively considered, as giving motion to the air and exciting summer breezes; as nourishing and beautifying the vegetable creation; as contributing to the fullness of navigable rivers, and consequently to the maintenance of commerce; and by that means, to the maritime part of military power.

The subject is therefore once again transformed into an Ovidian statement of the primitive immanence of spirits in nature. At the same time, it makes reference to the broad economic view of the natural world entertained by the Augustans. The specific topography of Scotland – relatively recently added to the repertory of the landscape artist – is hereby absorbed into a classical tradition stretching back to Claude in painting, and to the ancient poets.

40 The Artist's Studio *c*.1808
Pen and brown ink and wash with
some watercolour and scraping-out,
18.5 × 30.2 $(7\frac{5}{16} \times 11\frac{7}{8})$
Inscribed recto: 'Pictures either Judg-
ment of Paris, Forbidden Fruit/ Old
Masters scattered over ye floor/ Stolen
hints from celebrated Pictures Phials /
Crucibles retorts, label'd bottles
[*illegible*] varnish quiz'
verso: 'Pleas[d] with his work he views
it o'er and oer/ And find[s] fresh
Beauties never seen before/ The tyro
mind another feast controuls/ While
other thoughts the Tyro's soul
controul/ Nor cares for taste beyond a
butterd roll/ Exulting hopes for Taste
and butterd rolls/ Look forward to the
taste of butterd rolls/ and joyous hopes
for taste by butterd rolls/ But different
tastes different minds controul/
Magister amo artists th[ey] love
Butterd rolls/ The Master loves his
Art the Tyro butterd rolls'
TB CXXI B; D08257 [*col. pl. p.38*]

There is some doubt as to the correct
interpretation of this drawing, which must
be seen as a companion to Turner's study
for 'The Garreteer's Petition' (No. 41).
The principal figure has been identified as
that of P.J. de Loutherbourg (Gage 1969),
partly on the strength of its being 'portly',
though that characteristic is by no means
obvious in the drawing; and the satirical
tone of the sheet is at odds with Turner's
evident admiration for the older man,
whose work he had keenly imitated in the
opening years of his career. Another
theory (Ziff 1964) is that Turner had the
young Scot David Wilkie in mind when he

lampooned the pretensions of beginners in
the art of painting; and certainly the
reference to the 'tyro' in his verses implies a
man nowhere near as advanced in his
profession as de Loutherbourg was. But it
has also been suggested (Butlin and Joll)
that the 'tyro' is the apprentice who can
been seen apparently toasting a 'buttered
roll' in the right background. This seems
unlikely in the light of Turner's use of the
word to mean an inexperienced practising
artist like Wilkie in some verses he drafted
in his *Hastings* sketchbook (TB CXI, f.65v):

> Coarse Flattery, like a Gipsey came
> Would she were never heard
> And muddled all the fecund brains
> Of Wilky and of Bird
> When she calld either a Teniers
> Each Tyro stopt contented
> At the alluring half-way house

Yet the artist in his drawing is far from
being a youngster. He is an ageing tyro,
effectively an amateur lacking the criti-
cal faculty essential to the professional,
smugly gloating over his performance.
The verses on the back of the sheet give
us just this picture. It is the opposite of
the Garreteer who aspires to profession-
al recognition but nevertheless cannot
achieve anything to his satisfaction.
Turner's verses pointedly contrast the
amateur with 'the Master' who 'loves his
art' and is presumably a figure we are
understood to respect. If, alternatively,
the 'tyro' is to be seen at the fire in the
background, with the 'Master', a ludi-
crous rather than an admirable figure, to
the left, there can be no satirical contrast
between the preoccupations of each, and
the point of the poem is lost. Turner was
obviously at some pains to draw out the
pun on 'taste', which links these verses to
his drafts in *The Artist's Assistant* (No.43)
and to Shee's *Rhymes on Art*.

Although it is possible that he planned a
pair of pictures when he made this draw-
ing and No.41, it seems more likely that
they represent two separate approaches to
an idea which preoccupied him and which
he wished to formulate as a painting. The
relationship between genius and creativity
was particularly relevant to him at a time
when he was experimenting with genre
painting, a field rather outside his usual
range, and when he was beginning to see
himself as a poet as well. In the end, he
would perhaps naturally have chosen the
subject of the poet as a less obviously
personal vehicle for the theme – though it
did interest him profoundly.

41 The Garreteer's Petition *c*.1808
Pen and brown ink and wash with
some watercolour, 18.4 × 30.2
$(7\frac{1}{4} \times 11\frac{7}{8})$
Inscribed recto: 'Translation'
and 'Vida Art of Poetry/ Hints on
Epic Poem Reviews torn on Floor/
Paraphrase of Job/ coll. of odds and
ends'
verso: 'The Garreteer Petion [*sic*] to
the [his ∧] Muse'; and drafts of verse,
including: 'Lost in vast immensities of
space/ Man feeble efforts bearly trace/
a short true moment of the brain/ But'
and 'The hard urged Garreteer whose
stout brains/ Shake hands with
penury and pain/ Inverted looks for
inspiration to the ground/ Sinking
from thought to thought a vast
profound' and 'Hear me ye powers, O
give my thoughts to roll/ In quick
succesion animate my soul/ Give me
dear Maid a [?] thought divine/ To
finish well my long sought line'
TB CXXI A; D08256

A study for the picture that Turner
exhibited in 1809 (No.42). The relation-
ship between this subject and that of 'The
Artist's Studio' is discussed in that entry
(No.40), and on pp.39–40 above. The
technique of these two drawings is some-
what unusual, although it bears some
resemblance to that of the studies for
historical pictures and landscapes in the
Calais Pier sketchbook of *c*.1799–1805
(No.7), and evidently derives from
Turner's pen drawings of that time (see for
example the composition study 'Homer
reciting to the Greeks', No.17). There

may, however, be particular reasons for his adopting this style here: it is one that reflects the influence of Rembrandt's pen drawings, and may therefore have seemed appropriate for genre subjects of this sort; and it also relates to the sketching style of Hogarth, who is more or less explicitly invoked in 'The Garreteer's Petition'. The Hogarthian reference is, of course, not simply to the great painter of moral subjects, but to the London of his day which was that of Pope and Thomson as well. The line 'Sinking from thought to thought a vast profound' in Turner's draft is from the *Dunciad* (book I, line 118), and Hogarth had inscribed the same passage under his print of 'The Distressed Poet'. When Turner planned the picture, then, he had in mind the whole atmosphere of that comprehensive onslaught on literary incompetence, a key text of Augustan England and one which he must have felt, if wryly, peculiarly relevant to his own activities as poet.

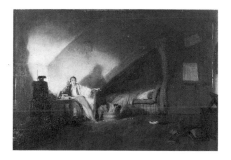

42 The Garreteer's Petition RA 1809
(175)
Oil on mahogany panel, 55 × 79
($21\frac{3}{4} \times 31\frac{1}{8}$)
B&J 100; N00482 [*col. pl. p.38*]

The technique of Turner's preparatory drawing for this picture (No.41), with its roughly sketched ink outlines and broad brown washes, seems to pay tribute to Hogarth's drawing style and hints at the Hogarthian intention behind it: despite its obvious debt to Rembrandt the subject is an exercise in satirical genre of the type that Hogarth made current in England, and which is quite distinct from the domestic scenes of seventeenth-century Holland. The print of Mount Parnassus on the far wall and the *Table of Fasts and Feasts* hanging on the back of the door to the right are characteristic devices of the satirists who followed Hogarth – Gillray, Rowlandson, and later illustrators such as George Cruikshank and Hablot Browne. The presence of these 'glosses' on the principal motif leaves little doubt that Turner's intention was indeed satirical, although the work has been seen as ambiguous in its presentation, relying on Rembrandt's dual reputation both as a sublime master and as the doyen of low-life painters. But the heroics, embodied in his pose, are surely the poet's own, grandiose but empty gestures like those of his verse. Turner presents his character vividly and to a degree sympathetically but carefully avoids any suggestion that he identifies with him in his lucubrations. The private implication, that this is a kind of ironic self-portrait, must remain an implicit subtext. The drafts on the drawing were reduced to a single quatrain for the Academy catalogue:

Aid me, ye Powers! O bid my thoughts to roll
In quick succesion, animate my soul;
Descend my Muse, and every thought refine,
And finish well my long, my *long-sought* line.

43 The Artist's Assistant
The Artist's Assistant, in the Study and Practice of Mechanical Sciences. Calculated for the Improvement of Genius.
Illustrated with Copper-Plates.
Printed for the Author; and sold by G. Robinson. London; and M. Swinney, Birmingham. n.d.
Private Collection

A mid-eighteenth-century textbook which Turner presumably acquired in the course of his researches for the Perspective lectures in the years 1807–10. It covers many aspects of art from painting and sculpture to gilding and marbling, but Turner was no doubt primarily interested in it as a manual of perspective drawing. He used the endpapers to scribble drafts of an involved poem which seems to take as its subject the position of artists in society, and in particular their need to stand together against the onslaughts of ignorance and indifference. In this he follows the arguments of Shee in his *Rhymes on Art*. It is possible that he intended to pursue the theme suggested by the title of the book, 'the Improvement of Genius', in response to Shee's second volume, the *Elements of Art*, which dealt with that topic, and which was equally one in which Turner took great interest. In practice, any precise interpretation of the meaning or intention of his poem is frustrated by the fragmentary and illegible nature of the drafts. It is impossible to be certain whether he was composing two or more separate poems, one of which was concerned with his dead colleague Thomas Girtin, or whether the scattered passages, like the extracts he published from the *Fallacies of Hope*, belong to a larger, if unrealised, whole in which Girtin is one example among several, including the engraver John Pye, of the artist in his context of social, economic and aesthetic pressures (see p.93–7).

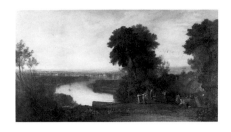

44 Thomson's Aeolian Harp

Turner's Gallery 1809
Oil on canvas, 166.7 × 306
(65⅝ × 120½)
B&J 86 [*col. pl. p.56*]
Manchester City Art Galleries

The importance of this picture in Turner's *oeuvre* has been stressed by Butlin and Joll; in its attainment of a delicate balance between an Old-Masterish ideal and the naturalistic it ushers in such paintings of his full maturity as 'Crossing the Brook' and the 'Dort' (B&J 130, 137). At the same time it preserves the luminous atmosphere of myth, and exemplifies the wide-ranging associationism that Turner aimed at in all his most important works of this period. Like the 'Avalanche in the Grisons' of 1810 (No.52) it is given its own accompanying verses by Turner even though apt lines could have been quoted from Thomson himself, who had written at length on the subject of the aeolian harp (see p.69). And Turner gave himself more trouble with the verses he published for this picture in his exhibition catalogue (No.46) than in the case of any other exhibited work. The thirty-two lines that appeared constitute the most substantial of his published fragments; though they are only a small part of the long lyrical poem that he was planning on the subject of Thomson and the Seasons.

On Thomson's tomb the dewy drops distil,
Soft tears of pity shed for Pope's lost fane,
To worth and verse adheres sad memory still,
Scorning to wear ensnaring fashion's chain.

In silence go fair Thames for all is laid;
His pastoral reeds untied and harp unstrung,
Sunk is their harmony in Twickenham's glade.
While flows thy stream, unheed'd and unsung.

Resplendent Seasons! chase oblivion's shade
Where liberal hands bid Thomson's lyre arise
From Putney's heights he nature's
 hues survey'd,
And mark'd each beauty with enraptur'd eyes.

Then kindly place amid thy upland grove,
Th' Aeolian harp, attun'd to nature's strains,
Melliferous greeting every air that roves,
From Thame's broad bosom o['e]r his
 verdant plains

Inspiring Spring! with renovating fire,
Well pleas'd rebind those reeds Alexis play'd
And breathing balmy kisses to the lyre,
Give one soft note to lost Alexis shade.

Let Summer shed her many blossoms fair,
To shield the trembling strings in
 noon-tide ray;
While ever and anon the dulcet air,
Shall rapturous thrill, or sigh in sweets away.

Bind not the poppy in thy golden hair,
Autumn! kind giver of the full ear'd sheaf:
Those notes have often echo'd to thy care,
Check not their sweetness with thy falling leaf.

Winter! thy sharp cold winds bespeak decay;
Thy snow fraught robe let pity's zone entwine
That gen'rous care shall memory repay;
Bending with her o'er *Thomson's*
 hallow'd shrine.

The poem is dedicated not to Thomson but 'To a Gentleman at Putney, requesting him to place one [i.e. an aeolian harp] in his grounds'. There is a trial stanza in the *Plymouth, Hamoaze* sketchbook (TB CXXXI, f.189), as well as a lengthy draft in the *Verse Book*. The aeolian harp is mentioned again among Turner's drafts for the poem on Thomson's tomb in the *Greenwich* sketchbook (TB CII, f.54r). The instrument that Turner depicts here is shaped like a lyre, presumably perfectly capable of producing the sounds expected of it, and a handsome ornament of the kind we know he was fond of designing, if not for realisation in actual gardens, at least as features in the gardens that occur plentifully in his pictures (see pp.76–8).

The immediate impulse for the picture may have been provided by a conversation with the gentleman of Putney, although it is difficult to know who he might have been. Whether it was a possible patron whom Turner hoped to lure into a purchase cannot be decided, since the picture remained in his studio for at least a decade, and was eventually acquired by James Morrison, who had first come to London about 1809, but probably did not purchase it until the 1820s. He acquired 'Pope's Villa' (No.35) in 1827; he was obviously interested in the poets, and Turner may just possibly have met him early on, and discovered this enthusiasm in common. However, Morrison did not live at Putney.

As Julius Bryant has pointed out, the picture distorts the topography of the Thames to ensure that the view is a celebration of both Pope and Thomson simultaneously, as the opening two lines of the printed poem suggest; for while the ostensible setting is Richmond, where Thomson lived, the distant houses are, much enlarged and altered, those of Pope's Twickenham, hardly visible in reality from Richmond Hill. The verses also allude more obliquely to Pope in their reference to 'Alexis' (see p.73).

There is likely to be a further literary allusion, to William Collins's *Ode on the Death of Mr Thomson* which evokes an Arcadian pastoral landscape that precisely corresponds to the idealised scene painted by Turner, and, furthermore, alludes specifically (in a footnote) to 'The harp of Aeolus' (see p.71). We cannot know whether Turner was aware of yet another link in the chain of local association – Wordsworth's *Remembrance of Collins*, composed '*upon the Thames near Richmond*' and published in 1798, which in turn alludes to Collins's *Ode* to Thomson.

By 1809, Turner's plans to build a house for himself at Twickenham were in hand, and his personal involvement in the area was becoming more practical. It is not surprising, then, that he felt the need to return to the subject, and that when he did so it was with another very large canvas, 'England: Richmond Hill, on the Prince Regent's Birthday'. In that case, the presence of Thomson's shade is once again made perfectly apparent (see No.67).

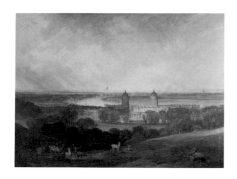

45 London Turner's Gallery 1809
Oil on canvas, 90 × 120 (35½ × 47½)
Inscribed lower left centre: '1809'
and 'J M W Turner RA PP'
B&J 97; N00483 [*col. pl. p.60*]

Turner rarely depicted views in the City of
London, either in watercolour or in oil;
while he frequently returned to the view
from Richmond Hill (see No.44), this is
his only treatment of the equally famous
panorama from Greenwich Park, though
he did re-use this composition as the basis
for a plate in the *Liber Studiorum* (R.26)
which gave it wide currency; and he
remodelled it in a somewhat eccentric
watercolour in about 1825 (W.513). The
smoky city is only glimpsed in the far
distance, and the focus of attention is on
the complex of buildings by Jones, Wren
and Hawksmoor which form the Royal
Naval Hospital and Queen's House. The
verses appended to the entry in the cata-
logue for Turner's exhibition of 1809 (see
No.46) appear to be his own, and do not
mention the hospital, though they
describe the other principal features of the
scene:

Where burthen'd Thames, reflects the
 crowded sail,
Commercial care and busy toils prevail,
Whose murky veil aspiring to the skies;
Obscures thy beauty and thy form denies,
Save where thy spires pierce thro the
 doubtful air,
As gleams of hope amidst a world of care.

('Thro' in the fifth line was omitted by the
typesetter but added in manuscript by
Turner to his own copy of the catalogue,
greatly improving the rhythm of the verse;
see No.46.) The presentation of the river
'burthen'd' with commercial traffic stems
from the Augustan prototypes of Thomson
and Defoe; this is a very different Thames
from that celebrated at Richmond, the
abode of the Muses and of rural calm. In
Autumn, Thomson celebrates London as

the culmination of the whole process of
world civilisation:

Then commerce brought into the public walk
The busy merchant; the big warehouse built;
Rais'd the strong crane; chok'd up the
 loaded street
With foreign plenty; and thy stream,
 O Thames,
Large, gentle, deep, majestic, king of floods!
Chose for his grand resort. On either hand,
Like a long wintry forest, groves of masts
Shot up their spires; the bellying sheet between
Possess'd the breezy void; the sooty hulk
Steer'd sluggish on; . . .
While deep the various voices of fervent toil
From bank to bank increas'd; whence,
 ribb'd with oak
To bear the British thunder, black, and bold,
The roaring vessel rush'd into the main.

(lines 118–33)

Turner takes up this theme and re-
shapes it with some subtlety, pointing out
that the evident grandeur of the subject,
both physical and moral, is built on a
foundation of toil and generates a far-
reaching corruption. His use of language,
if fairly conventional, is apt and richly
suggestive; 'burthen'd Thames' conveys
both the crowded waterway and the heavy
weight of human labour, as well as the
imposition man places on nature, an idea
developed in the 'murky veil' which
'obscures thy beauty'. Here, though, we
must assume that the poet is addressing the
city itself, whose name is the title of the
work: he is therefore acknowledging the
inherent beauty of London, especially as it
is represented symbolically in her church
spires. The allusion to hope makes this
passage another candidate *avant la lettre* for
inclusion in the *Fallacies of Hope* (see
No.52).

A substantially different draft of the
lines occurs among the important sketches
for poems in the *Greenwich* sketchbook
(TB CII, f.4v):

The extended town far stretching East & West
Thy high raised smoke no prototype of Rest
Thy dim seen spires rais'd to Religion fair
Seen but at moments thro that world of care
Where Vice & Virtue so commixing blends
Tho one retires while one distraction sends
Oer children's children whatever Low & Great
Debase or noble here together meet
To a concentrated focus hope together draws
The British Nation wealth the sovereign cause

Here the conclusion offers a more positive
economic gloss on the moral picture
painted in the opening lines, a gloss
appropriate perhaps to the larger pur-
poses of the long poem of which it seems to

form a part, and one which spreads the
promise of hope more generally than the
'gleams of hope' represented by the church
spires alone.

The whole of the long poem beginning
'O gold thou parent of Ambition's ardent
blush', from which this extract is taken,
and of which it may be the conclusion, is
concerned with the subjects of commerce
and exploration, and their implications for
British national pride.

**46 Catalogue for the Exhibition at
Turner's Gallery, 1809**
Private Collection

The year in which Turner showed 'Thom-
son's Aeolian Harp' (No.44) in his own
gallery was the year when 'The Garret-
eer's Petition' (No.42) appeared at the
Royal Academy. The latter can be read as
a wry piece of self-deprecation at his
temerity in attempting to rival Thomson
and Pope on their own ground. Never
before had he committed himself so exten-
sively to the printed word. In addition to
the thirty-two lines he composed for the
'Aeolian Harp', he published his six lines
of verse on 'London' (see No.45); he also
included a quotation from Gray's *Ode on a
distant Prospect of Eton College* for 'Near the
Thames' Lock, Windsor' (see No.25). The
range of works listed in his 1809 catalogue
covers many aspects of the pastoral and
Picturesque, but neither in his own gallery
nor at the Academy did he show anything
in the Sublime or 'terrific' mode: the year
seems to have been dedicated to poetic
contemplation and rural calm. This mood
was to be shattered with the showing of the
'Avalanche in the Grisons' (No.52) and
'Wreck of a Transport Ship' (B&J 210) in
1810.

The sheet bears a colophon indicating
that Turner had the catalogue printed 'by
L. Nichols' widow, at Earl's-court, Soho.'

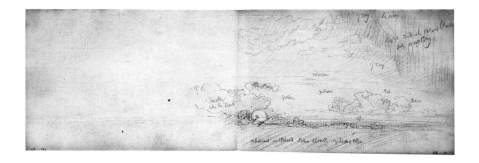

47 *Cockermouth* **sketchbook** 1809
Bound in blue laid paper; front cover
(now back cover) stamped
'J.M.W.T.'; Turner's label on spine
inscr.: '104 Cockermouth'. Contains
46 leaves of white wove paper,
11.5 × 18.1 (4½ × 7⅛). WM: 1802
TB CX

A book used by Turner on tour in the
north-west of England, after he had re-
ceived Lord Egremont's commission to
paint Cockermouth Castle (B&J 108).
The notes of figures in it are interesting for
the verbal observations of costumes and
implements of trade or labour which he
has added – an indication of his sense of
cultural distance which was to be very
apparent when he revisited the Continent
in 1817 and subsequently. There is also, on
f.1v, a short passage (whether of Turner's
own composition or copied from elsewhere
is uncertain) alluding to Tom Paine's
'tolerable definition' of the Sublime: 'the
sublime and the ridiculous are often so
nearly related that it is difficult to class
them separately. One step above the
sublime becomes ridiculous and one step
above the ridiculous makes the sublime
again.' On the same page, apparently
illustrating this point, are these lines of
verse, alluding to the ridiculous and the
Sublime as exemplified in two well-known
poems, Butler's *Hudibras* and Gray's *Bard*,
and breaking off into disconnected frag-
ments of an idea that seems to be related to
one Turner expanded in his Perspective
lecture notes, to the effect that both the
Sublime and the ridiculous may be exag-
gerated to exceed the bounds of effective
expression:

The beard of Hudibras and the Bard of Gray
The spinning of the earth round her soft axle
Ample room and verge enough

and below:

So nearly touch the bounds of all we hate

And on ff.43v–45v Turner has written an
extended note on the relationship between
poetry and painting. This is discussed on
pp.85–6 above.

> Open at ff.39v–40r; D07582–3
> Study of a Sunset
> Pencil
> Inscribed in the drawing, on f.40r:
> 'grey Rain/ light reddish colord Clouds
> /yet watery/ warm/ grey/ golden/
> yellow/ Red/ gray/ Orpiment and
> Blood Blue clouds yellow edge'; and
> on f.39v: 'Smoke like the Clouds'

Although Turner often used colour when
making notes of skies in his sketchbooks, he
equally frequently recorded them in pencil
alone, often adding memoranda of colours
and effects as in this example. The pro-
cedure is entirely consistent with that in
other drawings in this book; but this
common artist's practice perhaps derives
extra significance from the context of
Turner's lecture notes of the period. In his
discussion of Milton's description of even-
ing light, for instance, for the fourth
lecture of 1812 (see p.92), he particularly
singles out the use of words like 'grey' as
having manifold poetic resonances quite
different from the mere statement of 'grey'
which is at the disposal of the painter. The
merging of strictly chromatic terms with
more emotional ones like 'Blood' here
seems to reflect Turner's preoccupation
with the exact relationship of the two
different modes of description.

48 *Frittlewell* **sketchbook** 1809
Bound in calf with one brass clasp;
Turner's label on spine recorded by
Finberg: '63. [*illegible*]'. Contains 88
leaves of white wove paper,
10.7 × 18.2 (4¼ × 7 3/16)
TB CXII

A book in use when Turner was working
on his Perspective lectures, and containing
several diagrams and notes relating to that
project. There are also some topogra-
phical sketches, made in Sussex and else-
where. A poem drafted on the inside of one
of the covers is annotated 'Written at
Purley on the Thame. Rainy morning – no
fishing'; and on f.88v Turner has trans-
cribed a passage from Lord Holland's
recently published Life of Lope de Vega
which lays down an important principle of
poetical composition:

The chief object of Poetry is to delineate strongly the characters and passions of mankind to paint the appearances of Nature and to describe their effects to our imagination. To accomplish these ends the Versification must be smooth the language pure and impressive the images just natural and appropriate

On f.85v is a rather successful draft beginning 'What can the song of greatness be', broaching a theme of some personal significance for Turner (see p.167).

Open at ff.87v–88r; D07850–51
Draft Verses
Ink

It would seem that these verses, like those written inside the back cover of the book, were composed after a fruitless day's fishing: the references to 'The hapless fisher' and 'this finney brood' which 'no fly or worm can tempt' make this fairly plain. But Turner goes further than penning an angler's lament: the whole of nature is brought in to complement the mood of the poem, so that he illustrates in verse what he considered of vital importance in painting: the coordination of human action with natural context to create a unified and coherent statement. He proceeds to contrast the unhappy adult with the contented children, able to transform poverty to wealth – they are 'rich in content' – through an instinctive understanding of the natural world in which they find themselves. He uses the image of the paper boat sailing in the ruts created by the father's cart, which become for the boy 'a channel to the main', to link symbolically the cottager's child with the whole economic complex of the world he lives in. The toy boat was a favourite idea: Turner is recorded as having enjoyed making model ships for young friends; and in 'Dido building Carthage' (B&J 131) he employed the image to exquisite poetic effect, loading a vignette of childhood games – launching a boat – with a potent meaning for the whole sumptuous canvas.

49 *Perspective* **sketchbook** *c.*1809
Bound in red morocco with one brass clasp; Finberg records a label, now lost, numbered '56'. Contains 91 leaves, 8.8 × 11.2 mm (3 7/16 × 4 7/16)
WM: J WHATMAN 1808

A book in use while Turner was preparing his Perspective lectures, full of sketch diagrams and notes taken from his reading on the subject. There are also drafts of poetry, including the lyric 'Molly' and the long poem concerning the *Argo* (see pp.98–9).

Open at ff.53v–54r; D07448–9
Draft of Part of a Perspective Lecture
Ink

This passage extends over several pages used in reverse order at the back of the book between ff.53v and 48v, and although very tortuously expressed contains interesting reflections on the essential differences between the tasks of painter and poet. In particular Turner discusses the question of dynamism in the depiction of nature – a subject of central importance to his own work (see p.85). The whole note is sufficiently important to merit transcription in full:

f.53v The Painter['s] thoughts are inseperable while the Poets are imaginary as they relate to personification only that is attributable to imagination only. he seeks for attributes or sentiments to illustrate what he has seen in nature, and if he hints at the effect it is composed from.
– as like the sun *just* risen shines thro misty air shorn of his beams to elevate fal[l]en dignity
But the Painter must adher to the truth of

nature and has to give that dignity with the means of dignity or must produce it by other means and the mind is allowed him it must be deliberate while the queenly force into obscurity to evince that the luminary must have lost his beam be conveyd
f.52v Tho different the allurements but yet in the sentiment[s] produce[d] the Painter receives only the reward of having colored the Poet while the power of the Painter over other words the difficulty he has surmounted is lost to his merit for having given it to the eyes of every one, that he [is] allowed to be Poetic and seeking the acceptation of the utmost of his power [?having] to be if he succeeds as to be poetical, while he attends to the difficulties of his art and should omitt, what in many instances when [it] is [from] tantamount [*or* ?testament] to the beauty of the poet what in his language of Painting is ever distant and Paradoxical it may be that [?] the author try to blend known hues he is considered answerable to the
f.51v Poets thought tho his means are different he hears the censure with the power of redemption while he is confined to the local contrarieties of his art and if he is happy he is considerd only secondarily as endeavouring to give to the most vulgar age what has been admitted to be beautiful in the Poet, *by very different means* when failure he meets disgrace either as being deficient in the mechanical excellencies or [as] not feeling his author or not conveying his sentiment either has made a sorry choice but [h]as his sentiments of [= ?or] the Poets sentiments are his own and [h]as he must embody them by known effects of nature he should be allowed to [be] consider'd equal in sintiments and
f.50v having conquered his difficulties or made the contradis[tinc]tion – should be considerd to have produced what is exclusively *his own*
One word is sufficient to establish what is the greatest difficulty to the painter['s] Art[:] to produce wavy air as some call
The Wind
while at one frown the sun declining [?like] never has the Painter to give that [?] but [with] difficulty. he must give the cause as well as the effect and without which he would be nothing: but should he produce, that which every one must feel the declining ray. he must know that the Poet by giving that which is allowable only but by the greatest
f.49v difficulty and therefore master of such [?truth] continued with mechanicall hints of truth of nature perpetually trammle[d] with mechanical shackles
f.49r but cannot atract quality of motion: the great Poet of nature Thomson in his Summer [has] a line beyond delineation and yet most truly drawn

When from the bladed field the Hare limps
<div align="right">awkward</div>
And the wild deer gaze at early passengers
Rous'd by the cock the soon clad
<div align="right">shepherd leaves</div>
His peaceful cottage

f.48v Motion is conveyed by word and values
or impetuosity is given to the most sluggish
of perception[s] parts of the mind when the
reader must feel the importance of the and
is bor[n]e impert[ur]bale th[r]o the [?rank]
or in Dryd[e]n['s] line he recognizes the sea-
beat shore

and wave impelled on wave harsh
<div align="right">breaking on the shore</div>

an[o]ther line of Pope
but as the eye has by observation atraction
& certain quality and forms which approach
or at first glance [?accommodate] the idea of
motion as we admire the friezes of Polide to
be procession[s] or that the Horse curveting
is in motion is all that the Painter can
succeed [in] while the Poet gives its
concom[itant?]

50 On the River Arun 1809
Pencil, 23.6 × 37.1 ($9\frac{5}{16}$ × $14\frac{5}{8}$)
TB CIX, f.3; D07514

A leaf from the *Petworth* sketchbook, in use
while Turner was working in Sussex for
Lord Egremont on his view 'Petworth,
Sussex, the Seat of the Earl of Egremont:
Dewy Morning' (B&J 113). It contains
drawings in Westmorland, near Cocker-
mouth, where Egremont also owned
property. This slight sketch, which Turner
has inscribed on the verso 'Banks of Arun',
is hardly interesting as a drawing; but it
illustrates the way in which drawing and
verse interwove themselves in Turner's
creative thinking at this period. We gather
from a line in the *Hastings* sketchbook (TB
CXI, f.95r; see p.100) that, apart from the
personal connections with the countryside
of Sussex near the Arun which he was
beginning to evolve at this date as a result
of the relationship with Lord Egremont
that this book helps to document, he had

noticed a literary association with Thomas
Otway, author of the famous tragedy
Venice Preserv'd. It was, as Turner imagined
it, 'Arun['s] sedgy stream' that supplied
Otway's youthful environment. Otway
does not figure explicitly on this sheet,
though there is possibly an oblique allu-
sion to him. Both sides have rapidly
scribbled drafts of poetry that seem to
relate to the pastoral stanzas Turner wrote
in his *Verse Book* in connection with
'Thomson's Aeolian Harp' (see No.44).
They include references to a character
named 'Colin' who figures in other drafts
of a similar type. On the recto are these
lines:

A gleam so hopeful shone on Arun['s] [?reed]
<div align="right">strewn shore</div>
When Colin by the sedgy bank did
<div align="right">thoughtful roam</div>
Yon char[ming] ray of sunshine born
That memory of so fair a thought
Transient as the dew upon the thorn
That mark[s] the thorn [?apple] so
<div align="right">finely wrought</div>
When his mortal ray

The verso has further lines to similar effect,
the second quatrain almost illegible:

Then gleam shone young hope what
<div align="right">tender gleam</div>
When Colin all in thought along thy stream
By sedgy Arun awaited the crimson ray
Or rose to give thy varied charms to lay

The mention of 'young hope' is reminis-
cent of Turner's lines in the *Hastings* book
on 'the tender Otway', lured 'from a
parent[']s side . . . to feel the power/ Of
fortune'. But in fact 'Colin' is almost
certainly meant to be William Collins the
Chichester poet, who may equally well be
assumed to have roamed the banks of the
Arun, and who was responsible for the *Ode
on the Death of Mr Thomson* that seems to
have played a definite part in the concep-
tion of 'Thomson's Aeolian Harp'.

Turner was evidently alive to the possi-
bilities of rivers other than the Thames as
settings for his meditative verse. He was to
make two finished watercolours of the
Arun at or near Arundel, one for the *Rivers
of England* (w.748), the other for the
Picturesque Views in England and Wales
(w.854). In both the rustic life of the
riverside is much in evidence; the *Rivers of
England* drawing, which includes an
angler, is dominated by a colourful rain-
bow which may be a development of the
'tender gleam' and 'crimson ray' men-
tioned in these lines.

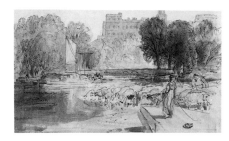

51 Windsor Castle from the Thames ?*c*.1809
Pencil, pen and brown ink and wash,
22.2 × 29.4 ($8\frac{3}{4}$ × $11\frac{9}{16}$)
TB CXVIII e; D08185

A design for the *Liber Studiorum* that was
never engraved or published, and does not
reproduce any of Turner's finished views
of Windsor. It is, however, a variant of an
oil painting of his first year beside the
Thames, at Isleworth (see No.12). In
particular the Thomsonian group of men
and women washing sheep in the right
foreground closely follows 'Windsor Castle
from the Thames' (B&J 149), which was
acquired by Lord Egremont and has hung
at Petworth ever since. At some point
Thomas Rowlandson saw that picture and
made a sketch of it (repr. Wilton 1987,
p.71, fig.99). Since the sketch was evi-
dently done from memory there is a strong
presumption that Rowlandson saw the
work in Turner's gallery, for Turner
placed a strict prohibition on copying,
which would not have obtained at
Petworth. The composition of the picture
is adumbrated in a coloured sketch in the
Studies for Pictures: Isleworth sketchbook
(No.12), where the foursquare planar
structure is anticipated. In this drawing,
Turner has radically modified the archi-
tecture to create a skyline of varied towers,
thereby giving the whole view a more
traditionally picturesque cast. A different
view of the castle was also considered for
the *Liber* as late as about 1818 (No.66), but
that too was never used.

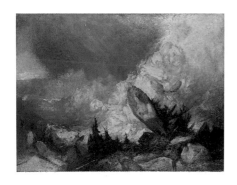

52 The Fall of an Avalanche in the Grisons Turner's Gallery 1810

Oil on canvas, 90 × 120 (35½ × 47¼)
B&J 109; N00489 [*col. pl. p.57*]

Turner had certainly not been to the Grisons on his tour of Switzerland in 1802. The impulse to paint this subject may have come partly from seeing de Loutherbourg's essays in the same genre, notably the examples in the collections of two of Turner's own patrons, Sir John Fleming Leicester and Lord Egremont (now respectively Tate Gallery and National Trust, Petworth House). A more direct stimulus was perhaps a newspaper report of an avalanche at Selva in the Grisons in December 1808. If that was a source for the subject, it coincides uncannily closely with a scene that Turner must have known in Thomson's *Winter*, and would have reinforced his sense of the realism of the *Seasons* while providing a practical justification for using Thomson as a basis for landscape painting:

Among those hilly regions, where, embrac'd
In peaceful vales, the happy Grisons dwell,
Oft, rushing sudden from the loaded cliffs,
Mountains of snow their gath'ring terrors roll.
From steep to steep, loud thundering, down
 they come,
A wintry waste in dire commotion all;
And herds, and flocks, and travellers,
 and swains,
And sometimes whole brigades of
 marching troops,
Or hamlets sleeping in the dead of night,
Are deep beneath the smothering
 ruin whelm'd.
 (lines 414–23)

In the event, however, he did not cite Thomson in his catalogue but supplied verses of his own which are strongly Thomsonian in flavour:

The downward sun a parting sadness gleams,
Portentous lurid thro' the gathering storm;
Thick drifting snow on snow,

Till the vast weight bursts through the
 rocky barrier;
Down at once, its pine clad forests,
And towering glaciers fall, the work of ages
Crashing through all! extinction follows,
And the toil, the hope of man – o'erwhelms.

(For a discussion of these lines in the context of the *Fallacies of Hope* see p.65.)

Exhibited at Turner's own gallery in 1810, this canvas marks an important stage in his technical development. The *Sun* (12 June 1810) noticed that it was 'not in his usual style'; and indeed he had never before offered an account of any natural phenomenon as broadly handled as this. So daring are the vacuous areas of grey in the upper left of the composition that it has even been suggested (by Martin Butlin, orally) that they are the result of a retouching in the 1840s. Turner's alterations to 'Tapping the Furnace' and 'The Wreck Buoy' (B&J 427, 428) in 1847 and 1849 lend plausibility to the argument. But the passage in question has a precedent in the handling of the waterfall in the 'Fall of the Rhine at Schaffhausen', shown at the Academy in 1806 (B&J 61), which is treated in parts almost identically, with the same bold smears of grey and white. Turner's apprehension of the technical pressures exerted on the thoughtful painter by the challenge of presenting Sublime natural objects had already led to radical changes in his watercolour style while he was in Wales in 1798–9 (see Wilton 1984); his experience of the Alps extended that process in both watercolour and oil, and the 'Schaffhausen' and this picture must be accounted the chief milestones on the road he was now pursuing. It was to lead, only two years later, to 'Hannibal crossing the Alps' (No.59), to which, in more ways than one, this bears the relationship of precursor and preliminary study.

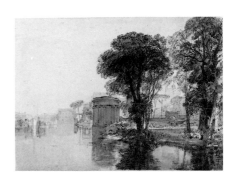

53 The Alcove, Isleworth c.1810

Pencil, pen and brown ink with brown and grey washes, 21.1 × 28.9 (8 5/16 × 11 3/8)
TB CXVIII I (Vaughan Bequest);
D08163

A design for the *Liber Studiorum* which Turner etched himself, for a plate mezzotinted by Henry Dawe. It was not published until 1819 (R.63). Like the *Liber* design entitled 'Isis' (see No.54), this takes advantage of a Neo-classical building beside the Thames to imply, if not actually to create, an antique landscape. The elements closely follow the features of the real Isleworth (which survive, more or less, today): the Alcove, the Duke of Northumberland's shooting lodge in the form of a circular Ionic temple, is in the foreground, and Isleworth church beyond, with the London Apprentice public house beside the water in the distance. The *Studies for Pictures: Isleworth* sketchbook (No.12) contains numerous drawings showing how the tempietto, and perhaps others like it, inspired Turner to invent grand compositions incorporating structures reminiscent of the Temple of the Sibyl at Tivoli, which as yet he had not seen; and how these in turn led him to consider subject-matter borrowed from Homer, Virgil, Ovid and the Bible (ff.3, 27, 28, 41v, 45v, 46v, 48v, 50v).

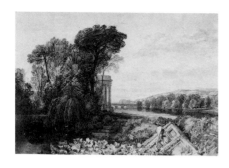

54 Isis *c.*1810
Pencil, pen and brown ink and wash
with scraping-out, 20.7 × 30
($8\frac{3}{16}$ × $11\frac{13}{16}$)
TB CXVIII N (Vaughan Bequest);
D08168

This design was etched by Turner and
engraved by William Say for publication
in the *Liber Studiorum* (R.68); it appeared in
the very last issue, in 1819, but like No.53
was probably prepared some time earlier.
As the published plate announced, it was
based on a picture which had been bought
by Lord Egremont for Petworth (B&J 204).
This was not shown at the Academy but
may well have been purchased by Egre-
mont from an exhibition in Turner's
gallery; its style and subject-matter both
suggest a date about 1807. There are
numerous drawings related to it in the
Studies for Pictures: Isleworth sketchbook
(No.12; ff.3–6, 9, 29–31 and perhaps 42).
Most of these feature a round temple-like
building, resembling the Temple of the
Sibyl at Tivoli, which also occurs in two
rough sketches on pages of the *Thames from
Reading to Walton* book (TB XCV, 8, 11),
which Finberg tentatively identified as
views of Temple Island at Henley, also
known as Regatta Island. That building is
a small pavilion surmounted by a classical
rotunda, designed by James Wyatt in
1771. Perhaps by pure coincidence Turner
had been involved in the depiction of
several buildings by Wyatt since his view
of the burnt-out Oxford Street Pantheon
of 1792 (W.27). The identification does not
seem to be correct, but Turner may have
adapted the idea of the Henley building
and combined it with the well-known
Alcove on the Duke of Northumberland's
estate at Isleworth (see No.53) to create
the present subject. Here and in the
Petworth picture the stretch of the
Thames on the right may be a paraphrase
of the mile of straight water between the
Island and Henley, with an idealised view

of Henley bridge in the distance. The
traditional title of the painting, 'The
Thames near Weybridge', does not seem
to have much justification. Unlike the
'Isleworth' subject, 'Isis' moves to a plane
rather more remote from the reality of the
Thames. The distant hills and woods are
unequivocally English, as is the distant
bridge; but the piece of detached cornice
on which a peacock sits in the foreground
transports us more effectively than does
the Claudean temple to the Mediterra-
nean world of classical ruins. Both the
cornice and the peacock were incorpor-
ated by Turner into his design for the
frontispiece to the *Liber*, published in 1812
(R.1). The effect of this detail is, as several
commentators have said, to render the
view a capriccio. Turner's intention was
plainly to evoke a pastoral idyll, his title
being that of the river addressed in his lines
on Pope's Villa (see No.35 and p.50),
where the classicising Augustan overtones
are manifest.

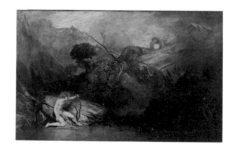

55 Apollo and Python RA 1811
Oil on canvas, 145.5 × 237.5
($57\frac{1}{4}$ × $93\frac{1}{2}$)
B&J 115; N00488 [*col. pl. p.79*]

The slaughter of the dragon Python by
Phoebus Apollo is one of the archetypal
parables of light overcoming darkness in
Greek mythology. Turner seems to have
contemplated a work with the death of a
dragon as its motif since early in the
decade; he evidently felt that the impli-
cations of the subject had not been
exhausted by his small picture of 1802,
'Jason' (No.9), which acts as an important
preliminary study for this much larger
work. Despite the lapse of time the
influence of Salvator Rosa is still strong,
and it is clear that Turner is pursuing a
train of thought that he had begun some
years earlier. And the canvas is more

closely linked to his meditations on the
pastoral Thames than one would at first
imagine. An important study for the figure
of Apollo is drawn in pen and brown ink
on a page of the *Studies for Pictures: Isleworth*
sketchbook (No.12; f.3r), over a pencil
drawing of a classical temple, apparently
that featured in the *Liber Studiorum* plate
'Isis' (No.54). The picture accordingly
emerges out of the ferment represented by
that book, and must be directly related to
the Associational work of the years 1805–
10. Indeed, even more than 'The Goddess
of Discord' (No. 30), 'Apollo and Python'
was bound up in Turner's mind with ideas
that he wished to express simultaneously
in poetry, and he seems to have conceived
the three subjects at about the same time.
In all of them the connotations of classical
literature are uppermost; this is made
explicit in the Academy catalogue entry
for 'Apollo and Python', where Turner
cites lines from Callimachus' *Hymn to
Apollo*:

Envenom'd by thy darts, the monster coil'd
Portentous horrible and vast his
 snake-like form:
Rent the huge portal of the rocky den,
And in the throes of death he tore,
His many wounds in one, while earth
Absorbing, blacken'd with his gore.

This is not, however, a direct quotation;
the lines are adapted, obviously by Turner
himself, from the translation by Christo-
pher Pitt which he found in Anderson's
British Poets (volume VIII), and perhaps
from other sources as well, notably Ovid's
account in book I of the *Metamorphoses*, of
which Dryden's translation was accessible
in Anderson (volume VI):

So monstrous was his bulk, so large a space
Did his vast body and long train embrace:
Whom Phoebus basking on a bank espy'd,
E'er now the God his arrows had not try'd,
But on the trembling deer, or mountain goat;
At this new quarry he prepares to shoot.
Though every shaft took place, he spent
 the store
Of his full quiver; and 'twas long before
Th' expiring serpent wallow'd in his gore.

The lines Turner published represent,
however, only the tip of an iceberg of
sustained interest in the subject which is
recorded in several drafts in the notebooks.
The *Hastings* sketchbook contains numer-
ous attempts (TB CXI, ff.26v, 36, 53, 70v,
78, 82v, 83v) which alternate with drafts of
what is apparently a quite different poem
on the subject of fancy and the imagina-

tion – pursuing the ideas of Akenside on which Turner was pondering, as we know, at about the time he was working on the picture (see p.88). It is therefore not inappropriate to read the subject as a commentary on the power of the imagination, represented by the god of poetry, and couched in the Sublime language that Akenside uses in describing the flights of the human fancy in his *Pleasures of Imagination*.

Although recent cleaning has brought out many subtleties previously unappreciated, the condition of the canvas hardly allows us to endorse Ruskin's opinion that it heralds Turner's emergence as 'the painter of the loveliness and light of the creation'. The verses suggest that he remains preoccupied with darkness and moral evil, and that it is into this tenebrous world that the creative imagination enters as a redeeming force. As with 'The Goddess of Discord', Turner may have been linking classical and Christian mythology, once again using *Paradise Lost* as his reference; for it is to Python that Milton likens Satan after his transformation into a serpent (book x, lines 529–32). The implications of this subject for Turner's interest in light and colour were not to be fully explored until he painted 'Light and Colour (Goethe's Theory) – the Morning after the Deluge – Moses writing the Book of Genesis' for the Academy exhibition of 1843 (B&J 405).

56 Pope's Villa 1811
Line engraving; image 17.4 × 22.9 (6⅞ × 9); plate 19.9 × 23.1 (7¹³⁄₁₆ × 9⅛)
Inscribed below: 'Class 1. Painting' and 'for the "Fine Arts of the English School"'; and, centre: 'POPE'S VILLA. Engraved by JOHN PYE, the Figures by CHAˢ HEATH, from a Picture by J.M.W. Turner Esqʳ RA and P.P. in the Gallery of SIR JOHN FLEMING LEICESTER, BARᵗ'
R.76; LO1475

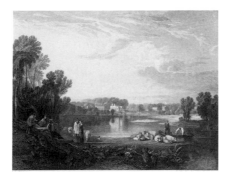

John Britton's *Fine Arts of the English School* was a handsome anthology of engravings with explanatory text; Britton, long an admirer of Turner's work, must have chosen Turner's painting of Pope's Villa (No.35) not only as representative of his art but also for its reflection of the literary and visual achievements of a previous age. He himself composed the commentary that accompanies this plate, and sent it to the artist for comment. Although Turner's response is well known, it needs to be quoted at some length here:

> As to remarks you will find an alteration or two in pencil. *Two* groups of sheep, *two* fishermen, occur too close – baskets to entrap eels is not technical – being called Eel pots – and making the willow tree the identical Pope's willow is rather strained – cannot you do it by allusion? And with deference: 'Mellifluous lyre' seems to deny energy of thought – and let me ask one question, Why say the Poet and Prophet are not often united? – for if they are not they ought to be. Therefore the solitary instance given of Dodsley acts as a *censure*. The fourth and fifth line require perhaps a note as to the state of the grotto that grateful posterity from age to age may repair what remains . . .
> (Gage 43)

The letter has often been cited as evidence of Turner's precision in the use of words, his concern for accuracy in technicalities (something occasionally belied by mistakes in the descriptive titles of his pictures), and his clear grasp of the significance and resonance of literary phraseology. All these facts strengthen the argument that it was dyslexia, not illiteracy, which occasioned his difficulties in composing poetry (see p.14).

The print itself is of importance as being the work that first alerted Turner to the full potential of line engraving as a medium through which his designs could be made available to a wider audience.

'This will do! You can see the lights', he is reported to have said when shown a proof, recognising Pye's sensitive transcription of his atmospheric effects. Thereafter his relations with the engravers became exceptionally close and fruitful. Some draft verses in *The Artist's Assistant* (No.43) apparently allude to this new perception of the possibilities of black-and-white printmaking: see above, p.96.

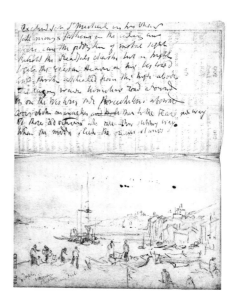

57 *Devonshire Coast No. 1* sketchbook 1811
Bound in calf with one brass clasp. Contains 250 leaves in all, 11.5 × 7.3 (4½ × 2⅞). The spine tooled with the title, '*BRITISH ITINERARY*'. This book is in fact an interleaved copy of that work, whose title page is f.10 in the interleaved sequence. It reads: '*The*/*BRITISH ITINERARY*/ *or*/ *Travellers Pocket Companion*/ *throughout*/ *GREAT BRITAIN*/ *Exhibiting*/*the Direct Route to every*/*Borough and Commercial Town*/*in the*/*KINGDOM.*/ *with the principal*/*CROSS ROADS.*/ *Compiled from Actual Measurement*/ *and the best Surveys and Authorities*/ *by*/ *Nathanl. Coltman.*;/*Surveyor.*/ *London*'
TB CXXIII

Turner has used almost every blank sheet of this book, for accounts of expenses connected with his tour to Cornwall in 1811, or for rapid pencil sketches of scenes on that journey, or for drafts of the long

poem he apparently wrote *en route*. The latter are for the most part in pen and ink, though occasional passages are in pencil. There is no direct link between drawings and verses, but it is clear that he intended them to constitute complementary records of the tour. In the event, although many of the watercolours he made from sketches in this and other books used on the journey were published in Cooke's *Picturesque Views on the Southern Coast of England*, they were accompanied by a more conventional prose text. There is no evidence that the poem was ever seriously considered for the purpose. It remains, however, the most sustained and substantial of Turner's efforts as poet, though with most of his usual faults of coherence and construction (see pp.170–76.

> Open at ff.132v–133r; D08619–20
> Draft Verses and Sketch of the
> Harbour at St Mawes, Cornwall
> Pencil
> Inscr.: 'Talking/ Woman/ Children/
> [?] Fish'

The information gathered in this succinct sketch served Turner in his work on the canvas he exhibited at the Academy the following year, 'St Mawes at the Pilchard Season' (No.60), as well as, almost certainly, the view of St Mawes engraved for the *Southern Coast* (w.473; see Smiles 1988, pp.53–4). Lines of verse on the subject of the pilchard trade are on ff.132–5 of the book (see No.60); on the page opposite this drawing the poem has reached a point still further west along the coast, St Michael's Mount:

> Exalted sat St Michael in his Chair
> Full many a fathom in the circling air
> Scarce can the giddy ken of mortal sight
> Behold the dreadfull chasm but in fright
> Forget the reason Heaven on her bestowd
> And strike appalld from thir high abode
> The raging waves tumultuous roa[r]d
> around . . .

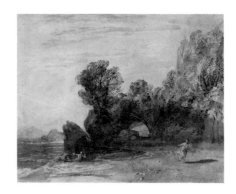

58 Glaucus and Scylla *c.*1811
Pencil, pen and brown ink and wash with stopping-out, 27.7 × 22.2 ($10\frac{5}{16} \times 8\frac{3}{4}$)
Inscribed in pencil, top right: 'Departure of Theseus'
TB CXVIII P (Vaughan Bequest); D08170

Ovid tells the story of Glaucus and Scylla in books XIII and XIV of the *Metamorphoses*. Glaucus was a fisherman who had been transformed into a sea-god, half man and half fish. He fell in love with the nymph Scylla as she walked naked along the shore, but she fled from him, uncertain whether he was god or monster. He sought assistance from the witch Circe, daughter of the Sun, but she was herself in love with Glaucus and with potions transformed Scylla into a rock surrounded by fierce hounds, one of the dangers encountered by Ulysses in his wanderings.

Turner etched this subject in outline, and it was engraved for the *Liber Studiorum* by William Say, but never published. Like so many of Turner's landscapes illustrating stories from Ovid, the composition is strongly reminiscent of Claude (see 'Narcissus and Echo', No.11); in this case, there are particular suggestions of the Earl of Leicester's 'Origin of Coral', which was also probably an influence on the watercolour of 'Chryses' (w.492) that Turner showed at the Academy in 1811 (see No.28). 'Chryses' seems to allude as well to the Duke of Sutherland's Claude of 'Ezekiel lamenting over the Ruins of Tyre'; and there is a possible debt to a more recent work, Benjamin West's 'The first Interview of Telemachus and Calypso' of about 1772, engraved by William Woollett and repeated several times by West (von Erffa and Staley, nos. 180–84). The motif of the arched rock in both 'Chryses' and 'Glaucus and Scylla'

was to recur in Turner's 'Ulysses deriding Polyphemus', shown at the Academy in 1829 (B&J 330) but already planned in the first decade of the century (in the *Wey, Guildford* sketchbook, No.28, f.5r).

Turner reverted to the theme of Glaucus and Scylla in a painting of 1841 (B&J 395), which makes use of a variant of this composition. Although he referred to Ovid in the catalogue entry, he did not actually quote any lines from the story, so we cannot say which translation he may have used. It is possible he had in mind that of Samuel Garth, printed in Anderson's *British Poets* (volume VII); however, Garth begins with Glaucus's appeal to Circe for help in his suit of Scylla, while here we are shown an earlier scene, with Scylla fleeing the sea-god's advances. Turner dramatises his subject by stressing the elemental significance of the characters, placing Scylla firmly on the shore and Glaucus equally decisively in the sea, so that each belongs to his or her own element and is separated from the other by the difference between land and water. In this subject he provides a mythological framework for his many later pictures of shore life: the ambiguous relationship of human beings to the sea, at once their livelihood and their enemy, is explored in the paintings and watercolours of fish-markets, of wreckers and of Excise inspections on the beach.

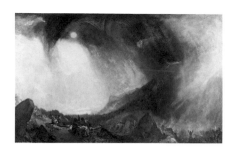

59 Snow Storm: Hannibal and his Army crossing the Alps RA 1812 (258)

Oil on canvas, 146 × 237.5 (57½ × 93½)
B&J 126; N00490 [col. pl. p.64]

The genesis of this picture is well known. Turner had been contemplating such a subject for several years, and may have been influenced by a rare oil painting by John Robert Cozens, 'Hannibal in his March over the Alps shewing to his Army the Fertile Plains of Italy', exhibited at the Academy in 1776. The idea of treating the subject may have come from Oliver Goldsmith; in his copy of volume II of Goldsmith's *Roman History from the Foundation of the City of Rome, to the Destruction of the Western Empire* Turner noted various possible Roman themes, among them 'Hannibal crossing the Alps'. The first impulse must indeed have been literary, but a famous story records his sketching a thunder-storm in Yorkshire and announcing that he would transform the effect into 'Hannibal crossing the Alps'. He probably had not heard of Gray's observation that the subject was one worthy of Salvator Rosa (whose 'terrific' manner Turner had already imitated in his 'Jason' and 'Apollo and Python', Nos.9, 55): Gray had proposed 'Hannibal passing the Alps; the mountaineers rolling down rocks upon his army; elephants tumbling down the precipices' (William Mason, ed., *The Poems and Letters of Thomas Gray*, London, 1820, p.302). In any case Turner's conception of the picture is somewhat different from that of Gray, who envisaged Salvator tackling the subject as a historical figure piece in a wilderness setting: Turner deliberately planned his treatment to shift the burden of the drama from the figures to the setting itself. The process by which he does this is made plain in the verses he printed with the title of the picture in the Academy catalogue when it was shown there in 1812.

The appearance of the first citation

from the *Fallacies of Hope* in connection with 'Hannibal' marks a kind of epoch in Turner's development as a poet. He was to make use of the 'Manuscript Poem' for the rest of his life; the last time he invoked it was in 1850, as commentary on his final entries to the Royal Academy exhibition. The verses, closely modelled on Thomson (see p.64–5), are these:

Craft, treachery and fraud – Salassian force,
Hung on the fainting rear! then Plunder seiz'd
The victor and the captive, – Saguntum's spoil,
Alike became their prey; still the chief
advanc'd,
Look'd on the sun with hope; – low, broad, and wan;
While the fierce archer of the downward year
Stains Italy's blanch'd barrier with storms.
In vain each pass, ensanguin'd deep with dead,
Or rocky fragments, wide destruction roll'd.
Still on Campania's fertile plains – he thought,
But the loud breeze sob'd, 'Capua's joys
beware!'
M.S.P. Fallacies of Hope

Despite their reliance on Thomson, they represent Turner's abilities at their best, and illustrate the way in which he expected poetry to give extra significance to his pictures. The passage begins with the enunciation of three ringing abstractions – precisely the kinds of idea which Turner complained were inaccessible to the painter. The central idea, however, is of course 'hope' itself, which Turner links with the sun, though in a more flexible and ambiguous symbolism than that of the Augustans (cf. pp.55–8). The elements of nature that Turner depicts are as much personages of the drama as the figures of Hannibal and his men: it is the 'loud breeze' that acts as message-bearer, warning of the seductions of civilisation and luxury, fatal to military enterprise. This dramatic interrelationship between figures and setting is typical of all his work, whether historical or topographical. Here, with the aid of poetry, the point is spelled out.

The role of the Alps as 'barrier' between north and south, between the invader and his objective, is a theme that Turner tackled again in the context of a modern crossing – that of Napoleon. 'The Battle of Fort Rock, Val d'Aouste, Piedmont, 1796' (No.63) appeared at the Academy in 1815 with very similar verses, also ascribed to the *Fallacies of Hope*, and making parallel points.

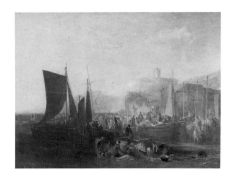

60 St Mawes at the Pilchard Season RA 1812 (175)

Oil on canvas, 91 × 120.5 (35⅞ × 47½)
B&J 123; N00484 [col. pl. p.103]

Turner visisted St Mawes, on the east side of Falmouth Bay, during his tour to the West Country in 1811, and made a number of drawings of it and the bay (see the *Devonshire Coast No.1* sketchbook, No.57). These provided the information for this picture and several watercolours, of which the view engraved for Cooke's *Southern Coast* (w.473) and that for the *Picturesque Views in England and Wales* (w.823) are both closely modelled on the composition of the painting. All three are distinguished by the great prominence given to the foreground scenes of landing and sorting fish. It has ingeniously been suggested that the import of these details differs in the watercolours, being there a commentary on the depression of the industry as a consequence of the Napoleonic Wars (see Smiles 1988). However, the painting, which was the first of Turner's finished views of St Mawes, presents the pilchard season as a time of universal and presumably profitable bustle, and it has to be admitted that in general mood and in the great majority of their details there is no immediately perceptible difference between it and the watercolours of the subject. Close to the sketches of St Mawes in the *Devonshire Coast No.1* book are lines of verse which allude to the industry, and to

those adventurers who dare thir slippery
way
Upon the muddy steep the owner stands
And call[s] aloud to those who ply the strand
With sein[e]s all ready for the pilchard soon
Awaits his orders
(ff.132v–135v)

None of this implies a market depression; however, Turner does refer to the 'once resounding shore' of Totnes 'now silent . . . thro war' later in the poem (f.161v).

There is a full parallel between picture and poem: just as he had depicted the economic connotations of particular places – the stone-quarrying of Portland, the rope-making of Bridport (see pp.60–61) – so in this painting he presents the topographical significance of the subject in all its dimensions. The sixteenth-century castle guarding the bay was a defence against French invasion; it bears obvious similarities to the martello towers being built in Turner's time on the south coast as precautions against a new threat from across the Channel. History both ancient and modern is brought to bear on the condition of the actual inhabitants of the place, who become the centre and focus of the work. It is characteristic that the human and economic detail of the view should take precedence over geographical or architectural facts: the ostensible reason for Cooke's series was the 'picturesqueness' of the chosen sites; Turner offers a more complex and altogether profounder interpretation of his experience as tourist. His poetry, too, was intended to bring this out.

61 Frosty Morning RA 1813 (15)
Oil on canvas, 113.5 × 174.5 $(44\frac{3}{8} \times 68\frac{3}{4})$
B&J 127; N00492 [col. pl. p.56]

This celebrated picture appeared at the Academy with a catalogue entry quoting Thomson's *Autumn* (line 1169):

The rigid hoar frost melts before his beam

– advertising the fact that although a winter piece it is in reality as much a celebration of the power of the sun as are Turner's more explicitly sun-centred works. The unusual composition, in which a blank greyish sky occupies much of the picture-space, seems designed to point out how bleak a void the world is before dawn. The empty cyclorama waits for the rising sun, just visible as it reaches the horizon at the right, to give it life and meaning, as the figures in the foreground wait for warmth to reach them. Turner's instinctive use of Thomson in connection with this earthily realistic subject underlines his constant awareness of the importance of linking poetry with painting. By citing this one line of *Autumn* he evokes the whole cast of human characters with which the *Seasons* are crammed, relating a single incident to the cycle of the year and to the activities of country people, prominently depicted here: the labourers digging, the man with a shot-gun, and the young girl warming herself in a rabbit-skin scarf. At the same time, he characteristically links the scene to the rest of the nation and its larger economy: the distant coach on the road at the far left stands for the infrastructure of communications which joins all members of the community in a universal purpose.

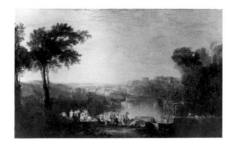

62 Dido and Aeneas RA 1814 (177)
Oil on canvas, 146 × 237 $(57\frac{1}{2} \times 93\frac{3}{8})$
B&J 129; N00494 [col. pl. p.82]

Although Turner had already broached the broad subject of the Trojan War and its Homeric or Virgilian sequels in 'The Goddess of Discord' (No.30), this was the first exhibited canvas in which he explicitly illustrated Virgil. The Academy catalogue entry quoted four lines from Dryden's translation of the *Aeneid*, book IV:

When next the sun his rising light displays,
And gilds the world below with purple rays,
The Queen, Aeneas, and the Tyrian Court,
Shall to the shady woods for sylvan games
 resort.
 (lines 164–7)

The subject had been in gestation for some years, and springs directly out of the dialectic of Thames landscape and classi-cal pastoral that had preoccupied Turner in his Isleworth and Hammersmith period. Both the *Studies for Pictures: Isleworth* and the *Hesperides 1* sketchbooks contain more or less elaborate designs for the composition (TB XC, f.21; XCIII, f.5r; see Nos.12, 13). The *Hesperides 1* book also contains some studies for the figures (on ff.4v–7r). This is the only full-scale classical subject to have been developed directly from a design in the *Isleworth* book, and reflects peculiarly faithfully the Epic Pastoral vision that lies behind its studies. The temple that appears behind the trees to the left of the *Isleworth* sketchbook composition is transformed into an embattled tower in the picture, appearing in the place occupied in the study by the pedimented temple-front, on the hill to the right. In other respects the details are transferred with some exactness, though Turner invests his architecture, especially the foreground bridge, which in the sketch has a rustic, Claudean air, with precise detailing of a distinctly Neo-classical order. It is a very different classicism from the pastiche of Claude in 'Apullia in search of Appullus' (B&J 128) which he sent to the British Institution in the same year (see No.11). 'Dido and Aeneas' may be seen, indeed, as a corrective to that work: a reminder of how much more than a mere Claude imitator he really was.

63 The Battle of Fort Rock, Val d'Aouste, Piedmont, 1796 RA 1815 (192)
Watercolour with scraping-out and stopping-out, 69.5 × 101 (27⅜ × 39¾)
TB LXXX G (W.399); D04900
[*col. pl. p.66*]

If 'Hannibal crossing the Alps' (No.59) was the outcome of many years' preparatory thought, this watercolour, a close equivalent in its different medium, also resulted from the slow maturing of Turner's ideas about the Alps. He had drawn the raw landscape setting in the Val d'Aosta during his Swiss visit of 1802 (w.360), and produced from it a large and elaborate watercolour showing the gorge, probably in about 1804 (w.399). Eleven years later he submitted this complex work to the Academy, accompanied by verses which emphasize what may be overlooked on account of the great difference in scale of the two pictures – its immediate relevance to the 'Hannibal'. Here it is Napoleon, a modern and not a classical hero, who braves the rigours of the mountains to attain and conquer Italy: the moral is applied to contemporary rather than past history. The verses from the *Fallacies of Hope* that appeared in the catalogue entry rehearse much the same arguments that Turner had deployed in connection with Hannibal – though the important abstractions are introduced towards the end this time, rather than at the beginning. The hostility and bleakness of the Alps is exactly paralleled by the violent actions of men. As in the lines Turner wrote for 'Hannibal', nature becomes a metaphor for humanity; the advancing army is likened to the torrential river cutting its way through the rocks which are once again described as a 'barrier'. The attractive countryside of Italy is evoked in a concluding warning, though this time not as a fatal diversion for the soldiers, but as a

helpless victim of the devastation of war:

> The snow-capt mountain, and huge
> towers of ice,
> Thrust forth their dreary barriers in vain;
> Onward the van progressive forc'd its way,
> Propell'd, as the wild Reuss, by native
> glaciers fed,
> Rolls on impetuous, with ev'ry check
> gains force
> By the constraint uprais'd; till, to its
> gathering powers
> All yielding, down the pass wide
> devastation pours
> Her own destructive course. Thus
> rapine stalk'd
> Triumphant; and plundering hordes,
> exulting, strewed,
> Fair Italy, thy plains with woe.
> *Fallacies of Hope. MS.*

The watercolour itself is made to do much of the work in drawing the parallel between human behaviour and natural phenomena: the composition, split as it is down its centre by the vast cleft in the mountains, is divided into two distinct halves which deal separately with man (on the left) and nature (on the right). The enduring superiority and indifference of the natural world is perhaps implied in the panorama of sunlit mountains around Mont Blanc which rears up in the distance.

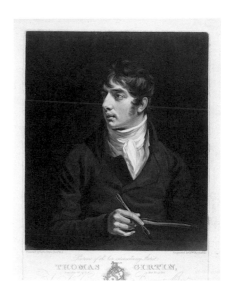

64 Thomas Girtin 1817
Mezzotint, image 30.9 × 26 (12³⁄₁₆ × 10¼), plate 38 × 26 (15 × 14¼), sheet 41.8 × 29.8 (16½ × 11¾)
Inscribed below left: 'Painted by John Opie Esqʳ R.A.' and right: 'Engraved by S.W. Reynolds'; and 'Portrait of the late extraordinary Artist, THOMAS GIRTIN, Natus Feb 18 1775 Obit Nov. 9 1802. To Sir George Beaumont Barᵗ One of his earliest Patrons This Print is with Permission respectfully dedicated by his very obliged & grateful Servᵗ IOHN GIRTIN. J. Girtin in the recent fire in Broad Strᵗ having lost all his property, excepting some prints &c which with this portrait of his late Brother, he respectfully offers to a liberal Public' and 'London. Pubᵈ May 16 1817, by J. Girtin, Engraver, Printer &cʼ
Private Collection

Thomas Girtin (1775–1802) was a close colleague of Turner's in the 1790s, and considered by many to be his superior in the field of landscape and topographical watercolour painting. Turner is known to have remembered and made use of some of his ideas as late as the 1830s. But little has survived outside the realm of anecdote to support the tradition that he admired him to the point of claiming that 'If Tom Girtin had lived I should have starved'. The extremely obscure drafts of poetry in *The Artist's Assistant* (see No.43 and pp.93–7), however, provide new evidence of Turner's brotherly feeling for Girtin:

'Twould call the memory from his C[ovent?]
G[arden?] room
Where lies the honor'd Girtin's narrow tomb

Difficult as the pencil jottings are to read, they seem definitely to have been written in memory of Girtin, and to discuss questions of genius, patronage and reputation in relation specifically to him:

struggling with each other for the
palm of worth
Need not the palm of patronage accursed

Girtin did not attach quotations of poetry to his own watercolours, but he did in his youth execute a series of designs illustrating *Paradise Lost*; and he was, with Turner, the principal heir of John Robert Cozens, whose work was later to be characterised by Constable as 'all poetry', and who is perhaps the artist who did most to recast the language of eighteenth-century topography in a romantic and poetical mould.

65 The Field of Waterloo RA 1818
(263)
Oil on canvas, 147.5 × 239 (58 × 94)
B&J 138; N00500 [*col. pl. p.107*]

Like 'The Battle of Fort Rock' of 1815 (No.63), this is a modern history subject; the motive impulse for it seems to have originated specifically in poetry. Turner had visited Waterloo on his tour to the Netherlands and the Rhine in the summer of 1817, and took with him a guidebook, Charles Campbell's *Traveller's Complete Guide to Belgium and Holland*, which printed verses by several poets in the course of its account of the Field of Waterloo (a section added to the new edition of 1817). The poets in question were those of a more recent generation than Turner's favourites: Southey, Sir Walter Scott, and Byron. Campbell quoted from Byron's stirring elegy for the dead of Waterloo in canto III

of *Childe Harold*, and Turner took up the reference in his catalogue entry for the picture:

Last noon beheld them full of lusty life;
Last eve in Beauty's circle proudly gay;
The midnight brought the signal –
sound of strife;
The morn the marshalling of arms – the day,
Battle's magnificently stern array!
The thunder clouds close o'er it, which
when rent,
The earth is covered thick with other clay
Which her own clay shall cover, heaped
and pent,
Rider and horse – friend, foe, in one red
burial blent!

Indeed, his picture seems to be quite specifically an illustration of Byron's sentiment. It is a most unusual view of the battle, very different from the heroic panoramas of the field during the action beloved of such artists as Turner's close friend George Jones. There is no heroism here: only darkness and the uncertainty of the women who search among the heaps of dead – French *cuirassiers* and Scottish infantrymen – for their dear ones by the light of flares and the burning farm of Hougoumont. Turner explores the human, not the political consequences of war, and presents us with a bleak and moving, unexpectedly intimate image. The nocturnal chiaroscuro is rare in his landscapes, harking back to the work of Adam Elsheimer and other Caravaggio-inspired masters of the seventeenth century, though the flashes of brilliant colour in the clothes of the foreground figures foreshadow the glowing palette of Delacroix and the French Romantics of the 1820s and 30s.

Turner used the design again in a watercolour illustration to the works of Byron (W.1229), published in 1833 (R.425). Indeed the picture stands at the beginning of a new epoch in Turner's relationship with poetry. Whether it was Campbell's *Guide* that first drew his attention to Byron is not certain; but the new enthusiasm was to prove important. Byron was henceforward to be a major influence on his vision.

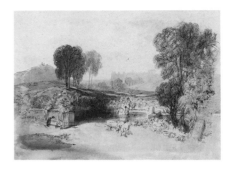

66 Windsor Castle from Salt Hill
c.1818
Pencil, with pen and brown ink,
brown and grey washes, 22.5 × 31.5
(8⅞ × 12 7/16)
TB CXVIII Q (Vaughan Bequest);
D08171

A design for the *Liber Studiorum* which was etched by Turner and engraved by Charles Turner but never published (R.74). It is based on one of several drawings made in the *Skies* sketchbook in June 1818, when Turner stayed at Salt Hill with the Fawkes family on a visit to the Eton Boat Race (TB CLVIII, f.62v). The plate must have been begun afterwards, since the *Liber* ceased publication in the following year. But it belongs with the work of about a decade earlier when Turner worked on several pictures using Windsor Castle and sheep washing as motifs (see No.24), among them an oil sketch of the castle from Salt Hill, dating from about 1807 (B&J 177). The rustic incident of the foreground figures in the drawing is also typical of those years, as is its organisation, with the horizontal mass of the castle glimpsed in the distance beyond clumps of trees. These motifs were of central significance to Turner, and he was evidently inclined to perpetuate them in some of his work of the late 1810s.

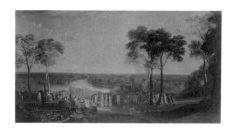

67 England: Richmond Hill, on the Prince Regent's Birthday RA 1819
(206)
Oil on canvas, 180 × 334.5
(70⅞ × 131¾)
B&J 140; T00502 [*col. pl. p.49*]

One of Turner's largest canvases, this work marks the apogee of his interest in the topography of Richmond and Twickenham. It follows naturally from the slightly smaller 'Thomson's Aeolian Harp' of 1809 (No.44) and takes up some of the same themes, though this is altogether a more public statement. The title is enough to announce that we are concerned here with a grand patriotic account of the English landscape, whereas the earlier picture had treated of a private passion, the profound veneration felt by Turner for two great British poets, and for the power of creative genius. Thomson is once again invoked: the Academy catalogue entry included this passage from *Summer*:

Which way, Amanda, shall we bend
 our course?
The choice perplexes. Wherefore should
 we chuse?
All is the same with thee. Say, shall we wind
Along the streams? or walk the smiling mead?
Or court the forest-glades? or wander wild
Among the waving harvests? or ascend,
While radiant summer opens all its pride,
Thy hill, delightful Shene?
 (lines 1401–8)

From that vantage point Thomson describes the great city, Windsor, Ham, Twickenham, Hampton Court and Esher; he refers to the Thames and its tributary the Mole; celebrates Gay and Pope, and compares the prospect favourably with those of ancient Greece: it is 'beyond whate'er the muse/ Has of Achaia or Hesperia sung!' He concludes by hailing the whole panorama of

 glittering towns, and gilded streams, till all
The stretching landscape into smoke decays!
Happy Britannia! where the Queen of Arts,
Inspiring vigour, Liberty, abroad

Walks unconfin'd even to thy farthest cots,
And scatters plenty with unsparing hand.
 (lines 1440–45)

The gathering of figures in the foreground of the picture illustrates this broad view of English happiness. The royal birthday provides an occasion for all sorts and conditions of men, women and children to celebrate the prosperity of the nation. The relative crudeness of this 'message' is explained if we suppose Turner to have been seeking the patronage of the Prince Regent in painting the picture. That he was happy to paint such subjects for royal favour is shown by his acceptance, shortly afterwards, of the commission to paint a 'Battle of Trafalgar' for St James's Palace (B&J 252) – an even larger canvas.

The Richmond view retained its personal associations and special importance for him, and he continued to use it as a subject for his watercolours: one was executed shortly after this date, in the early 1820s, and a second, engraved for the *Picturesque Views in England and Wales*, in the mid-1830s (w.518, 879). They retain something of the Claudean format that is so distinctive a feature of 'Thomson's Aeolian Harp' and of the 1819 canvas. But this work introduces another art-historical reference which significantly modifies the classicising flavour of the earlier picture: the figures are no longer Arcadian; or rather, they belong to a more modern Arcadia, that of the fey, elegiac pastorals of Watteau. The reminiscence of early eighteenth-century France overlays the robust English celebrations with an aristocratic elegance foreign to their bourgeois directness. This is in keeping with Turner's new interests at the time; it signals a fundamental change of mood which brings the period of this exhibition to a close. See also Turner's first 'Byronic' picture, No.65.

The Transcriptions

No complete and indisputable transcription of Turner's verse drafts is ever likely to be achieved. As explained in the Introduction, although he could write beautifully and clearly on occasion, his manuscript is often extremely difficult to read for numerous reasons. To this fact must be added the inevitable rubbing and blurring of many passages over the years, a process enormously accelerated when the sketchbooks of the Turner Bequest were submerged in the Thames flood of January 1928.

These transcriptions of the poetry written between about 1805 and 1819 attempt to provide a reading for all but the most obdurately faded or confused passages. In doing so, they frequently diverge in the interest of clarity from what Turner actually wrote. Dyslexic as he evidently was, he did not always write what he meant; and if he has a reputation for incoherence as a poet, that may be due in part to his failure to ensure that the manuscript tallied with the idea. In many cases it has been possible to make perfectly good sense of an apparently nonsensical passage simply by altering a word or two in a fairly obvious way. In other contexts this would be inexcusable; but there are occasions when, in Turner's case, it is wholly justified, bringing to light a vigorous intelligence flourishing beneath the clouded surface of the handwriting. Such changes have been made if by their means his creative purposes are better revealed.

Similarly, some of the random marks that he made on the paper have been silently ignored: his numerous dots, for example, are sometimes to be equated with orthodox marks of punctuation; when this is the case, they have been transcribed. More often, they represent the fumbling of the pen while ideas are awaited, and fulfil no grammatical purpose. For this reason the numerous instances of the row of dots have been omitted altogether. If they seem to indicate a gap in the thought, a space has been left; spaces are also left when Turner has left them. Occasional Cockneyisms like 'has' for 'as' have also usually been corrected without comment, and other superfluous letters that impede the sense are similarly ignored. Otherwise, ease of reading has been consulted as a guide to what ought to be altered and what left to stand. Many words carelessly but uninterestingly misspelled have been corrected. However, it would be a pity to iron out entirely the wayward orthography and schematic syntax of many of these drafts, even if that could easily be done, and as a rule the transcripts follow them as closely as possible.

Editorial symbols have been kept to a minimum., All drafts are in ink unless enclosed between pointed brackets ⟨ ⟩; these indicate that the passage is written in pencil. Letters added by the editor to complete the sense of words are placed in square brackets. Words interlineated by Turner are enclosed in square brackets with a caret ∧ or ∨ to indicate that they occur respectively above or below the relevant line. It has to be understood that much of the transcribing has been effected by informed guesswork; but where a reading is more than usually uncertain the word or phrase is enclosed in square brackets and preceded by a query. Words that have defeated the editor altogether are represented by a query in square brackets. Deletions are also given in square brackets, and followed by *del*. Where a word has been misspelled so as to suggest another word, or even nothing, a proposed correct reading is inserted, preceded by = .

The *Verse Book* c.1805–10 (see No.27)

On front endpaper:
 and chance to vermill gave first place
 he wondring view'd

p.1 The origin of Vermillion or the Loves of Painting and Music

 In days that's past beyond our Ken
 When Painters saw like other men
 and Music sung the voice of truth
 Yet sigh'd for Paintings homely proof

 Her modest blush first gave him taste
 And chance gave Vermill first in place
 as Snails trail oer the morning dew
 he thus the lines of Beauty drew

 Those far fame'd lines Vermillion dyed
 With wonder view'd enchanted crid
 Vermillions honors mine [and hence ∧] to stand
 The Alpha & Omega in a Painters hand

 To dim futurity decend to [o'er all ∧] time prevail
 Envy [gabling *del.*] o'er heard, and [gabling ∧] told the tale

p.2 and tast had then not op'd her eye
 then [ga]zing drew
 as snail[s] trail or the Morning dew
 But self conceit became his friend

p.3 Art e'er hues essayd the use
 He first Invoked the graphic muse
 guide thou needs thou muse of art
 give raidient colour healing to the heart
 and Beauty soft mellifluous part
 But Practice never heard him sigh
 and doubtful taste

 It chancd one day the dame was tired
 Recumbent Beauty Genius fird
 and Dutch Vermillion close at hand
 Scrow'ld on the marble forth as coarse as sand

 No matter ready love supplied
 What niggard nature here deny'd
 but ever he first essayd

 To future fame
 but finest snatcht in of fame
 in search of taste.
 but practice never heard him sigh
 nor taste on him had cast an [her ∨] eye
 and natures charms so check his haste
 Trembling the pencils course of color trace
 as snails trail oer the morning dew
 he thus the line of Beauty drew

p.4 Those far famd lines Vermillion dy'd
 He wondring view'd with consious pride
 and self-conceit alas too near allied
 Grasps the whole range of art & cried
 Vermillion

p.5 The early river feed
 from Marsh or Bog or rushy mead
 In silver rippling wandring wild
 As the puking changling child
 lolls its head
 The Nurse's fair Breast its downy bed

So gay so fair – so mild Serene
Seems every weed beneath its stream
And seems more fresh than those in air
Kissing its parent as it flows
As Children's love by kindness grows
disturb the stream it quick refines
It passes on in chequer'd pride
From Child to Man and love its guide

Till nature difficulties interpose
For ever sally and deny repose
Across the way the rocky barrier throws
With manly power

p.6 from the coming age
 6 7 8 9 10 11
 The Hesperian Sisters to ass[u]age thy ire
 1 2 3 4 5 6 7 8 9 10 11
 Profferd the fruit yet [and ∧] with prophetic fire
 discord pale'd
 Foretold what would insue pleased the
 its fatal power pleased the Goddess
 1 2 3 4 5 6 7 8 9 10 11

p.7 Ode to Discord
 1 2 3 4 5 6 7 8 9 10
 Discord, dire Sister of Etherael Jove
 1 2 3 4 5 6 7 8 9 10 11
 Coeval, hostile even to heavenly love
 1 2 3 4 5 6 7 8 9 10 11
 Unask'ed at Psyche bridal feast to share
 Stung by revenge and envious of the fair
 Fierce as the noxious blast of wintry skies
 Rushed oer [ye ∧] vale where Hesperian Garden rise

 Discord dire sister of Etherial Jove
 Coeval hostile even the heavenly love
 Unasked at Psyche bridal feast to share
 1 2 3 4 5 6 7 8 9 10 11
 Mad with neglect and envious of the fair
 1 2 3 4 5 6 7 8 9 10 11
 Feirce as the noxious blast thou cleav'd the skies
 1 2 3 4 5 6 7 8 9 10 11
 And sought the Hesperian Garden golden prize
 1 2 3 4 5 6 7 8 9 10 11
 The Guardian Dragon in himself [equal to ∧] a host
 1 2 3 4 5 6 7 8 9 10 11
 Aw'd by thy presence slumber'd at his post
 1 2 3 4 5
 The timid sisters feard thy wrathful ire
 Proffer the fruit [urge'd *del.*] [told ∧] by prophectic fire
 what mischief would insue. the Goddess heard
 With vengfull pleasure then her choice preferd
 The shiny mischief to herself she took
 Love felt the wound. Troys foundations shook

p.9 The Guardian Dragon in himself an host
 Aw'd by thy presence slumberd at his post
 [The gentle sisters dread thy wrathfull ire
 Proffered the fatal fruit told with prophetic fire *del.*]
 The timid Sisters with prophetic fire
 profferd the fated fruit and fear'd thy wrathful ire
 With vengfull pleasure pleas'd the Goddess heard

 I 2 3 4 5 6 7 8
of future woes and then her choice preferred
 I 2 3 4 5 6 7 8 9 10
The shiny mischief to herself she took
 I 2 3 4 5 6 7 8 9 10
Love felt the wound and Troy's foundations shook

p.11 On the demolition of Pope-House at Twickenham

 Dear Sister Isis tis thy Thames that calls
 See desolation hovers o'er those walls
 The scatterd timbers on my margin lays
 Where glimmering Evening's ray yet lingering plays
 There British Maro sung by Sceince long [endear'd ∧]
 And to an admiring Country once rever'd
 Now to destruction doom'd thy peacefull grott
 Popes willow bending to the earth forgot
 [Forbid *del.* ∧] Save one weak scion by my fostering care
 Nursed into life wild fell destruction there
 On the lone Bank to mark the spot with pride
 dip the long branches in the rippling tide
 And sister stream the tender plant to rear
 On Twickenham's shore Popes' memory yet to hear
 Call all the rills that fed our spacious Urn
 Till twylight latest gloom in Silence mourn
 Lodona gratefull flows, Alexis all deplore
 With
 Lodona gratefull hears, Alexis still deplores
 And flowing murmurs oft Alexis is no more

p.13 Sir William Wootton often said
 Tuscan was like the Labourer made
 Ioniac with her scrowl-like fan
 The meritricious courtezan
 Corinthian looked mature and Chaste
 Not like the Corinth maid in haste

 Sir Wm Wootton has compared
 The Tuscan to the labourer hard

 Sir William Wootton often said
 Tuscan like to the labourer is made
 And now as such is hardly used
 Misplaced mouldings much abused
 At Gateway corners thus we find
 That carriage wheels its surface grind
 Or placed beneath some dirty wall
 Supports the drunken cobler's stall
 Ioniac with her scrowl like fan
 The meritricious courtezan
 It now is used at front of Houses
 To shew those horns belong to spouses
 And at a place thats entre nos
 Not many steps from Charing Cross
 Fast bind fast find it has been said
 Suit not the Mistress or the maid
 Yet architecture has her plea
 And the chaste matron keep the key
 But Chastity does sometimes lean
 And Man doth slip alack between

p.15 The painted column's at the door
 Prove Vice is [her ∧] strong & Virtue poor [growing power ∧]
 The neighbouring doorways full as base
 Yet bold Ionic hold her place
 Three golden ball[s] above suspended
 Tell two to one to all's intended
 The scrowl bespeaks a lybirinth of woe
 Who once gets in must onward go

The little dentals in sofiete
Show grinding power here complete
And placed as the teeth of Shark
Alike unerring at their mark
Here usurey most strongly savours
For Money Lent by special favours
So luring to the poor's this guile
Tho Interest must be paid the while
Each day adds more unto the sum
That pledge and pled[g]er soon is one
And forfeiture then swallows all
Who trusts the triple jointed ball
Corinthian grave mature grace
At every shop front shews her face
Can it be said that she is chaste
or like the Corinth maid in haste
Where she is so often out of place wrongly placd
or like the damsel out of place
Who fears the thought of bursting lace
Her full blown beauties float around
Acanthus leaves and budding horns abound
With great display above below
Placed any where [and merely ∧] for a show to make a show
The beauty of [and ∧] her flutes are gone
So long they have been play'd upon

p.19 Horor
 by the hollow roots of trees
 Whose bald top[s] catch the Morn[ing] breeze
 Horror skill[d] in magic spells

p.21 The dewy drops on Thomson's Tomb seem tears
 Since Pope's fam'd mansion sunk unto the ground
 Sure Memory still to worth and verse adheres
 May not that honor in thy Eye be found

 Sullen [with sighs ∧] and slow Thames rolls th[r]o Twicknam
 glade

 The pastoral reed and aerial Harp unstrung
 Sunk is the harmony their friendship made
 The gurgling current echo'd as they sung
 Then Thames in echo's babbled as they sung
 Thro checquer[d] shades Thames

 Yet Sheen's delightful bank retards [relieves ∧] its haste
 Reflecting rich the hill where Thomson lies
 Along that ridge and Putney's airy waste
 He caught the truth of nature and her dyes

 Place then amidst thy upland groves
 The Eolian Harp soft tuned with natures strains
 Meliferrous cheering Thames that he roves
 Meandering honors thro the verdant plains
 Rich with the bounty of the verdant

 Inspiring Spring with renovating fire
 Will pleased bind those reeds Alexis play'd
 [and ∧] While breathing balmy kisses tho' the Lyre
 give one soft note to lost Alexis shade

 Summer will shed her many blossoms fair
 And shields the trembling strings in noon-tide ray
 While ever and anon the dulcet air
 Will rapturous rise [thrill ∨] or meltingly descry [sigh in sweets
 away ∨]

 [Weave *del.*] Bind not the Poppy in thy golden Hair
 Autumn kind giver of the full Ear'd sheaf
 Those notes have often melted to the care
 Check not their sweetness with thy falling leaf

p.22 Thy hill O Sheen and Pu[tney]
 resplendent Sheen and Putney water
 The curfew tolls the knell of parting day
 Full many a gem of brightest ray serene

p.23 On Thomsons tomb the dewy drops like tears
 Shed in [Hang in ∧] rembrance [sad ∧] of Pope's lost fane
 Sure Memory yet unto their worth adheres
 She cannot drag capricious fashion's chain

 On Thompson tomb the dewy drops like tears
 Hang in remberance sad for Pope's lost fane
 Sure Memory still to worth [&] verse adheres
 She cannot drag capricious fashion's chain

 Sullen and deep pours Thames thro the glade
 Airiel Harp and Pastoral reeds unstrung
 Gone is that Harmony when Friendship playd
 The gurgling current echo'd as they sung

 Sheen yet remains
 But Sheens delightful bank relieves its haste
 Thy varied Bank O Sheen relieves its haste
 Reflects the hill

 Thy varied bank O Sheen relieves its haste
 Rich in reflections hues there
 Here Thompson sleep rich in reflection dyes
 Along thy hill and Putneys airy waste
 He looked with [for ∨] the truth of [in ∨] Natures Eyes
 The simple stone yet marks thy hill with pride
 "Here Thompson Author of ye Seasons art lies"
 Along thy bank and airy Putneys side
 He looked with the Truth of Natures eyes

 Here Thompson rests but in [accent chaste ∧] Natures dyes
 but in Natures sighs
 along by Sheen or airy Putney waste
 He lookd to the truth in Natures eyes

p.24 Give then a place to check Oblivion haste
 [at Sheen ∧] a simple stone mere mark that Thomson lies
 Along the hill and heathy Putneys waste
 He look'd and Nature sparkled in his eyes

 Resplendent Seasons [check oblivion haste ∧] as chaste
 one simple stone yet marks where T[hompson] lies
 He sought thy smile on Putney Heath waste
 He look'd and Nature sparkeld in his Eyes

 Then kindly place amidst thy [upland ∧] groves
 His Eolian Harp softuned in nature's strain
 Expanding Thames will listen has he roves
 Rich full and floating honors thro the plains

 Then kindly place in aid of truth his harp
 Soft tuned mellaforous in Natures strains

p.25 On Thompson tomb the dewy drops like tears 9
 Hang in remembrance for Pope's lost fane 9
 Sure memory still to worth and verse adheres 9
 She cannot drag capricious fashions chain 9

 Sullen and deep the stream now leaves y[e] glade 9
 Aerial Harp and Pastoral reeds unstrung 9
 Sunk is that Harmony then Friendship play'd 9
 And Thames look'd gay & glitter'd has [when ∨] they sung 9

 Resplendent Sheen thy bank reli[e]ves its haste 10
 A simple stone yet marks where Thompson lies 9
 Along the hill and Putneys airy waste 9
 He looked and Nature sparkled in his eyes 10

Place then amidst thy upland groves 8
The Eolian Harp soft tuned in nature strains 9
Meliferous cheering Thamisis as he roves 10
Rich with the tribute of the verdant planes 10

p.26 Meliferous greeting every breeze that roves
 Rich full and floating
 From freighted Thames meandring thro the plains
 In silence go fair Thames for all is laid
 His Pastoral reeds, unty'd and Harp unstrung
 Sunk is their Harmony in Twickenham glade
 And thou flows on unheeded and unsung

 Elegaic [*N.B. this word is evidently a memorandum or spelling check; it is
 not connected with the verses on this page*]

 Then nature looked, she sparkled in his Eyes
 Then kindly place amidst thy upland groves
 His Eolian [aerial ∧] Harp softuned in natures strains
 Expanding Thames will listen as he roves
 Rich with his floating honors [tributes ∧] from the main
 Floating his freighted honors thro' the plane

 Bind not the Poppy in thy golden Hair
 Autumn kind giver of the full ear'd sheaf
 Those notes have often trembled to thy care
 Check not their sweetness with thy falling leaf

 Winter thy sharp cold winds bespeak de[c]ay
 Thy snow frought robe with pity gently twine
 And Memory will thy generous care repay
 And thou with her will live at Thompson Shrine

p.27 On Thompson tomb hangs dewy drops like tears
 Fall in rememberance sad for Pope's lost fane
 Sure Memory will still to Worth and Verse adheres
 She cannot drag capricious fashions chain

 Sullen and deep the streams laves Twitnams glade
 The Eolian harp and Pastoral reeds unstrung
 Sunk is their Harmony, then friendship play'd
 And Thames lookd gay & glittered when he sung

 Resplendent Seasons, check Oblivions haste
 [The lonly ∧] One simple stone but marks where Thompson lies
 He sought thy smiles [varid hues ∧] o'r Putneys heathy waste
 He looked and Nature sparkled in his Eyes
 And nature saw she

 Then kindly place amidst thy upland groves
 His Eolian Harp soft tund in Nature's strains
 Meliferous greeting Thames harken tho as he flows
 Expanding Thames will listen has he roves
 Rich Full with [his ∧] his floating honors thro the plains

 Inspiring Spring with renovating fire
 Will pleased bind those reeds Alexis made
 And breathing balmy kisses to the Lyre
 Give one soft note to lost Alexis shade

 Summer will [untied ∧] shed her many blossoms fair
 and shield the trembling strings in noon tide ray
 While ever and anon the dulcet air
 Will rapturous thrill then sighing [in ∧] sweets [sparkle ∨]
 decay [away ∨]

p.28 Pleasure breathing Spring [Harmonice displace]
 Dancing Kisses greet thy string [pleasant]
 Pleased Spring thy
 and blossoms that exceed in dyes

The Ether blue of Summer Skies
Summer waving to thy strain
Noon tide radien[ce] gild the plain
Thy chords her influence knows
and
& giving each a sigh
That thou by kindness may more sweet reply

Autumn's [rich with ∧] nodding sheaf
will withhold the falling leaves
Not to check thy pla[i]ntive shrills
That gentle Pity's eye en fills
How Winter follow and decay
Will all the melting softness lay
Lull'd by Her snowy breast till spring
When she and Seasons honors sing
Lulld in snowy breast from care
Till spring calls up [sweet music ∧] thy spirit from [its ∧] lair
Lull in a melting breast of snow
Till Spring inspiring touch give all the rapturous flow
Till Spring recall thy music from its [lair]

p.29 He sweetly sang his lays to thee

He sweetly sang who sung of thee
Eolian Harp most pleas[ant] lye
That thou the yielding air beguile
And cheats expectancy the while
Expectancy yet [means ∧] not the measure
luld by wind of promised pleasure
As the buds in early Spring
Around thy will ring
With blossoms that exceed belief
Summer gay & Autumn sheaf
Summer dancing to thy strain
her raidance
in Breeze fill the plain
Autumn golden nodding sheafs
Will withold the falling leaves
Nor check thy plaintive shrills
That gentle Pity eye e[e]n fills
That winter follow & decay
And all thy melting softness lay
Till
But Memory and returning Spring
Will lead the fainting string
[written along side of page]
or rushing sudden on the [oer the ∧] earth
Ner sheds thy dulcet burthen to the wind

Winter
Lull'd be thy care on robe of snow
till nature's melting touch gives spring all the rapturous flow

p.31 He sweetly sung his lays to thee

He sweetly said who sung of thee
Eolian Harp, most pleasantlye
That thou the yielding air beguile
And Cheat expectancy the while
Wispering a lingering measure
As the bud of promised pleasure
Or rushing sudden o'er the mind
Gives all thy dulcet burthen to the wind

Pleasure breathing Spring
Balmy Kisses greet thy string
From Blossoms that exceed in dyes
The Ethereal Blue of Summer Skies

Seasons dancing to thy strain
Noon-tide radience gilds the plain
And giving each a tender sigh
That thou in kindness may more sweet reply

Autumn rich in nodding sheaves
Will withhold the falling leaves
Not to check thy plaintive thrills
That gentle Pity's Eye e'n fills
Now Winter follows and decay
Will all thy melting softness lay.
Lull'd on Her snowy [robe ∧] breast till Spring
Lulld be thy cares in robe of snow
Till nature's melting touch bids rapturous music flow

p.33 He sweetly sung his lays to thee
Eolian Harp most pleasauntlee
That thou the yeilding air beguile
And cheat expectancy the while
Whispering a lingering measure
As the bud of promised pleasure
Or rushing sudden o'er the mind
Give all the dulcet burthen to the wind

Pleasure breathing Spring
Balmy kisses greet thy string
From blossoms which exceed in dyes
The Etheriael blue of Summer's Skies
Noon tide radiance gilds the plains
Season's dancing to thy strains
Giving each a tender sigh
That Thou in sweetness may more sweet reply

Autumn rich in nodding sheaves
Will withold her falling leaves
not to check thy plaintive thrills
That gentle Pity Eye e'en fills
How Winter follows and decay
Must all thy melting softness lay
Till natures Kind inspiring air
Tunes thee sweetness with parental care

p.35 On Thompson's tomb the dewy drops distill
As Pity's gentle tear for Popes lost fane
To worth and verse adheres sad memory still
Scorning to wear capricious fashions chain
On Thompson tomb the gentle dew drop strays
Like Pity's tender tear for Popes lost fane
In memory minds then
But memory yet recall her various lays
That scorns to wear capricious fashions chain

p.150 Aged Menalcas hear the labour[er's] tale
and Colin['s] Courtship tale [with del.] from the Vale
[tending] his sheep – by – Thames
Aged Menalcas has he hom[e]ward hy'd
by Silver Thames
The labourer's tale with heavy heart he heard
(how ∧] Aged Menalcas by Thames side
with colin clout
Aged Men[alcas] heard the labourer's tale
How Pope then raze[d] timbers strew['d ∧] the Vale
and Silver Thames [was heard to groan ∧]
and hollow voices in the croft to mourn
shows the the [torn ∧] cornice doom'd to feed the fire
light his low cottage with ore
For has he homewards drew the sheep store
[Heard ∧] O father let us at next Lammas fair
Part with sheep and all our lamkin[s] shear

My Bloss [maid?] will give shining hair
Sleek as the thread, [the shining with a care ∧] my Mother's
Lobb will add I am sure [tis ∧] frail
That even the if it will ough[t] avail
To buy those pieces but you said that fame
would always be remember'd by his fame

p.151 I did my Colin but of wealth and power
in – the House low as the lowest plower
or like this elm that on[c]e the margin graced
and round the trunk when growing oft [I] paced
At Twickenham wake – but it[s] high top
 it suddenly did rot
Alas old mammon fell'd its branching top
but memry yet will tell tale
now useless as the fragments canst recall
Pope or there one loved wall,
depart[e]d worth or stay there

Then B with grief will ty with weed[s] her hair
With Black next year I'll all my yearlings smeer
No riddel that the tear which
but sooty black and harken frail
useless all winter hang like broken pail
and all the long summer shall my own sheep
and near the spot we k[eep]

If has the sower arguement with tried
For yet old oak Thames side
The Farmer with cords to loosen
The breeze crying thro the vale
and sighing winds unknots the flag sail
In idleness

Inside back cover:
His task perform[d] the hyed
and met Menalcas by Thames far side
and Colin & [?Merlyn] gay
That led by she[ph]erd in Evening sunshine lay

in mournful song will Thames in Music flow

Draft on a loose piece of paper in the *Verse Book*:
Resplendent Seasons ! chase Oblivions shade
While insence pure from liberal hands shall ris[e]
To Thomson's worth; The Spot now sacred mad[e]
Whence nature oft engaged his raptur'd eye[s]

While liberal hands the sacred Trophy told
On Putney's Lawns – where Thomson oft [survey'd ∧]
Nature, pure subject of his simple Lays

Written on the back of a letter from the Royal Academy

When Phoebus swift descending deign'd to show
His heavenly skill to draw the golden bow
For when no mortal weapons could repel
Enormous Python horrible and fell
From his bright bow incessant arrows flew
and as he rose this hissing serpent slew
Thou cans't the great preserver of mankind
So Death
as thou decended from the sky
The monster Python meet thee and thou slew him
with thy golden bow, hence arrow after arrow shot
untill the quiver shrinks the monster fell

Portenous horrible so proud
Struck by thy darts the monster coil'd
His snake like form voluminous and vast
and writhing turns his wounds 'ore the moist earth
Till the moist Earth een blackens in his gore
Struck by thy dart een the Python coil'd
Voluminous and vast in deathly coils his snake like form
then the moist Earth absorbed the reeking [gushing ∧] gore
Burst all his wound in one
Struck by the Darts the Monster Python coil'd
Voluminous and vast his snake form

TB XCVI *River* sketchbook *c.*1807 (see No.32)

f.66r ⟨Pope's House & G[?arden] the [? curved river entwind]
In Twickenham lower reach Isis inspired
In Kew sunshine Tompson the moral mind
The noble say that man himself might staunch
This throbing wound
The panting swain to beg in favour rose
Some heavenly honor ner did worth oppose
In vain the when sweet horns a heard
dance the gay hours in Tw[ickenham's] sound
Stallion and Hunter she view
and he would pity⟩

⟨In deep dun gloom Umbrage throw
In awfull silence⟩

f.69r ⟨Proudly alone
Her straining canvas courts each [raging gale ∧]
Glides with the command of canvas sail
But Poesy the [?pride] of tunefull swains
That courted nature on the Thames
On Richmond's crownd hill or meads
or Ham's the season leads

Her rosy fingers May for him morn
or sunny summer golden river dawn
Autumnal Mist bedecks the [ripen ∧] corn
or Winter freezing fingers on the nak[ed] [thorn ∧]
all dust by him who ruled the [h ∧] show
With chearful numbers sing the V year
Thomson the [?founder] of the mo[ral?] man
Adore his Maker as his verse ran
As T[hames] fair Banks reflect her var[ied] dyes
 the azure vault[ed] skies
He sang as the h [runs]
in gazing between the silver river [returns]⟩

f.68v ⟨or he who touched the rankling smart
of Cloister[d] love but not requited heart
Sigh for her husband her secret woes
The dread curse from when[ce] woe arose
[With ∧] or fair Lodonas [?brimming] stream
so near proud Windsor [ray or ∧] beam
And peaceful Binfield naked shade
 [?parted comrade he playd]
In rustic Verse his early time beguiled
& often natures sweetest flowers are wild⟩
With conscious power the manly Nile dos break
And gathring strength from high Gambia's Lake
Impelled o'er rocks decends thundring wide
and bursting wave amid concussion [ruins ∧] ride

So Troys dread Son & battle hostile power
burst thro the bulwark of the Grecian Towers
In Slaughtered heaps his wrathful course controul
Man oer slain in dreadful tumult roll
Patroculas corse defield with dust & gore
The struggling Greeks drags from shore to shore
Pale Hectors in triumph trails the [?agamemnon ∧] plain around
His Troy to deep fountain (= foundation] feels his fatal wound

f.70r ⟨When gathering clouds all willing borne
And Edding leaves portend an approaching storm
Oft hope kind gleams shed by the west
And fires the cloud with glory not their own
Then the dark prospect of my present care
No toiling hand no breezes fan my hair
With strong potion stain hope – appear
Unheard scorching sighs the more do to fear

For Some I'll morn or the lengthning Vale
retains the light while lengthning shadow fail
Around his head beams high the sacred fire
The weary [?] & by Poetry her soul inspire
For vanity now all laws dispute
The right of nature lies in common scorn
[*written along side of page*]
When evening glimmer ray, yet [stormy ∧] falls⟩

f.70v ⟨Unhoused unfriended pelted by the Shower
Like the torn
Her heavy sigh with sad rember[ance]
When the poor lamb caught in the thorn
Which shelter gave [when ∧] [?wool] to roll
Midwinter so niggard like bare insidious shades
Denys return [given ∧] its tender [fleece ∧] sides invades
When [?fierce] Aquarius reigns th[r]o half the pole
 the land
At first rate judgement sooner bought
Each like thrilling shout the pregnant [shrill ∧] strand
Placd at your board or in the sunshine play
The parting crew as cravd like on lease
The wriggling salmon each though both praises
Useless as thistles – shew arts sister land
Stick to them alike oer its surface flee
 as the dawn by every window creep
 Glorious Wreck
Alas perhaps or soil of generous mould
No fishy cotton [muslin ∨] but the arts open cold
Warm to the ray of arts but soon grow cold
but warm fallows
The weedy mischief all his treasure binds
Thomson or the whole the fresh Earth Wind⟩

f.71r ⟨As sure in Art the bearer of the cradle
Host of Opinion dogma unheard
 Thou best understood
 seat self love
Trust all to consequential boasting
 self conceit
For arts each man as ready as his meat
Born into friendship scarce lets the great door
Creak on its hinges which must hang before
Draws up the current or drains it dry
prevents another catch his Patron Eye
By inwards consuming – each has a frail part
Thus reigns disfavour round in things of [art ∧]⟩

f.71v ⟨O lost to honor and the sence of shame
Can Britain so forget his well [Popes ∧] earnd fame
To desolation doom the poet['s] fane
The pride of T[wickenham's] bower and silver Thames
 lost book
That charm his Summer hours be forgot
Mark my sister Isis all my tears
Yes silver Sister Isis join my woe
Let scorn wound not lily's gilded brow

By your dear banks may I follow
 where silvery beams do fall
 To us thy claim
Tho it[s] desolated walls

To us rembrance hangs worth with double claim
Tho an ungrateful country may forget thy name⟩

f.72r ⟨Hark the rude hammer
 harsh steel the sawn rafter Breaks
Down from the roof the massy give way
Rent the wall, and let in the day
Like some fair that onc[e] the margin graced
By beauteous ruins at once displaced
In slender frame or the grass[y] mead
 dew around
Recalls each echo desolating sound
No more I'[l]l wear the lily on my brow
But sooty weeds now Popes fair fane is low
And as my streams do wash the lowly wall
In sorrowful embrace – deeply fall⟩

f.72v Raised like the house by some rude afront –
[*13 lines of further illegible pencil draft about the Thames and Pope's Grotto*]

f.73r [*4 lines of illegible draft*]

f.73v ⟨While spent in a golden torrent held
Scarce dare to urge to
but trace sure works its weedy way
Looks round and screams amen
Who holds the rank of Poet
Nor those who aspiring ambition fires
And love insatiate of the bay inspires
but nurturing rank demand and looks
The judgement praise as some giver
There was the time when rem[embrance]
When those who soar above soft cond[ition]
Who careless of the raptured eye thy
rousd by thy
about I listen and [?remember]
Myne was the time when [?]
When those who sought to say
 Poet who bloom and they disdained
To court in courts amongst the social trains
To make even Harley seek the courts
For Parnell poor to welcome to his dome
[*Now only the pointed del.*] fingers point
The pointing finger now
And though it now, now I want to digress
To know or regard at poets fane
Even – he who left fair Binfield pleasant heath⟩

f.74r ⟨And living on the Bank of Thames
 delighted
 Expanding charmed to his tender hope
 The thankful country whose altar Pope
 The mansion honor on [are ∧] far Twickenham pride
 The Grotto to chant the far trees to save
 or in silver stream
 To me the Grott – the grave
 alas our view the fatal hour [is] nigh
 when the torment must meet the eye
 Unclean hands in deep recess to lie
 The cause of all my [?] woe
 for whence my tears infin[ite] flow
 could not one man tho favord ill [thy worth ∨]
 [?Evince] for Ostentation
 Taste unheeded draws hea[r]t here
 but – usurps her heavenly veil
 and to the vulgar labour ap[p]ear [wealth ∧]
 Each think the Jewel Centerd in himself
 no not one to love of none
 but sordid pelf
 deaf to the names of the [illustrious dead ∧]
 yet oer this page some earnd⟩

f.71v ⟨The drop [?] from the dewy rill
 by Autumn dews the down[ward] bud distil
 caught by the orient light of early morn
 by which gay colour born
 The happy riv[er]
 ravished her fair eyes independent of the ill
 Envious of his value she fain the guile
 Can merit suffer and can all rise
 such like
 of Binfield bind the pastoral reed
 or lament over Troy grown proud the [?courteous] deed
 or War sad victims or the sad [?constant] care
 of poor Eloisa low tenebrous lair

 or Windsor subtle beauties shine in view
 his Kew, Rich[mond], Twick[enham], Binfield too
 Ah when his future to court fair bower
 Mourn in the [?Summer] her vac[ant] hours
 while Britons loudly in the [?forest] sang
 and Halcyon days around him.⟩

 ⟨And for mere wealth might [?reply] [cry Pope ∨]
 when cost or nothing of matchless
 nor virtue left to stop the [lifted steel ∨]
 That oer the manor now [tread weal ∧]
 lifts from those walls the [masy beams tho bold ∨]
 The princely honor as in days of yold
 Whind the timbers and let in the day
 And dancing sunbeam[s] now do play
 Or my low grot as in a [mere ∧] highway
 I live the longer yet can think
 But in Kind Thames shall hide [my woes ∧]
 Should ever Art as in the [nation saw ∧]
 Amidst the rude jar of deadly War
 Hark the dread crash the fall
 And of desolation to bury all
 Ever the young victor gay in joy
 and causes always this our alloy⟩

f.75v [25 lines of largely illegible pencil draft: ⟨wealth and virtue⟩]

Inside back cover:
 ⟨That man the price of lead not state
 Can [?Thomson] cross only feel applause
 Why native honor bleeds in England's cause
 Perish the common lot the constant toil
 Pardon my muse the envious might
 Then embark for my country's weal
 Each pendant dew drop oer the dawn to [steel ∧]
 Like – ⟩
 [A further 16 lines of almost illegible pencil draft from opposite end of page:
 ⟨Thames Bowers⟩ and ⟨oceans Grotto⟩]

TB XCVII *Windsor* sketchbook *c*.1807

f.83r ⟨Discord dire Sister of Etherial Jove
 Coeval – hostile even to heavenly love
 [By envy *del*.] Stung unasked the feast to share
 [For Psyche *del*.] marriage
 unasked at Psyche marriage feast to share
 Stung with revenge and envious of the fair
 Fierce as the noxious blast of wintry skies
 Rushed oer the vales where Hespherean Gardens rise⟩

f.83v ⟨Discord dire Sister of Ethereal Jove
 Coeval hostile even to heavenly love
 Ranckling with rage, unask[ed] the feast to share
 For Psyche marriage rites divinly fair
 Rush'd like noxious blast of wintry skies
 O'er the [guardian ∨] Hesperion garden rise
 The far stretch dragon in himself a host
 aw'd by her presence, slumber'd at his post
 The timid sisters, fear'd her wengfull ire
 Profferd the fatal fruit & ate prophetic fire
 With wrongful pleasure, the golden apple took
 Love felt the wound and Troy's foundation shook
 What mischief would insue: The Goddess heard
 With warm pleasure then her choice preferd
 The shiny mischief so wisely thou took
 Love felt the wound & Troys foundations shook⟩
 [*written at side of page*]
 ⟨At Psyche marriage feast to share striving to
 revenge our love of the fair⟩]

[155]

TB C *Spithead* sketchbook 1807 (see No.31)

Inside front cover:
> Come Oh Time nay that is stuff
> Gaffer, thou comest on fast enough
> Wing'd foe to feathered cupid
> But tell me Sandman ere thy train
> Have multiplied upon my brains
> So thick to make me stupid
>
> Tell me Death's Journeyman but no
> Hear [me *del.*] thou my speech spoil not grow
> Incumbant while I try it
> For though I mock thy flight tis said
> Thy forelocks fill me with such dread
> I never take thee by it
>
> List then old *is was* and then to be
> I'll state accounts twixt me and thee
> Thou gave me Ist the measles
> With teething would have taken me off
> Then mad'st me with the Hooping cough
> Thinner than 50 weasles.
>
> Thou gave'st smallpox the dragon now
> That Jenner combats in a cow
> & then some seeds of knowledge
> grains of grammar, which the trails
> of pedants thrash upon our tails
> To fit us for a college
>
> & When at christ Church twas thy sport
> To rack my brains with sloe juice port
> & Lectures out of number
> There fresh men Folly, quaffs & sings
> While graduate Dullness clogs thy wings
> With Mathematic lumber

On flyleaf:
> Thy pinions next which while they [gave *del.*] [wave ∧]
> Fan all our birth days to the grave
> I think ere it was prudent
> Ballooned me from the schools for town
> Where I was parachuted down
> A Dapper Temple Student
>
> Then much in Dramas did I look
> Much slighted thee and great Lord Coke
> Congreve beat Blackstone hollow
> Shakespeare made all the statues stale
> And in my crown no pleas had Haled
> To supersede Apollo.
>
> So Time, those raging heats I find
> Were the mere dog star of my mind
> How cool is retro[s]pection
> Youth gaudy [Summer ∧] Solstice – oer
> Experience yeilds a mellow store
> an autumn of reflection
>
> Why did I let me [lure *del.*] God of Song
> Lure me from Law to join this throng
> galed by some slight applauses
> What arises to a when B
> or what, John Bull a Comedy
> To pleading ditto Causes

> But thought my childhood fill dreams
> Though my lank purse unswollen by fees
> some ragged music has netted
> Still honest chronos tis most true
> To thee in faith & others too
> I am very much indebted
>
> [*written along side of page*]
> For thou hast made me gaily tough
> Inured me to each day thats rough
> In hopes of calm to morrow
> When Old Mower of us all
> Beneath thy sweeping Sythe I fall
> Some few dear friends will sorrow
> Then though my idle prose or rhime
> Should half an hour outlive me time
> Pray bid the Stone ingravers
> Where 'er my bones find church-yard rooms
> Simply to chisel on my tomb
> Thank Time for all his Jewels

f.71v A shepherd boy as he drove along
> And fleecy charges [along the thames side ∧]
> Sought the Old Swain in his usual seat
> With faltering accents his tender lambkin bleat
> Tell all the news he fraughtful came
> the of Pope well earned fame
>
> Alas my lamb my heart full can have heard
> The mournful Thames sent back the dolf [= doleful] sound
> When balmy wispers on the ground rebound
> The mournfull rustling of the aspen tall
> As yesteryear even some day did [forever ∧] befall
> To homely remains

Inside back cover:
> Hind head tho[u] cloud-capt winded hill
> In every wind that heaven dos fill
>
> On thy dark hearth the traveller mourns
> Ice[y] nights approach & growns
> The low wan sun had downwards sunk
> The steamy Vale looks dark & dank
>
> The doubtful roads scarce seen
> Nor sky lights give the doubtful green
> but all seem d[r]ear & horror
>
> Hark the kreaking Irons
> Hark the screaching owl

TB CI *Boats, Ice* sketchbook 1806–8

f.85v ⟨Then B shall ty with yew her hair
My lamb I mark with hemlock sheer
Twickenham or fill the milking pail
and Colin Clout hang up the useless flail
In sad content and sad T dos flow
And on its bosom bears the bargemen woes
I'll tell them that
 Where he guides the floating wood
and mocks the place w[h]ere Pope Hou[se] stood⟩

⟨The lengthy shadow fall as goes
the weary⟩

f.86r ⟨The weekly cash perform and wages paid
The weary labourer quits the farming glade
With sorry face [show all ∧] wind[s] o[e]r the stony shore
To poor
Till all his toils the blunted ax[e] had [wore *del.*] [bore ∧]
Saw the razed timbers fall from famed Alex[is] roof⟩

f.86v ⟨As you my son
I'll sell our flock a[t] next Lammas fair
My tender fleece I will carefull sheer
My Bloss [?maiden] will give her golden hair
That with the harvest sheaf does full compare
Poor Colin Clout a wield the saw flail
or all next winter oft will not avail
To keep on T[wickenhams] banks Alexis name
his to record his fame

This low laid Elm that now may behold
once flourished high in verdant vigour bold
around its trunk the swains the song resound
Regaling [?make] a country dance around
Spread round the mead the band
From scorching sunbeam lowing heifer
but powerfull wealth its top most [lopt ∧]
Indignant nature felt the wound and stopt
The vernal moisture now useless lies
So will you pray or my tongue belies
Lost is Alexis to me
The Swains of Thames sigh[ing] sing his name⟩

f.87v ⟨On Twickenham Banks as living sunbeams play
a Shepherd Boy his early lay
The flock
A Shepherd Boy with [labourers ∧] mien leads
his flock by Thames flowry meads
And the trembling throng the foaming rim leap
The pride of Thames

Fraught with the reeds which harbour sheep
his aged Grandsire sought
Alas my son nay too long thou soul of toil
have on my fears –
Old have sent them dolfull [on ∨] [around ∧] [to my breast *del.*]
Each falling timber from the wall resounds
The mournfull rus[t]ling of the Aspen tall
At yester eve some ruin would befall
To or men ah little my
Ah little did I think yon hous's fame
Would lose its once respected name⟩

f.88r ⟨As my son could behold the [?respected rich]
Alexis name your mercy would reach
He thou oft has told me left the shade
of Beau[t]ifull Binfield and a Grotto made
Where silver Thames with [but ∧] scouts
With silver and g[old] facing every court
Him shew how hast said call Windsor gr[eat?]
At on[c]e the Monarchs and the Masters seat
Amidst his house sank
& your Thames so Thomson to fame⟩

Inside back cover:
⟨To workmen show him in weekly gain
and tear the flesh of him that his Ax[e] had made
Age M[enalcas] heard far less rejoice
Like lenten lambing
With B your Colin newly bride
Which B of Lob with pity smote
All like Alexis⟩

TB CII *Greenwich* sketchbook 1808–9

f.1v O Gold thou parent of Ambitions ardent blush
Thou urge the brave to utmost danger rush
The rugged terrors of the northern Main
Where frost with untold rage does wid[e]ly reign
The long lost Sun below the horizon drawn
Tis twylight dim no crimson blush of morn
The deepning air in frozen fetters bound
Gives up to cheerless night the Expanses round
Contending Elements in cong[r]egated clo[uds]
Th[r]o the drear void contending horrors roll
and jarring elements [worlds ∧] in uproar Heaps the pole
Packs mass on mass with [while ∧] cong[r]egated clouds
In orefull darkness the dire Geni – shrouds
Slumbers for ages till Britain daring grown
Sent valour tried, in search of climes unknown
Thy keel O Willoughby with solitary sound
First broke the limits of the vast profound
Fiercer than [the ∧] savage War-hoops yell
more fierce than Medea's charms or Runic spell
rouzed the at his s[l]umbers broke
The Au [northern ∧] light ignatidly he spoke

f.2r ⟨In ardent Summer's golden [?measure]
and balmy ether sweetness full⟩
Sweet as the fragrant gale that blows
By dewy morn o['e]r opening rose
Sweet as the flower that calls the bee
To revel deep in Luxury
As wild Thyme sweet on sunny bank
That morn's first ray delighted drank
Sweet as the Honey'd drop that holds
The Wanton fly in treachrous folds
Such sweets does summer daily pour
Oer man oer field oer hill oer flower

f.2v Alas that Woman should so fear its sway
That against nature, nature should so obey
Alas that man should so deceitfull prove
That for thy show should so impatient rove

Change after change in Hypercritic Love
Should so neglect the breast that for him fears
Turn from that Eye for him oft wet with tears.

f.3r Few the sweets that Autumn yields
The enfeebled Bee forsakes the fields
The drooping year the shortend day
No glittering rays o'r fallows play
Th[r]o thickened Ether doubtful peeps the dawn
The humid air bedecks with drops the thorn
Few gilded Mornings chears the skies
But fog or Mist oer Uplands flies
Sighs th[r]o the branching Beeches mossy grown
On Knockholt's a[i]ry hills to [every ∧] season thrown
Hail Silver Thames far famed Augusta's pride
On thy broad wave lo crowded navies glide
Far in high horizon trace the extended sail
That Commerce sends to brave the Winter gale

f.3v Thou bids the sailor hoist the pliant sail
That struggling flies beneath the rising gale
To the all pervading [?] fail
When the furious North & E Winds prevail
And kindest thoughts to stay him aught avail
In harsher accents all the storm defies
Alike to him the danger and the prize
Th[r]o every Wave the dauntless Sailor plies
He fears the rush of Equinoctial skies
For these undaunted plies the hardstrained Sails
Thro every wave and Equinoctial gale
O Winter the nurse & the bane of life
Thy very name bears oft domestic strife
The spur to Industry the misers fall
So Beastly. ⟨grainy⟩ His deep scored wall
bequeaths his wealth even to his eyes & cares denied
For fear denies
even fear forbids a gleam a light to share
a moments Knowledge of his golden care
Suspicion guide where real dangers fail
The fly might hum to him the sounding frail
O lovely Woman ⟨with open mouth then to know⟩
With sorrow feel alas why man did to bow
Obsequious at thy wealth of Gold displayed
Not of that worth ordain'd by Heaven [or Man ∧] to aid
Tho[u] bidst the Sailor hoist the pliant sail
When the fierce North & Eastern gales prevail

f.4r In harsher accents all the storm defyes
For the[e] he braves the crash of icey skies
The swallow Circling sees the rising skies
For Southern gales her full grown pinions trys
Leaves us to care to shrink beneath the blast
That to the ground the woodland honor cast
The crimsond briar the deadly night shade bare
Tells Winter keen approaching [does approach and piercing ∧] air
Chilld Nature sinking feels thy coming power
Deep thrilling feels the change at midnigh[t] hour
By long days and nights or
The blustring winds at Eve & driving rain
Each long drain[d] Pond pours oe'r again
Each way worn Path proves a [guides narrow ∧] rill
Each deep swoln ditch the dun colord river fill
Far oer the Vale [heath ∧] the Edding leaves are hurld
The chequered Vale shows natures robe unfurled
Of felon strong to rend the massy door
A life of misery by [more ∧] miserably poor
Extends his beastly hands to save store
Relieved from fear he only thirsts more more

f.4v The extended town far stretching East & West
Thy high raised smoke no prototype of Rest
Thy dim seen spires rais'd to Religion fair
Seen but at moments th[r]o that world of care
Where Vice & Virtue so commixing blends
Tho one retires while one distruction sends
Oer children's children whatever Low & Great
Debase or noble here together meet
To a concentrated focus hope together draws
⟨The British Nation wealth⟩ the sovereign cause

f.5r Fell winter soon the r[e]maining leaves will shed
An[d] snow and sleet press gently oer thy head
Till Spring resumes her [chearing ∧] renovating store
Oer Man & fields her balmy influence pour

Each Embr[y]o bud that wakes the torpid bee
The blooming Orchard & the Hawthorn tree
Gives life to Myriads close each narrow cell
Warm by the sunny ray contented dwells
 [soaring scans ∧]

The ploddindg care vain toil of human Hands
Till the revolving year brings Winter on again
And binds all nature in a frozen Chain

Hail life returning balmy Spring
Thy praise O Summer insects sing
Autumn thy worth the fields proclaim
And Nature chills at Winters name

f.5v As the bold Merchant with [?leaping] [warmth ∧] heart
Looks oer the maze of Speculations chart
Views competition with exulting eyes
As oer the wave his full fraught vessel flies [ride ∧]

f.6r The Sun-crackt path and summer [bell ∧] blue
By children strew'd at play or fairing new
Delighting boys with brightening rays the [days ∧] display
 [gay ∧]
or calls or broken silver shines the way
That now so slippery prove to plough-boy tread
As heavy as his team, slow pacing to their shed
When loud insects in summer ray
Accross a road in summer stray
The [?exhausted] [struggling ∧] beetle in rut delug'd around
The Winter darkened & by drown'd

f.6v For th[e] he braves the rugged northern skies
Explored the Greenland icey bay
To ope to golden shore another [shorter ∧] way
For the North West Pass. in vain was tried
The daring Willoughby for the unshakenen
For thee the daring Willoughby died
With stiffning sails the congelating [plies ∧] tide
But Willoughby in frozen regions died

f.7r ⟨Say Friendship and accept a thought tho wild
of him who long has struggled to impart
His love of nature and meek natures child
Alex's' reed no more this minstrelsy playd
Sweet in the pastoral dignity of Twick[enham] glad[e]
The honord mansion gone [?Rich.] that cheer the Eye
And silver Thames flow dull & Sullen by⟩

f.7v ⟨Birth or nature steers the doubtful [light ∧]
That round him broke harsh effrontery
That [?watchful Prophecy] has try[d] in vain to tell
The mighty mother conscience catch⟩
Then terror and dismay o['e]r Southern [ether ∧] burst
Presagefull of thy fate for fatal word

From frozen nostril hast unfurld
Rold the full summons th[r]o the central world
⟨Th[r]o [?Eastward] ice bound ribs the sun hurld⟩
The coral cavern of the main resound
In repercussive roar the frost bound ocean sounds
In the dark conclave rush the high compeer
Lo Britains bark too daring hither steers
⟨Did I for this withhold your sway
That sweeps or thy billow rise way
Check thy
Allows the Sun to gleam o[e]r G[reenland's] bay⟩

f.8r ⟨Disporting on thy margin green
The paths of pleasure trace
Who foremost move delight to cleave
With pliant wave [sic] thy glassy waves
To chase the rolling circle speed
Or urge the flying ball⟩

f.8v Roared the fierce Geni of the northern main
Enflam'd, the north West passage to retain

⟨Then with⟩ a fear benumbing look
Like the moon visage in a blood stained brook
Portentious [lurid ∧] shone summond all the host
Of wind and snow & never ceasing frost
Black Grim Typhon crouds
Slumbering in their Hall
Rushd from their Halls of congregated clouds
Did I for this command you to forbear
Your utmost power o'er the tempestuous air
But did you not allow the beam of day [play ∧]
Oer nights Latitudes to let in day

Or wished you all to brave the utmost pole
 the northern soul
Or loose the frozen chain that binds the whole
Tis true I wish'd their Island [famed ∧] shoud share
That the stern soul should double honest [? = honour] bear
By our wharding influence with my Care
Should banish from their breast all though[t] of fear

f.9r And in southern enfeebling climes afar
Should carry conquests bleeding spear
To every shore to strain the adventurous sail
And pursue in icy seas the Greenland whale
But you insidiously have given them pride
To dare these realms by mortals yet untry'd

Contentious as the warring clouds
At Winter Eve the Ariel power crouds
Accused enflame avengefull harm
In silence awful presagefull [as the coming ∧] of a storm
As the deep fermenting humor crouds the skies
Who rage [?against] cloud of varied dyes
Blots out the day to dismal darkness turnd
[All del.] Existenc[e] lost, save when lightning burns
With flash[ing] horror see the vivid light
That life destroy'd and peacefull nature blight
 power but that piercing light
And scaiths all nature by its banefull light
That life destroys and natures blossom blight

f.9v Lowring as the thunder mighty cloud
At Winters Eve the awe power's croud
On congregated clouds with rage comprest
Accursed extending their spacious breast
With rage contentious ether load

Presagefull of a storm in awful silence bowd [showd ∨]
Roll oer the world['s] far shining breast
In awful silence but a treacherous rest
For as
Lowring on [?anguish] sat the ariel band
As countless as the grains of oceans sand
Medi[t]ating revenge till like the lightning flash
Signaling wrath their powers together clash
Confused and various all contentious rush
Reprisal seeking by the world to crush
Chaotic strife eleme[n]trary uproar wide
Confusion heaped upon Confusion's tide
must have insued but the Geni husht
The gathering turmoil, behold the first
Who for his country dared to roll
His all upon unfurling the ar[c]tic goal
must ne'r return

f.10r But the powerful charm
That keep discor[d]ant nature prone to harm
To judge twixt good and ill husht
The gathering turmiole but the first
Who dared
Husht the impending ruin alarm
Roaring main for the[e] she long will weep
But thy unfading honor neer can sleep
In History['s] page thy brave companions toil
In [thy ∧] dear Country honor'd tears shall smile
When Hope for thy return [h]as bowd to care
And not a ray remains to check de[s]pair
No Vestige left of thy fated bark prow
No scatter'd Plank of Iron branded Oar
Or the least tiding reach thy native shore

f.10v [O Seasons fair of gourd the shrine
Think of your honor T[homson] shrine
Then watery may its sweet entwine
While Phoebus o'er our valies shine
High the Coral Shell then fill
With distant Thames stream rill
The summer breeze his lyre yet fills
With memory sweet and h[a]unt[ing] thrills
Of him that made the Season shine
With watery may, the bays intwine
While Phoebus over our valies shine all del.]

⟨He made the charm of Seasons shine⟩

f.11r ⟨Bring a deck
Fair seasons guard your T. shrine
With watery may
 [?playing] fresh all day P. shine
And wary way it round [w]reath intwine
Where Phoebus over your valies shine
Fill high the coral shell the[n] fill
In many age his lyre let thrill
Speak to the heart [?Pity] yet thrill⟩

f.11v Invocation of Thames to the Seasons
 upon the Demolition of Pope's House
 O Season fair, guard Thompson Shrine
He sung the charms of Seasons [ver[n]al ∧] prime
With watery-may his bays entwine
While Phebus oer our Vallies shine
High then the Coral Shell yet fill
With distant Thames' translucent rill
With Memory sweet and truest thrill
Yet his lyre with Summers breeze fill

f.12r O Season's fair bedeck the Shrine
 of him who made the Seasons shine

 O Seasons fair guard Thomson shrine
 He made the charms of Seasons shine
 With watery may – his bays intwine
 While Phebus dart his raident line
 In Mid-day glare and sultry time
 High then the Coral shell then fill
 with distant Thames translucent rill
 While Summers breeze his lyre yet fills
 with memory sweet and truest thrills

f.12v Not so the studies of [?Mammon's ear] at school
 he in addition add or multiply by rules
 Lay on the masters desk. the cards

f.13r ⟨Guard then that Lyre that every year raisd [fair] time
 Strew riper weed upon his humble shrine
 As raisd they blossom tho the year
 The tunefull reeds that guerdon share
 B[r]eathing whose care
 Lest in responsive cadence to lyre
 The silent reeds beneath Alexis wall⟩

f.13v O Spring with renovating fire
 Snatch from Twickenham shore the tuneful reed

 O Gentle Spring yet renovating fire
 O take from Twickenham the w reed
 Alexis tuned now useless on the meed
 To trip responsive cadence [silent ∧] to seasons lyre

 Attuned to pastoral sweetness thy [harmonious Alexis reed ∧]
 lead
 responsive Sisters oft to Thompson lyre
 Responsive Season break in Thompson lyre
 Thy soft Seasons round the Seasons lyre
 varing in Pastoral sweets memory lead thy sighs
 To Thomson rich harmonous lyre [the Season ∧]

f.14r O gentle Spring yet [with ∧] renovating fire
 Snatch from Twickenhams shore the tuneful reed
 Wove with the Laurel crown the Poets mead Alexis reed
 To trip responsive cadence to his Lyre

 In Summers ardent blush properly give
 Thy many blossoms shield with generous care
 While Phebus pours [around ∧] the Sultry glare
 In thy soft breezes let his verses live
 Thy nodding poppies Autumn kindly weave
 O Benefactress of the passing year
 those strings have [often ∧] trembled with thy care
 Check not their sweetness with the falling leaf

f.14v Winter [sobbing winds ∧] thy sobs bespeak decay
 But yet with melting Pity's eye entwine
 Thy garments round the Lyric shrine
 In [May ∧] While memory sweet each Seasons play
 may sign each parting day

f.23v Beside the masters desk he trembling stands
 But not with fear of smarting birchen brands
 But views his writing fearful he may lose
 The weekly prize when all his joys accrus
 The strimulus of all pride to some is given
 But here share Mammon and appearing even
 Yet small beginnings
 He Builds his mansion but fretfull p[ride]
 To which on and his oil provide
 he bore the com[mand?] of [?futurity] pride

Seizes the collar right contrasted grows
and multiply the his continuing woes
Like the same pain plain
Slugish behold its silver to the main
mid reeds and swamp its damp exhales
with dazzling vapour nor cheer the gli[ttering?] sails
Let other strands that [?futurity] e[e]n pours
Hea[l]th and commercial vigor on their shores

f.24r The smoking roll is eat with greedy haste
 And hope and fear depicted on his face [pace ∧]
 His forfeit paid if avarice will allow
 To pay save a newly crave[n] cowar[d] blow
 Last in privation further loss of pelf
 Such small beginnings are the germ of Wealth

f.33r Vacuity but only yesterday
 oer these fair leave maintain
 Oer these fair leaves but yesterday
 Vacuity maintain her sway
 Untill the sun did immolate
 Yet innocence did consecrate
 Its stain it proved a mark of fame
 When writ in dear Eliza name
 More than perhaps he did [had ∧] desired
 But Paul speake but when inspired

f.39r Scarce the dappled morn does rise
 But Music sweet ascends the skies
 The soaring Lark with fluttering wing
 Does sweet her early matins sing

 With var[y]ing tones at evenings hour
 Sweet Philomela resumes her power
 The echoing Woods the moonlight gleam
 With silver radiance gilds the stream

 The darkend heath once gay with Green
 The feathered songsters hail their Queen
 Impassioned spread their spotted wings
 and Love with Music's influence sings

 O calmly sweet inspiring power
 Shine not my low but anxious bower
 Lulld with harmonious melody to rest
 Let not one angry moment wound my breast

f.40r But nature with her care renew
 Nature kindly will renew
 Thy strings with music & with touches true
 Till natures pours anew
 Thy sweets with tenderest touches true

 ⟨The dewy drops on thy tomb never fade
 but Popes lost mansion sank into the ground
 Sure memory still unto [?their] worth adheres
 Then let that honor on the[e] long be found⟩

f.41r [Seven lines of illegible pencil draft]

f.42v ⟨Till nature kind inspiring touch our air
 Bid the airy strain and all sky
 Strung all thy monody with mothers care
 Her Nature kind inspiring air
 Tunes the[e] to sweetness with impartial care⟩

f.45r Scarce the dappled morn does rise
 But Musick's sweets ascend the skies
 The soaring Lark with fluttering wings
 And [does ∧] sweet her early matins sings
 High oer her nests her matins sings

And Pleasure
In varying sweets at Evening close
Poor Philomela sings her woes
 silvery moonlights gleam
By the glittering moon whos[e] beam
In [whose ∧] sparkling radiance gilds the stream
The darken'd heath now gay with green
returning Spring
 feathered songsters hail their queen
Impassioned spreads their spotted wings
and Love with Musicks influence sings

The music sweet and
Shun not the roof of my low bower
With low harmonious melody to rest
Nor let one angry passion wound my breast

f.45v Restless with care with hope closed her eyes
The Phantom shining calm o[']r her pillow
With care and love she heard her l[over's] cries
As he clings on the rock savd from billows
Kind sleep ⟨repeated in hope closed her eye⟩
Her prayer she deep sighed in hope
That kind heaven would drive from her pillow
⟨The phantom dim sprite as he fled often sighd⟩
The one Phantom as ruling [?another's] sigh
They Lover he is save from the Billow

f.46r Her Prayers then repeated in hope closed her eyes
That Kind Heaven would drive from her pillow
The Phantom dim sprite as he fled often sighs
Thy Lover he is save'd from the Billow

f.54r ⟨He caught the truth of Nature & her dyes
Thompson lone tomb seen wet with tears
Since Pope's remains were lowerd to the ground
that the memory [?softens] worth oer its tears
Let that in thy Eye be found

Season and now show T[wickenham] glade
The Past. reed and Eol[ian] harp unstrung
 is the harmony that [?friends made]
Sunk in plains of chequered shade
And Thames willows [?gurgled] as the[y] sing

Inspiring Spring her renovating fire
With pleased bind those reeds Alex[is] play'd
With pleasure breathing kiss touch the Lyre⟩

TB CVI *Derbyshire* sketchbook 1807–9

Inside front cover:
 The high rain mill that cheats the traind eye

 The bursting spire that cheard our youthfull day
 Warms in our hearts by recollecting plays
 And hope ⟨with a in further sway⟩

f.2v Few the Sweets that Autumn yields
 The drooping year the
 The enfeebled Bee forsakes the fields
 Few ⟨cheerful mornings gild the skies
 But fog or rain oer uplands flies
 But sigh the swain [brand of man ∧] as round
 The leaves turn of the year softens the ground
 Views the last glories of the year depart
 The seething Vale of life impress his heart⟩

 ⟨Yet when rude winter rules [?drear] oer
 The ho[a]ry glebe the sea torn shore
 The memoury seens alone to roar
 Oer gleam
 defies its utmost ray of⟩

 Few the sweets that Autumn yields
 The enfeebled Bee forsaken the fields
 The d[r]ooping flowr and scarlet briar declare
 The approach of Winter entomerlay care
 Few cheerful mornings gilds the skies
 But fog or rain oer uplands flies

 The Beetle windblown feels the gale
 The high reard
 The drooping year the shortend day
 No cheery gleams on fallows play
 ⟨The night shade sheds a [?brier] like [?dream]⟩
 The long drawn Vale the summer pride [?glowd]
 Tho

f.3v Few the Sweets that Autumn yields
 Far roams the Bee on fields
 Few cheerfull mornings gilds the skies
 But fog or Rain oer uplands flies
 The long drawn Vale where smiling ether glowd
 Show'd every stream that slowly glittering flow'd
 [2 illegible lines in pencil]
 In sallow weeds the deluge champagne lies
 ⟨The long lost age with [early ∧] fondness trace
 Each [?] or spin amid the chequered space⟩
 The driving rain deneys the eye to trace
 The Pine clad hight or [denies the view ∨]

f.35r ⟨The parth of the sprightly fair oft trod
 Proves to the labouring Swain and earthen log⟩
 And seeking Nature fear they power
 Deep thrilling feels each Evenings hour
 That thrilling feels chilld with rain
 That changes with rain chilling leaves
 Each long draind pond pour o'er again
 Far oer the Vale the edding leaves are hurled
 [Wide ∧] The chequered vale [heath ∧] shows nature Robe
 unfurld
 Fell Winter soon the remaining leafs will shed
 And snow and sleet press gently oer thy head
 Till spring resumes her renovating store
 Oer Man & fields the balmy influence pour
 Each Embrio bud that wakes the torpid Bee

The blooming Orchard & the Hawthorn Tree
Gives life to Myriads Mark each narrow cell
Warm in the [sunny ray ∨] contentd seems to dwell
Hums or its little tune or soaring scans
The plodding cares vain toils of human hands
Till the revolving year brings Winter on again
And binds all Nature in a frozen chain

The sun burnt path where Children oft playd
With fancy newly got with vanity display'd
No sun parched cracks but deluged oer with rain
Proves treachorus to the step of labouring swain

f.34v ⟨And [or ∧] fancy newly got with vanity displayed
And the drear copse his doubtful way explored
Deep with the river
The well known way to lonely open hills
Twill first with leaves decaying the stranger fills⟩

The swallow circling sees the rising skies
To Southern Gales her full grown pinion trys
Leaves us to care shrink to the piercing blast
That to the grounds the woods and honor cast
⟨And seeking nature deep and brown around
That to the ground the leafy honours cast
See the year honors⟩
The Crimson briar the darkend hair
The the deadly night shade bare
Winter approaching chills the nightly air

f.35v ⟨Sweet the to the Bee
Sweet as the Arab shiny tree
Sweet the morning dew that shew
or the wild Thyme sap winter bed⟩

⟨Sweet as the fragrant glade [= gale] that blow[s]
By dewy morn oer opening rose
Sweet as the flower [th]at call[s] the Bee
To revel deep in Luxury
Sweet as wild thyme on Sunny bank
That morns first ray [dew ∧] in [hath ∧] drank
Such sweets does summer gaily pour
Oer Man & field thro hill and flower

That Man a thrill with
Sweet as the honey drop that shines
That⟩
Hail life returning balmy spring
Thy praise of Summers insects sing
Autumn thy worth the field proclaim
All Natures chills at Winter's name
 Summer

f.36r Sweet as the fragrant gale that blow[s]
By dewy morn oer opening rose
Sweet as the flower as calls the Bee
To revel deep in Luxury
Sweet as wild Thyme on Sunny Bank
That morns first ray delighted drank
Sweet as the honey drop that binds [?holds]
The wanton fly in treachous [twines del.] lines folds
Such sweets do[e]s summer gaily [shed del.] pour
Oer man and field oer hill oer flower
Such sweets as these does Summer shed lead
Oer Sunny hill and flowering Glades mead

But when Autumn streaks the dawn
The timid drop [dew ∧] hangs brightning on the thorn
Few the sweets that Autumn yields
The enfeebled Bee forsaken the fields

The drooping year the shorten'd day
No glittering rays oer fallow play
Few gilding mornings chears the skies
But fog or mist oer uplands flies

f.36v When ardent summer's glory oer does rise
What balmy ether – nature
What
Then Morning Fragrant nature rise

f.65v ⟨Thy leafy honour fill the gale [?vale]
As Even sobs the thirsty Gale

Sweet the breath of early morn
Sweet the Lark thrills oer the corn
Sweet the day Spring sweet the flower
The honey dew bell [?] the shower
That summer
When scorching noon
But Autumn now oer skies presides
and thundry ether clogs the skies
Low in furrowed g[l]ebe the plo[ughing] deep
Hark the sobs oer his sheep
Thy beeches rock to each su[cceeding] blast
Their virdant honor⟩

f.89v ⟨My honor reard and as thy smoke aspire⟩
But pity's sullen eye is brightest seen
When
In yon eglantind cottage beside the lea
[?Josephine] lived as happy as happy could be
For rich is content she neer heeded being poor
And many a Winter & Autumn blesst the door

Those that work hardest get the least for it
Some that are idle live with the most show
Then live

Inside back cover:
⟨[?Josephine] was as happy as could be⟩
[7 lines of illegible pencil draft]
Till love the sly rogue
he crave for admitance disgui[se]dly poor
For pity's kind sake pray open the door
ah simple maid dont believe the lad['s] tale
His words [sighs ∧] are deceitfull & cool as the gale
⟨delighted he [?] the [?] carest⟩
The ungratefull intruder plac'd a thorn in her breast
Then as fickle as false as base as unkind
He left her, he left her and sorrow behind
⟨Conten[te]d had lived but love at last found
Disgui[se]dly poor as the rain it does pour
for pity soft kisses open the door⟩

O Silver Thames far famed Agusta's Pride
On thy broad st[r]eam see trades fair vessel glide
 [thy (?honest) rulers ride ∧]
Far in the flat Horizon trace the extended sail
That commerce sends to brave the Winter Gale
While scarce seen thy numerous spires
in honour reard & as the smoke aspire

TB CVIII *Perspective* sketchbook *c*.1809 (see No.49)

f.8r O apathy unfriendly power
 Tho[u] foe to merits brightest hour
 Sure no genial ray of morn
 Eer glimmerd when thou wast born
 The vernal earth the nature hue
 Where [?cherry] bloom in rankest hue
 That clog the soil or sterile clay
 Where weeds not blossom eer display
 Then cheery drink the sunny ray
 But darkest vapour dewy blight
 More dreary than the darkest night
 Attuned at thy birth arrayed
 And nature's self appear dismaid
 And dreaded feard that half her race
 Would feel thy and disgrace
 What pregnance could help thy birth
 To give a [?balmy home] on earth
 But dischord as she strayd

f.9r In chequer garment sad arrayed
 Disliked by all the sons of earth
 Disclaimed by all men from their birth
 No welcome found in any roof
 But chid with words of sharp reproof
 In kindness wished to escape
 Tho[u] didst sustain our willing rape
 Remorse oertook on the way
 When midnight darkens oer the day
 Remorse of cold ambition born
 With head erect but heart of thorn
 The dourfull moment then allaid
 Infiderence then lent her aid
 Futurity even gave her curse
 and Merlin wishd to be a nurse
 With ramblest eye to give a force
 And cherish in his course
 With heaving loins with eye of fire

f.11r Thou gave remorse as strong desire
 Engraved thee for to controule
 To plunder merit richest soul
 and from his lips to dash the bowl
 That fame delivered to his hands
 Rich with the worth of every [distant ∧] lands
 Leave him to disap[p]ointments thirst
 To feel by every one accursed
 Or loaded with contempt to strive
 and dead to joy and scarce alive
 To nature bliss [full ∧] cheering ray
 That lead him on in youthful play
 [What ∧] Wrought him [on to ∧] the memberd hight
 With prospects gay & pleasures bright
 To leave him to thy baneful sight
 That thou hast for thy sad disgrace
 Entaild upon his future race

f.13r Thanks dearest Vale thou alone
 Has broke dire apathy sad throne
 Where thought had drown'd and lost
 Like shipwrecked marriners are tost
 Lost to all [hope *del*.] joy unknown their way
 But hope with them yet hold[s] her day
 Amid the blackness of the unknown coast [land ∧]
 Still glimmers still enervates the hands

 To brave tho dire misfortune sternest day
 And through contending evils work their way
 Long lost in thy entangling toils
 My mind sank deep within the coils
 Each pleasure that my former powrs
 Had given to fishing grew even sour [anxious hours ∧]
 Below the Summer Hours they pass
 The water gliding clear as Glass
 The finny race escapes my line
 No float or slender thread entwine

f.14r Nor urge my hand to catch a fly
 So careless so indifferent am I
 Whatever passes pass it may
 No moment urge the rising lay
 The wind it is too high too scant
 Tis East or North not what I want
 The sails they give me so much trouble
 And what is pleasure [sailing ∧] but a bubble
 When set I wish they were unfurld
 And fain would give een all a World
 A World of indifference I think
 Nature dame Nature hold each link
 In the great chain that is a Zone
 Where cause and its effect are one

f.20r Must toiling Man for ever meet disgrace
 And eat his hard earn'd bread with heated face
 And all his acts in dull Oblivion lay
 And not with honor pluck one little spray
 Of Fame's famed laurel, while in brass
 Some work their honors some in Glass
 Some paint some chisel out the stone
 And pray to Clio for melodious tones
 Some dare the restless billows to provoke
 And float secure to fame in British Oak
 But then the workman should be know[n]
 To all the world the effort all his own
 Exulting Greece, saw the first to float
 And Argo Argo strained each Grecians throat
 Why not in Britain Novelty is found
 Why should not Novelty again resound
 Then try on Thamias fertile shore
 Where falling waters yields their muddy store
 Describe the form materials where began
 The mighty frame the artificer man
 Whose pregnant mind long in confusion lay

f.21r Like its foundation stretched from day to day
 While grew the timber once so gayly spread
 That foilaged covering of their stately heads
 By rapid Rhone Precipitous and bare
 Stood like a tower in the nether air
 Bared by the tempest or the rage of war
 That marked thy bea[u]ties with an iron scar
 Down fell thy leafy honors to the main
 And more art cherished in the muses strain
 From rugged Norway waves worn coast
 The fir the glory and the Baltics boast
 And harshly sounding to the workman stroke
 Rings firmly s[t]ubborn British Oak
 Squared ready beams and winter lies
 And only wait the great designer eyes
 The eager workmen for this great design
 Tumultous to chalk the line
 That must delimit all whose mark

With that of old was told in Noah' ark
Made out its length and width and brea[d]th
Made out its utmost breadth and length
On which the workman must exert his strength
Or in vain trifles but his ardent mind
Cl[e]ar copious interlects – defined

f.22r This which and which alone to fame
He builds a name [himself ∧] in laying Argo frame
The planks are sever'd with a Sawyer's art
From each that proved its Counterpart
And placed side by side alternatly
Then crossed by pieces transversely
Thus for the bottom that to waves unknown
That binds the world in with a liquid zone
Or thrown upon the hardest stony beach
Presumtuous man a [usefull ∧] lesson teach
The sides are bent and turned with care
The seams are closed with tar and Hair
The powerful head [like *del.*] an ancient prow
Rakes forward with commanding brow
Sides timbers bolted to receive the shock
And bear her burthen on the dreadfull rock
Sails, scuppers, gridions, pintels all
and loud for pitch the noisy workmen call
Who can recount the names, or toil
Thro labyrinth himself to only coil
Like knotted rope that bin[d]ing over spun
Twists into which can never be undone
Which twists and cannot be undone

f.23r Suffice my muse onwards turn your care
And for the Launch thyself prepare
Recounts the lofty banner on the prow
The painted pride of humbled Nations show
And eager eyes that glitter in a row
Beauteous and bright like summers streams
When noon-day radiance downwards gleams
All beamd on Argo on that day
And made her bright in beautys ray
The mighty rollers to conduct her o'er
The dreaded journey are placed before
[To *del.*] sustain her weight upon the groaning shore
Besmear'd with unction rich distant sought
and only with the sweat of thousands bought
To stride in gaudy pride upon the plain
Free from dire accident or strain
And disappoint [the ∧] fair attending train
Tackel and blocks and all made sure
To make success even more secure
And now the ensigns broad displayd
Britannia glory waved arrayed
In Crimson grounds the moral Crown
Of Commerce fair resplendant shone

f.24r The cross and Union sympathize
And wide oer all thy banner flies
Of fam'd St George of sanguine hue
Whose t[r]enchant sword the dragon slew
Waved oer the field of maiden white
Thy crimson cross appear more bright
The humbled pride of Gallic chance
The boasted triple flag of France
Batavia since she now must groan
And painted Liberty but not her own

Iberia flag tho now as an ally
In equal portions meet each pleased eye
In dazzeling folds and rich as Flodden field
Not in gay colors could the page[a]nt yield
And now the Gun flashes th[r]o the air
Its thundering voice prepare prepare
Remove the shore that hence her weight
May not upon the shrouds so great
Bind all the ropes more tackel have
That may perhaps her honor save
Where ever danger most appears
There the chief artificer steers

f.25r Directs, enforces, threats & pray
Orates and chid[e]s and fears delay
Looks with most anxious eyes to fame
And thinks that he can grasp the dame
All ready, ready let her go
Long as the Thames shall flow
May thou be blest my dear Argo
All ready, ready every one replies
O Goddess hear my ardent sighs
Swift as an arrow from a bow
She goes she goes then let her go
Long as the Thames shall flow
O Goddess bless the ship *Argo*
Argo be blest the strain resound
Argo be blest the shores rebound
Even Echo murmured Argo long
But dire mischance she broke the thong
Most carefull care had thought so strong
Crash – tackles block fell on the deck

f.26r Even Argo's self had gone to wreck
Had not the Artificers hopes
Rely'd on self instead of ropes
Bore Argo safe from all alarms
Eneas like upon his Arms
Rage disappoints fired his breast
He plunged her into Thame breast [distrest ∧]
You shall no longer loose your prize
She is good for nothing dam her eyes

f.28r The Sweets of the Bee and the bloom of the Rose
Did fair Josephine in her May day disclose
Contented had lived as the day rolled its round
But to Wills Cottage [by ∧] love at last found

She craved for admittance despairingly poor
For pitys Kind sake pray open the door
Alas simple maid she believes his sad call
When love drops a tear can that tear ever fall

The blossom of hope even [thou ∧] by Cupid cares[s]t
Looked languid and dropt upon Cupid possest
Then as false as the breeze as false as unkind
He left her he left her & sorrow behind

f.29r Be still my dear Molly be still
Why urge a soft sigh to a will
That is eager that wish to fulfill
So I prithee Dear Molly be still

By thy lips giving motion I wheen
To the centres where love lies between
A passport to bliss is thy will
So I prithee dear Molly be still

By those Hairs which hid from my sight
Thy sweet eyes when half closed with delight
Then with kisses thy Lips I will fill
Yet I prithee dear Molly be still

By bosom wild throbbing with youth
Their heaving to me speak reproof
[Where love might a kiss emprint]
By the half blushing mark on each hill
Yet I prithee Dear Molly be still

f.29v Love between them take a rest
And Revels in thy downy nest
The rival in his lair I'll Kill
So prithee dear Molly be still

By the touch of lip or rove of my hand
By the critical moment no Maid can withstand
Then a bird in a bush is worth two in the hand
O Molly dear Molly. I will

f.31r Be still my dear Molly dear Molly be still
No more urge that soft sigh to a will
Which is anxious each wish to fulfill
But I prithee Dear Molly – be still

By thy lips quivering motion I ween
To the center where love lies between
A passport to bliss is thy will
Yet I prithee dear Molly be still

2

By thy Eyes when half closed in delight
That so languishing turn from the light
With kisses I'll hid[e] them I will
So I prithee dear Molly be still

By thy bosom so throbbing with truth
Its short heavings to me, speaks reproof
By the half blushing mark on each hill
O Molly dear Molly be still

f.31v For love between them takes his rest
I am jealous of his downy nest
My rival in his lair I'll kill
So I prithee dear Molly lye Still

By the touch of thy lips sure loves band
By the critical moment no maid can withstand
Then a bird in the bush is worth two in the Hand
O Molly dear Molly. – I will

TB CX *Cockermouth* sketchbook 1809 (see No.47)

f.1r Adverse frown[s] my wayward fate
Fast selling on my poor estate
O Heaven avert the impending care
O make my future prospects fair

f.1v The beard of Hudibras and the bard of Gray
The spinning of the Earth round her soft axle
ample room and verge enough

So nearly touch the bounds of all we hate

TB CXI *Hastings* sketchbook 1809–11

f.18v ⟨And where Power if Power could prevail
That urges all our actions yet without avail
Give impulse to our thoughts Fancy sight
Wake us for what [= want] of other [?] words
Stands as a word indefinite yet weak
For Fancy is in infancy [but ∧] a mere caprice
In Manhood headstrong patron sways
Yet still we hardly call it Fancy form
That forces on our mental quality
To guide thus wrong & right others doubt
Can claim thy aid who dares to ask
What is imagination where its seat within
That lift the soals of some to soar beyond
The power of perseption yet by perseption
Of material forms and qualities feebly shown
To persue the unknown force that razes all
Passions that makes the difference betwixt
The fool and he of sense the indownment
Given at our birth⟩

f.26v ⟨The earth unruly gave thy body [form ∨]
The mind fled pictured harm
Till young Appollo with his bow untryed
And only with the blood gushing dyed
Gave thy [?invisible] [?inwards] the gory wound
And with thy agony thy cave resound[s]
Wrything here conquered your gore no more
Of theft they each thy warm body tore
In agony thou racked thy coils in vain
Still then thee
And writhe but to swear the stain
Dashing thy en[ormous] bulk on the rocky floor
That grind on earth thy blackened gore⟩

f.36r ⟨Gord by this dart the monster coild
Portentous horrible and vast his [?stumbling] form
Rent the high world of his rocky cave
And in the hold of death intwine
Wound fully round in one which Earth
Absorbing blackened [with ∧] in his gore⟩

f.40r ⟨Oh thou I thought mark only
My longing Eye
Bent on earth rapturous delight
Art thou too fled
Say did those souls beneath the roses win
Or hostile heads by midnight gloom
More dreadfull made
Or by the thrusting cliff that echoing
Down thy winds laid
Prone in dust and all the conflict done
And only lift a frail monument [stone ∧]
To mark thy once domain
Where pleasure seemed to reign
Gently lifted over the azure main
That humbled at the feet rest
But when even and the dusk⟩

f.39v ⟨Sent forth that power in dread array
Thy loving favours tumble to thy ground
And all mingled combine threw arround
Gone [?before] to the once loved roof
I felt the power of loving with reproof

A sigh to be thy inmate by just fate
Him by what we're taught to call
And that power so condemned rest
Whatever it is mistaken for the best⟩

f.53r ⟨Where thy Victorious hand vouchsafed to show
The wonders of thy shaft and golden bow;
When Python from his den was seen to rise,
Dire, fierce, tremendous of enormous size;
By thee with many a fatal arrow slain
The Monster sunk extended on the plain
Shaft after shaft in swift succession flew
As swift the people prays in
 shouts and prayers pursue⟩

f.52v ⟨Thy vengful arrow deep transfixed
 in faling tore
[The ∧] which the⟩

f.54r Where's the distance throw
me back so far but I may boldly speak
In right, tho proud oppression will not hear me

f.64v For ever Philomena whose powers admits thy sway
Or why so many lunatics who shriek and scorn
And boldly condemn and loud decry
All those who pray so fervent or devout
Think perhaps more rationaly and just
That the extend[ed] gate of mercy not deny'd
To those who Err or ask a William's fate
Outcast with misery the felon
Who tho all the course of the law parts
Een at the last faint glimpse of hope
Hopes with a steady firmness and Views
The ignominious scaffold hand in hand
Upon his last breath to Fancy'd hopes & fear[s]
And in the most unfeigned merit of his birth
Gives that a disgrace to all before
A Solemn benediction to the croud who press
By thy overwhelming powers to behold
The great grasp of human misery

f.65v ⟨Coarse Flattery, like a Gipsey came
Would she were never heard
And muddled all the fecund brains
Of Wilky and of Bird
When she call'd either [alike ∧] a Teniers
Each Tyro stopt contented
At the alluring half-way house
Where each a room hath rented
Renown in vain taps at the door
and bids [each *del.*] them both be jogging
For while false praise sings
 talent songs
They'll call for works nogging⟩

f.66v ⟨World I have known the[e] long & now the hour
When I must part from the thee is near at hand
I bore thee much goodwill & many a time
In thy fair promises repos'd more trust
Than wiser heads & colder hearts w'd risk
Some tokens of a life, not wholey passed
In Selfish strivings or ignoble sloth
Haply there shall be found when I am gone
What may dispose thy candour to discover
Some merit in my zeal & let my words
Out live the Maker who bequeaths them to thee

For well I know where our possessions End
Thy praise begins & few there be who weave
Wreaths for the Poet brow, till he is laid
Low in his narrow dwelling with the worm.⟩

f.70v ⟨The Monstrous Python
Durst tempt thy wrath in vain for dead he fell
To thy great Strength and Golden Arms unequal
So while thy unerring hand Elanced
another and another dart
 Callimaccus
 Hymn to Apollo
On Et[n]a Gloomy cliffs o'erwhelmed he glowrs
There on his flinty bed outstretched he lies
Whose pointed rocks his tossing Carcass wounds⟩

f.76v Here placed in dust
 leith [= lieth]
 Here in silent dust
 placed and just
 plac'd in life as now his dust
Who felt the anguish pain
Yet left this world without strain
Of mammon shriek or narrow soul
Virtue self here held controul

f.78r ⟨The monstrous Python wreath
in raging rocks innormous bulk⟩

f.82v ⟨Exausted gasping in the throw of death
The mighty Python wrythed
The harder rock his coiling body wounds
Beneath the face the crashing soul demands
In dreadful hold they shift along the ground⟩

f.83v ⟨The wrything Earth the Monstrous Python tore
The wounded Python on the rocky floor
Rolld each⟩

f.95r Oh fancy did'st thou not lure
⟨The tender Otway from a parents side
By Arun sedgy stream to feel the power
Of fortune adverse tho rich in thy strength
And full in thy realms of gay conceits
Did dare to cast his eye that scorn to shed
The tears of weak complaints but snatchtd
The hardened morsel from a passing friend
In death like easiness to be his last
Then on the world cast that reproving eye
That tells severely thou hast done thy worst⟩

f.94r Thou devils when ⟨All in the feverish night
When the livid dog star rages denying rest
To the weak Eyelids that the noon tide beam
Has glared to nothingness thou blood
Throbing through all in meandring more swift
Quick urges thoughts on thought [Columbus like *del.*]
Columbus like wishing for day to crown
His long sought controul that went the last ray
Seen crowning on lenghened gleams of Rayleigh
Or Bruce our raptuous gaze enchanted saw
In the minds eye alone the splendid Nile
Gushing in wide widening torrents drops to the coast
Attund by the flowers of the world unknown
Thus thy enchanting prospects passing on
Bruce's deeds the cold cold eye of sense
and sends all headlong in the wild turmoil⟩

f.93v ⟨Rich in Imaginations flowery meeds fair minds
More willing and ordinary word that this
Sence soon lost within the wide expanse
Returning eer it thinks of failure [and *del.*]
Encounters difficulties even to loss of life
Strong with the hope that such mothers cheerd
He panted to the course in hot pursuit
Led by thy power coy there strew in heaps
The jealous natures when natures truth
Thought[t] him a mad man or a fool⟩

Deservedly sent to perish not explore
Which could but them seem but inexplicable
To search for what to them but fabled nonsense
And such it proved to him, what to him
His hard hard bed and burning suns
pouring intense heat upon his head
fevering his thoughts to madness in dispair
And disappointment keenest made by mockery
Coy fair then left him on the Splas[h]y brook
Where Nilus oozes like another stream
Driven in a corner what could he but admit
No drooping Ocean from the clouds direct

f.93r Or forcing its way magestic proud & bold
Fortifying grandeur with all the full form charm
Of Abessinian beauties like the Hesperedes of old
Attending [all ∧] to charm its labours irigating earth
Whose odoriferous sweets perfumes each gale
[And sell] by creating delights like to Mahomets heaven
All provd but a dream cleared of the mist
That thou for many an age had hung around
The source at last he saw and thy deceit
Look'd down with wonder on the tepid pool
And shed his baffled [sense ∧] but to dispurse [divest *del.*]
The cloud which rwecks and gives uncertainty forms
Spare inprinting of folly clear to sense
Does but a generall good and hence we know
That Nilas and the Thames [Niger ∨] but bubbles into day
And feel content that they should be so
Without further search yet to compress
By cold singing good can from trifles flow
Would be greatest extreme far from good
Witness the various accidents that have caused
The deepest wisest most profound of scarch
The laws of Gravity thou assisted to inspire
And hangs yet fondly o'er its beam pristine
The first great cause cannot be overturned

f.92v Thus by analogy we judge on of effects
of causes which we know arc true and many
Those triumph [ever ∧] by investigation [that may *del.*]
Which when brought to the point at issue
Then always yet has fled the trial who then
Can hope to be successfull in thy cause ingrate
To many far more powerfull and wise
Could Raleigh linger out so many years
In a damp prison in thy service prone
Had once thought of such a doom he suffered
Live as show his manly mind or thought that
Then mere Caprice in balance part to all
His worth generous, brave, complaint would quell
The pity or the justice of a Prince he serve
So nobly 'No' he dyed his History with his death
That Englands armies never can wash out
Even with Fancy's utmost tears to come

TB CXII *Frittlewell* sketchbook 1809 (see No.48)

f.85v ⟨What can the song of greatness be
Can it resist that fated shock
High towering like the beech tree
Which long the rudest blast does mock

In growing greatness as a tree
It undermines the feeble root
and tho
Yet appear to vigourous shoots

Till exausted nature check her aid
Rebukes every attempt to draw
Down all her leafy honor are decayed
and the fallen trunk beneath the saw⟩

f.88r Alas another day is gone
As useless as it was begun
The crimsond streak of early morn
Check's the sweet lark that oer the corn
Flutterd her wings at twilight grey
Expectancy eyed the rising ray
Twitterd her song in sadning mood
To calm;
 hush her clamours callow brood
In hope of less inclement skies
In circles small the swallow flies
round the loved roof that shelters all
Her present joy [care *del.*] their mother call
The humid ether mocks her care
No insects wings the doubtfull air
The low bent leaves of Aspen tall
Fortell in sadness [now ∧] sudden whirls affall
 the scwall
No honey'd dew [now ∧] tempts the bee
The drooping flower denies its luxury
Deep in its cup some [hapless *del.*] insect lies
And helpless by a humid drop een dies
One drop when the travelers fall
Portentious tells [lows ∧] the heifer calls
To distant mates from homeland driven
and dripping stared ascansce to heaven
Turn their

The hapless fisher feels anew his cot
thinks of its comfort compare his lot
No fly [or worm *del*] can tempt this finney brood
When the washd bank gives up its mud
Beneath some tree he takes his strands
 in doubtful shelter
The useful angle trembles in his hands

f.87v Looks out enough between the falling rills
That through its foliage every drops distills
holding most eagerly and every way
anxious to fancy may break a ray

Not so the Cotter's children at the door
Rich in content tho Nature made them poor
Standing in threshold emulous to catch
The pendant drop from of[f] the dripping thatch
The daring boy, thus Britain early race
To feel the heaviest drop upon his face
or heedless of the storm or his abode
Launches his paper boat accross the road
Where the deep gullies of his fathers cart

Made in their progress to the mart
Full to the brim deluged by the rain
They prove to him a channel to the main
Guiding his Vessel down the stream
[Sow *del.*] the pangs of hunger vanish like a dream

Inside back cover:
Vacancy most fair but yesterday
Oer these pure leaves maintained her sway
untill the pen did immolate
But with a stain inviolate
Tho spotless innocence retreats
From every leaf as fancy beats
⟨as the under April showers⟩
Pure like the stream that pours
⟨that gives each brook a double power⟩
From April's cloud the driving shower
Hope still accompanys & sighs
Hope that with ever sparkling eyes
Looks on the yellow melting skies
Yet still with anxious pleasing care
Think [makes ∧] every leaf appears more fair
Delusion sweet thus tempts us on
Till all the leaves are like to one
Yet Hope looks back as hertofore
And smiling seems to say encore

(Written at Purley on the Thame
 rainy morning no fishing)

TB CXIII *Lowther* sketchbook *c.*1809

f.3v Drawn Monarch stand and Crecy glorious field
The lilies blazon on the regal shield
Then from her roofs when Verrio colors fall
And leave inaminate the naked wall
 W Forest

When brass decays when trophies lie or thrown
And mouldring into dust the proud stone

Led by the lights of the morning [memories ∧] Star
He steered securely and discovered far
He when all nature he subdued before
Like his great pupil. sighd, and longewd for more
 Essay on critisism

f.13v ⟨Away then far away no more shall thought
Nor Kind pursuasions or enticement ought
Tempt me no more the fatal tube to hold
Or point with false security so bold⟩

f.14v ⟨Hence far from me Sporting field
To all those joys, if joy they yield
Where chance [who need not *del.*] [and accident ∧] abound
And blood strewd the thundring sound
The gun too oft it owner wound
As brings the winged quarry to the ground

Away there all sport of the fields
Its pleasur e and its pain I joyfull yield
No more my finger give thc ignited flash
But teach indifference to the fated crash

That frought with one impending fate
Else death and its awful forms await

Or worse than Death enrobd of Vision [verses ∧] gem
No longer view thy course with brag men
Shut out from my joy in nature's day
A sighing blank without a pearly ray
Where [?reflection losses] [recollection must ∧] more keenly
 prove
The interlectual mirror given as above⟩

f.15v ⟨O Graceous power that preserves us here
Chears us in Hope and checks us from despair
That turns away the blot of our mischance
And made the ac[c]ident turn this advance
To teach us how unfortunate to know
In works of goodness is to all b[e]low⟩

f.17r From the wild [peat *del.*] [gorse ∧] on rushy moor
Whose humid ether holds her store
Course brackens high and blo[o]ming ling
From which the moorcock plies his wing
Exalting calls his callow brood & race
And bids them call the wilds to trace

Oer bushy beacon soaring sails
The mountain stone with rapid gales
Beats, hard and swallows up the wind
That twilight imagining now dimmed
Gives every pool a fresh supply
That mantled with the blackest dye

Beneath whose dark ungental breast
The treacherous peat moss lake at rest
So gay so green so soft a bed
But who to them like deny to tread

f.16v Brown spread their gloom
So
To irigate the lowly glen
And privilege the will of men

f.18r ⟨Ah why unfortunate victim to my zeal
To prove myself a shooter didst thou wheel
High oer his head thy birds plumage young
Not griefull thou he wish thy song
That sounds so [even ∧] like to zealous ears
Dishonoured home succession [all waken his tears ∧]
But cir[c]ling round his yellow eye
He doomd thy to die⟩

f.24v To settle the dispute Asterea rose
The briliant drop hung pendant at her nose
Thence useless timber

To settle the dispute Asterea rose
Bright as the drop that pendant at her nose
In doubtful balance hung but heat and cold
Thence useless timber ever bold [with cold ∧]
And know that those to earn aspire
Where kind Gods are proved by fire
The prize to judge & so desire
To win Zeus chair and Pollo Lyre

f.28v But some voice their faults [tend failing *del.*] blame
Admired their works immortal be their name
Be it resolved that this be sacred ground
That babbling critices be to silence bound
Be it resolved that when occasion calls
Unlucky boys do not pollute these walls
⟨Youths do not pollute their walls⟩ [Persuis sat ∧]

f.62v ⟨The rushy rill the stoney gill
The prickly tuft, the velvet moss
upon the moors Savannah shew
While with briney blue

The falling dew or cloudy veil
oer the empurpled moor prevail
and scarce the morning usher in
But man their murderous power begin

Wide roves the dog whose accute scent
Oer every wondring escape prevent
The humid vapour sent the gales
ʟo he soars but soaring fails
Headlong the father of broods soon falls
Whose cack[l]ing note the youth full calls
Wide roves the widow tremulous and weak
To [seek del.] some more distant covert seek⟩

But vain her hopes her care and pain
Still man more keen pursues his game

f.61v ⟨Again the thundring gun then flies
Again another helpless lies

Not the coarse ling or splashing Spring
Prevent oh no tis alike to him
Wades falls or swims [alike ∧] pursue
And must with blood his hand embrue⟩

f.65r On a Jewel [Brooch ∧] guarding a Ladies breast

f.64v The sparkling gem upon her breast
Shines not so bright as Lauras tears
Formed thought [through ∧] compasion quite distrests
I kiss the jewel and its influence fears

Take it [on ∧] but from the downy nest
That lap of peace tis beautys throne

Thy value lurks by being dispossest
And I should blush and every kiss disown

I envy the[e] for thou doest riot there
Thou feelst the warmth of her [anxious ∧] I love
Claspng the robe it looks like jealous care
To shie[l]d her bosom from the prying air

Dull in the attraction heavy in desire
No longer hold what thou canst neer enjoy
The gently loosen to a lovers fire
A sight which nature made without alloy

f.65v Winds if you dare to interpose
And fan her with your cooling wing
While Laura sleep and beauty weeps
And tenderest sigh unrivall Spring

Gently oer her beautious face
And should thou steal a kiss so bold
Exalt not but with stealing pace
Return let not the rape be told

Play in her breath and crisp her hair
But the gale be soft with love
She'll make it sweet like spring air
Rich breathing as the Arabian grove

Hush as the breath when lovers lie
Or that [which ∧] opes the Morning door
Sweet as the muted winds or sigh
That makes the richest jewel poor

TB CXIV *Windmill and Lock* sketchbook 1810–11

f.4r To thee whose Villa once this shore along
⟨Hath Thames reechoed to thy Pas[toral] song⟩
Remembring [?cheering] [M ?]
⟨Yet demolition caught my wan eyes⟩
Which bid it yet to live in various dyes
Rem(em)bring [?cheering] to days of sunny cheer
And asks this Witness to thy men bear
and the remorse from its partin[g] home
Stands here to Pope a monumental Stone

f.77r ⟨To thee whose Villa once this shore along
When [And ∧] Thames rolld glittering upon Alex[is] song
Makes chequered shades the Memry loves to meet
And Time and reput[ation] loved to greet
Thy disolving waters leads a distant skies
Sad [?Monument] of worth to wondring eyes
And cold rancour by rich impulsive dyes
Sinks. but men of tragic shores
Rest here in peace from thy dreer lives
Till Nature shall even in the course
and bear the marks of pity not of force
To Art and music stand here thy
And tell to all to ask
 that Pope did asuage⟩

TB CXVI–C verso *c*.1807–10

A row of poplars in disgrace
Because they would no stop their pace
or grew irregularly tall
Their Master came and lop'd them all

Some neighbouring poplars stood hardby
Beheld thir growt[h] with jealous eye
Now saw – exulting – cried
How near is pride to earth allied
Friends said the poplars in disgrace
You see the fault of making hast[e]
Ambitious greatness caused my woe
Mind while you run you are bare below
 ambition shun, mind how you grow
 for while you run you are bare below

TB CXXIII *Devonshire Coast No.1* sketchbook 1811

(see No.57)

f.18v To that kind Providence that guides our step
Fain would I offer all that my powrs hold
And hope to be successfull in my weak attempt
To please. The difficulty great but when nought
Attempted nothing can be wrought
Trials thankfull for the mental power givn
Whether inate or the gift of Heaven
Perceptionᵗ reasons actions close ally
Thoughts that in the mind embeded lie
[?Kindly] expand thy monumental store
and as the [?working world] continues power

f.20v A steady current nor with headlong force
Leaving fair natures bosom in [its ∧] course
But like the Thames majestic broad and deep
Meandring greatness behold the yon
 on each circling sweep
Ah could my
Through varigated Chelseas growing meads
To Twickenham bowers that love Alexis read
In humble guise should eas'd my pled assume
My self reard willow or the grotto gloom
T'would be my pride its hold from further scorns
A remnant of his love which once the bank adorn
What once was his, can't injure but in

f.21r [Is this the Scandinavian theory true
That the great spirit rests not *del.*]
If then my ardent love of thee is said with truth
Alexis and the demolition of thy House forsooth
Broke thro the [all ∧] trammels doubts and gingling [some
 say ∧] rhyme
Tost [?Roll] into being
Has leagued and cheerd since that fatal time
 Lead me along with thy [h]armonious verse
Teach me thy numbers and thy style rehearse
Throughout the lingering nights careers to stand
And sunny incidents to write by natures hand
The passing moments of a chequered life to give
To cheer
 find a moments pleasure that we live

f.23v To call what heroic into force and show
But immitate alas the glowworms fire

f.25v From thy famed banks I'll may way
And with regret must leave and have to stray
Traverse the gloomy heath of Hounslow wild
Render[d] more dreary by Remembrance' sigh
That by the sounding nettles nowhere tell
The dire frought grains may natures rebel
And wreak full mischief stand around
Fra[g]ments blacken
And air horribly resounds
The swains around who b[r]east the silver Thame
Sequesters

f.26r But arts and the love of war at mortal strife
Deprives the needy labourer of his life
Untill those days when leguerd Barons strong
Dared to tell their monarch acted wrong
And wrung a charter from [his ∧] fallen pride
And to maintain it freedom all have diyd

The parched tracks of Memphis arid sands
And planted laurels wreath in hostile lands
Thus native bravery Liberty decreed
Received the stimulus act from Runny mead
A little island still retains the name
laved by its parent silvery Tame

f.28v Ah little troubled seems the humble cot
That marks the island and its inmate lot
The meshy net bespeak the owner power
Like to the spider web in evil hour
The roaming fly and joining playfull webs
The joining webs
Within its mazes struggles in vain for [but to die ∧]
Westward the sandy tracks of Bagshot rise
And Windsor further brave the circling skies
Alas the gloomy care dreams [on her *del.*] create
Concomitant ever of a Princely State
Should hang so long to a clear sooth
 sayer oft coy

f.29r Oft changes on the moon the gleam of joy
So fair so gay assumes a gloom of woe
And prince and peasant feel alike the blow
But distant rising through the darkning skies
The bleak expanse of Sarum plain arise
Where mouldring tumuli sepulchral steep
Gives but a niggard shel[t]er een to sheep
The stunted thorn and Holly barely live
And Nature asks of Heaven a short reprive
The scudding clouds distill a constant dew
And by the high exposure life renews

f.30v Hill after hill incessant cheats the eye
While each the intermediate space deny
The upmost long call to attain
When still a higher calls on toil again
Then the famed Icknield street appears a line
Roman the work and Roman the design
Exposing hill or streams alike to them
The[y] seemed to scorn impediments for when
A little circuit would have given the same
But conquering difficulties cherished Roman fame
Hill after hill

f.33v There on the topmost hills exposed and bare
Behold yon [?] court the upper air
To guard the road maintain the watch and ward
Twas then old Sarum knew their high regard
The triple ditch but [?] where earth denyd
Her kind assistance they by toil supplied
Witness the inmost mount of labour all
And still remains a monument and wall
What perseverance can attain and bind
The unconquerable germ that wills the human mind
Power on Abettance thus by mutual strife
[Now *del.*] of Priests and Soldiers Salisbury sprang to life

f.35v Peaceful the streams lave now the [unbounded ∧] hills
No warlike clans of hostile armies thrill
The timorous female with due alarms
Or tear a faithful [?vassal] husband from her arms
Now roams the native oer the wide domain
No feudal rights demands or claims
The recompence of labours all his own
Content and pleasure crown his humble home
That by the prattling murmur of the rill
Which rushing onwards feeds the malty mill

f.38v Whose stores the neighbouring village [farms ∧] supplyd
and tell a justice never ear denyd
Close to the mill race stands the school
To urchin dreadful, on the dunces stool
Behold him placed behind the chair
In doleful guise twisting his yellow hair
While the grey matron tells him not to look
at passers by [thro doorway *del.*] but his Book
Instant the din goes round the tender throng
Who meet its murmuring heard her part along

f.43v Close to the [t]hreshold way worn stone
Her coifs hang bleaching on the spiky thorn
Her only pride beside the thread & reel
For time had steeld her bosom even to feel
Tho once in May of life that half [c]losed Eye
Had [taught ∧] that the proudest of her time to sigh
But mutual impulse only truimph gaind
And homely love to higher thoughts maintained
But here again the sad concomitant of life

f.45v The growth of family produced strife
Roused from his long content cot he went
Where oft the labour and the osizer bent
To form the snares for lobsters arm[ed] in mail
but man more cunning over this prevail
lured by a few sea snail and whelks a prey
That they could gather in their watery way
Caught in a wicker cage not two feet wide
While the whole oceans open to the[ir] pride
Such petty profits could not life maintain

f.48v From his small cot he stretcht upon the main
And by one daring effort hope[d] to gain
What hope appeared ever to deny
And from his labours and his toil to fly
And so she proved entrapt and overpowrd
By hostile force in Verdun dungeon lowered
Long murmured gainst his hard thought lot
Rebeld against himself and even his wife forgot
But she returned yet hoped, no tiding gaind
And fondly cherished [h]oped yet hope restrained
And only the babbling
Would sighing pass delusive many an hour

f.50v By Church ancient walls and [?isolate] frownd
That nature gave by verdant greensward ground
Amids[t] a marsh of rushes saved by mounds
That irrigate the meadows sarve for bounds
To the overwhelming influx of the Sea
Which make the marsh appear an Estuary
Westward the sands by storms and drift ha[ve] gaind
a barrier and that barrier maintained
Backed by a sandy heath whose deep worn road
buryd the groaning waggons pondrous load
Then b[r]anching southwards as the point of Thule

f.52v Forms the harbour of the town of Poole
a little headland in a marshy lake
Which probably contemptuously was given
That deeps and shallows might for once be even
The floating sea weeds to the eye appears
And by the waving medium Seamen steers
One straggling street here constitutes a town
Across the gutter here ship owners frown
Gingling their money passenger deride
The arrogance of misconceived pride

f.54v Southward of this indentured strand
The ruins of Corfe ruind turrets stand
Between two lofty downs whose shelving side
The lesser mountain for his towers supplyed
Caused by two slender streams which here unite
But early times give of their might
The arched causeway towring keep
And deep foss scarce fed the str[a]ggling sheep
While overhanging walls and gateways nod
Proclaim the [the *del.*] power of force and times keen rod
Even Earth inmost carving [? = caverns] [own his sway ∧]
and prove the force of time in Studland bay [break to day ∧]

f.56v Where massy fragments seem disjoined to play
With sportive sea nymphs in the face of day
While the bold headlands of the seagirt shore
Receive engulpht old ocean deepest store
Embayed the unhappy Halswell toiled
And all their efforts Neptune [?herewith] foild
The deep rent ledges caught the trembling keel
But memory draws the veil where pity soft does kneel
And ask St Alban why he chose to rest
Where blades of grass seem even to feel distrest
Twixt parching sun and raging wind
And often but a temporary footing find

f.57v disjointed mas[s]es breaking fast away
Till the sad news grows and of the sway
of wintry billows foaming oer
In fell succession waves incessant roar
Denying all approach ah haples they
Who from mischanc[e] reaches means [?convey]
Or jutting headland for another takes
For Natures jealous has allowed no breaks
Of streams or valley sloping save but one
And there she still presents a breast of stone
Above all downs where press the nibbling sheep
Below the sea mew full possession keep

f.58v A little hollow excavated round
To a few fishing boats give anchorage ground
Guarded with bristling rocks whose strata rise
like vitrified [?scoria] to southern skies
Called Lulworth cove but no security to those
Who wish from stormy sea a safe repose
Whoever lucklessly are driven
From Portland seeks an eastern haven
Must luff against the south west gale
and strike for Poole alone the tortured sail
For Wight again their safe return denys
The needles brave the force of Southern skies

f.60v The long long winter months but summer skies
Permit the Quarry to give up its prize
The tinkling hammer and the driving bore
Detaching fragments from the massy store
Then squared or rough in a shallow yawl
The wadding workmen by mere strength do hawl
Invention kindest friend to weak formd man
Taught him the leaver accumulating span
Seems palsied paralized hopeless here
Even Swanage itself cant boast a pier
A single cart conveys a single stone
Into deep water foreigners must own

f.61r But habit alas follow and we find
That each excuse most savours of the kind
Hence rugged Portland steps upon our view
And the same efforts tracing but anew
The ponderous shaft each track contains
Upsets a load drags on a lengthened chain
As down the tracks worn step it glides
And by it draging w[e]ight ever serves to guide
Keeps the poor horse beneath the ponderous load
From the oer poured adown the shelving road
Some small endeavours of mechanic still
To ship they steer overhanging at the will
Of takle firmly place[d] by the Jetty's side

f.61v But here no depth of water even at tide
Allows what Nature all around has thrown
While great profuseness here alone is stone
Along the south and west no creeks appear
No bay or harbours labouring eyes to cheer
Who vain watching throng the creaking shrouds
[When ∧] And night and darkness mix the gloomy clouds
Chaotic warfare [when ∧] surges tell aloud
The trembling pilot to beware nor hold
An onward course eer while the cable holds
The struggling ship her bows unto the wind
Nor rush on danger by the hope to find
Upon the iron coast the Portland race

f.65v No hope amongst direfull reefs a resting place
Indented west and north a bank extends
Even to the utmost stretch the eye
Loose shelving beach thrown up by restless waves
A usefull barren carefull nature craves.
Beneath the western waves the marshes lie
Luxuriant bearing every varied dye
Even Melcombe sands their safty owes
Melcombe whos sands oft trace the lover['s] vows
Whose yielding surface tells the loved name
But Neptune jealous washes out the same
Alas the yielding type commixing gives
Its tender hope and then coquetish leaves

f.67v So hopefull fancy le[a]ds us through our care
Strecht wide our visionary minds on air
Build all our u[t]most wishes could atain
Even to the sandy frailty of the main
And ask the blessing which we all desire
To give what Nature never could inspire
What madness asked or passion fans the flame
At once our pilots and our early bane
Enwrapt we hope [wish ∧] the object not in scope
And prove a very libertine to hope
⟨Can a[r]dour [?imitate] our of youthful fire
Check for a mome[n]t all our warm desire⟩

f.70v Tempt us to declare to all who view
The name we hold most lovely and hope true
But thought created by the ardent mind
Prove oft as chang[i]ng as the changing wind
⟨A great for [?] renders all our care
A short to others who are thought more fair⟩
Absence the dreadful monster to delight
Delusion like the silent midnight blight
Frailty that ever courted oft beloved
And modestly though slighted most approved
All give and urge the intolerable smart

f.75v Of love when absent rankling at the heart
[4 lines of illegible pencil draft]
She tended oft the kine and to the mart
Bore all the efforts of her father's art
And homeward as she bore the needfull pence
Would loiter careless on or ask [taken ∧] through mere pretence
To youth much mi[s]chief for maturity grown

f.77v It proved alas a mischief all her own
Guileless and innocent [as ∧] she passed along
And cheered her footsteps with a morning song
When craft and letchery and combined
Proved but to triumph oe'r a spotless mind
To guard the coast their duty not delude
By promises as little heeded as thir good
When strictly followe'd give a conscious peace
And ask at the Eve of life a true [just ∧] release
But idleness the bane of evry country['s] weal

f.80v Equally enervates the solider [= soldier] and his Steel
Lo on yon bank beneath the Hedge they lie
And watch with cat-like each female by
One sidelong glance or hesitating step
Admits of not recall who once oer leap
The deep plowd sand are p[i]led up by the main
But time denies the cure of love or gain
Deep sinks the cur[s]e of lucre at the heart
And virtue staind o'er powers the greater part
Wan melancholy sit the once full blooming maid
Misanthrope stalks the soul in silent shade
On the bold promontory thrown at length he lies
And sea mews shrieking are her obsequies

f.87v Or on the blasted heath or far stretchd down
Exposing still the field by iron sown
Barrow after barrow tell with silent awe
The dreadful cause prevading nature's law
That the rude hands of warfare feudal strife
Denying peace and oft denying Life
Along the upmost ridge the Maiden way
The work of Norman prowess brave the day
With triple ditch and barbican arise
Defying the hand of Time and stormy skies
Which from the wide distance deepfull driving oer
Pour oer those bulwark cas[t]les clouds or showers

f.90v Oh powrful beings hail whose stubborn soul
Even oer itself to urge even self control
Thus Regulus who[m] every torture did await
Denyd himself admitance at the gate
Because of captive to proud Carthage power
But his firm soul would not the Romans lower
Not wife or children dear or self could hold
A Moments parley love made him bold
Love of his country for not au[gh]t beside
He loved but for that love he died

f.95v The same inflexibility of will
Made them to choose the inhospitable hill
Without recourse they stood supremely great
And firmly bid defiance even to fate
Thus stands aloft this yet commanding fort
The Maiden called still of commanding [entrenched ∧] fort
So the famd Jun[g]fra[u] meets the nether skies
In endless snow untrod and man denies
By with all his wiles preciptous or bold

The same great characters of Simplon [summits ∧] hold
Thus braves arround [oer all ∧] the guarded area tell
Who fought for its possession and who fell

f.100v The chieftains Tumuls and the vassals sword
Own the dread sway of death, tremendous Lord
On every side each hill or vantage ground
The awfull relics evrywhere abound
And feelingly its ancient prowess own
Though power and arms and carnage roam
Oer other lands yet still in silent pride
It looks around majestic though decried
And useless now so on the sea girt shore
Where Abbot[s]bury cliffs beats back the watery [reecho to the
 roar ∧]
Another guards the passage to the main
And on the right in land some vestige yet remain

f.102v Where the soft flowing gives renown
Mid steep worn hills [lead ∧] and to the low sunk town
Whose trade has flourished from early time
Remarkable for thread and [cald ∧] Bridport twine
Here roars the busy mill called breaks
Through various processes eer takes
The flax in dressing each with one accord
Draw out the thread and meet the just reward
Its population great and all employed
And children even draw the twisting cord
Behold from small beginnings like the stream
That from the high raised downs to marshy ream

f.105v First feeds the meadows where grows the line
Then drives the mill that all its powers define
Dividing the vegetating pass with care till
Withdrawn high swels the stoney mass
[written along side of page]
Pressing, dividing all vegetating pass
withdrawn high swels the stoney mass
On the peopled town who all combine
To throw the many strands in lengthened twine
Then onward to the Sea its freight it pours
And by the [its ∧] prowess holds to distant shores
The straining vessel to its cordage [as to canvas ∧] yields
So Britain floats the produce of her fields
Why should the Volga or the Russians
Be coveted for hemp why such [thus ∧] supply'd
The sinew of our strength our naval pride
Have not we soil sufficient rich or lies

f.107v Our atmosphere to[o] temperate or denys
The Northern Eria to harden or mature
The vegetable produce or can it not indure
The parching heat of Summers solstice oer
Weak arguments Look round our shore
Sterile and bleak left thro all the vari[e][d year
With w[h]ins and gors[e] alone possesst
Would [not del.] here the seedling hemp then be distressed
Look farther north of wanted Scotias heights
With firs and snows and Winters full delights
No[t] north enough [then ∧] transatlantic lay
Some vast extended land of Hudson Bay

f.110v If heat is requisite more than our suns can give
Ask but the vast continent where Hindoo live
More than the mother country ten times told
Plant but the ground with seed instead of Gold

Urge all our barren tracts by Agriculture skill
And Britain Britain British canvass fill
Alone and unsupported prove her strength
By mean[s] her own to meet the direfull length
Of continental hatred called blockade
When every power and every port is laid
Under the proscriptive term themselves have made

f.117v Oer the Dorsetian downs that far expand
Their scathed ridges into Devon's land
The mounting sun bedeckd with purple dyes
As o'er the[i]r heathy summits beaming flies
The gilding radiance on the upmost ride
That looking Eastwards on rocky rampart stood
A Guardian once like others thro the land
Where native valour dare[s] to make a stand
Against [?despotism] and Rome fought
The prize of valour gaind though dearly bought
Thus wrought their nature by progressive degrees
As morning fogs that rising tempt the breeze

f.120v Grey and condensing hovering o'er the swamp
Of deep sunk woods or marshes dull and dank
Crowd like tumul[tu]ous legions beneath the hill
Like concregated clouds and edd[y]ing rill
This way or other as the air incline
Till the all powerfull doth on them shine
Dispersed and shewing on their edge its powers
In varied lights sometimes in force combined
It seems to brave the force of Sun and wind
Blotting the luminary, sheds a dou[bt]full day
Besprinkling oft the traveller on his way

f.122v At others stealing neath each down of hill
And scarce diaphinous the valley fill
Then day brings on is courser[s] and sultry car
All nature panting dreads the ruling star
Along the narrow road whose deep worn track
Fill up with dust the us[u]al burthened pack
Plods heavily and dull with heat opprest
And champs and snorting tells his great distress
Burthened with stone or sand where the steep ascent
Prevents the earth or slide whose quick descent
Make even a load of nothing endless toil
And to the over loaded path ever quick recoil

f.127v Upon its gall'd withers; and the heavy Sand
Upheld by pegs within the panniers stand
Relieved from its load the other flies
like Satan scal[e]s aloft in nether skies
Or sulfrous cloud at open east fortells
Where atmospheric [?contraries] doth dwell
And the warm vapour condensing from the main
Oer the wide welkin darksome clouds remain
Till borne by various currents dimly spread
The sickness rays of the wan sun begin to shed
A gloomy lurid interval succeeds
As from the high reard noon the orb recedes
Spotty as partial quenching the evening sky

f.130v In tinted of clouds of every shape and dye
Meantime an up[p]er current rolls around the clouds
And bear against the blast the thunder loud
Breaking on the upmost hills then quick ascends
The scattered magazines and congealing tends
To the full charged elementary strife

To man even fears and oft [?relinquished] Life
A corse treme[n]dous awful ⟨Dark indeed
Died the smitten wretch not doomed to bleed
The current dead charred with the veins
Sulphurous and livid still the form retains
Most dreadful visitation Instantaneous death
Of supreme goodness sapient allows the fleeting breath
To fall appartently without a thought of pain⟩

f.132v Exalted sat St Michael in his Chair
Full many a fathom in the circling air
Scarce can the giddy ken of mortal sight
Behold the dreadfull chasm but in fright
Forget the reason Heaven on her bestowd
And strike appalld from thir high abode
The raging waves tumultuous roa[r]d around
As on the Western side precipitous abound
Cover with manacles that to the t[r]ead give way
To those adventurers who dare thir slippery way
Upon the muddy steep the owner stands

f.135v And call aloud to those who ply the strand
With seins all ready for the pilchard soon
Awaits his orders but the high born noon
That bid so fair is sudden wrapt in gloom
Harsh sounds the wind and in the grim S. West
The Welkin looks in gloomy mantle drest
The sickening [?sinking] sun by slow degrees grow[s] wan
And scarce a shadow gives or shines on man
The man prognostic sudden heaves on high
A grand swell calm and rolling ply

f.137v The [?shaggy] rocks with what this shore is girth
In overwhelming betray their mirth
For the topmost hills the clouds descends
and Earth and Ocean in one [?twine] ends
The vessels which so plain plow this coast
Shirk the Haze even as ever the lost
So must the land to them they hold
Their course in confidence by needle told
How awful must the land appear to them
Scarce with keen [?powr] lost and then again
In doubt be[t]wixt optical and magnatic point

f.140v The good Honiton embayed in awfull hours
What port to leeward Roadstead none
No chance save but a dreadfull one
To lure the ship on shore to save the crew
O could the pencil point no justice true
Crash goes her mast compleatly by the board
Even by that fright her sides all gored
Indignant to the waves who[s]e power alone
Sufficient proved stood her on beach of stone
Of Granite Marble Slate and Lime stone formd
are all of this harculean character forms disarmd

f.141v all smooth and polished harshly sounding roll
and clamourous till the oceans great controul
Yet the last refuge for within this bay
To those who dare to cross the Atlantic sea
Penzance Neyland [? = Newlyn] and little Limer's
 [? = Lamorna's] cove
Still offer safety to them to [?house]
From the winds the winds that rage upon our Isle
And stormily bid [?favourites] not to smile
Deceitful fierce [?noisily] frail
Often they tempt to sea the anxious sail

f.146v Looking most smooth and calm within Mount bay
While big with ruin lurks the washy way
First shoots [?Tol-pedn-penwith] to the main
And by her rocky breast the roaring surges sustain
The waste of waters which the Atlantic pours
From all her [?waves] and Ocean utmost stores
Here. Ends their last recourse the stragling land
Suppli[e]s no fishing cove or even sand
Shapeless and huge the rock abound
Range about grey Granite upmost bound
In every form the human mind could think
Bind the Channel coast's impenetrable link

f.149v Of Horizontal strata, deep with fissure gored
And far beneath the watry billows cored
In caverns ever wet with foam and spray
Impervious to the blissfull light of day
Blocked up by fragments or by falling give
a rocky Isle in which the sea ma[i]ds live
Bear their rough forms and brave the utmost rage
Of storms that stain our Britain parish page
With plunder Shipwrecks deathfull woe
And even life itself has been for plunder far to low
To feel the misseries of anothers woe
[2 further lines in illegible pencil]

f.151v ⟨For Heaven ah nought beyond
The raging water our continuous bond
Engulph again its [?] raging tries
To forse it[s] passage back to air and skies⟩
Precipitious and horrid rock on rock
Bare on their bosoms each impetuous shock
Aloft the covring spray imper[v]ious hurld
Display the sutborn [= stubborn] prowess of this rocky world
The babbling water recoiling in vengefull power
To every inlets deep insidious roar
Sounds thro each rocky cavern tempest wrought

f.152v Betiding notes of woe more direfull fraught
With Sea mews clangings and the gannet [screams del.] squeal
The slap and [?billows] clamouring, circling wheel
In endless warfare

f.154v Can man unheedfull see the coming storm
Roll gathering on and to himself disarm
Of fear behold the meek heifer and the savage bull
Seek shelter and no longer rang[e] and cull
The various blossoms of the culture filled
and think that he more power shall not yield
His life beneath the forked blaze
That the next instant may eraze
His boasted prowess courage, reason, all
Prostrated lifeless [?beamless]
To madness [rushing del.] turned or [?igniting] lif[e]less fall
Till passing onward quick the scattered robes
All their parting show the purple bow
Right Eastward till the near decline
Of all the chearing light that glorious shines
On skies [?o'er spread] clouds empurpled flushed in streaks

f.156v Mornings reds and golden glows the rich welkin cheek
Blue charms but little shone in such a sky
While distant hills ma[i]ntain the powerfull dye
In all its changes even the russet dawn embrownd
By midday sun or rock or mossy mountain crownd
And deep sunk hamlet smoke assumes a tone
That true to Nature Art is proud to own

Beyond herself in fair harmonious [?dyes]
And practically imitations dies
How man[i]fold the tones yet all harm[on]ious blend
In sweet succession following each to lend
The ever lovely running link of harmony
That pleasing ever cheating the anxious Eye
To measures distance and its lines defy.
Deep in the foreground [way *del.*] the various wods afford
In verdure richly clad lies Pennelford

f.159v Between the dark [?embosomed] forest sheen
Sparkling [?partial] greeting the stream
Where fall[s] the western light enbeaming ray
Excluded, there the deep reflections play
Then wide extended downs of go[r]s[e] and corn
Wild & cultured land and those that never shorn
Lie only tended by the scatterd sheep
Where the neglected ever seems to creep
Struggled with difficulty like a [?] train
In form in writing with [?disease] and pain
Beyond these barren tracts you level plain
T[h]rough which the Ex[e] rolls sullen to the main
Begirt with honors of Pomona's care
his busy crowded clamours Exeter
The Town [?] and civic then attest
and Commerce

f.161v Totnes the port where hangs the neglected bar
This once resounding shore now silent is thro war
Yet gleams afar by her blanched Sails
And straining pendants which the [?] regales
amidst the mass of richness floating round
Did hurt the right from quantity till a bound
striving to find by [?happiness] coming hour
The West country but allows that power
Towring above the long inclined space
Where Dawlish pastures fair and watering place
Tiegnmouth and Babicombe and [?Ore]
Refer in majestic greatness bleak Dart moor
Whose upmost Crag like broken ridges rest drest
in sombre majesty oft capt in cloudy vest

f.164v Call the gay occident of Saffron hue
In tendrest medium of distant blue
While the deep Ocean denies a smooth entrance
Calm foamless far enhance
the bea[u]ties and the wonder of the deep
While the blanchd spots of canvass creep
upon the dark medium and as
Like natures landmarks village spires
Point as in [on who thro ∧] form where hope aspires
The blanchd sand within the reach of tide
Glimers as lucid interval the washy pride
One little [?murmurs] track along the shore
In treacherous smoothness surely blanched [white ∧] or
With foam frail power undulating

f.166v deceitful smoothing that the wreckers sloop boat
made up sticks and to where sails float proof
Require the little native wading in the stream
Guides his first Essays thro the glorious theme
Spreads thro the village s[c]hool and all the throng
bare the triumphant Argo quest anon
A little navey rears thus begin
the stream of glory oft to accident akin
⟨So oft has small beginning given birth
To the great Demagods that tyranize on Earth

Lifted the warrior from the ranks to hold
And sh[i]eld on [solider (= soldier) ∧] from sceptic men would
[?]
War reard the humble and devoted the way [of the cot ∧]
To scenes that fancy neer could form his lot⟩

f.169v [*15 lines of illegible pencil draft*]

f.171v ⟨Hangs having bloomd sheds upon the bear [= bier]
of fallen greatness its last fragrant tear
Lost oer the first and ask if little pride
Can stand the contest by fair minds side
Rang all their power even so and bright
[*2 lines of illegible pencil*]
Alas that might reward for merit tried
Should give a means of [?losing] & [?] pride
Should longer thy house abuses⟩

f.174v Alas [so ∧] soon the high raised Nelsonian star
Should extension suffer and gory Trafalgar
With all thy well earne[d] glorys written on
In brotherhood bereft of Heaven a son
In gracious powr [long ∧] shed for some wise end
Deprives to him which the [?best deign] to send
The scourge of Europe hence exults unseen
In deep futurrity on this Island green
Obstructions gives and shorten his repose
In rancourous hate implacable serve
The lash recoiling gives a lash to fear
A nation prowess by untimely laws
In weakend not inforced while just app[l]ause

f.176v Such that most een follow Nelson
Will navy defenders emulate his fame
Alas no second Blenh[e]im yet is found
No monument but yet decks the ground
[?Activate] in our hearts but still our eyes
Would pleasing view his Cenotaph arise
On some bold promontory where the western main
Rich with his actions ever blesst by fame
Beheld him weather oft in naval pride
Our roaring Channels strong all[i]ance tide
⟨Us[e]full as the Eddystone beams its honor drest
And high the lighted gleam in flamey vest
A Sea mark emul[at]ing reverd and ever known
My nation gratitudes [in] monumental stone⟩

f.179v ⟨Binding in one generous emolument the Sailor mind
In action dreadfull in his last moments kind
Seen far a[t] sea a tear bright to those
To beating the drum [?eer] sighing for repose
With locks bedecked with brave spray borne
and to [?] worth [?] storm
Unlike his mastman [?security] in the smoke
Whose long last action gravely great with weeping eye
Bespeak a naval [?prowess] [?] defy
Yet ever ready when the threatning storm shall rage
Tis above that the thundring cannon roar
Then murderous guns send with resounding air
[?Blank] deep in hostile plank, have [?shed] in gore
The stubborn Man and his country bore⟩

f.180r crashing falls the mast beneath the blow
and [?bearing] along the hostile ensign'd fo[e]
The shattered hull rolls dreadfull drinks
Deep at her many wounds she sinks
above below tho all her trusted crew
still for existance Evil to eschew
Then the bold seamen enemies no more

Ply round the sinking ship the busy oar
Incessant acting what their noble hearts soul [? = sigh]
Rich with human[i]ty swells high
Thus in that horrid night on Egypts strand shore
Heard the shrill [?scrack] and hostile cannon roar
Flashing amidst the darkness till anon
Rising in blood staind vests the waning moon
gleaming athwart Aboukir[s] narrow bay
Th[r]o smoke and carnage victory dreadfull way

f.180v The crippled ships whose scuppers bleeding run
Dy'd the death of heroes even Victorys daring son
The gallant Nelson felt for Britons fate
And

f.201v Howling the wild south west with boistrous sweep
Lash the rude shore that rising from the deep
Presents a bristled front Basaltic like or [r]anged
Rock pilled on rock in many forms arranged [?estranged]
Disjointed looks and se[e]ming promiscuous thrown
By nature['s] hand yet the water owns
A Power supreme on the upmost stones
Fringed o'er with mossy lichen which attones
For Earth [?allimiting] quality rears aloof
Denys all footing with a stern reproof
Piramidal and rough refuse to [?guide]

f.204v a [?justman] even the [?feather] fish
Who congregate and waits the rising tide
Clamorous shriek in thrilling note of care
and ominous the rising air
That edding thro the caverns yield a note
more harmoniously

TB CXXIX *Woodcock Shooting* sketchbook 1810–12

Inside front cover:
Doth prying Phipp continue [now ∧] still
To practice or lie still
Both cries credulity and Howe

Co adjunct now to look and lie
and wit since he knows Howe
must

To look and lie to lie again he will
Must act since he knows Howe

f.1r Doth Phipp continues practice still
Or doth he quite [= quiet] lie
Neither replies – the clamorous world
Pry in or probing others
He acts since he [now ∧] knows Howe
either his smile
or looks or eyes against his will

Can Phipps retire from practice
Can [k]nown from influence

Doth Phipp een hope to practice on
Credulity and British fair – pain

Lie on, or look again but tell

Co adjuncts make of look and lie
Should act has he knows Howe

To look or pry or lie at will

f.1v Doth W. Phipps continue on
to practice or lie still
a Blindness case requires him now
To act even more by knowing Howe

How asked the skillfull Oculist
To practice, not desist
a blindness requiring the fair
requires all that you can spare

Her blindness case the shining hair
required more than he could spare

f.2r [*3 lines of illegible pencil draft*]
Howe asked the Oculist his fee's
to ease her blindness case
To ease her purblind
In doubt as to care as to ease
 ease or to cure

Whitbread [the *del*.] known by blue and buff
Still raised once
and potent held for humming stuff
Frothy tho poor [is ∧] a Rodney wig
Reform be gentle eer you swig
Drink deep or taste not least [spare ∧] your brains
Tis gas at top or bottom be the gains [for his gains ∧]

f.2v Doth prying Phipp now practice on
Credulity or Gain
To look and lie in practiced skill
or lie to look but [to ∧] lie at will
Must act since he knows Howe
⟨or practice by knowing Howe
or Howe know [more by] as trade deep
That hunger begs ner look before they leep⟩

Doth prying Phipps continue now
So practice or lie still
To look to lie – but lie at will
Must act since he knows Howe
 to prove his skill
Must act

f.6v ⟨Twas the Oculist hope
In the Grotto of Pope
To retire yet still lie on
Lie still from practice from prying and peeping
But the nymph of the Grotto lay in not sleeping
So Eneus so died you
The then ever

Twas the Oculists hope
In the Grotto of Pope
To desist and dein to probe or to peep
From the practice of living from prying and peeping
To relingquish the
 lie still within practice of probing or peeping

To E[neus] returned
and dido accused
The practice and practice eased
In drinking Howe deep
That memory does leap
Twas the Oculist hope
In the Grotto of Pope

To be still and desist eer to probe or to peep
So Eneus returned
and Dido required
Both practice and practice eased⟩

f.7r ⟨Twas the Occulist hope
In the Grotto of Pope
From practice and wounds to be still
But Nymph of the Grotto

From wound not herself
Like Dido deep
So knew Howe
In darkness got a leap

Twas the Oc[ulist's] hope
In the Grotto of Pope
from on much of keeper lie still
To lie on and look at her cold
But like Dido her death
To be still would [tho doth ∧] faim like a heep
But like Dido dark[en]ing did sleep
Like dido knew Howe
That Springing dogs ner look before they leap

So Eneus returns so dido knew [require ∧] Howe
Both the practice and care both made deep
practice and practice ease
 both knew deep
By former joys deep knowing Howe
The present case in knowing Howe
That Howe does ner look before he leaps⟩

f.17r Discarded London thou must now forgo
The praises of the great the very few
Amongst the many who delight to prate
To keep the chit chat of the tables round
Alive by nothingness yet talk of taste
Must thou depart so soon to quit
The splendour that [thou ∧] helped to give
Displaced though friendship victim to desire
and love of charge that treading constant on
The Heel of talent goads it to the fate
of all that toiled before down thoughts
That trouble but to see the placed unheedfull
Recreant against that wall which echoed oft
That blushed a higher glow [as ∧] truth delights
So feels the breast that fears thy hapless charge
Like the once favourite fallen meet the eye
Of those who knew in thy lost estate
Shut the chil eye, or bid the pliant tongue
Till all the misery thou knows thy self
Was once beloved respected honored
Held high to make the fall the greater
Envid[i]ous exaltation [broke ∧] shake the blast
That bears the bough Holly from earth
 or bending reeds
Alike when winter undermines the root
And unembraced by earth of leaves told decay

f.18r Or scattered as the leaves of Autumn heaped around
Tell too loudly all impending fate
That some days these Vegetating power
Called by the quickening sun [seems ∧] to tender shoots
Through the hard rind which brave the Winter frosts
and pendant isciles [= icicles] [brown ∧] gleam the first of green
Gay livery of the groves that coiling runs

Round vegitation in her varing course
From the banefull nights [shed ∧] dark entwined
In the low quickset to the topmost bough
That yelling in the breeze of alpine h[e]ights
Bears the grey Lichen midst the upmost storm
Where ed[dy]ing snows and cracking Glaciers fall
Wide rounds distruction
To the [healing ∧] calm sunny vale when summer binds
Her auburn ringlets by the yellow gourd
That lost by brightness yields the conquest power

f.43v ⟨The widows in Art on the cheek
In life gay may blush
A prey to grief
tell no relief
Exceeds belief
While looks round other prey
Yet hope in part
And yet not to start
Made one smere
And then one stealing tear

Making to the on the blush cheek
Twas oer the sight who the vital
Of blushing our love betrays
Concerns starting bright and oft he
Loves mellow blush reflected as every age
Kiss one gay By thy own smile
light ask the blush shining
Then show to hope again doubt yet believing
the lost hope soft yielding
 light in the heart glows
 do and that all
 disrobe the after gem
 the natures shed to hand around
 the the wound
natures sweet balm
her finest charm
heal
the even
 Then nature enquires
Natures tear
To the gay accent
Request dark paint
 yesterday
our loved convey
And its⟩

f.44r ⟨Then oer hope feel the blast
Till nature steel around
The drop the wounds
In charm self healing
So thus loved stealing
Thus round the never I
Look and looker die
Like in gay fly
Blow lower to his eye
Sweet oer the cheek cheek
The Vermillion musk bloom The cheery musk stealing
Italy inspiring Hope inspecting
[Hope oft del.] reflecting Joy reflecting
Love directing love directing

In four tongues speak
 In love own love love revealing

Cause rememring
Grief subduing
Love returning whence
In man longing speaks Love grief implies⟩

f.122v They would have thought, who heard the strain
They saw in Tempe's vale her native maids
To some unwearied minstrel dancing

TB CXXXI *Plymouth, Hamoaze* sketchbook 1811

f.188r Resplendent Season[s] check oblivion['s] shade
Whose lib ⟨Putney thy changfull forms he placd
Whose beauteous beaming⟩
From Putney Heights he all thy charms surveyd⟩
And painted Nature thro' [?description] Eyes

f.188v ⟨Bind not the Poppy in thy Golden Hair
Autumn kind giver of the full eard sheaf
Those notes have often echo'd to thy care
Check not their sweetness with thy falling leaf

Winter thy sharp cold winds bespeak decay
Thy snow fraught robe with Pe[a]rls still entwine
Thy sisters will thy generous care repay
[?Bending] with the[e] round Thomson's hal[low]ed shrine

Inspiring Spring with renovating fire
Shall pleasing bind those reeds Alexis playd
And breathing balmy kiss[es] to the lyre
Give one soft note to lost Alexis shade

Oer Thomson tomb Morn dewy dew drop beams
True friendship tribute shed for Popes lost fane
Sunk is his House – but worth and Verse yet gleams
They smile nor fear capricious fashions reign
 trace Oblivions shade
whose [?generous] Care bids Thomson's Harp arise
from P surveyd⟩

f.189r ⟨Oer Thomson tomb soft Pitys tears distill
Shed in remembrance sad for Pope's lost fane
To Worth and Verse – retains kind Memory still
Scorning to wear capricious fashions chain

In silence go fair Thames for all is laid
His pastoral harp and reeds unstrung
Lost is all [their ∧] harmony in Twickenham glade
While flows thy stream unheeded and unsung

Then place amidst thy upland Shade
His Harp Eolian, to Thomsons hon[or]ed fame
From Putneys Heights he Natures hues surveyed
[?Mellifluous greeting] every air that roves
And caught her beauties as each season came
From Thames [?lovd] bosom o[e]r his verdant waste

Spring, with gentle breath will greet the string
That balmy kiss greet the Spring
While ever and anon the dulcet air
Shall sigh in sweet ar[ray]

Resplendant Season check oblivions haste
Whose liberal hands bade Thomson name arise
From Putney heights he Natures charm surveys
and caught each beauty with enamourd Eyes

Summer will shed [bring ∧] her many blossoms fair
To shield thy trembling string in noon tide ray
Shall shield thy trembling string in noon tide ray
While ever and anon each dulcet air
Will rapturous thrill or sigh in sweets away⟩

f.189v O Man that vanity alone
Should tempt us all thro life
To give to furnish pleasure wings
That waft and kills with exquisite delight

Far – from what is real joy
We hurry onward, in madness recal
In wooing trifles, our employ
Will time and Death.
Neglecting time tho time we steal

For as the shadow ⟨passeth on
So man neglectfull soon declines
Looks anxiously for [?] gone
always the [?] too late aspires⟩

TB CXXXIII *Devon Rivers No.2* sketchbook 1811

f.1r Hoarse on the rocky margin of the deep
The tide swell falls in constant flow
O'er the pale welkin [see ∧] gathering darkness creep
While the low bark, plows heavy at the prow
Sullen at each pitch the parting waters [leave deck ∧]
 but only to be wreck't
Insated rise to seize the fated prey
 and strive to gain the deck
Ah few, escape tho oer the floating waste
Thrown back their imperfectal splash
Shining on the bows by Cinthia light bedeckt

Reputed not humbled, miriad like they join
Untied portions role but onward to the shore
Giving a daily lesson to combine
The Man himself so niggard of his store

TB CLII *Aqueduct* sketchbook 1816–18

Inside front cover:

Sweet independence rough is thy nature hardy sincere
Tho[u] gives[t] the humble roof content devoid of fear
Even of tomorrows fate and adds a blissful joy
To its perhaps lone inmate, even without alloy

To thee the social bring carrolls as he goes
or tells his pratling babes at his return
Een To thy honor'd name the whitend wall ever [shows ∧] glows
With acts which telling makes his bosom glow

Through thee the mind who in itself innate
a quality possesses – [own ∧] the power of wealth
guides its self choice – own no contrasting power
but self recourse – a personal Estate
Far beyond purchase or the grasp of State

f.1r and f.1v [*pencil drafts of further stanzas of this poem*]

Drafts in *The Artist's Assistant* 1811–12 (see No.43)

On front flyleaves:

(1) 〈Een painting assisted aye languish for thy look

You saw their work on show from Nature[s] book
Nay blush not that she evr thought
Twas stolen blush could the
 or that the teacher was taught

Then when she heard him brawling at thy door
Thou generous man enchanting them tho poor
Poor ah no, lowly tho he is when thee
hark at their early sounds with see see see
Imagining know who thy accent to record
caught only half engulph[d] ah now my word

like that thou the best writings〉

(2) [*?continued from (3)*]

〈amongst his kindred [?commands] whos[e] [?plastic] Earth
Where many lived and often to wacth [= watch] th[e]ir birth
here struggling with each other for the palm of worth
but not the plam [= palm] of Patronage accursed
The sweet fore finger of a man of taste
sure held it offered but withdraw[n] in haste
hark the dear teacher guards the
and evade the debt like a soapt pig tail

[?Ah] known now no more sinc[e] shew[n] the door
What made you and bitter to the very poor
Poor brother proud to those ye men of straw
 only calld by patronage to withdraw
 poor would the summer in it[s] way [wound ∧]
 in eyes at last as the wound [?soothing] bound
[?Girtins] dread of dullness even hear hold sway
Dullness in wisdom〉

(3) 〈Twould call the memory from his C G [? = Covent Garden] room
Where lies the honor'd Girtin's narrow tomb
Not so by this he fits thy powrfull sway
While his frail tenament of mortal clay

and thou who must not sup thy Bohea Tea
or show us living artists where in he lay〉
[*?continued on (2)*]

On back flyleaves:

(4) 〈[?Peace] ungra[te]full boys the mighty mother weeps
To hear some base a wanderer sweeps
Till bursting point who in water play
The artist ring so Newton record his shadow ray
like Joseph's coat of many color dyed
But being ground in coal alum dust so long
The deep retentive soil, did eer to its story still cling
Would help schools with gratitude and shame
Cry when should I eer reclaim
What I have pledged for you nor passed
My word
nought was thought value but black
see I have change my
Pye stood beloved my many color to
Dip in oblivious obsequies for you
ungrateful boy cease nay did all become
Become a fit age marry one by one
To make the most of you – and forsooth
Nay not one can say is not truth
did not King Robert Bruce to make a show
Place at his shoulder boy[s] in brighter row
To appear what they were not deny
This truth if you can that dead of day
And so have ye all in the same way
Would ye not have quarrell'd had he placd
one fore the other to be more disgraced
Commend him for it, not condemnd
 [g]one is his spirit some apart
It rose from love alone the love of Art
Nay smile not – can you think
That Art means cunning – woes on woes
will win your mother therefore to your way
appears shadows of enduring〉

(5) 〈had the Bruce placed with less art
His rank and file, every man and man apart
Had with less cunning Bruce then placed his troop
of trembling minions one by one like public coop
One blow had levelled all, the rank and file
There have made one lot ere while
The Enemy had triumphed oer his guile
This self conceit carries you must own
That you have only, failed one by one
In gentlest succesline [= succession] doth not the bud
ra[i]sed by the stemm blossom out
 expand court the sun
That gives it lustre, but ye would bend
But sutborn stood ingratious in array
Immured in [by ∧] shade where color now play
while each and all might never come in to play
a City master one [?author] subtlety of line displayed
and all together tastin[g] grapes portrayed
But they were sowr, and old and cant be reacht
But had you, substituted k[n]ees for feet
You had a patron in every narrow street
 later what you'll now never greet
would have been round of [= or] smoothfaced to the touch
Her cloth or need then seen strength enough
and ground glass would not have then provd rough
Warm lucent glow, your conglomerate whole

reflected and replied⠀⠀in the bowl
Where acid need drops so also thou
Who has the impudence to tell his woes⟩

Inside back cover:
(6)⠀⟨Hath he not bought two pictures more than thou
⠀⠀⠀⠀⠀⠀⠀⠀⠀⠀⠀⠀⠀pictures bought aye two
⠀⠀[Then ∧] Two pence is more than one sounds money to the few
⠀⠀Nor hath not sold them⠀⠀too
⠀⠀as some one did who what for pence
⠀⠀⠀⠀⠀⠀palms oft meeting even in countin[g] house
⠀⠀and chasers declining age as common sense
⠀⠀chasers with all, with striding pace
⠀⠀Has walked around the realms of taste
⠀⠀as almost have the pleasing honour of state
⠀⠀Salves, ointment, emolient, conserves and simples
⠀⠀wort, blooms and shrubs and simple juniper
⠀⠀Thus like corrosive works of dread screw
⠀⠀And surely alas gives a second to revue
⠀⠀Has he not built a house that figure [?] [hath a door ∧]
⠀⠀Hang equal on its hinges to rightous poor
⠀⠀Thus giving temper wheel and click clonk click
⠀⠀And the great engines belches smoking quick
⠀⠀and the steamers Piston spouting thick and thin
⠀⠀Till the conclusion of the trial working subility and
⠀⠀A six team horses but many do more
⠀⠀A cork drawing becomes a patriot show
⠀⠀But whether worked by Horses, coal or gass
⠀⠀The old grey mare like Sp[anish] Calves are sent to grass

⠀⠀aye any one hath coals why all this clatter
⠀⠀Nay doth not he give away the very best
⠀⠀The [?cull] was over even later before twas dry⟩

The *Fallacies of Hope*

Citations in Royal Academy Catalogues, 1812–50.
Including titles with references to the poem unaccompanied by quotation.
Numbers in brackets are Royal Academy catalogue numbers.

1812
(180)⠀Snow Storm: Hannibal and his Army crossing the Alps

⠀⠀⠀⠀Craft, treachery, and fraud – Salassian force,
⠀⠀⠀⠀Hung on the fainting rear! then Plunder seiz'd
⠀⠀⠀⠀The victor and the captive, – Saguntum's spoil,
⠀⠀⠀⠀Alike became their prey; still the chief advanc'd,
⠀⠀⠀⠀Look'd on the sun with hope; – low, broad, and wan;
⠀⠀⠀⠀While the fierce archer of the downward year
⠀⠀⠀⠀Stains Italy's blanch'd barrier with storms.
⠀⠀⠀⠀In vain each pass, ensanguin'd deep with dead,
⠀⠀⠀⠀Or rocky fragments, wide destruction roll'd.
⠀⠀⠀⠀Still on Campania's fertile plains – he thought,
⠀⠀⠀⠀But the loud breeze sob'd, 'Capua's joys beware'!

1815
(190)⠀The Battle of Fort Rock, Val d'Aouste, Piedmont, 1796

⠀⠀⠀⠀The snow-capt mountain, and huge towers of ice,
⠀⠀⠀⠀Thrust forth their dreary barriers in vain;
⠀⠀⠀⠀Onward the van progressive forc'd its way,
⠀⠀⠀⠀Propell'd, as the wild Reuss, by native Glaciers fed,
⠀⠀⠀⠀Rolls on impetuous, with ev'ry check gains force

By the constraint uprais'd; till, to its gathering powers
All yielding, down the pass wide devastation pours
Her own destructive course. Thus rapine stalk'd
Triumphant; and plundering hordes, exulting, strew'd,
Fair Italy, thy plains with woe

1817
(197)⠀The Decline of the Carthaginian Empire – Rome being
⠀⠀determined on the overthrow of her hated rival, demanded from
⠀⠀her such terms as might either force her into or ruin her by
⠀⠀compliance: the enervated Carthaginians, in their anxiety for
⠀⠀peace, consented to give up even their arms and their children.

⠀⠀⠀. . . At Hope's delusive smile
⠀⠀The chieftain's safety and the mother's pride,
⠀⠀Were to th'insidious conqu'ror's grasp resign'd;
⠀⠀While o'er the western wave th'ensanguin'd sun,
⠀⠀In gathering haze a stormy signal spread
⠀⠀And set portentous.

1830
(349)⠀Palestrina – Composition

⠀⠀Or from yon mural rock, high crowned Praeneste,
⠀⠀Where, misdeeming of his strength, the Carthaginian stood,
⠀⠀And marked with eagle-eye, Rome as his victim.

1831
(357)⠀Caligula's Palace and Bridge

⠀⠀What now remains of all the mighty bridge
⠀⠀Which made the Lacrine lake an inner pool,
⠀⠀Caligula, but mighty fragments left,
⠀⠀Monuments of doubt and ruined hopes
⠀⠀Yet gleaming in the morning's ray, that tell
⠀⠀How Baia's shore was loved in times gone by?

(358)⠀Vision of Medea

⠀⠀Or Medea, who in the full tide of witchery
⠀⠀Had lured the dragon, gained her Jason's love,
⠀⠀Had filled the spell-bound bowl with Aeson's life,
⠀⠀Yet dashed it to the ground and raised the poisonous snake
⠀⠀High in the jaundiced sky to writhe its murderous coil,
⠀⠀Infuriate in the wreck of hope, withdrew
⠀⠀And in the fired palace her twin offspring threw.

1839
(481)⠀Fountain of Fallacy

⠀⠀Its rainbow – dew diffused fell on each anxious lip
⠀⠀Working wild fantasy, imagining;
⠀⠀First, Science in the immeasurable abyss of thought,
⠀⠀Measured her orbits slumbering.

1840
(533)⠀Slavers throwing overboard the Dead and Dying – Typhon
⠀⠀coming on

⠀⠀Aloft all hands, strike the top-masts and belay;
⠀⠀Yon angry setting sun and fierce-edged clouds
⠀⠀Declare the Typhon's coming.
⠀⠀Before it sweep your decks, throw overboard
⠀⠀The dead and dying - ne'er heed their chains.
⠀⠀Hope, Hope, fallacious Hope!
⠀⠀Where is thy market now?

1842
(548)⠀Peace – Burial at Sea

⠀⠀The midnight torch gleamed o'er the steamer's side,
⠀⠀And Merit's corse was yielded to the tide.

(549) War. The Exile and the Rock Limpet

> Ah! thy tent-formed shell is like
> A soldier's nightly bivouac, alone
> Amidst a sea of blood –
> – but you can join your comrades.

1843

(550) The Opening of the Wallhalla, 1842

> *L'honneur au Roi de Bavière.*
> Who rode on thy relentless car fallacious Hope?
> He, though scathed at Ratisbon, poured on
> The tide of war o'er all thy plain, Bavare,
> Like the swollen Danube to the gates of Wien.
> But peace returns - the morning ray
> Beams on the Wallhalla, reared to science and the arts,
> For men renowned, of German fatherland.

(551) The Sun of Venice going to Sea

> Fair shines the morn, and soft the zephyrs blow,
> Venezia's fisher spreads his painted sail so gay
> Nor heeds the demon that in grim repose
> Expects his evening prey.

(553) Shade and Darkness – the Evening of the Deluge

> The moon put forth her sign of woe unheeded;
> But disobedience slept; the dark'ning Deluge closed around,
> And the last token came: the giant framework floated,
> The roused birds forsook their nightly shelters screaming,
> And the beasts waded to the ark.

(554) Light and Colour (Goethe's Theory) – the Morning after the Deluge - Moses writing the Book of Genesis

> The ark stood firm on Ararat; th'returning sun
> Exhaled earth's humid bubbles, and emulous of light,
> Reflected her lost forms, each in prismatic guise
> Hope's harbinger, ephemeral as the summer fly
> Which rises, flits, expands, and dies.

1845

(565) Venice, Evening, going to the Ball
 – *M.S. Fallacies of Hope.*

(566) Morning, returning from the Ball, St Martino
 – *M.S. Fallacies of Hope.*

(567) Venice - Noon
 – *M.S. Fallacies of Hope.*

(568) Venice-Sunset, a Fisher
 – *M.S. Fallacies of Hope.*

1846

(572) Queen Mab's Cave

> Thy Orgies, Mab, are manifold.

1847

(580) The Hero of a hundred Fights

> An idea suggested by the German invocation upon casting the bell: In England called tapping the furnace. – *M.S. Fallacies of Hope.*

1850

(586) Mercury sent to admonish Aeneas

> Beneath the morning mist,
> Mercury waited to tell him of his neglected fleet.

(587) Aeneas relating his Story to Dido

> Fallacious Hope beneath the moon's pale crescent shone,
> Dido listened to Troy being lost and won.

(588) The Visit to the Tomb

> The sun went down in wrath at such deceit.

(589) The Departure of the Fleet

> The orient moon shone on the departing fleet,
> Nemesis invoked, the priest held the poisoned cup.